Twilight Memories

Twilight Memories
Marking Time in a Culture of Amnesia

Andreas Huyssen

Routledge
New York and London

Published in 1995 by

Routledge
29 West 35 Street
New York, NY 10001

Published in Great Britain in 1995 by

Routledge
11 New Fetter Lane
London EC4P 4EE

Copyright © 1995 by Routledge

Printed in the United States of America

Library of Congress Cataloging-in-Publications Data

Huyssen, Andreas.
 Twilight Memories: marking time in a culture of america / Andreas Huyssen
 p. cm.
 Includes bibliographical references and index.
 ISBN HB 0 415 909341 1 — ISBN PB 0 415 90935 X
 1. Germany—Intellectual Life. 2. German—Civilization.
 3. Germany—History—1993–1945—Historiography. 4. Memory in literature.
 5. German literature—History and criticism.
 I. Title.
 DD260.3.H89 1994
 943.08—dc20 94–27439
 CIP

For Nina

Contents

Acknowledgments

Most of the essays in this book were previously published and appear here essentially unaltered. All of these essays were originally presented as papers, and their final form has benefited immeasurably from comments, criticisms, and, especially in the case of the political essays on recent German events, heated debate. I could not even begin here to acknowledge all those friends and colleagues in the United States and in Germany who have had a hidden hand in the writing and rewriting of this book. Nor could I give appropriate thanks to all those who provided me with the institutional spaces to test and to refine my ideas. A summary expression of gratitude will have to suffice, but it is no less genuine for that.

Chapters 2 and 6 were previously published in *New German Critique* 52 (Winter 1991) and 59 (Summer 1993); chapters 7 and the two parts of chapter 11 in *October* 46 (Fall 1988), 48 (Spring 1989), and 62 (Fall 1992); chapter 3 in *Discourse* 16.3 (Spring 1994); chapter 9 in *assemblage* 10 (December 1989); chapter 5 in *Modernity and the Text*, edited by David Bathrick and myself (New York: Columbia University Press, 1989); chapter 8 as a Foreword to Peter Sloterdijk, *Critique of Cynical Reason* (Minneapolis: University of Minnesota Press, 1987); chapter 10 in *In the Spirit of Fluxus*, published by the Walker Art Center, Minneapolis, in conjunction with the exhibition *In the Spirit of Fluxus* (1993); and chapter 12 in James E. Young, ed., *The*

Art of Memory: Holocaust Memorials in History (New York: Prestel Verlag and the Jewish Museum, New York, 1994). All materials are reproduced with permission.

My special thanks go to the students in my graduate seminars at Columbia whose intelligence, inquisitiveness, and dissatisfactions with the current state of the discipline continues to encourage me to pursue uncharted courses of investigation. My thanks also go to two of my fellow editors at *New German Critique,* Anson Rabinbach and David Bathrick who were always there when I needed them for intellectual and personal sustenance. Both were invaluable with their many detailed comments and criticisms on practically every chapter of the book. I am grateful to Rosalind Krauss for having enticed me, years ago when I first came to New York, into writing more about art than I would have dared to if left to my own devices. And I thank Bill Germano for being an enthusiastic and supportive editor. Mark Boren, Stewart Cauley, and Eric Zinner at Routledge deserve much credit for their meticulous care in steering the book through production.

I dedicate this book to my wife Nina Bernstein who not only came up with the title riding the West Side subway, but is still my best and most exacting copy editor. Her own work as an investigative reporter, giving voice to the forgotten and neglected, has not only inspired me over the years, it has given me perspectives on writing that no theory of representation could possibly match.

New York, January 1994

Introduction
Time and Cultural Memory At Our Fin de Siècle

You have to begin to lose your memory, if only in bits and pieces,

to realize that memory is what makes our lives.

Life without memory is no life at all ...

Our memory is our coherence, our reason, our feeling, even our action.

Without it, we are nothing ...

Luis Buñuel

Identities are the names we give to the different ways

we are positioned by, and position ourselves in,

the narratives of the past

Stuart Hall

I

As we approach the end of the twentieth century and with it the end of the millennium, our gaze turns backwards ever more frequently in an attempt to take stock and to assess where we stand in the course of time. Simultaneously, however, there is a deepening sense of crisis often articulated in the reproach that our culture is terminally ill with amnesia. Inevitably, comparisons are made with earlier ends of centuries, especially the last one with its sensibility of decadence, nostalgia, and loss that we deem symptomatic of a fin de siècle. One hundred years ago, however, this notorious malaise was also accompanied by a simultaneous upsurge of renewal and rejuvenation as a long period of economic recession and crisis was coming to an end. The end of the Victorian age, often glorified as one of bourgeois security and *bien-être*, ushered European societies into a frenzy of modernization that has not come to rest to this day. A comparison with the period around 1800 is even more telling. The end of the ancien régime in the French revolution and the even earlier end to British colonial rule in America produced emphatic visions of the future that captured the imagination of generations to come and gave shape to our world far into this century.

The major historical upheavals of 1989, exactly two centuries after the storming of the Bastille, have left us with few such projections for the future. Neither the Western victory in the Cold War nor German unification have given rise to sustained exuberance, and they certainly have not produced much political imagination with which to envision the next century. On the contrary, the imminent move beyond the year 2000, which only twenty-five years ago fired the imagination of American futurologists, fills few of us with confidence either about what the future has in store or about how, let alone if, the past will be remembered. The catastrophes haunting Los Angeles, that postmodern metropolis par excellence, and the fictional worlds of cutting-edge sci-fi films such as *Blade Runner* or *Total Recall* suggest more about the ways American culture imagines its future and deploys its memories than political projections about a new world order or a partnership for peace.

Of course, it is always precarious to predict the future, but looking at the state of the world in 1994, it seems very unlikely that the 1990s will be remembered as another *belle époque,* and given what followed only a few years after the last fin de siècle, the whole comparison is not very comforting to begin with. For this twentieth century was simultaneously a century of indescribable catastrophes and of ferocious hopes, and often enough the hopes themselves ended up legitimizing some dictatorship of the future (the pure race, the classless society, the pacified consumer paradise), turning a blind eye to persecution and mass destruction, voracious exploitation of resources and environment, migrations and dislocations of whole populations to an extent the world had never witnessed before.

As generational memory begins to fade and ever later decades of this modern century par excellence are becoming history or myth to ever more people, such looking back and remembering has to confront some difficult problems of representation in its relationship to temporality and memory. Human memory may well be an anthropological given, but closely tied as it is to the ways a culture constructs and lives its temporality, the forms memory will take are invariably contingent and subject to change. Memory and representation, then, figure as key concerns at this fin de siècle when the twilight settles around the memories of this century and their carriers, with the memories of the Holocaust survivors only being the most salient example in the public mind.

It does not require much theoretical sophistication to see that all representation—whether in language, narrative, image, or recorded sound—is based on memory. *Re*-presentation always comes after, even though some media will try to provide us with the delusion of pure presence. But rather than leading us to some authentic origin or giving us verifiable access to the real, memory, even and

especially in its belatedness, is itself based on representation. The past is not simply there in memory, but it must be articulated to become memory. The fissure that opens up between experiencing an event and remembering it in representation is unavoidable. Rather than lamenting or ignoring it, this split should be understood as a powerful stimulant for cultural and artistic creativity. At the other end of the Proustian experience, with that famous madeleine, is the memory of childhood, not childhood itself. If it were otherwise, we would probably not have *A la recherche du temps perdu.* The mode of memory is *recherche* rather than recuperation. The temporal status of any act of memory is always the present and not, as some naive epistemology might have it, the past itself, even though all memory in some ineradicable sense is dependent on some past event or experience. It is this tenuous fissure between past and present that constitutes memory, making it powerfully alive and distinct from the archive or any other mere system of storage and retrieval.[1]

The twilight of memory, then, is not just the result of a somehow natural generational forgetting that could be counteracted through some form of a more reliable representation. Rather, it is given in the very structures of representation itself. The obsessions with memory in contemporary culture must be read in terms of this double problematic. Twilight memories are both: generational memories on the wane due to the passing of time and the continuing speed of technological modernization, and memories that reflect the twilight status of memory itself. Twilight is that moment of the day that foreshadows the night of forgetting, but that seems to slow time itself, an in-between state in which the last light of the day may still play out its ultimate marvels. It is memory's privileged time.

II

The essays assembled in this book were written over a period of some seven years, following the wide-ranging debate about postmodernism of the early to mid-1980s. As discussions about postmodernism focused on issues of space, relegating the thematics of time and temporality to an earlier cultural moment of high modernism, I became increasingly interested in issues of time and memory as they keep haunting our present. The marking of time and memory in individual artists such as Kluge and Kiefer as well as the multiple traces of the past in the work of theorists of the postmodern such as Baudrillard (on McLuhan) and Sloterdijk (on Weimar) then led to broader questions about the status of memory in contemporary culture. Here I was particularly struck by the surprising popularity of the museum and the resurgence of the monument and the memorial as major modes of aesthetic, historical, and spatial expression. Architecture itself has

become ever more interested in site-memory and in inscribing temporal dimensions in spatial structures, most stunningly in Daniel Libeskind's Jewish Museum in Berlin which is currently under construction. In the political realm, the issues of memory and forgetting, memory and repression, memory and displacement resurfaced in the wake of German unification. There was the unresolved question of German nationalism and the acrimonious reevaluation of the past four decades of German culture, East and West, topics treated in the second and third essays of this collection.

Indeed, all of the essays are marked by time, and I attribute their sometimes visible, sometimes more subterranean interconnectedness to two factors. For me as a member of the first post-World War II generation growing up in West Germany, born in the Third Reich, but too late to have any conscious remembrances, the politics of memory in the German context has been a formative issue since adolescence. The current conjuncture in Germany, with its contested reorganization of cultural capital and realignment of national memory will certainly keep this issue in the forefront for some time to come.

Secondly, I have been interested for a long time in the effects of media on modern culture. The work of both Walter Benjamin and Theodor W. Adorno on art in the age of mechanical reproduction and on the culture industry had been energized by issues of memory and temporality, while diverging in its respective assessments of culture in the age of modernism, fascism, and communism. The critique of amnesia as terminal malady of capitalist culture was, after all, first articulated by Adorno in his work on the fetish character in music in the late 1930s and then again in the famous culture industry chapter of *Dialectic of Enlightenment*. While Adorno's and Benjamin's analyses pertain to another, now historical stage of modern culture, the issues of memory and amnesia have been exacerbated by the further development of media technologies since their time, affecting politics and culture in the most fundamental ways.

Thus the essays in this volume are about cultural memory as it is articulated in institutions, in public debates, in theory, in art, and in literature. Time and again, the essays reach back to earlier moments of twentieth-century culture (the essays on Rilke and Jünger, but also the work on Fluxus and on McLuhan and the reflections on the modern museum). Only the essay on Baudrillard deals explicitly with media theory, but the issue of media—and this is assumed throughout—is central to the way we live structures of temporality in our culture. In his work on Baudelaire, Walter Benjamin once said that the mass was the agitated veil through which Baudelaire saw and represented Paris, the capital of nineteenth-century modernity. Similarly I would suggest that in this book the media

are the hidden veil through which I am looking at the problem of cultural memory and the structures of temporality at the end of the twentieth century. The struggle for memory is ultimately also a struggle for history and against high-tech amnesia. Like Alexander Kluge, I worry about the destructive power of the media as much as I appreciate, even get excited about their potential for new forms of communication. The high-tech world we have entered is neither apocalypse nor panacea. It has elements of both, and it does have profound effects on the ways we think and live cultural memory.

Some of these effects have led to a major and puzzling contradiction in our culture. The undisputed waning of history and historical consciousness, the lament about political, social, and cultural amnesia, and the various discourses, celebratory or apocalyptic, about *posthistoire* have been accompanied in the past decade and a half by a memory boom of unprecedented proportions. There are widespread debates about memory in the cultural, social, and natural sciences.[2] In an age of emerging supranational structures, the problem of national identity is increasingly discussed in terms of cultural or collective memory rather than in terms of the assumed identity of nation and state. France designated the year 1980 as *l'année du patrimoine* (heritage year) and England, independently, celebrated its national heritage that very same year. Even Israel, where the memory of the Shoah has always played a crucial political role for state and nation, has witnessed a marked intensification of its memorial culture, and Germany (then West Germany), gritting teeth and dutifully contrite, went through a never-ending sequence of Nazi related 40th and 50th anniversaries in the 1980s that produced a number of fascinating public debates about German identity as well as the embarrassment of Bitburg and the *Historikerstreit* (historians' debate). All that time, both the United States and Europe kept building museums and memorials as if haunted by the fear of some imminent traumatic loss.

But the concern with memory went far beyond the official political or cultural sphere. Struggles for minority rights are increasingly organized around questions of cultural memory, its exclusions and taboo zones. Other memories and other stories have occupied the foreground in the raging identity debates of the 1980s and early 1990s over gender, sexuality, and race. Migrations and demographic shifts are putting a great deal of pressure on social and cultural memory in all Western societies, and such public debates are intensely political. Monolithic notions of identity, often shaped by defensiveness or victimology, clash with the conviction that identities, national or otherwise, are always heterogeneous and in need of such heterogeneity to remain viable politically and existentially. How do we understand this newest obsession with memory? How do we

evaluate the paradox that novelty in our culture is ever more associated with memory and the past rather than with future expectation?[3] Clearly, it is related to the evident crisis of the ideology of progress and modernization and to the fading of a whole tradition of teleological philosophies of history. Thus, the shift from history to memory represents a welcome critique of compromised teleological notions of history rather then being simply anti-historical, relativistic, or subjective. Memory as a concept rather than merely material for the historian seems increasingly to draw literary critics, historians, and social scientists together, while a more traditional concept of history, certainly in some prominent discourses of literary theory, just gives rise to disciplinary trench warfare. The privileging of memory can be seen as our contemporary version of Nietzsche's attack on archival history, a perhaps justified critique of an academic apparatus producing historical knowledge for its own sake, but often having trouble maintaining its vital links with the surrounding culture. Memory, it is believed, will bridge that gap. There is a double paradox in this privileging of memory today. Our mnemonic culture rejects the idea of the archive while depending on the archive's contents for its own sustenance. And it marks its vital difference from the archive by insisting on novelty, the novelty of no longer fetishizing the new.

My hypothesis, therefore, is that the current obsession with memory is not simply a function of the fin de siècle syndrome, another symptom of postmodern pastiche. Instead, it is a sign of the crisis of that structure of temporality that marked the age of modernity with its celebration of the new as utopian, as radically and irreducibly other. When Nietzsche stated in the foreword to the second of his *Untimely Meditations* that we are all suffering from a consuming historical fever, he was arguing against the past as burden, against archival and monumental history, and he attacked the stifling historicism of his times in the belief that a more vital form of history could invigorate modern culture. That is what *The Birth of Tragedy* and some of Nietzsche's other early writings were all about. In those texts, and especially in the meditation on the uses and abuses of history, Nietzsche was a utopian modernist, standing at the beginning of an intellectual trajectory from Bergson to Proust, from Freud to Benjamin, that articulated the classical modernist formulations of memory as alternative to the discourses of objectifying and legitimizing history, and as cure to the pathologies of modern life. Here memory was always associated with some utopian space and time beyond what Benjamin called the homogeneous empty time of the capitalist present.

That, however, is no longer our situation. Nietzsche's polemic addressed the hypertrophy of historical consciousness in public culture, while our symptom

would seem to be its atrophy. Certainly, there is evidence for the view that capitalist culture with its continuing frenetic pace, its television politics of quick oblivion, and its dissolution of public space in ever more channels of instant entertainment is inherently amnesiac. Nobody would claim today that we have too much history. But how does one reconcile the amnesia reproach, articulated already in the inter-war period by philosophers as different as Heidegger and Adorno, with the observation that simultaneously our culture is obsessed with the issue of memory? Clearly, Adorno's brilliant Marxist critique of the freezing of memory in the commodity form still addresses an important dimension of amnesia today, but, in its reductive collapsing of commodity form and psychic structure, it fails to give us the tools to explain the mnemonic desires and practices that pervade our culture.

The difficulty of the current conjuncture is to think memory and amnesia together rather than simply to oppose them. Thus our fever is not a consuming historical fever in Nietzsche's sense, which could be cured by productive forgetting. It is rather a mnemonic fever that is caused by the virus of amnesia that at times threatens to consume memory itself. In retrospect we can see how the historical fever of Nietzsche's times functioned to invent national traditions, to legitimize the imperial nation states, and to give cultural coherence to conflictive societies in the throes of the Industrial Revolution. In comparison, the mnemonic convulsions of our culture seem chaotic, fragmentary, and free-floating. They do not seem to have a clear political or territorial focus, but they do express our society's need for temporal anchoring when in the wake of the information revolution, the relationship between past, present, and future is being transformed. Temporal anchoring becomes even more important as the territorial and spatial coordinates of our late twentieth-century lives are blurred or even dissolved by increased mobility around the globe.

Indeed, I would argue that our obsessions with memory function as a reaction formation against the accelerating technical processes that are transforming our *Lebenswelt* (lifeworld) in quite distinct ways. Memory is no longer primarily a vital and energizing antidote to capitalist reification via the commodity form, a rejection of the iron cage homogeneity of an earlier culture industry and its consumer markets. It rather represents the attempt to slow down information processing, to resist the dissolution of time in the synchronicity of the archive, to recover a mode of contemplation outside the universe of simulation and fast-speed information and cable networks, to claim some anchoring space in a world of puzzling and often threatening heterogeneity, non-synchronicity, and information overload. This argument is most fully developed in the essays about the

museum as mass medium and about the monument.

At stake in the surprising memory boom of the past decade and a half is indeed a reorganization of the structure of temporality within which we live our lives in the most technologically advanced societies of the West. Historians such as Reinhart Koselleck have shown how the specific tripartite structure of past-present-future, in which the future is asynchronous with the past, arose at the turn of the seventeenth to the eighteenth century.[4] The way our culture thinks about time is far from natural even though we may experience it as such. In comparison with earlier Christian ages that cherished tradition and thought of the future primarily and rather statically, even spatially, as the time of the Last Judgment, modern societies have put ever more weight on thinking the secular future as dynamic and superior to the past. In such thinking the future has been radically temporalized, and the move from the past to the future has been linked to notions of progress and perfectibility in social and human affairs that characterize the age of modernity as a whole. Often enough this modern structure of temporality, of living and experiencing time, has been criticized as deluded or dangerous, especially in the tradition of romantic anti-capitalism and critiques of the Enlightenment. In our century, different political versions of some better future have done fierce battle with each other, but the quintessentially modern notion of the future as progress or utopia was shared by all. It no longer is.

Thus we are not just experiencing another bout of pessimism and doubt of progress, but we are living through a transformation of this modern structure of temporality itself. Increasingly in recent years, the future seems to fold itself back into the past. The collapse of the post-World War II status quo that carried with it its own register of a rather stable sense of temporality and global zoning has resurrected the specters of the past that are now haunting Europe. The twenty-first century looms like a repetition: one of bloody nationalisms and tribalisms, of religious fundamentalism and intolerance that we thought had been left behind in some darker past. The increasing two-way interpenetration of First and Third World adds yet another dimension. Rather than moving together, if at different paces, into the future, we have accumulated so many non-synchronicities in our present that a very hybrid structure of temporality seems to be emerging, one that has clearly moved beyond the parameters of two and more centuries of European-American modernity. Some have spoken about a "global postmodern" to capture this novel and exhilarating diversity, but the term remains problematic for two reasons. The old relations between center and peripheries known from an earlier modernity are by no means simply obsolete today and the structures of an emergent postmodernity are very unevenly developed throughout the

world. And yet, for the cultures of Western societies the "global postmodern" marks a significant shift in their cultural memory which can no longer be safely secured along the traditional axes of nation and race, language and national history.

At the same time, modernity's engine of the future, namely technological development, continues at its accelerated pace ushering us into a world of information networks that function entirely according to principles of synchronicity while providing us with multiple images and narratives of the non-synchronous. The paradox is that we still harbor high-tech fantasies for the future, but the very organization of this high-tech world threatens to make categories like past and future, experience and expectation, memory and anticipation themselves obsolete. The jumble of the non-synchronous, the recognition of temporal difference in the real world thus clashes dramatically with the draining of time in the world of information and data banks. But the borders between real world and its construction in information systems are of course fluid and porous. The more we live with new technologies of communication and information cyber-space, the more our sense of temporality will be affected. Thus the waning of historical consciousness is itself a historically explainable phenomenon. The memory boom, however, is a potentially healthy sign of contestation: a contestation of the informational hyperspace and an expression of the basic human need to live in extended structures of temporality, however they may be organized. It is also a reaction formation of mortal bodies that want to hold on to their temporality against a media world spinning a cocoon of timeless claustrophobia and nightmarish phantasms and simulations. In that dystopian vision of a high-tech future, amnesia would no longer be part of the dialectic of memory and forgetting. It will be its radical other. It will have sealed the very forgetting of memory itself: nothing to remember, nothing to forget.

Time and Memory

The battle against the museum has been an enduring trope of modernist culture. Emerging in its modern form around the time of the French Revolution that first made the Louvre into a museum, the museum has become the privileged institutional site of the three centuries old *"querelle des anciens et des modernes"* (quarrel of the ancients and the moderns). It has stood in the dead eye of the storm of progress serving as catalyst for the articulation of tradition and nation, heritage and canon, and has provided the master maps for the construction of cultural legitimacy in both a national and a universalist sense.[1] In its disciplinary archives and collections, it helped define the identity of Western civilization by drawing external and internal boundaries that relied as much on exclusions and marginalizations as it did on positive codifications.[2] At the same time, the modern museum has always been attacked as a symptom of cultural ossification by all those speaking in the name of life and cultural renewal against the dead weight of the past.

The recent battle between moderns and postmoderns has only been the latest instance of this *querelle*. But in the shift from modernity to postmodernity, the

museum itself has undergone a surprising transformation: perhaps for the first time in the history of avant-gardes, the museum in its broadest sense has changed its role from whipping boy to favorite son in the family of cultural institutions. This transformation is of course most visible in the happy symbiosis between postmodern architecture and new museum buildings. The success of the museum may well be one of the salient symptoms of Western culture in the 1980s: ever more museums were planned and built as the practical corollary to the "end of everything" discourse.[3] The planned obsolescence of consumer society found its counterpoint in a relentless museummania. The museum's role as site of an elitist conservation, a bastion of tradition and high culture gave way to the museum as mass medium, as a site of spectacular mise-en-scène and operatic exuberance.

This surprising role change calls for reflection, as it seems to have a profound impact on the politics of exhibiting and viewing. Put more concretely: the old dichotomy between permanent museum collection and temporary exhibit no longer pertains at a time when the permanent collection is increasingly subject to temporary rearrangement and long distance travelling, and temporary exhibits are enshrined on video and in lavish catalogues, thus constituting permanent collections of their own which can in turn be circulated. Strategies such as collecting, citing, and appropriating have proliferated in contemporary aesthetic practices, often of course accompanied by the declared intent to articulate a critique of the museum's privileged and pivotal concepts such as uniqueness and originality. Not that such procedures are entirely novel, but their recent foregrounding points to a strikingly broad cultural phenomenon that has been described adequately with the ugly term "musealization."[4]

Indeed, a museal sensibility seems to be occupying ever larger chunks of everyday culture and experience. If you think of the historicizing restoration of old urban centers, whole museum villages and landscapes, the boom of flea markets, retro fashions, and nostalgia waves, the obsessive self-musealization per video recorder, memoir writing and confessional literature, and if you add to that the electronic totalization of the world on data banks, then the museum can indeed no longer be described as a single institution with stable and well-drawn boundaries. The museum in this broad amorphous sense has become a key paradigm of contemporary cultural activities.

The new museum and exhibition practices correspond to changing audience expectations. Spectators in ever larger numbers seem to be looking for emphatic experiences, instant illuminations, stellar events, and blockbuster shows rather than serious and meticulous appropriation of cultural knowledge. And yet the

question remains: how do we explain this success of the musealized past in an age that has been accused time and again for its loss of a sense of history, its deficient memory, its pervasive amnesia? An older sociological critique of the museum as institution that saw its function as reinforcing "among some people the feeling of belonging and among others the feeling of exclusion"[5] does not seem to be quite pertinent any longer for the current museum scene which has buried the museum as temple for the muses in order to resurrect it as a hybrid space somewhere between public fair and department store.

The Old Museum and the Symbolic Order

To begin with a properly museal gesture, we must remember that, like the discovery of history itself in its emphatic sense with Voltaire, Vico, and Herder, the museum is a direct effect of modernization rather than somehow standing on its edge or even outside it. It is not the sense of secure traditions that marks the beginnings of the museum, but rather their loss combined with a multi-layered desire for (re)construction. A traditional society without a secular teleological concept of history does not need a museum, but modernity is unthinkable without its museal project. Thus it is perfectly within the logic of modernity that a museum of modern art was founded when modernism had not yet run its course: New York's MOMA in 1929.[6] One might even suggest that the need for a modern museum already inhered in Hegel's reflections on the end of art, articulated over a hundred years earlier. Except, of course, that the first such museum could only be built in the New World, where the new itself seemed to age at a faster pace than it did on the old continent.

Ultimately, however, the differences in the pace of obsolescence between Europe and the United States were only differences of degree. As the acceleration of history and culture since the eighteenth century has made an increasing number of objects and phenomena, including art movements, obsolete at ever faster rates, the museum emerged as the paradigmatic institution that collects, salvages, and preserves that which has fallen to the ravages of modernization. But in doing so, it inevitably will construct the past in light of the discourses of the present and in terms of present-day interest. Fundamentally dialectical, the museum serves both as burial chamber of the past—with all that entails in terms of decay, erosion, forgetting—and as site of possible resurrections, however mediated and contaminated, in the eyes of the beholder. No matter how much the museum, consciously or unconsciously, produces and affirms the symbolic order, there is always a surplus of meaning that exceeds set ideological boundaries, opening spaces for reflection and counter-hegemonic memory.

This dialectical nature of the museum, which is inscribed into its very proce-
dures of collecting and exhibiting, is missed by those who simply celebrate it as
guarantor of unquestioned possessions, as bank vault of Western traditions and
canons, as site of appreciative and unproblematic dialogue with other cultures
or with the past. But neither is it fully recognized by those who attack the
museum in Althusserian terms as ideological state apparatus whose effects are
limited to serving ruling class needs of legitimation and domination. True
enough, the museum has always had legitimizing functions and it still does. And
if one looks at the origins and history of collections, one can go further and
describe the museum from Napoleon to Hitler as a beneficiary of imperialist
theft and nationalist self-aggrandizement. In the case of so-called natural history
museums especially, the link between the collectors' salvage operation and the
exercise of raw power, even genocide, is palpably there in the exhibits themselves:
Madame Tussauds of otherness.

I don't want to relativize this ideological critique of the museum as a legitimizing
agent for capitalist modernization and as a triumphalist showcase for the loot of
territorial expansion and colonialization. This critique is as valid for the imperial past
as it is in the age of corporate sponsorship: witness Hans Haacke's brilliant satire on
the link between museum culture and petro-capital in "Metromobiltan" (1985).
What I am arguing, however, is that, in a different register and today more than ever,
the museum also seems to fulfill a vital anthropologically rooted need under modern
conditions: it enables the moderns to negotiate and to articulate a relationship to the
past that is always also a relationship to the transitory and to death, our own
included. As Adorno once pointed out, museum and mausoleum are associated by
more than just phonetics.[7] Against the anti-museum discourse still dominant among
intellectuals, one might even see the museum as our own memento mori, and as
such, a life-enhancing rather than mummifying institution in an age bent on the
destructive denial of death: the museum thus as a site and testing ground for reflec-
tions on temporality and subjectivity, identity and alterity.

The exact nature of what I take to be the moderns' and, for that matter, post-
moderns' anthropological need for the museum is open to debate. All I want to
emphasize here is that the institutional critique of the museum as enforcer of
the symbolic order does not exhaust its multiple effects. The key question here
is of course whether the new museum culture of spectacle and mise-en-scène
can still fulfill such functions, or whether the much discussed liquidation of the
sense of history and the death of the subject, the postmodern celebration of
surface versus depth, speed versus slowness has deprived the museum of its
specific aura of temporality.[8] However one may answer that question in the

end, the purely institutional critique along the lines of power-knowledge-ideological apparatus, which operates from the top down, needs to be complemented by a bottom-up perspective that investigates spectator desire and subject inscriptions, audience response, interest groups, and the segmentation of overlapping public spheres addressed by a large variety of museums and exhibition practices today. Such a sociological analysis, however, is not what I will offer, as I am interested in broader cultural and philosophical reflections regarding the changing status of memory and temporal perception in contemporary consumer culture.

At any rate, the traditional museum critique and its postmodern variants seem rather helpless at a time when more museums are founded and more people flock to museums and exhibitions than ever before. The death of the museum, so valiantly announced in the 1960s, was evidently not the last word. Thus, it simply will not do to denounce the recent museum boom as expressing the cultural conservatism of the 1980s which presumably has brought back the museum as institution of canonical truth and cultural authority, if not authoritarianism. The reorganization of cultural capital as we experienced it in the 1980s in the debates about postmodernism, multiculturalism and cultural studies, and as it has affected museum practices in multiple ways cannot be reduced to one political line. Nor is it enough to criticize new exhibition practices in the arts as spectacle and mass entertainment the primary aim of which is to push the art market from craze to ecstasy to obscenity. While the increasing commodification of art is indisputable, the commodity critique alone is far from yielding aesthetic or epistemological criteria on how to read specific works, artistic practices, or exhibitions. Nor is it able to go beyond an ultimately contemptuous view of audiences as manipulated and reified culture cattle. All too often, such attacks are indebted to vanguardist/avant-gardist positions in politics and art which have become themselves frail, exhausted and consumptive in recent years.

Avant-garde and the Museum

The problematic nature of the concept of avant-gardism, its implications in the ideology of progress and modernization, its complex complicities with fascism and Third International Communism, have been discussed extensively in recent years. The evolution of postmodernism since the 1960s is not understandable without an acknowledgment of how first it revitalized the impetus of the historical avant-garde and subsequently delivered that ethos up to a withering critique.[9] The debate about the avant-garde is indeed intimately linked to the

debate about the museum, and both are at the core of what we call the post-modern. It was after all the historical avant-garde—futurism, dada, surrealism, constructivism, and the avant-garde groupings in the early Soviet Union—that battled the museum most radically and relentlessly by calling (in different ways) for the elimination of the past, by practicing the semiological destruction of all traditional forms of representation, and by advocating a dictatorship of the future. For the avant-gardist culture of manifestos with their rhetoric of total rejection of tradition and the euphoric, apocalyptic celebration of an altogether different future that was thought to be on the horizon, the museum was indeed a plausible scapegoat.[10] It seemed to embody all of the monumentalizing, hegemonic, and pompous aspirations of the bourgeois age that had ended in the bankruptcy of the Great War. The avant-garde's museumphobia, which was shared by iconoclasts on the left and right, is understandable if one remembers that the discourse of the museum then took place within a framework of radical social and political change, especially in Russia in the wake of the bolshevik revolution and in Germany after the lost war. A culture that believed in the breakthrough toward an utterly new life in a revolutionized society could not be expected to have much use for the museum.

This avant-gardist rejection of the museum has remained a staple in intellectual circles to this day.[11] The wholesale critique of the museum has not yet liberated itself from certain avant-gardist presuppositions that were rooted in a historically specific relationship between tradition and the new that was different from ours. Few who have written on the museum in the 1980s have thus argued that we need to rethink (and not just out of a desire to deconstruct) the museum beyond the binary parameters of avant-garde versus tradition, museum versus modernity (or postmodernity), transgression versus co-option, left cultural politics versus neoconservatism. Of course, there is a place for institutional critiques of the museum, but they should be site-specific rather than global in that avant-gardist sense.[12] For some time now and for good postmodern reasons, we have become suspicious of certain radical claims of avant-gardism, revived, as they were, to a considerable extent in the 1960s. I would suggest that the avant-garde's museumphobia, its collapsing of the museal project with mummification and necrophilia is one such claim that belongs itself in the museum. We need to move beyond various forms of the old museum critique which are surprisingly homogeneous in their attack on ossification, reification, and cultural hegemony even if the focus of the attack may be quite different now from what it once was: then the museum as bastion of high culture, now, very differently, as the new kingpin of the culture industry.

Alternatives: The Museum and the Postmodern

As we are groping toward redefining the tasks of the museum beyond the museum/modernity dialectic, a look further back into the nineteenth century, the prehistory of avant-gardism, may be useful. This earlier phase of modernity reveals a more complex attitude toward the museum than that held by the historical avant-garde, and to that extent it helps free us from the avant-gardist prejudice without delivering us to the insidious cultural conservatism of recent years. A few brief comments will have to suffice. The German romantics simultaneously attacked the museal gaze of the eighteenth-century classicists and engaged themselves, quite consciously so, in their own museal project of gigantic proportions: collecting ballads, folklore, and folktales, obsessively translating works from different ages and different European and Oriental literatures, and privileging the Middle Ages as site of a redeemed culture and future utopia, all in the name of a radically new, post-classical modern world. In their time, the romantics constructed an alternative museum, based on their pressing need to collect and to celebrate precisely those cultural artifacts that had been marginalized and excluded by the dominant culture of the preceding century. The construction of the cultural identity of modern Germany went hand in hand with museal excavations that later formed the bedrock of German nationalism. The selectively organized past was recognized as indispensable for the construction of the future.

Similarly, Marx and Nietzsche were very much concerned with alternative, anti-hegemonic views of history: their very different celebrations of the storm of progress, of liberation and freedom, and the emergence of a new culture were always coupled with an acknowledgment of the need for a lifeline to the past. More than that: only historical understanding and reconstruction guaranteed for either that the past as burden and nightmare, as monumentally stifling or archivally mummified could be shaken off. Texts such as *The Eighteenth Brumaire* or the introduction to the *Grundrisse* as well as *The Birth of Tragedy* or the second of the *Untimely Meditations* on the uses and abuses of history demonstrate that they fully understood the dialectic of innovative drive and museal desire, the tension between the need to forget and the desire to remember. Marx and Nietzsche's texts are themselves testimonies to the productivity of a thought that locates itself in that tension between tradition and anticipation. They knew that the struggle for the future cannot operate e*x nihilo,* that it needs memory and remembrance as vital energizers.

Of course, one could suggest that despite claims to the contrary, the museal gaze was even present within the avant-garde itself. Apart from the dependence on a shared image of the bourgeois culture one rejected, we might think of the

surrealists' play with obsolete objects as sites of illumination, as interpreted by Benjamin. We might see Malevich's black square as part of the tradition of the icon rather than a total break with representation. Or we might recall Brecht's dramaturgical practice of historicizing and estranging, which achieves its effects by inscribing a relationship to the past in order to overcome it. The examples could be multiplied. However far one might wish to push such an argument, it does not change the basic fact that avant-gardism is unthinkable without its pathological fear of the museum. The fact that surrealism and all the other avant-garde movements themselves ended up in the museum only goes to show that in the modern world nothing escapes the logic of musealization. But why should we see that as failure, as betrayal, as defeat? The psychologizing argument advanced by some, that the avant-garde's hatred for the museum expressed the deep-seated and unconscious fear of its own eventual mummification and ultimate failure, is an argument made with the benefit of hindsight, and it remains locked into the ethos of avant-gardism itself. Since the late 1950s, the death of the avant-garde *in* the museum has become a much cited trope. Many have seen it as the ultimate victory of the museum in this cultural battle, and, on this view, the many Museums of Contemporary Art, all projects of the post-war period, have only added insult to injury. But victories tend to imprint their effects on the victor as much as on the vanquished, and one may well want to investigate the extent to which the musealization of the avant-garde's project to cross the boundaries between art and life has actually helped to bring down the walls of the museum, to democratize the institution, at least in terms of accessibility, and to facilitate the recent transformation of the museum from fortress for the select few to mass medium, from treasury for enshrined objects to performance site and mise-en-scène for an ever larger public.

The fate of the avant-garde is tied to the recent transformation of the museum in another paradoxical way. The waning of avant-gardism as dominant ethos of aesthetic practices since the 1970s has also contributed to the increasing (though of course not pervasive) blurring of boundaries between museum and exhibition projects which seems to characterize the museum landscape these days. Ever more frequently, museums get into the business of temporary exhibitions. A number of auteurist exhibitions in the 1980s were presented as museums: Harald Szeemann's Museum of Obsessions, Claudio Lange's Museum of the Utopias of Survival, Daniel Spoerri and Elisabeth Plessen's Musée sentimental de Prusse. While some exhibition practitioners will still hold on to the old dichotomy, fearing the museum like the kiss of death, museum curators increasingly take on functions formerly considered to lie in the domain of the temporary exhibition

such as criticism, interpretation, public mediation, even mise-en-scène. The acceleration within the curator's job description is even grammatically indicated: there now is a verb "to curate," and it is precisely not limited to the traditional functions of the "keeper" of collections. On the contrary, to curate these days means to mobilize collections, to set them in motion within the walls of the home museum and across the globe as well as in the heads of the spectators.

My hypothesis would be that in the age of the postmodern the museum has not simply been restored to a position of traditional cultural authority, as some critics would have it, but that it is currently undergoing a process of transformation that may signal, in its own small and specific way, the end of the traditional museum/modernity dialectic. Put hyperbolically, the museum is no longer simply the guardian of treasures and artifacts from the past discreetly exhibited for the select group of experts and connoisseurs; no longer is its position in the eye of the storm, nor do its walls provide a barrier against the world outside.

Banners and billboards on museum fronts indicate how close the museum has moved to the world of spectacle, of the popular fair and mass entertainment. The museum itself has been sucked into the maelstrom of modernization: museum shows are managed and advertised as major spectacles with calculable benefits for sponsors, organizers, and city budgets, and the claim to fame of any major metropolis will depend considerably on the attractiveness of its museal sites. Within the institution, the position of museum director is ever more frequently split into the different functions of artistic director and budget director. The long-standing but often hidden intimacy between culture and capital is becoming ever more visible, not to say blatant, and, as Jürgen Habermas has observed, a new intimacy has developed in recent years between culture and politics, realms which a now obsolete cold war ideology went to great contortions to keep apart.[13]

Of course, this new and public politicization of the museum is highly suspect, but it can also be turned to productive use. Thus it strikes me as a failure of dialectical thinking if the same critics who, at an earlier time, went to great lengths to lament the ideological staying power of the autonomy aesthetic and who insisted that no art can ever avoid the inscriptions and effects of the political now shed tears over the blatant and crude politicization of art and culture in the current American *Kulturkampf* (culture war).

There are, after all, contradictions. On the one hand, the new politics of culture clearly harnesses the museum to improve a city or company image: Berlin and New York need this kind of image help as much as Mobil or Exxon (two major sponsors of 1980s blockbusters in the United States) and in both

cities museum politics has become a matter of high public interest. The museum is pressured to serve the tourist industry with its benefits to urban economies, even to advance party politics, as when Chancellor Helmut Kohl planned to donate a museum of German history to Berlin as part of his effort to nurture a "normalized" national identity for the Germans, to sanitize Germany's past.[14] On the other hand, this new museum politics also decapitates traditional strategies that safeguarded the exclusionary and elite nature of the museum. Thus the myths of aesthetic autonomy and scientific objectivity of museum collections can no longer be used by anyone with a straight face against those who, with persuasive political arguments, claim museum space for aspects of past and present culture repressed, blocked out, or marginalized by traditional museum practice. There has been slow but important progress in the past decade in the tracings of hidden and repressed pasts, the reclaiming of underrepresented or falsely represented traditions for the purposes of current political struggles, which are always also struggles for multilayered cultural identity and forms of self-understanding. New cultural and organizational networks have been created both within and without such cultural institutions as the museum or the academy. It is a great irony that Walter Benjamin's often cited demand to brush history against the grain and to wrest tradition away from conformism has been heeded at a time when the museum itself bought into the capitalist culture of spectacle.

There are yet other ways in which the new intimacy between culture and politics can open up avenues for alternative museum practices. Think of the old quality argument, often advanced by traditionalist critics in order to marginalize the art and culture of minority groups or peripheral territories. This kind of argument is losing ground in an age that does not offer any clear consensus as to what actually belongs in a museum. Indeed, the quality argument collapses once the documentation of everyday life and of regional cultures, the collecting of industrial and technological artifacts, furniture, toys, clothes, and so forth becomes an ever more legitimate museal project, as it has in recent years. Ironically again, it may have been the avant-gardist blurring of the boundaries between art and life, high culture and its various others, that has significantly contributed to the falling of the walls of the museum. Surely, Adorno was quite prescient when, almost forty years ago, he observed: "The process that delivers every artwork up to the museum . . . is irreversible."[15] But he could hardly have foreseen the extent of institutional changes wrought on the museum during the 1970s and 1980s. Nor could he have intimated that what to him had to appear as the victory of the museum over the avant-garde might in the end turn out to

be a victory of the avant-garde over the museum, even though not in the way the avant-garde hoped for it. A Pyrrhic victory, to be sure, and yet a victory.

The Lure of Polemics

Of course, the recent museummania and exhibition craze has its downside, and it is tempting to polemicize. Take acceleration: the speed with which the work of art moves from studio to collector, to dealer to museum to retrospective, and not always in this order, has been dramatically increased. As in all acceleration processes of this kind, some of the stages have been tendentially victimized by this vertiginous speed. Thus the distance between collector and dealer seems to move toward a vanishing point, and given the increasingly poor performance of museums at Sotheby's or Christie's, some would cynically argue that the museum is left in the cold while art itself is moving toward the vanishing point: the work disappearing into a bank deposit and emerging into visibility only when it is put back on the auction block. The main function left to the museum in this process is to validate the work of a few young super-artists (Schnabel, Salle, Koons come to mind) in order to supply the market, to drive up the price and deliver the trademark of young genius to the auction banks. Thus the museum helps put the price of art out of its own reach. And even though the market is no longer quite as overheated as in the 1980s, only a financial crash, it seems, could prevent the further implosion of art via speculative money and museal asset management.

Acceleration has also affected the speed of the bodies passing in front of the exhibited objects. The disciplining of bodies in the show in the interest of the growth of visitor statistics works with such subtle pedagogic tools as the walkman tour. For those refusing to be put into a state of active slumber by the walkman, the museum applies the more brutal tactics of overcrowding which in turn results in the invisibility of what one has come to see: this new invisibility of art as the latest form of the sublime. And further: just as in our metropolitan centers the flaneur, an outsider already in Baudelaire's time, has been replaced by the marathon runner, the only place where the flaneur still had a hide-out, namely the museum, is increasingly turned into an analogue of Fifth Avenue at rush hour—at a somewhat slower pace, to be sure, but who would want to bet on the unlikelihood of a further speed-up? Perhaps we should expect the museum marathon as the cultural innovation of the impending fin-de-siècle.

Acceleration, of course, has also occurred in the foundation of new museums all through the 1980s, the expansion of venerable old ones, the marketing of exhibition related T-shirts, posters, Christmas cards and repro-preciosities. The

original artwork has become a device to sell its multiply-reproduced derivatives; reproducibility turned into a ploy to auraticize the original after the decay of aura, a final victory of Adorno over Benjamin. The shift toward show business seems irreversible. Contemporary art is delivered to the museum in the manner of in-time production, the museum itself is delivered to the postmodern culture net, the world of spectacle. What, after all, is the difference between the Rolling Stones' blown-up giant honky tonk woman in their show *Steel Wheels* and the larger than life femme fatale nude in gold, taken from a Gustav Klimt painting, that adorned the roof of Vienna's Künstlerhaus at the occasion of the 1985 exhibit of turn-of-the-century Viennese art and culture!

As one gives in to the temptation to polemicize, one tends to overlook the risk that such polemics may lead straight back to a nostalgia for the old museum, as the place of serious contemplation and earnest pedagogy, the leisure of the flaneur and the arrogance of the connoisseur. One may even perversely long for the museum tourism of the 1950s which was able to "do the Louvre" in ten minutes: Venus de Milo, Mona Lisa and out again, a utopian dream for today's multitudes forced to wait outside the infamous pyramid in the Louvre's courtyard. Surely, the rush of the culture masses into the museum must not be mistaken for the ultimate fulfillment of the call of the 1960s to democratize culture. Nor, however, should it be vilified. The old culture industry reproach, now levelled against the former guardian of high culture, not only has to deny the undeniable fascination exerted by the new and spectacular exhibitions. It also hides the inner stratification and heterogeneity of spectator interests and of exhibition practices. Polemics against the newly found reconciliation between masses and muses skirt the basic issue of how to explain the popularity of the museum, the desire for exhibitions, for cultural events and experiences which cuts across social classes and cultural groups. It also prevents reflection on how to use this desire, this fascination, without giving in unconditionally to instant entertainment and blockbuster exhibitionism. For desire there is, no matter how much the culture industry may stimulate, entice, seduce, manipulate, and exploit. This desire needs to be taken seriously as a symptom of cultural change. It is something that is alive in our contemporary culture and should be worked into exhibition projects in productive ways. It is not exactly a new idea to suggest that entertainment and spectacle can function in tandem with complex forms of enlightenment in aesthetic experience. It may be more difficult to define terms like "aesthetic" and "experience" at a time when both terms have fallen victim to the populist pieties of the anti-aesthetic and the ecstasies of simulation. At any rate, the attractions of the spectacular

show—whether it be of Egyptian mummies, historical figures, or contemporary art—must be explained, not dismissed.

Three Explanatory Models

It seems to me that there are three fairly distinct, though partially overlapping and competing models that seek to make sense of the museum and exhibition mania of recent years. First there is the hermeneutically-oriented culture-as-compensation model developed by a number of neoconservative philosophers in Germany, who go back to Arnold Gehlen's social philosophy, Gadamer's hermeneutics of tradition, and Joachim Ritter's philosophical thesis that the erosion of tradition in modernity generates organs of remembrance such as the humanities, societies for historical preservation, and the museum.[16] Secondly, there is the poststructuralist and secretly apocalyptic theory of musealization as terminal cancer of our fin-de-siècle as articulated by Jean Baudrillard and Henri Pierre Jeudy. And thirdly, least developed but most suggestive, there is the more sociologically and Critical-Theory-oriented model that argues the emergence of a new stage of consumer capitalism and calls it, untranslatably, *Kulturgesellschaft*. All three models are symptomatic products of the 1980s, not only in the sense that they seek to reflect empirical changes in the culture of museums and exhibitions, which they all do, but also in the sense that they reflect the cultural and political debates of the 1980s and offer disparate, even conflicting views on contemporary culture and its relationship to the body politic. I do not think any of these models can make an overriding claim on truth, but that is not a deficiency to be remedied by some as yet-to-be-articulated meta-theory. The lack of, or rather the renunciation of the pretense to an Archimedean point, the impossibility of the one correct narrative must be taken as strategic advantage, a liberating rather than restricting moment. By playing the three positions— neoconservatism, poststructuralism, Critical Theory—against each other, we may indeed arrive at a better understanding of musealization as a key symptom of our postmodern culture.

Let me first take the compensation thesis. Its two major representatives are Hermann Lübbe and Odo Marquard, who emerged in the preunification *Kulturkampf* (culture war) of the 1980s in West Germany as major opponents of Critical Theory, Habermas and so on. Already in the early 1980s, Hermann Lübbe described musealization as central to the shifting temporal sensibility (*Zeit-Verhältnisse)* of our time.[17] He showed how musealization was no longer bound to the institution in the narrow sense, but had infiltrated all areas of everyday life. Lübbe's diagnosis posits an expansive historicism of our contemporary culture, and he claims that never before has a cultural present been obsessed with

the past to the same extent. In the tradition of conservative critiques of modern-ization, Lübbe argues that modernization is accompanied by the atrophy of valid traditions, a loss of rationality and the entropy of stable and lasting life experi-ences. The ever increasing speed of scientific, technical, and cultural innovation produces ever larger quantities of the non-synchronous, and it objectively shrinks the chronological expansion of what can be considered the present.

This, I think, is an extremely important observation, as it points to a great paradox: the more the present of advanced consumer capitalism prevails over past and future, sucking both into an expanding synchronous space (Alexander Kluge speaks of the attack of the present on the rest of time), the weaker is its grip on itself, the less stability or identity it provides for contemporary subjects. There is both too much and too little present at the same time, a historically novel situ-ation that creates unbearable tensions in our "structure of feeling," as Raymond Williams would call it.[18] In Lübbe's theory the museum compensates for this loss of stability. It offers traditional forms of cultural identity to a destabilized modern subject, pretending that these cultural traditions have not been affected them-selves by modernization.

The argument about shifts in the sensibility of temporality needs to be pushed in a different direction, one that accepts rather than denies the fundamental shift in structures of feeling, experience, and perception as they characterize our simultaneously expanding and shrinking present. Here it may be useful to think back to some of the classically modernist formulations in Adorno and Benjamin. Thus today the perpetual appearance of the present as the new can no longer be described critically as the eternal recurrence of the same, as Adorno and Benjamin had suggested. Such a formulation suggests too much stability, too much homogeneity. Consumer capitalism today no longer simply homogenizes territories and populations as it did in America in the 1920s or in Weimar Germany. As mass consumption has spread into the furthest reaches of modern societies, the code word has become diversification, whether it is soft drinks or software, cable channels or electronics equipment. The new is precisely not the eternal recurrence of the same. The frantic pace of technological invention together with the expansion of sectors of virtual reality in the *Lebenswelt* (life-world) are producing changes in the structures of perception and feeling that a theory based on the concept of homogenization and homogeneous time cannot grasp. Thus our fascination with the new is always already muted, for we know that the new tends to include its own vanishing, the foreknowledge of its obso-lescence in its very moment of appearance. The time span of presence granted the new shrinks and moves toward the vanishing point.

In the field of cultural consumption, too, we can observe a shift in the structures of perception and experience: the quick fix seems to have become the goal of the cultural experience sought after in the temporary exhibition. But this is the crux of the issue: an older concept of culture, based as it is on continuity, heritage, possession, and canon, which of course should not be simply abandoned, prevents us from analyzing the potentially productive and valid side of the quick fix. If modes of aesthetic perception are indeed linked to modes of modern life, as Benjamin and Simmel have argued so forcefully, we would have to take the quick fix more seriously as a type of cultural experience symptomatic of our age, one that reflects the processes of acceleration in our larger environment and relies on more advanced levels of visual literacy. Here the key question is this: How do we distinguish between what I earlier called instant entertainment, with all its shallowness and surface therapeutics, and what a past vocabulary would describe as aesthetic illumination and "genuine" experience? Is it plausible to suggest that the highly individualized modernist epiphany (as celebrated by Joyce, Hofmannsthal, Rilke, and Proust) has become a publicly organized phenomenon in the postmodern culture of vanishing acts? That, here too, modernism has invaded the everyday rather than having become obsolete? If that were so, how could the postmodern museum epiphany be distinguished from its modernist predecessor, the experience of bliss in the museum hall as Proust's remembering gaze associates it with that other symptomatic space of nineteenth-century modernity, his beloved Gare St.-Lazare?[19] Does the postmodern museum epiphany, too, provide a sense of bliss outside time, a sense of transcendence, or does it perhaps open up a space for memory and recollection denied outside the museum's walls? Does the transitory museum experience have to be read simply as banal repetition à la Lionel Trilling's notorious comment about the 1960s as modernism in the streets? Or are those equally negative critics right who would claim that the postmodern museum experience is totally spatial, replacing older presumably temporal and contemplative emotions with free-floating and impersonal intensities characteristic of a culture without affect and expression?[20]

Empirically verifiable answers to such questions are obviously hard to come by, and some speculative reflection may be unavoidable. But it seems undeniable to me that rather than having been displaced by categories of space, "the great high-modernist thematics of time and temporality"[21] are alive and well in the museum boom. The question is not if, but how they are alive, and how they are perhaps coded differently in postmodern culture.

One thing seems true. As the present moves experientially toward entropy, feelers are cast toward different times and other spaces, dialogues are opened up

with voices formerly excluded by the strong present of Western modernity. What Benjamin used to call the "homogeneous empty time" of everyday life under capitalism may be emptier than ever, but it is not extended nor substantial enough any longer to be called homogeneous. The turn toward the residues of ancestral cultures and local traditions, the privileging of the non-synchronous and heterogeneous, the desire to preserve, to lend a historical aura to objects otherwise condemned to be thrown away, to become obsolete—all of this can indeed be read as reaction to the accelerated speed of modernization, as an attempt to break out of the swirling empty space of the everyday present and to claim a sense of time and memory. It reflects an attempt by ever more fragmented subjects to live with the fragments, even to forge shifting and unfixed identities out of such fragments, rather than chasing some elusive unity or totality.

Within modernity itself, a crisis situation has emerged that undermines the very tenets on which the ideology of modernization was built, with its strong subject, its notion of linear continuous time, and its belief in the superiority of the modern over the premodern and primitive. The former exclusions and marginalizations have entered into our present and are restructuring our past. Given the current demographic shifts in the United States and the migrations worldwide, this process is likely to intensify in the coming years. Some within the fortress of modernity will experience these changes as a threat, as dangerous and identity-eroding invasions. Others will welcome them as small but important steps toward a more genuinely heteronational culture, one that no longer feels the need to homogenize and is learning how to live pragmatically with real difference. We are far from that.

And this is where the difficulties with the notion of cultural compensation emerge. While Lübbe also accounts for the loss of a sense of future, for a certain fatigue of civilization—even a growing fear of the future—so typical of the early 1980s in Europe, he never really comes to terms with the crisis of the ideology of progress, universalism and modernization, a crisis that produced the museummania of the past decades in the first place. In Lübbe's scheme, museum culture provides compensation for that which one cannot prevent anyway: Hölderlin's Rhine hymns and Schumann's Rhine symphony as compensation for the Rhine as communal European sewer, as a cynic might suggest. Technological progress is accepted as destiny, but the notion of culture as experiment, of the museum as laboratory of the senses, is abandoned to a regressive notion of culture as museum of past glories. A strangely unreal traditionalism of modernity results as the museum is asked to abandon the kind of self-reflection to which modernity owes its very existence. The museum and the real

world of the present remain separated, and the museum is recommended (quaintly and not unlike the family in the Victorian age) as the site of leisure, calmness, and meditation needed to confront the ravages of acceleration outside its walls.[22]

The compensation thesis thus ultimately fails to account for the internal change of the museum itself and it remains blind to the multiple blurring of boundaries between museal and non-museal (historical, archeological) sites of cultural production and consumption today. Compensation here means culture as oasis, as affirming rather than questioning the chaos outside, and it implies a mode of viewing that is simply no longer in tune with the specular and spectacular nature of contemporary museum practices.

It comes as no surprise, then, that Lübbe's companion theorist Odo Marquard, in an explicit turn against all left readings of modernity, calls for a yes to the modern world and offers the philosophy of compensation as the desired non-crisis theory of modernity.[23] For him unavoidable disturbances of modernization are always already compensated for: technification is compensated for by historicization, homogenization by pluralism, the dominance of science and a totalizing view of history by the multi-perspectival narratives of the humanities. Conservative philosophy finds itself in a happy embrace with a caricature of sociological systems theory, but the real crises and conflicts in contemporary culture are left far behind.

These are not innocent suggestions to be excused with the intellectual provincialism of their place of origin. It is almost pathetic to see how the compensation theorists still celebrate the benefits of universal modernization (with some lip service paid to ecological concerns), while discussing cultural compensation exclusively in terms of a national or regional culture. They ignore the new multinationalism of the museum world and thus never even get close to reflecting on the promises and problems inherent in the new multicultural pluralism of recent years. Here compensation theory gets stuck in nationalist muck and one-dimensional identity politics. This is Kohl culture, but I fear it is not just a German symptom. One does not have to be a pessimist to forecast a bright future for this kind of theorizing in a united Europe. National or regional identity on the cultural level compensate for the withering of national political sovereignty in a united Europe and serve as a means to keep the outside out and the foreigners inside in their place: Fortress Europe in this double sense. Compensation theory, indeed.

Diametrically opposed to compensation theory is the simulation and catastrophe theory of musealization as it has been developed by the French theorists Jean

Baudrillard and Henri Pierre Jeudy.[24] Where the conservatives paint a quaintly antiquated picture of the museum without ever raising the question of media, Jeudy and Baudrillard view the museum as just another simulation machine: the museum as mass medium is no longer distinguishable from television.

Like the compensation theorists, Baudrillard and Jeudy start from the observation of the seemingly unlimited expansion of the museal in the contemporary world. Jeudy speaks of the musealization of whole industrial regions, the restoration of inner cities, the dream to provide every individual with his or her own personal museum via collection, preservation, and video recordings. Baudrillard analyzes a number of different strategies of musealization, from the ethnographic freezing of a tribe (the Tasaday of the Philippines), the doubling of an original museal space (the caves of Lascaux), to exhumation and repatriation (reconstruction of an original state), and finally to the hyperreality of Disneyland, that strange obsession of so many European theorists.

For Baudrillard, musealization in its many forms is the pathological attempt of contemporary culture to preserve, to control, to dominate the real in order to hide the fact that the real is in agony due to the spread of simulation. Like television, musealization simulates the real and in doing so contributes to its agony. Musealization is precisely the opposite of preservation: for Baudrillard, and similarly for Jeudy, it is killing, freezing, sterilizing, dehistoricizing and decontextualizing. These of course are the slogans of the old critique that dismisses the museum as a burial chamber. But this Nietzschean critique of archival history receives its postmodern spin in the age of unchecked proliferation of nuclear weapons and the armament debates of the early 1980s. The notion of the world as museum, as theater of memories, is an attempt to cope with the anticipated nuclear holocaust, with the fear of disappearance. In this scheme, musealization functions like a neutron bomb: all life will have been drained from the planet, but the museum still stands, not as a ruin, but as a memorial. In some way, we already live after the nuclear holocaust which does not even need to take place any more. Musealization appears as a symptom of a terminal ice age, as the last step in the logic of that dialectic of enlightenment which moves from self-preservation via domination of self and other toward a totalitarianism of collective dead memory beyond any self and any life, as Jeudy would have us believe.

Clearly, this apocalyptic view of an exploded museum as imploded world renders something important of the sensibilities of French intellectual culture in the late 1970s and early 1980s, and it had a certain hold on the imagination during the time of the missile crisis. But even though it valiantly polemicizes against the deadly Eurocentrism of museum practices, it hardly escapes the orbit

of what it attacks. In its desperate desire for apocalypse, it never so much as acknowledges any of the vital attempts to work through repressed or marginal-ized pasts, nor does it acknowledge the various attempts to create alternative forms of museum activities. The old ossification critique held the day in both Jeudy and Baudrillard.

Yet Jeudy was right in suggesting that it would be a collective delusion to believe that the museum can neutralize fears and anxieties about the real world. He implicitly rejected the conservative notion that the museum can provide compensation for the damages of modernization. He also recognized how the museum had moved from mere accumulation to mise-en-scène and simulation. But neither he nor Baudrillard were able or willing to open up the dialectic move-ments within this process. The concept of simulation prevents them from focus-ing on the differences that might obtain between the television gaze and the gaze in the museum. Jeudy gets close to it when he suggests that cultural relics or residues are ambivalent, that they represent simultaneously the symbolic guar-antee of identity and the possibility of exit from that identity.[25] As relic the object irritates and seduces, he says. The relic is not a sign of death, it holds the secret. But—and this is where Jeudy goes into reverse again—any museal mise-en-scène can only drain this mysterious element that the relic holds. It becomes clear that Jeudy harbors some notion of the original relic, untainted by the present, unpol-luted by artificial mise-en-scène. But the notion of the relic before the museum, as it were, before any mise-en-scène is itself an originary myth. Here Jeudy is simply not poststructuralist enough. There never was any presentation of the relics of past cultures without mediation, without mise-en-scène. Objects of the past have always been pulled into the present via the gaze that hit them, and the irritation, the seduction, the secret they may hold is never only on the side of the object in some state of purity, as it were; it is always and intensely located on the side of the viewer and the present as well. It is the live gaze that endows the object with its aura, but this aura also depends on the object's materiality and opaque-ness. That fact, however, cannot enter into view if one continues to describe the museum as medium of ossification and death, as simulation machine, which, like television, sucks all meanings into the Baudrillardian black hole of the end of time and the collapse of visibility.

As the nuclear threat has faded in the wake of the political collapse of the Soviet Empire, the argument about the museum as catastrophic anticipation of the end of Europe is fast becoming irrelevant, especially since the museum boom shows no signs of abating. That permits us to focus more pragmatically on the relationship between museum and media consumption, an aspect that was

raised, but short-circuited by Baudrillard and Jeudy. Here the theory of a *Kulturgesellschaft*, developed primarily in the orbit of the Berlin cultural journal *Ästhetik und Kommunikation*,[26] can provide a good starting point for further questioning. *Kulturgesellschaft* is a society in which cultural activity functions increasingly as a socializing agency comparable to and often even against the grain of nation, family, profession, state. Especially in youth cultures or subcultures, identities are provisionally taken up and articulated via lifestyle patterns and elaborate subcultural codes. Cultural activity in general is not seen as providing rest and compensation for a subject desiring to regenerate stability and equilibrium in the mirror of a unified (or reunified) tradition. The growth and proliferation of cultural activity is rather interpreted as an agent of modernization, as representing a new stage of consumer society in the West. Instead of being separate from modernization, the museum functions as its privileged cultural agent. Contrary to the simulation phantasm, which reduces social theory to media theory in the shadow of an all-but-forgotten Marshall McLuhan, the notion of a multi-layered *Kulturgesellschaft* holds on to insights of Frankfurt School critical theory, but it refuses simply to extend the old culture industry reproach to include the phenomenon of musealization.

The *Kulturgesellschaft* thesis addresses the culture industry problem where it suggests that the mass media, especially television, have created an unquenchable desire for experiences and events, for authenticity and identity which, however, television is unable to satisfy. Put differently: the level of visual expectations in our society has been raised to a degree where the scopic desire for the screen mutates into the desire for something else. This is a suggestion I would like to pursue, because it puts the museum in a position of offering something that cannot be had on television. The link between the museum as mass medium and television is maintained, but it is not sacrificed to a false identity logic.

Surely, it is no coincidence that the museum boom emerged simultaneously with the cabling of the metropolis: the more television programs available, the stronger the need for something different. Or so it seems. But what difference does one find in the museum? Is it the real, the physical materiality of the museal object, the exhibited artifact that enables authentic experience as opposed to the always fleeting unreality of the image on the screen? The answer to that question cannot be unequivocal, for in human culture, there is no such thing as the pristine object prior to representation. After all, even the museum of old used strategies of selection and arrangement, presentation and narrativization which were all *nachträglich*, belated, reconstructive, at best approximating what was held to have been the real and often quite deliberately severed from its context. Indeed,

the point of exhibiting was quite frequently to forget the real, to lift the object out of its original everyday functional context, thereby enhancing its alterity, and to open it up to potential dialogue with other ages: the museum object as historical hieroglyph rather than simply a banal piece of information; its reading an act of memory, its very materiality grounding its aura of historical distance and transcendence in time.

In the postmodern world, this venerable museal technique is put to new purposes, enhanced by spectacular mise-en-scène and obviously meeting with great public success. The need for auratic objects, for permanent embodiments, for the experience of the out-of-the-ordinary, seems indisputably a key factor of our museumphilia. Objects that have lasted through the ages are by that very virtue located outside of the destructive circulation of commodities destined for the garbage heap. The older an object, the more presence it can command, the more distinct it is from current-and-soon-to-be-obsolete as well as recent-and-already-obsolete objects. That alone may be enough to lend them an aura, to reenchant them beyond any instrumental functions they may have had at an earlier time. It may be precisely the isolation of the object from its genealogical context that permits the experience via the museal glance of reenchantment. Clearly, such longing for the authentic is a form of fetishism. But even if the museum as institution is now thoroughly embedded in the culture industry, it is precisely not commodity fetishism in a Marxian or Adornean sense that is at stake here. The museum fetish itself transcends exchange value. It seems to carry with it something like an anamnestic dimension, a kind of memory value. The more mummified an object is, the more intense its ability to yield experience, a sense of the authentic. No matter how fragile or dim the relation between museum object and the reality it documents may be, either in the way it is exhibited or in the mind of the spectator, as object it carries a register of reality which even the live television broadcast cannot match. Where the medium is the message, and the message is the fleeting image on the screen, the real will always inevitably remain blocked out. Where the medium is presence and presence only, and presence is the live telecast of action news, the past will always necessarily remain blocked out. From a media-specific material viewpoint, then, it does not make sense to describe the postmodern museum as just another simulation apparatus. Even when the museum uses video and television programming in supplementary and didactic ways (which it often does to great advantage), it offers an alternative to channel flicking that is grounded in the materiality of the exhibited objects and in their temporal aura. The materiality of the objects themselves seems to function like a guarantee against simu-

lation, but—and this is the contradiction—their very anamnestic effect can never entirely escape the orbit of simulation and is even enhanced by the simulation of the spectacular mise-en-scène.

The museal gaze thus may be said to revoke the Weberian disenchantment of the world in modernity and to reclaim a sense of non-synchronicity and of the past. In the experience of a transitory reenchantment, which like ritual can be repeated, this gaze at museal things also resists the progressive dematerialization of the world which is driven by television and the virtual realities of computer networking. The gaze at the museal object may provide a sense of its opaque and impenetrable materiality as well as an anamnestic space within which the transitoriness and differentiality of human cultures can be grasped. Via the activity of memory, set in motion and nurtured by the contemporary museum in its broadest and most amorphous sense, the museal gaze expands the ever shrinking space of the (real) present in a culture of amnesia, planned obsolescence and ever more synchronic and timeless information flows, the hyperspace of the coming age of information highways.

In relation to the increasing storage capacity of data banks, which can be seen as the contemporary version of the American ideology of "more is better," the museum should be rediscovered as a space for creative forgetting. The idea of the comprehensive data bank and the information superhighway is just as incompatible with memory as the television image is with material reality.

What needs to be captured and theorized today is precisely the ways in which museum and exhibition culture in the broadest sense provides a terrain that can offer multiple narratives of meaning at a time when the metanarratives of modernity, including those inscribed into the universal survey museum itself, have lost their persuasiveness, when more people are eager to hear and see other stories, to hear and see the stories of others, when identities are shaped in multiply layered and never-ceasing negotiations between self and other, rather than being fixed and taken for granted in the framework of family and faith, race and nation.

The popularity of the museum is, I think, a major cultural symptom of the crisis of the Western faith in modernization as panacea. One way of judging its activities must be to determine to what extent it helps overcome the insidious ideology of the superiority of one culture over all others in space and time, to what extent and in what ways it opens itself to other representations, and how it will be able to foreground problems of representation, narrative, and memory in its designs and exhibits.

Of course, many museums still have trouble adjusting to their new role as

cultural mediators in an environment in which demands for multiculturalism
and the realities of migrations and demographic shifts clash increasingly with
ethnic strife, culturalist racisms, and a general resurgence of nationalism and
xenophobia. The notion, however, that the museum exhibit invariably co-opts,
represses, and sterilizes is itself sterile and induces paralysis. It fails to acknowl-
edge how new curatorial practices and new forms of spectatorship have made the
museum into a cultural space quite different from what it was in the age of a now
classical modernity. The museum must continue to work with such change,
refine its strategies of representation, and offer its spaces as sites of cultural
contestation and negotiation. It may be, however, that precisely this desire to
move the museum beyond a modernity that hid its nationalist and imperial
ambitions behind the veil of cultural universalism, will ultimately reveal the
museum as that which it always also could have been, but never became in the
environment of a restrictive modernity: a genuinely modern institution, a space
for the cultures of this world to collide and to display their heterogeneity, even
irreconcilability, to network, to hybridize and to live together in the gaze and the
memory of the spectator.

I

The patterns of intellectual and political discourse in the new unified Germany are undergoing a fundamental paradigm shift. Innumerable feuilleton and magazine essays, books and conference proceedings, lecture series and round table discussions in the year and a half from the fall of the Berlin wall through unification to the gulf war reveal a far-reaching crisis in the self-understanding and public role of German intellectuals. A certain high-pitched tone betrays raw nerves. Tempers are fraying; irritation and exasperation abound. The threshold from reasoned argument to confession and last judgment is crossed ever more quickly and ever more frequently. A rhetoric of accusation and self-righteousness accompanies the escape from critical reflection into the realm of pure morality. Something is rotten in the state of German culture.

The crisis can be described in terms of three cumulative phases with a shifting focus: domestic politics, culture, and war. It has moved from the initial reactions to the process of national unification (fall 1989 and spring 1990) through the Christa Wolf debate (summer and fall 1990) to the current bitter feuds about the gulf war (February 1991). In each of these phases, important building blocks of a

long-standing, broadly based consensus have been dismantled or have disintegrated. In this essay, I will discuss the first two phases only, with occasional references to the debate on the gulf,[1] one which has brought a simmering crisis into full national consciousness. As the discussion is still very much in flux, one cannot venture a prediction about the future shape of the intellectual life of Germany except to say that the cards are being shuffled anew. At best one can hope to sketch the novel constellations beginning to emerge. Things may have been *"unübersichtlich"* (obscure) before, to use Habermas's phrase of 1985, but what was then the static opaqueness of a postmodern labyrinth appears now as fluidity and chaos, confusing and exhilarating at the same time. Against the prevailing tone of Schillerian elegy and lament in Germany today, I would claim that the crisis is both necessary and welcome.

More is at stake in this crisis of intellectuals than the bruised egos resulting from the repeated misreadings of events during the year of *Wende* and unification, the inability to keep up with the pace of events, to provide cogent analysis, to function as a seismograph for the changes underway. Here, indeed, intellectuals have not cut a good figure, and they know it—from the East German writers' misreading of the desires of their own population before November 9, 1989 to their lament about annexation and colonization in the months thereafter, from Stefan Heym's dismay at the Leipzigers' rush for the discount bins in Western department stores to Bärbel Bohley's lament that the fall of the Berlin wall came prematurely. And in the West, Günter Grass's ever more stubborn insistence that because of Auschwitz Germans did not have a right to a unified national state; the dire warnings of a Fourth Reich and a new pan-German nationalism; the intellectual contempt for the East Germans' cravings for bananas and video recorders; and the ritualistic warnings about the cost of unification to the West German taxpayer. East and West, the rhetoric and behavior of German intellectuals seemed mostly out of step with events. It lacked sovereignty, perspective, and compassion; it betrayed self-indulgence and arrogance, a fatal aloofness from reality and a desperate clinging to projections, and, when under fire, melancholic self-pity and unrepentant self-righteousness. Surely, every generalization has its exceptions, and the writings by Peter Schneider and Klaus Hartung prove that there were intellectuals who understood early on that 1989 was a major political earthquake that had shaken all political identities, but especially those of the left, to their very foundations.[2] Of course, some of the positions taken in the fall of 1989 and winter of 1990 (e.g., the arguments for a federation rather than instant unification; the call for a new constitution based on §146 instead of §23 of the *Grundgesetz*) can be understood to reflect early stages of a process that proved too protean to allow positions to stand for very

long. But on the whole the picture that emerges is best described with the frequently heard term, "the failure of the intellectuals."

My interest here is not to moralize about failures, amnesias, or the mistakes of others, nor to claim that they could have been avoided. Recent and not so recent debates about Heidegger and Lukács, de Man and Bloch, Benn and Brecht, Céline and Sartre remind us that the Bermuda triangle of politics, philosophy, and literature is rich in casualties and poor in awards, even for those who get away by the skin of their teeth. The risk of political error is unavoidable, and there is no guarantee against a sacrifice of the intellect. To claim anything else would be to mystify intellectuals whose first delusion, as Bourdieu once put it, is that they do not suffer from delusions about themselves. Rather than parcel out blame, it is more important to understand the discursive logic and historical determinations of certain arguments and to ask whether that logic itself has not been undermined by what has been described as both the end of history and the rebirth of history. From that emerging new vantage point, be it end or beginning, the past itself begins to look very different. At the same time, the intellectual historian will want to avoid judging exclusively from that perspective. Teleology in reverse, tempting as it may be, is as reprehensible as the kind of metaphysics of history that has collapsed all around us.

Thus it is both necessary and prophylactic to admit to a sense of failure and ending at this juncture. But rather than shedding political identities of the past in a *Wendehals*[3] euphoria or sinking into the paralysis of the loser's melancholy, intellectuals need to raise fundamental questions about the structure and scope of delusions pierced by the events of the last couple of years. One of the more depressing aspects of the year of unification, however, is the unwillingness and inability of many left and liberal intellectuals to admit error, to analyze the nature of their delusions and political projections, and to admit that a thorough reorientation is the order of the day. Instead one observes a frantic and somehow relieved rush toward old trenches by some, while others happily desert a lost cause. The necessary debate, whose chances were already badly damaged in the skirmishes of the summer of 1990 about Christa Wolf, has become one of the first German casualties of the gulf war. Even more than in the preceding quarrels about unification and the value of GDR culture, the moralizing tone of German intellectual life has captured the streets in the current crusade for peace at all cost. When convictions and confessions are demanded, the unconditional for or against, the labor of critical exchange and self-questioning is shut down. Political and intellectual discourse yields to a theology of historical sin—on both sides of the issue.

II

How to begin then? When I was watching the events of 1989 on American television, I shared much of the reluctance about potential unification while being emotionally riveted. Like most others, I was overwhelmed by the scenes of joy and celebration when the refugee trains arrived from Budapest and Prague and when the wall opened and the *Trabis* came. Who, aside from some crazy poet, would ever have thought that one could dance on the wall ... However, continued *Zweistaatlichkeit* (dual statehood) or perhaps a confederation did not just seem likely (even Helmut Kohl thought that in November 1989): it seemed on principle preferable to unification. The idea that perhaps Germany could some day be a nation like others still seemed too adventurous at the time; it smacked of forgetting and normalization, too close to certain recent CDU politics (the Bitburg effect); it also seemed too much of an imposition on European neighbors East and West. And Helmut Kohl's calculated clumsiness concerning the Polish borders made the arguments against a larger, unified Germany even more persuasive. But the turn-around for me came before Soviet domestic politics began to shift into reverse in the Baltic states—events which at least for now make Helmut Kohl look like a genius and his politics of breakneck acceleration like the only rational course to take. I began to accept the idea of unification as inevitable, necessary, even desirable when it became clear in 1990 that the East German population was not willing to serve as guinea pigs in yet another political experiment, that of a "third way" democratic socialism. The pragmatic American acceptance of unification as the most normal thing in the world further softened up my scruples. No doubt, the view from abroad helped overcome a deeply ingrained feeling, widespread in my generation, that *Zweistaatlichkeit* was, if not punishment for Nazi aggression, its legitimate and permanent consequence.

In the spring of 1990, however, there was no comfortable position to be had. Angry about the arrogance with which the Bonn political parties invaded the GDR, making fast alliances with the GDR block parties who were as a matter of course exculpated from their former routine support of the SED regime, and sad about the marginalizing of the already weakened opposition movement, I was still appalled by the contempt so many left intellectuals showed for the East Germans' desire for Western consumer goods, about the facile separation of the good revolutionary Leipzigers of the fall from the bad commodity fetishists and misguided nationalists of the spring. The lack of political ethics on the part of the governing Bonn parties and the leftist moralizing about the lure of consumer society seemed only two sides of the same coin.

By early February of 1991, less than a month into the gulf war, the left

intelligentsia's insecurities and frustrations of the year of unification has given way to a newly found security, to the firming up of shopworn convictions about what is good and right in this world. Apart from a small though growing number of notable exceptions, left intellectuals and the peace movement East and West were celebrating *their* unification after having been left out in the cold during the October unity fest. East and West German intellectuals, who, after the collapse of the benefit of mutual exoticism, had found it immensely difficult to talk to each other, discovered common ground in a ritualistic Third World theology and an anti-imperialism that mixes blatant and subtle anti-Americanism and plain disregard for the Iraqi threats to Israel with touches of latent and not so latent anti-semitism. Never before had I felt that the slogans "*Ami* go home" "*Türken raus*," and "*Saujud*" (smeared on Brecht's grave in East Berlin, June 1990) were deep down of the same ilk: the need to occupy a morally and ethnically purified space, an impulse from which not even the left is free. Despite the major cracks in this newly found unity that emerged with a number of broadly publicized and debated defenses of the UN actions (Biermann, Enzensberger, and Habermas among them), the united peace front seems broad and self-assured enough to suggest that it will further postpone the necessary and painful discussions about failures of the past. It certainly slows down a dismantling of the multiple booby-traps we as East and West intellectuals get caught in as we move about in that phantasmagoric no-man's land of our political desires without the protective divide of the wall. The newly found unity in opposition to the war functions like a temporary repression of the fundamental difficulties facing the new East-West dialogue, a dialogue which is now further burdened by the incredible callousness in Bonn's dealings with the five new German states.

But then, perhaps, the failures of the past are only being exacerbated in the current debate about the gulf war. In the long run, this newly found unity will not paper over the fundamental fissures in a left politics and culture that have been revealed during the events of the last year. The best way to guarantee the success of a conservative restoration, which some (falsely, I think) already take as a *fait accompli*, is to remain silent about leftist delusions and to cling to the comfort of the old *Feindbilder* (projected image of the enemy).

Of course, there have been attacks on intellectuals before. Aside from the repeated prosecutions and marginalizations of East German writers, artists, and scientists by the Party and its cultural apparatchiks, West Germans will remember the attacks by politicians on the *Gruppe 47* in the 1960s as a new *Reichsschrifttumskammer* (Reich Chamber of Literature), the derisive comparisons (Erhard, Strauss) of intellectuals with nonhuman forms of life such as *Pinscher,*

Ratten, and *Schmeißfliegen* (terriers, rats, and blow flies), or the later attempt to claim an affinity between the Frankfurt School and the RAF terrorists. But this time, it is different. Bonn does not bother; power ignores intellect. Perhaps this fact, more than anything else, indicates the depth of the crisis. The politicians win, the intellectuals lose in the year of unity, or so it seems. Never in the history of the Federal Republic has the sense of self-confidence and self-worth of intellectuals been at such a low point. The multiple protestations to the contrary, a tone of self-righteousness, futility, and self-pity, accusations about witch hunts against left intellectuals and organized media campaigns against the revived peace movement only prove the point.

What is at stake, I think, is the crisis of a certain kind of intellectual discourse, a crisis which many still deny or repress, as well as an inevitable redefinition of the role of intellectuals, writers, and artists in the new Germany. Of course, it is too early to predict the shape of intellectual life in the unified country. But attempts to redefine the *ethos* of German culture abound, and it is possible to provide a preliminary sketch of an intellectual constellation as it has emerged in 1990, in which ideological, generational, political, and aesthetic arguments crisscross to form an ever denser web. What remains unclear is the size of the spider—not, however, the exact nature of the prey.

III

At a time when simplifications and slogans abound, nothing is more necessary than critical reflection. Slogans such as the end of utopia, the collapse of socialism, or the end of history are more often than not projective rather than descriptive terms. To begin with, it must be remembered that the crisis of left intellectuals takes quite different forms in the two Germanies. In the former GDR, intellectuals have to adjust to the disappearance of a state and its cultural institutions that in complex ways provided the restrictive framework for all intellectual and artistic discourses, a framework that is perhaps best described as an arbitrary mix of a feudo-patriarchally charged repressive tolerance with repression pure and simple. Complex patterns of censorship and self-censorship, resistance and critique, the carving out in recent years of protected niches and spaces for a new kind of subcultural discourse outside the system of censorship (Prenzlauer Berg in East Berlin) have all collapsed, opening up a void into which market forces rush like air into a formerly airless space. The crisis of the East German intellectual today is not so much a crisis of thinking (although it is that, too) as an existence-threatening crisis of all cultural institutions, including universities, museums, libraries, theaters, galleries, schools, newspapers, publishing houses, and bookstores. The issues are

money, ownership, and jobs. This was a society in which the printed word, both heavily censored and artificially, even wastefully subsidized, maintained a prominent position long since gone in the West. Its transformation into a Western style media society requires a wrenching practical adjustment from its intellectuals. Small wonder that members of the older generation who still remember the *ethos* of building that other Germany have a much harder time coping with the situation than the younger generation, for whom the GDR was never the site of utopian longing. At any rate, most energies are still absorbed by that process of adjustment and orientation, and will be for some time to come.

There are reasons to believe that the continuing legal and institutional insecurities and the often brutal pressures in the process of unification will result in the forging of a nostalgic GDR identity that feeds on the hazy beautification of a past that "Westerners will never understand since they have not lived it." So goes the refrain. New walls are everywhere being erected, understandably perhaps, even inevitably. The danger is that while they may provide a sense of comfort and solidarity now, they will end up deepening the resentment and blocking attempts to find a common language.

In West Germany, on the other hand, an amorphously left and left-liberal consensus had come to dominate intellectual life since the 1960s. Because of its persistent criticisms of *deutsche Zustände* (German conditions), it has helped to improve and to legitimize the "unloved republic," thus contributing to its institutional stability and evolution. Of course, this consensus was itself multiply-layered, but since its early days of struggle and opposition in the 1960s, it has become part of the mainstream in many media, in institutions of education and publication, in museum exhibition culture as well as in the federally subsidized presentation of German culture abroad. This consensus, as I call it in shorthand, is not only fraying on its margins but is challenged to its very core. Central to the challenge is the reproach that for most leftist intellectuals, despite their long-standing critique of Stalinism, the downside of GDR politics and culture remained at a dead angle of toleration, that a "dissident bonus" was uncritically given to writers and intellectuals who, while critical of "real existing socialism," were ultimately beneficiaries of the SED state and supporters of "this other, better Germany." The need to fight the right-wing ideology of anti-communism of the cold war blinded many on the left to the fundamental democratic deficit of "real existing socialism." A repeatedly invoked anti-Stalinism provided the necessary good conscience. The abstract need for a potentially utopian space, an "other" of capitalist Germany, led to the continued hold of the official GDR on the West German left's imagination, however subliminal it may have been. As a result, the developing grassroots opposition

movements in the GDR and elsewhere in Eastern Europe were either not appro-
priately acknowledged or they were even assessed as endangering East-West coop-
eration. The warnings by the West German left that *Charta 77* and *Solidarnosz*
were going too far characterize a discourse that kept putting its hopes in the inter-
nal reformability of state socialism. For many years, after all, this was official Bonn
policy. The same attitude continues up to this day, when the blame for the back-
sliding of *perestroika* is put on the Lithuanians: to want sovereignty and indepen-
dence is again seen as going too far. The reproach to the left does hit home and
must be taken seriously in its cumulative effects. It is bad faith for intellectuals to
claim innocence simply because Bonn kept rolling out the red carpet for leaders
and dignitaries from the GDR and other East European states during a period of
improved relations.

What I am calling here in shorthand the left and liberal consensus is currently
not under attack from the outside so much as it is disintegrating from within.
Having weathered the *Berufsverbot* (job ban in the public service for members of
the Communist Party) campaign and the sympathizers' hysteria of the 1970s,
having gained renewed strength and an ecological cutting edge in the peace move-
ment of the early 1980s, this intellectual consensus emerged victorious one more
time—and for good reasons—in the historians' debate of the mid-1980s. The vari-
ous attempts to "normalize" the German past and to shift the blame for Auschwitz
to the Soviets by some specious argument about the historical priority of the Gulag
were soundly and publicly rejected. Furthermore, the "*kulturpolitische Wende*"
(cultural-political shift) advocated by Helmut Kohl at about the same time and
articulated by a group of neoconservative philosophers (Odo Marquard, Hermann
Lübbe) never took hold. Their happy-hour theory of culture as compensation for
the inevitable damages of technological and civilisatory progress remained an all
too transparent ideological maneuver. Thus it was not surprising to see that during
the fall of 1989 and in subsequent months, the protagonists in the debate about
unification were still Jürgen Habermas and Günter Grass, Heiner Müller and
Christa Wolf, Peter Schneider and Christoph Hein, members of the East and West
German left who first emerged in the 1960s or early 1970s as major writers and
political intellectuals. They clearly eclipsed other voices, such as those of the former
leftist Martin Walser or the old-time maverick Karl Heinz Bohrer, who spoke out
in favor of "the nation" and unification. Even though their positions differed signif-
icantly, it was precisely their joint opposition to the course of events which
produced the image of their failure.

Of course, one should not expect left intellectuals to jump happily onto the
CDU bandwagon and to celebrate the events as the *telos* of forty years of

conservative politics and victory in the cold war. After all, intellectuals are supposed to question the course of events, rather than simply accept the force of "facts." Their failure lies rather in the inability to recognize the extent to which the falling of the wall and the March elections in the GDR implied the collapse of a whole set of long-held leftist assumptions and projections. The demise of the GDR marks the end of the unquestioned role in West German intellectual life of the left-liberal consensus. Much depends on whether the left in both parts of Germany can come to understand this end as a chance for renewal, or whether it will simply lead to manic conversions or a melancholic fixation on loss, as Helmut Dubiel described the double danger in a perceptive essay in the summer of 1990.[4]

IV

How then does this deeper crisis manifest itself and how concretely are intellectuals implicated in it? Looking at the German crisis in a broader Central European context, one is struck by the absence in intellectual discourse both in East and West Germany of daring forays into a joint future, of anticipations of new tasks and visions. The visionary and utopian elements that other liberation movements in Eastern Europe invested in notions of civil rights and a civil society are largely absent from the public debate, in which Habermas, in an oft-quoted phrase, labeled the East European events a "*nachholende Revolution*," a catching-up revolution. Compared with the emphatic claims of a rebirth of history, used by Misha Glenny as the title for his book, or with Timothy Garton Ash's gripping accounts of East European events in *The Uses of Adversity* and *We the People*, Habermas's rhetoric (though not necessarily his argument) seemed to cap the long-standing resistance of the West German left to take the Czech or Polish dissident movements seriously.[5] The notion of a catching-up revolution, though plausible in terms of a revival of political structures and traditions of the interbellum years and the desire to be integrated into a larger democratic Europe, underestimates the ways in which the East European revolutions foregrounded civil rights, thus attempting to shed the murderous left-right scheme of earlier bourgeois revolutions.[6] The task of creating a new kind of civil society resting on the expansion of civil rights and the containment of the destructive potential of capital, is formidable.[7] But the very term of a catching-up revolution had to be offensive to the East European opposition movements, particularly as it was coupled with the argument that the East European revolutions lacked any innovative ideas pointing toward the future.[8]

The notion of a "*nachholende Revolution*" is perhaps more adequate as a description of events in the GDR than in other East European countries. For one,

the motif of catching up in an economic rather than a political sense was certainly stronger in the GDR than elsewhere, precisely because of the privileged, double-bind relationship with the Federal Republic. And the embrace of a fresh construction of a civil society was hampered in East Germany first by the illusion of radical reform of real existing socialism and then by the prospect of a ready-made currency union with the Federal Republic. As a Westerner, I also get the impression that the strength of the *Feindbild* image in the GDR prevented many from understanding the political evolution of the Federal Republic since the 1960s, the increase in liberalization and in civil rights politics which clearly went beyond "social democratism." All too often, the FRG is still seen primarily as the successor state to the Third Reich. It is not only that Westerners don't understand the complexities of life in the GDR. The reverse is also true.

The lack of an emphatic intellectual discourse about civil society in East Germany should not immediately lead to the standard reproach that Germans per se have an underdeveloped relationship to freedom, civil rights, and democratic process—an argument that even West German leftists advance when they voice their fears about these 16 million unreconstructed Germans who presumably threaten the gains and achievements of a fragile leftist culture in West Germany. Yes, the lack of figures such as Adam Michnik or Vaclav Havel in the East German *Bürgerbewegung* (citizens' movement) is striking, but it can be reasonably explained by the special situation of the two Germanies, the escape valve of a same-language exile not available to Polish, Czech, or Hungarian intellectuals, the possibility for East German writers to publish in the West, the short history of the opposition movement, the sheer extent of Stasi surveillance, and other such factors.

Ironically, the absence of a powerful intellectual leadership in the East German opposition may actually have contributed to the movement's fast and peaceful success in bringing down the state. As the East German essayist Friedrich Dieckmann has argued, it was a revolution without revolutionaries.[9] The East German state security system was prepared to deal with strategists of revolutionary upheaval, with the traditional type of revolutionary who would attempt to occupy centers of state power. They were not prepared to counteract the kind of diffuse mass protest which seemed to get its kicks out of discussions with officials and politicians in the streets but which never challenged power head-on. It was a revolution without the storming of a Bastille.

None of this is to minimize the role that intellectuals such as Christa Wolf, Stefan Heym, Daniela Dahn, Christoph Hein, Jens Reich, Bärbel Bohley and many others played during the events of October and November 1989 or on the various committees investigating police brutality and Stasi machinations in subsequent

months. The problem is not so much the absence of an internationally visible and identifiable intellectual leadership of the German opposition movement as the fact that intellectuals such as Wolf, Heym, Müller as well as many in the *Bürgerbewegung* (citizens' movement) invested the emerging forms of a *Basisdemokratie* (grass roots democracy) with the hopes for a reform of the socialist project. The old dream of realizing socialism with a human face was revived at a time when, as Frank Hörnigk has argued, this project could no longer be saved.[10] To recognize this fact and to insist that internally the collapse of the SED regime was driven by economic disaster more than by political and intellectual critiques from the left opposition is not to deny the legitimacy of pride in the grassroots politics of the fall of 1989. But it is to point to a continuing level of self-delusion which very few intellectuals have admitted in public. On the contrary, in many discussions these days, one can observe already a tendency to romanticize those brief and glorious moments of those massive grassroots demonstrations and to forget that their political energy was and could only be maintained as long as the SED state had not yet fallen.

By early 1991, a mood of nostalgia and mourning seems to have overtaken the former GDR. But a distinction needs to be made here: on the one hand, there are those who mourn the loss of a former security without wanting the old system back. Their nostalgia is motivated by the wrenching experiences of massive unemployment and imminent poverty, of regulations and procedures that cover every single aspect of everyone's everyday life. It is a nostalgia of despair, exacerbated by the fact that so many representatives of the old regime, whether in education, legal institutions, communal administration, or privatized business, have been able to hold on to positions of power and influence.

On the other hand, there is the nostalgia and melancholy of those, mainly intellectuals, who still think that the GDR was the better starting ramp for a democratic socialist society in the future, who still hold on to a utopian alternative to capitalism at a time when the discourse of utopia and socialism must be radically challenged by its proponents rather than simply reiterated. To be sure, these intellectuals recognized much earlier that socialism without democracy is not possible, and many of their literary works of the 1970s and 1980s articulated the deformations of "real existing socialism" in powerful and persuasive ways. They may even have recognized then that it might already be too late to expect a thoroughgoing reform of "real existing socialism" in East Germany. A number of works from the early 1980s (Wolf's *Kassandra*, Volker Braun's *Übergangsgesellschaft*, a number of texts by Heiner Müller, Christoph Hein's *Der fremde Freund [Drachenblut]*) can certainly be read that way. But when was it ever not too late? In 1976, 1968, 1961,

1953? Perhaps the question itself is inappropriate, and the difficulty of imagining an answer shows what is at stake: not just the collapse of a state and a way of life, but the collapse of the hopes and illusions of an epoch. Thus we see the existential and intellectual confusion, the defensive melancholy of so many leftist intellectuals in East Germany, where the left shares the loss of the utopian project, even if most Western leftists never believed that the GDR was going to be its place of implementation.

The lingering nostalgia for the "other" of capitalism is resurfacing with a vengeance. The resurgent identification with what writers used to call "the better half," which seemed to crumble for good with the onslaught of last year's ever more depressing revelations about the decay and deformation of the GDR's material and social structures, goes with the rhetoric of victimization. The discourse of colonization and of a new Manchester capitalism overtaking the former GDR runs rampant among intellectuals when in fact the problem is that industrial capital does not colonize enough, does not build up or take over production facilities that would provide jobs and income to the beleaguered communities in the East. The complaint that West Germany is taking over the East sounds both absolutely correct and strangely inappropriate at a time when benign neglect interspersed with ultimately inadequate subsidies seems to be the preferred strategy in Bonn, and the withering away of the East German state is now followed by the withering away of East German productive capacities, leaving no chance for those firms and enterprises that might have survived and adjusted to international competition.

But the discourse of colonization, similar in tone and fiber to the discourse of occupation by the "*Siegermächte*" ("victorious forces") after World War II, points to a political problem: the lack of understanding, if not contempt, for Western style democratic institutions. Between an oppressive state and *Basisdemokratie* there seems to be no middle ground. Thus in East Berlin, one often hears these days that one has just swapped one system for another equally undemocratic one. The fact that capitalist culture itself has undergone important transformations since the 1960s in its increased emphasis on *Bürgerrechte* (civil rights), on ecological concerns, and on alternative organizations of everyday life is simply not acknowledged by many East German intellectuals. The future potential of such developments for a united Germany is flatly denied when Heiner Müller claims that the rebellion of 1968 was nothing but a departure "in the service of industrial capital" and merely created new opportunities for consumption,[11] or when Christa Wolf dismisses Western style freedom simply as a myth, thus not acknowledging that it is both myth *and* something else.[12] It is as if communist cold war ideology is having its last fling.

On the other hand, the discourse of colonization, absurd as it may be from any viewpoint beyond the narrowly German one, gains credence as it gives expression to growing disillusionment and a legitimate anger about broken promises which could assume dangerous proportions if the incompetence with which Bonn is implementing a seriously flawed unification treaty is not remedied soon. The fact that currently the East Germans cannot but experience unification as humiliation and subjection is poorly understood by the West German politicians on the Rhine, where politics these days seems to mean throwing money at problems rather than addressing, much less solving them.

V

In the early summer months of 1990, when the treaty of unification between the two Germanies, the *Staatsvertrag*, was negotiated by ministerial bureaucrats behind closed doors, the discourse about the failure of the intellectuals gained momentum and intensity in the media, at public events, and in the many heated private discussions. The voices that had been very prominent in the debate about unification had fallen strangely silent after the March elections. It was as if their unheeded opposition to the unfolding events had taken its toll in exhaustion, disenchantment, and frustration. Gorbachev's warning to Honecker, "Wer zu spät kommt, den bestraft das Leben" ("He who comes too late will be punished by life"), had not only come to haunt the GDR leadership from Honecker and Mielke to Krenz and Modrow, but the German intelligentsia as well.

With the West German publication of Christa Wolf's story *Was bleibt*[13] in early June of 1990, the still inchoate discourse about the political failure of intellectuals took on a literary and cultural focus and entered a new phase. The failure of intellectuals became now the failure of Christa Wolf: it was political failure in that she was never really critical enough of the SED regime; it was moral failure in the sense that *Was bleibt* represented Wolf's attempt to claim victim status, to extricate herself from culpability after the *Wende*. Thus read the bottom line of the accusations. And suddenly the famous East German author served as a cipher for everything that was held to be wrong with postwar German culture.

A slim and modest volume, *Was bleibt* was written in 1979. For good reason, Wolf had kept it in a drawer since then. It describes a day in the life of the author. It details Christa Wolf's experience of being observed by the Stasi in that period between the expulsion of Wolf Biermann (1976) and the massive exclusions from the GDR Writers' Union in 1979, a period of intense intimidation of writers and intellectuals in the GDR. The book records her reactions to Stasi surveillance, her growing fear and psychic insecurity, her apprehension about the withering away

of relationships and of dialogue, her increasing isolation, a numbing of feeling, affect, and language. The text reenacts scenes of self-discipline and self-censorship and fully recognizes Wolf's own privilege and weakness. It describes the helplessness of the older artist in an encounter with an oppositional writer of the younger generation, the pointlessness of her advice which triggers an acute crisis of perception and language, leading to the terror of indifference, a frozen self. This crisis culminates in the narrator's despair about the city, Berlin, a place which has become a "*Nicht-Ort,*" a dystopian "non-place [...], without history without vision, without magic, corrupted by greed, power, and violence" (35). The text ends with the bleak assertion "that there is no catastrophe beside that of not living. And in the end no despair beside that of not having lived" (108). The syntactical ellipsis points to the distance Christa Wolf has travelled since Christa T.'s "When, if not now?" It is as if the deadly disease of Christa T. has caught up with the author-narrator herself.

It is easy to see how this text fits with other texts from that same period, texts such as *No Place on Earth* (*Kein Ort. Nirgends,* 1979) or even the somewhat later *Kassandra* (1983), both of which were celebrated in East and West as major achievements. One could go on to argue, through close reading and historical positioning, that like these other texts though in a different mode, *Was bleibt* articulates a radical critique of real existing socialism, a good-bye to the GDR as "the better half," a loss of confidence in the utopian promise of GDR socialism, and thus a radicalization of the propositions couched in historical guise in *No Place on Earth.* The fact that this critique is articulated from an ever more imploding and ultimately vanishing space inside is precisely what makes it pertinent as an expression of a certain GDR sensibility. One could argue that and more without denying at any moment Wolf's privileged position within the GDR's *Literaturgesellschaft* (book culture), the always careful and hesitating style of her critique which some see as hedging, others see as going to the root. One may very well wonder why Wolf did not leave the GDR at that time. But her staying should then not be read as unqualified support for the SED regime. Processes of dissidence and identification under communism are too complex to be reduced to the stay-or-leave model. That model, however, was the basis for many of the criticisms of Wolf in the summer of 1990.

Immediately after its publication, the book became an occasion for an intense and wide-ranging debate about the political role and responsibility of intellectuals East and West. The issue was not just the reproach that intellectuals had misread the course of historical events and substituted their own agenda of a continued *Zweistaatlichkeit* (dual statehood) for the popular will as expressed in the GDR

demonstrations since December and affirmed in the March elections. What came under fire then and in subsequent months was the leftist consensus in the West that over the years had turned a blind eye to GDR realities and had given GDR intellectuals and such writers as Christa Wolf the "dissident bonus," while often ignoring those dissidents, mainly of a younger generation, who were harassed, jailed, expelled, or "eased out" of the GDR. Indeed, West German critics and media had played an important part in elevating Christa Wolf and Heiner Müller into major figures of resistance, deputies in the here and now, as it were, of a socialism yet to come. Simultaneously they had celebrated them as prophets of imminent nuclear or ecological doom, as radical critics of the destructive potential of Western civilization, its Eurocentrism and patriarchal deformations. This myth of the writer and artist as priest, prophet, and seer which in general had regained a lot of lost ground in the West during the 1980s, was now dismantled with a vengeance, but only as far as East German writers were concerned.

The public questioning of this dissident bonus, timely and legitimate by itself after the 1989 events, was couched in a demand of a wholesale rejection of GDR culture which was taken to be as polluted as Bitterfeld/Leuna, as obsolete by Western standards as the steel conglomerate of Eisenhüttenstadt, as bloated as any old collective farm. Moreover, the assault on GDR culture was coupled with the demand for a reassessment of the role intellectuals and writers had played in the forty year history of the Federal Republic. The imminent end of GDR and FRG, their merger into a new state whose cultural identity would be up for grabs, provided the occasion for a major settling of accounts. Small surprise that the debate became ever more loaded with displaced aggressions, narcissistic defense strategies, and hidden agendas.

The hypothesis I wish to offer is this: with the attacks on Christa Wolf, the discourse about the failure of intellectuals became something like a second historians' debate.[14] The immediate purpose is not the normalization and exculpation of Nazi Germany as it was in the earlier debate. But at issue again is a selective and self-serving apportioning of guilt, as well as the erasure of the past, this time that of the predominant culture of the two German states from 1949 to the present. As one of Wolf's critics put it: "This is no academic question. He who determines what was also determines what will be."[15] The purpose of this discourse is closure: the *Abwicklung*—to use a term recently invented for the closing of whole faculties at East German universities—or "winding down" of a divided yet multiply connected postwar German culture. While Günter Grass, in his defense of *Zweistaatlichkeit,* had claimed the unity of the *Kulturnation* as a good substitute for a unified state (itself a dubious proposition given the role of that concept in the rise

of Nazi ideology), Grass's opponents postulated the unity of FRG and GDR culture only in order to relegate both to the garbage heap of history.

The basic truth of this culture debate is that we are indeed experiencing a historical rupture. What is bothersome is the obsessive intensity with which complex structures of cultural and literary understanding are short-circuited, selectively simplified and judged with intent to condemn. This is where the comparison with the historians' debate, which at first might seem unfair, assumes plausibility. For the ultimate goal of both debates is similar: one wants to get away from a past that is considered either a burden or an embarrassment in order to construct an alternative agenda for the future. While the attempt to overcome the German past in the name of "normalization" was not successful in the historians' debate, it may very well end up successful in its more removed and diluted form in the current culture debate. Only time will tell to what extent the Wolf debate and the attack on a literature that has made *Vergangenheitsbewältigung* its primary task is waged in the service of a willed forgetting. At any rate, a new *Nullpunktthese* is in the making which can be expected to play a major role in the foundational myths that are bound to spring up around the years 1989 and 1990. This *Nullpunktthese* will be constructed differently from that of 1945, but it will similarly be based on denial of the past and serve to legitimize the new state and the desired and anticipated new culture. And it will be similarly false.

VI

I will not attempt to tell the story of the Wolf debate in its cumulative and unnerving entirety, although media dissemination and the endless repetition of identical arguments are of course an important factor in the constitution of intellectual consensus.[16] I will rather reconstruct a triangle of three critics and three publications which have been central both in a cumulative sense and in the sense of intertextual references. It is this trio of Wolf critics, in their amplification through other media, that is triggering the shift in German intellectual culture here under review.

The attack on Christa Wolf and her Stasi story was first launched almost simultaneously in two articles, by Ulrich Greiner in *Die Zeit,* the other by Frank Schirrmacher in the *Frankfurter Allgemeine.*[17] Earlier critiques of Wolf's work, of her role as both representative and dissident of GDR culture (e.g., Reich-Ranicki in the television talk show "Literarisches Quartett"), and a vicious *ad hominem* attack by Jürgen Serke in *Die Welt* of May 3, 1990, notwithstanding, I will take these two pieces as the beginning of the debate. After all, without the publication of *Was bleibt,* this debate could not have taken place or it would have taken on a very different shape. Greiner's piece was accompanied by a positive, though weak

review by Volker Hage in the same issue, and Schirrmacher was called to task and reminded of his youth and lack of experience—never a good argument in literary matters—by Wolfram Schütte in the *Frankfurter Rundschau*, but neither of these pieces was of much significance.

The first wave of criticism, seconded by Helmut Karasek in *Spiegel* a few weeks later,[18] was followed by a massive outcry of West and East German writers who understood quite well that they too were implicated. While the critics pretended that all they had done was criticize a weak text by Christa Wolf, those who felt stung by the critique called it a witch hunt and spoke of an organized media campaign. Walter Jens felt reminded of the *"Spruchkammerverfahren"* of postwar denazification. Volker Braun spoke of a *"grosse Treibjagd"* (a "great hunt") against critical intellectuals designed to draw attention away from the real problems of unification.[19] Stefan Heym, exiled in the United States during the Third Reich, compared the critique of Wolf with the techniques of *Meinungsterror* (indoctrination) inflicted by American officers after 1945 on the German population.[20] The German PEN, with inimitable up-to-dateness, warned of a "postmodern McCarthyism," and Günter Grass, while defending Wolf in a *Spiegel* interview with reasonable low-key arguments,[21] felt compelled somewhat later to warn of an imminent conservative restoration.[22] Such absurdities continued into the fall, when Ivan Nagel spoke of a "right-wing conspiracy" and Heiner Müller, never short of a bon mot, of "the Stalinism of the West."[23] Coming on the heels of the *de facto* defeat in the unification debate, much of this defense had all the markings of a paranoid overreaction and did not help much to clarify the issues raised by the critique of Christa Wolf and her work. Especially beside the point, it seems to me, was the seemingly moderate, but ultimately evasive, if not hypocritical, claim often heard in those days that Wolf was the wrong target, and that one should have attacked Hermann Kant, president of the East German Writers' Union and loyal apparatchik in the service of the regime. No, a debate on Kant would have been redundant. There is nothing much there to debate. In the case of Christa Wolf, there is.

As often happens in the wake of overreactions, this one, too, functioned like a self-fulfilling prophecy. At the time of the Frankfurt book fair and in the weeks thereafter, it called forth another even broader attack on GDR literature and on the West German intelligentsia. Just one day before the fireworks of unification on October 3, Frank Schirrmacher published his broadside salvo entitled "Good-bye to the Literature of the Federal Republic" in which he declared this literature brain-dead at age 43 (1947-1990), a clear reference to the centrality of the *Gruppe 47* for his argument.[24] In the 500th issue of the *Merkur,* which also coincided with the

month of unification, its editor Karl Heinz Bohrer, ardent nationalist, Ernst Jünger fan, and seasoned veteran in contemporary aesthetic debates, sided with Greiner and Schirrmacher and accused the East and West German utopian milieu of preferring metaphysics and didactics to aesthetics in literary matters, thus creating a kind of "GDR cultural preserve."[25] Wolf's *Was bleibt* is dismissed with one word and no discussion as moralizing kitsch *(Gesinnungskitsch)*. Bohrer's arguments were then taken up by Greiner in an article entitled "A German Good-will Aesthetics," in which he seconded Schirrmacher's diagnosis of an ending and pursued Bohrer's claim that postwar German literature had been vitiated by its coupling of aesthetics with political and moral utopianism.[26] By this time, the trenches were fortified, the positions known, and scripted convictions had begun to block a necessary and potentially fruitful debate.

Christa Wolf herself chose to keep a very low public profile. To the best of my knowledge, she did not give any interviews to Western media during this whole period, nor did she publish any response. She did participate in a number of conferences and lecture events where she spoke rather defensively about the threat of a demonization of life in the GDR, a coordinated attempt to deprive GDR Germans of their memories, of their lived reality.[27] When she accepted a high literary honor in France, she herself used the term *Hexenjagd* (witch hunt) for the West German critiques of her latest book.[28] By late November, as far as I can tell, the debate about Wolf and the political responsibility of intellectuals had petered out in the media, only to be revived again, on yet another terrain, with the outbreak of the gulf war.

VII

From the beginning, there were three dimensions to the assaults on Christa Wolf. The first has to do with the timing of the publication, the second with Wolf's alleged role as *Staatsdichterin,* a state laureate, and the third with the parallel between Wolf and West German writers of her generation. The book appeared at a time when daily revelations about Stasi crimes and machinations hit the newspapers, when the heretofore unknown extent of Stasi surveillance and infiltration shocked even those who thought they knew everything about Stasi activities (6 million files, 80,000 full time employees, over 500,000 spies, all in a population of 16 million). In those same months, there was a broad and agitated public debate about whether Stasi files should be made accessible with a kind of Freedom of Information act or whether they should forever remain closed or even be destroyed. The bitter and extended quarrel in the summer of 1990 over the publication of Stasi addresses that split the then nascent joint venture of the East and

West Berlin *taz*, an alternative newspaper, is a good indication of the intensity of
that debate. Surprisingly many in the GDR, including impeccable opposition
figures, preferred the past closed and done with, fearing civil war and fratricide if
people were to begin reading their files and finding out the identity of informers
in the family, among friends, and on the job. The Christian principle of forgiveness
held sway over the urgent political need for openness and found broad support
among all those, East and West, who feared revelations.

But who could ever hope to be rehabilitated if access to Stasi files remained
blocked? Who could prove that he or she was a victim, and what exactly constitutes
victim status if more than a third of the population ended up in some Stasi file?
Who was a perpetrator, who shared responsibility, who was implicated through
silence or passive cooperation? How and to what extent was it possible to refuse
cooperation in this all-pervasive system of surveillance, harassment, and destruc-
tion of lives? Where did intellectuals fit in, the cultural institutions, the organiza-
tion of publishing and distributing books? Most of these questions may seem
external to the Wolf debate, but they are not. As long as the files remain off- limits,
allegations and counter-allegations will continue unchecked. The accusatory tone
and intensity of the Wolf debate was certainly energized by the continuing fog
shrouding Stasi activities in the former GDR. Just imagine if we could read the
Wolf files together with *Was bleibt* . . .

The necessary debate about the role and implications of intellectuals in this
system of surveillance and intimidation did not take place. Wolf's story provides a
case study of how the regime sought to control and invade every aspect of life and
ended up polluting the social fabric all the way down to the inner core of feelings of
dignity and self-worth. But Wolf's account of her experiences with Stasi surveillance
was not read as a welcome inside view that could help elucidate how the system
functioned, how a major writer, precisely a representative of culture rather than a
typical victim, reacted to such surveillance. After all, Wolf does not minimize the
effect of surveillance as many others who had managed simply to live with it. The
text was instead read as an attempt by the celebrated author and SED member
(until the summer of 1989) to claim victim status and to plead for exculpation. The
rationale for such a reading is obvious: in comparison with those whose lives had
been materially and existentially destroyed by the Stasi, Wolf was less than a "real"
victim, an assessment that is also shared by many in the GDR, including authors of
the Prenzlauer Berg generation and members of the *Bürgerbewegung.*[29]

Wolf's surveillance had been called off after a few months, and she continued
to enjoy the privileges of a representative of GDR literature. Her books were still
published, and she could travel abroad, bringing literary reputation back home as

a kind of cultural hard currency. She herself does not deny any of that, nor does her text ever claim victim status for its author in the sense suggested by Greiner. But neither does Wolf—and this is a problem—ever reflect on the events of the past from the perspective of 1989. This absence of any retrospective comment, say, in a postscript in which she might have relativized her plight without diminishing the intensity of her experience at the time of writing, makes the publication very vulnerable to attack. Furthermore, Wolf indicates that the text was reworked in November 1989, but there is no explanation as to what that reworking consisted of, thus provoking Schirrmacher's snide comment that the slim truth of the text is already the reworked version of truth. Did Wolf leave these questions open, fearing that any explanation would make it look even more like an attempt at a whitewash, or did she simply not anticipate the almost inevitable reaction? And how do we assess the potentially apologetic function this text may still have in the former GDR, where, according to an East Berlin friend, everybody now turns out to have been either a victim or a resistance fighter?

Neither Greiner nor Schirrmacher suggested that Wolf should have tried to publish this text before the *Wende,* to be a heroine, to defy the state. But why then go to the other extreme, call her a *Staatsdichterin* and dismiss her surveillance as a mere trifle (Greiner), an anachronism (Schirrmacher)? Surely Greiner knows that Wolf has never gone after official positions, in the Writers' Union for instance, and that her record includes courageous defenses of censored colleagues (the 11th Plenum of 1965, the Biermann protests, the tribunals in the Writers' Union in 1979[30]), as well as problematic silences, which may be as indefensible as they are understandable. Why accuse her writing of hypocrisy, even of the "virtuoso and hypocritical exploitation of the real existing threat," not only in *Was bleibt,* but in other unnamed texts as well, as Greiner does? Why is literary and artistic deficiency claimed, with specious arguments always focussing on the same few metaphors, when the issue really is moral and political rather than literary (Greiner, Schirrmacher, Karasek)? Is a deliberately evasive metaphor such as "the master who dominates this city" (34) proof of the author's moral corruption? Why does one suddenly incriminate what used to be celebrated before as the cunning of slave language, the outsmarting of the censor? And perhaps this metaphor may not simply refer to the SED or the Stasi, as the critics assume, but rather attempt to get at the complicity of so many with this system of domination and surveillance. Finally the critics, in their insistence on aesthetic deficiencies, might have simply acknowledged the special nature of this text, which clearly is a *Selbstverständigungstext* (a text of self-understanding), and as such perhaps indeed literarily weaker than other works by Wolf.

The attack on Wolf as a person is so overdetermined that one begins to suspect a hidden agenda. In Greiner's piece, it is intimated in the rhetorical question of the title "What remains. Does something remain?" But perhaps Greiner personally does not even have a hidden agenda. Perhaps he only compensated for the media's earlier willingness to give certain GDR authors the dissident bonus—criticism, then, of one's own earlier projections, and his review does meekly suggest that much. That is certainly a legitimate and currently not untypical gesture, but then the critique of one's own errors should be as sharp and as merciless as that of the criticized author. In Greiner's case, it isn't. Admission of former bias is rather side-lined by the venom of inveighing against the author, and in the end Greiner makes himself a spokesperson for the "real victims" of the Stasi—compensation all the way, from one kind of projection to the next without a pause for thinking. The rhetorical question of Greiner's title assumes its prophetic viciousness in the context of a Western discourse which already in the summer of 1990 considered the GDR in toto as a pile of junk not worthy of any differentiated assessment.

VIII

The case of Frank Schirrmacher, the feuilleton editor of the *FAZ*, is different. As a member of a younger generation, he does not need to compensate for past judg-ments. His critique of the timing of *Was bleibt* is similar to Greiner's, but his review of Wolf's latest text is only part of a much larger reassessment of Wolf's *oeuvre*. His attack on Wolf as *Staatsdichterin* (though he does not use the term) is much more elaborate and interesting than Greiner's. He begins his polemic by stating that Wolf's literary reputation is overblown and that, in any case, she does not interest him from a literary point of view. The key reproach is that Wolf, from *The Divided Heaven* on, saw it as her task to prop up a regime suffering from inferiority and rivalry complexes. Due to a mixture of illusionist wishful thinking and bigotted affirmation, Wolf was unable to understand that she lived in a totalitarian state. Why this inability? A generational and psycho-historical argument takes shape, one which draws on published accounts by Wolf herself, only to turn them against her. According to Schirrmacher, Wolf suffered from a fundamental misapprehension of social and political relations as family relations. Given her generationally exemplary biography—childhood under fascism, adolescence in the postwar years, and conversion to communism; unquestioned loyalty to the old communists who returned from exile or concentration camps and who guaranteed, with their lived antifascism, that there was a better Germany—Wolf never grasped the complexity of social relations and political oppression in the GDR. This blockage, according to Schirrmacher, was caused by feelings of permanent and ritual gratitude toward the

paternal saviors of a people that had gone astray under fascism. Feelings of shame, guilt, and restitution thus created the same authoritarian structure of character that had prepared the ground for the Third Reich in the first place.

Here the infamy begins. It is one thing to point out Christa Wolf's political socialization and her contradictory misapprehension of the state she lived in, especially with the benefit of 1990 hindsight. But even here historical distinctions must be made. Rather than collapse legitimate gratitude with authoritarian obedience, one would want to consider Wolf's multiple attempts to write herself out of the tortured interlacing of utopian longing and generationally conditioned blockages. The critique that she did not go "far enough" can certainly be made, but to deny the critical complexity of Wolf's work by accusing her of authoritarianism smacks of denunciation. One would also have to discuss the political role of an officially prescribed antifascism, which produced a classical double–bind situation for GDR intellectuals of Wolf's generation to the extent that antifascism provided the moral basis of a postfascist intellectual identity that was used by the regime to legitimize its rule and to muzzle its opponents. But Schirrmacher is not interested in such historical contingencies, nor is he interested in distinguishing between Wolf's political utterances as a public figure and the work of her texts. Attention to specific textual strategies used by Wolf, programmatically excluded from Schirrmacher's review, might have helped here. It is certainly necessary to note a certain avoiding of taboo zones in Wolf's work (1953, the Berlin wall, 1968, the *Schießbefehl* [order to shoot]), even to criticize her one-sided assessment of the Federal Republic and Western democracy which remains dogmatically tied to long-standing left interpretations about the similarities between fascism and capitalism. It is entirely another thing to diagnose and to denounce her as a closet totalitarian with a father complex whose writing cannot but be the outflow of this worst of all German traditions: authoritarianism.

It is ironic that Schirrmacher's psycho-historical argument enacts exactly what Wolf stands accused of: it reduces the political and historical dimensions of a biography and a literary project to its psychic aspects rooted in family relations. The dog chases its own tail and spins around in circles. Schirrmacher seems to have forgotten that it was Wolf who explored the continuities between life under fascism and life in the GDR in *Nachdenken über Christa T.* as well as in *Kindheitsmuster,* and did so in ways that provoked censorship and controversy. He overlooks the fact that Christa Wolf herself criticized the antifascist liturgy in the GDR as an obstacle to a better coming-to-terms with the past, as an obstacle even to the construction of a socialist future. And he ignores the not inconsiderable role Christa Wolf and other intellectuals have played over the years in nurturing a climate of passive and mental

resistance to the regime and that this resistance helped prepare the ground for the opposition movement of 1989, even if the intellectuals did not play a major role in the GDR revolution itself.

Of course, Schirrmacher has not forgotten these things. But he brackets them in order to pursue his larger aim: accusing left intellectuals of a second fall into sin in the 20th century. The implication is clear: Wolf's inability to understand the totalitarian aspects of the GDR regime equals Heidegger or Gottfried Benn's inability in the 1930s to understand the true nature of national socialism. Even while differences between fascist and communist totalitarianism are acknowledged, the failure of intellectuals then and later is held to be fully comparable.

The vehemence of the attack on Christa Wolf serves another, deeper purpose. Throughout the article, the critique of Wolf is projected onto the leftist literary culture of the FRG, a move that reveals the third major aspect of the Wolf debate. The first polemic equates Wolf with intellectual supporters of fascism in order now to prove the analogy between Wolf and the dominant West German literary culture, truly a new kind of *Vergangenheitsbewältigung* (coping with the past). This argument, which is further developed in Schirrmacher's piece of October 2, nevertheless contains a salutory and welcome challenge to what I have earlier described as the saturated leftist consensus of German intellectual and literary culture. I will take issue with Schirrmacher's strategy and argumentation but not with the desirability of the debate itself. The howls of outrage prove that he has struck a nerve, and one can only hope that this will set a process in motion that will eventually go beyond the current face-off between self righteous triumphalism and self-righteous lamentation and denial.

Only toward the very end of the earlier article does Schirrmacher make his decisive move in the battle of the book. He reads *Was bleibt* as an apocryphal act of resistance against the Stasi which is then compared to the ethos of a belated resistance to fascism that supposedly prevailed in the postwar culture of the FRG (Grass, Böll, Walser, Weiss, et al.). Indeed, the notion of a belated resistance to fascism and its identity-creating and legitimizing function captures important aspects of GDR and FRG culture. And Schirrmacher is not the first to observe it. But he chooses to dismiss the literary opposition to the Adenauer restoration as a heroic legend, thus wiping out the difference between a critical intellectual project of major importance for West German culture and its later ossification into palliative dogma. Schirrmacher joins in with the popular 1960s bashing: "The postwar legend of many German writers, artists, and intellectuals is the claim that after the experience of national socialism writers have developed a stable, anti-authoritarian, critical mindset."[31]

The case of GDR writer Christa Wolf and her dilemma with real existing social-
ism is used to claim a continuity of the intellectual culture of the two postwar
Germanies with the tradition of authoritarianism and *"machtgeschützte
Innerlichkeit"* (power protected inwardness). This is a distortion of history of the
first order. Not only are major differences between the FRG and the GDR erased
in this parallel, but the history of FRG literature is relentlessly interpreted from a
viewpoint in the present that focuses exclusively on aspects of its current senility,
ossification, and self-indulgence. Just as all of Christa Wolf's work is only inter-
preted from the standpoint of the collapse of the GDR, the cultural history of the
FRG appears frozen in the snapshot of its ending.

But is it really the fault of old-timers such as Günter Grass, Martin Walser, or
Walter Jens that they are still seen as representatives of German literature and
culture today? It is one thing, it seems to me, to state the obvious and to point to
the lack of radically new literary developments in West Germany in the 1980s. It is
also correct to say that the *Gruppe 47* has played a major role in creating a foun-
dational myth for the culture of the FRG (though certainly not for its politicians)
and in shaping West German intellectual identities. It is quite another thing and
patently absurd to blame the *Gruppe 47,* an entity that dissolved itself over twenty
years ago, for the stagnation of West German literature since then, and to accuse
them, by implication, even of a kind of posthumous thought control.

The legitimate polemic by Schirrmacher against the veterans of the 1960s and
their often insufferable preachiness (which has been successfully transmitted to the
next generations, as the recent peace movements have made amply clear) becomes
apology when he uses the old-timers implicitly to excuse the absence of fresh
developments that might parallel the literary departure of the years 1959 to 1961.
It is striking here to observe how the desire for a radical new departure, for a gener-
ational rupture which indeed does not exist, blinds Schirrmacher to the fact that
the literary scene is much more complex and layered than he would want to admit.
Even if one agrees that there is a dearth of new literary talent, one would still have
to observe that since the 1970s novel aesthetic tendencies have emerged, perhaps
not so much in literature, but certainly in the new German cinema as well as in the
visual arts. The claim that West German culture has remained the same for forty
years seems itself more the effect of a repetition compulsion than genuine insight:
Schirrmacher's predecessor at the *FAZ* Marcel Reich-Ranicki, made the same
argument on the day he left his chair at the *FAZ* feuilleton, December 31, 1988. So
much for generational rupture. . .

Other suspicions arise. Schirrmacher's need for scapegoating may come to a
large degree from his unspoken despair about the fact that the role of literature

itself is no longer what it used to be, say in the 1950s and 1960s. If that is so, his polemic against GDR literature can be seen as a belated revenge for the fact that literature in the GDR until the *Wende* played a public role always unimaginable in the FRG.

What is there, after all, in Schirrmacher's view, to replace Grass or Böll, Johnson or Peter Weiss, Rühmkorf or Erich Fried? I have no quarrel with the suggestion that 1989 marks the end of a long wave of postwar literature. But what will grow from the new *Nullpunkt* (zero hour). How can the new *Nullpunkt* thinking avoid the kinds of contradictions and delusions Schirrmacher analyzes quite cogently regarding the *Gruppe 47* and its own *Nullpunkt* mentality? What is this *"neue Zeitrechnung auch im Erzählen"* ("a new chronology in narrative literature, too") about which Schirrmacher fantasizes? The answers are meager. At the end of "Good-bye to the Literature of the FRG," he mentions Paul Celan and Thomas Bernhard, authors who for a long time have been central (rather than marginal) to the self-understanding of literary culture in this country, certainly as central as the *Gruppe 47.* And he talks about the need for a literary memory that reaches farther back than just one generation, as if writers such as Grass, Koeppen, Bachmann, Weiss, or Enzensberger had ever been *Nullpunkt* practitioners in their texts. Even Enzensberger's 1968 claim about the end of literature and demand for cultural revolution, it seems, had more of a notion of what kind of texts should replace the bourgeois system of literature. Schirrmacher utters a radical good-bye only to demand more memory and a purer aesthetic, one which is uncoupled from social identities and political responsibility, a literature of a radical *"Ich,"* as if we had not already had enough of that since the 1970s.

IX

With the separation of the aesthetic from the social, and the vague demand for a long-wave literary memory, the *éminence grise* of the whole debate comes into view. It is none other than Karl Heinz Bohrer, whose long maverick fight against the dominant culture of the Federal Republic finally seems to bear fruit. With Bohrer, the literature debate also circles back, and not coincidentally, to questions of national identity and German unification. It was Bohrer who, in his *FAZ* article of January 13, 1990, articulated one of the most intelligent arguments favoring the need for a German nation.[32] His defense of nation was as much directed against the various current theories of a new German *Sonderweg* (Grass's polit-theology of guilt and atonement, the left's "third way" utopianism, and Habermas's constitutional patriotism) as against the provincialism and shallowness of official West German conservatism. Bohrer was a latecomer to the Wolf debate proper, which

he addressed succinctly in his marginalia column in the October/November issue of *Merkur*. But practically all of the terms that were choreographed and featured in the discussion about Wolf and the literature of the two postwar Germanies in Greiner and Schirrmacher are already there in Bohrer's plea for unification and nation. His lament about the loss of an emphatic concept of nation in postfascist Germany is grounded in the reproach of hypocrisy and sentimentality directed at left intellectuals who are said to mistake a colonized consciousness for political reason. He speaks of the *"machtgeschützte Innerlichkeit"* of German small-town culture, criticizes the prevalence of authoritarian character structures in the GDR, and rejects the prevalent moralizing in the literature of the FRG. As panacea he proposes to counteract the notorious entropy of cultural remembrance in all of Germany with the category of nation, to nurture and develop the symbolic and reflexive constants of a collective historical and cultural ability to remember. What kind of politics could emerge from such remembrance he does not say in that article—except that it will be national.

Treating Bohrer as *éminence grise* of the Wolf debate is not to advance some conspiracy theory, nor to claim original authorship for the ideas and notions that have surfaced in the Wolf debate. Nor do I want to reduce the various political positions manifest in the debate to the political viewpoint of Karl Heinz Bohrer. The point is rather that Bohrer's well-known, long-standing arguments have now assumed larger discursive dimensions as a result of the recent historical events and the manifest crisis of leftist and liberal discourse. I will also claim that it is only in his work that the political and literary dimensions of the Wolf debate reveal themselves fully. This is so because Bohrer, in his reworking of an elitist anti-bourgeois, even right-wing politics and of a Nietzschean modernist aesthetic, sharpens the arguments beyond the guilt-ridden *Wendehals* liberalism of Greiner or the ultimately apolitical aestheticism of Schirrmacher. It is interesting to note that among Christa Wolf's critics only Bohrer is able to acknowledge the literary merits of Wolf's *oeuvre* while still condemning *Was bleibt* as *Gesinnungskitsch*. It is Bohrer's categorical separation of politics from aesthetics which allows him to criticize the muddling of aesthetic and political categories, as it characterizes not only much of postwar German literature but also most of the Wolf debate. On a scale of increasing distance from the literary political consensus of FRG culture, Bohrer's position is the farthest from the center, farther even than Schirrmacher, who remains mired in generational warfare, and farther than Greiner who in his manic *Wende* cannot deny at any moment the feuilleton's former participation in what he now rejects. This view from a distance gives Bohrer a better perspective and reduces the need for displaced aggression.

But what is Bohrer's goal in the current debate? The point of demanding an end to GDR and FRG literature is to lay the foundations for a new national consciousness. Only Bohrer seems to have a concept of what should replace the critical aspects of the old system of literary and intellectual discourses. Only in his work, which insists on the autonomy of the aesthetic imagination, is the idea of a cultural renewal tied to a specific political vision. Given the breadth of Bohrer's aesthetic and literary thinking, I will have to limit myself to a few observations and preliminary suggestions. The debate with Bohrer, which even in Germany has barely taken place, will still have to be conducted in much detail. It is essential to understand that Bohrer is both an academic literary critic (one of the most prolific and interesting in Germany today) *and* a political thinker, or rather an aesthetician who sees aesthetic theory as somehow central to political thought. His political views have been shaped by the tradition of an anti-bourgeois modernism that includes Baudelaire and surrealism as well as self-styled right-wing aristocrats such as Ernst Jünger, and by a strong and emphatic understanding of nation which I suspect was nurtured in his long years as *FAZ* foreign correspondent in London.

For decades Bohrer has understood his extremely ambitious work as part of the tradition of an aesthetic modernism at war with social and economic modernity. Modernity, as defined in the sociological and philosophical tradition from Max Weber to Habermas, is radically criticized from the position of an aesthetic Nietzscheanism. Liberal and Marxist views of progress, the peculiarly German tradition of a philosophy of history and its teleology, the philosophy of art from Schiller to Hegel and the enslavement of art and literature in the service of politics, history, and pedagogy—all of this is swept away in the name of a radically modern imagination.[33] Against that left-Hegelian and Marxist tradition, Bohrer revalidates a literary tradition that has consistently been dismissed as reactionary by the left in the two Germanies, the tradition of romanticism, of the fantastic, and of an anti-leftist modernism. Friedrich Schlegel and Novalis, Nietzsche and Jünger are his guarantors of the imaginative potential of German culture.

Bohrer's infatuation with Ernst Jünger, bard of the wonders of the trenches of the Great War to whom Bohrer gives more literary credit than his intelligence should permit, is no coincidence. To many it is simply evidence of his right-wing politics. Yet it would be a mistake to identify Bohrer simply with Jünger's proto-fascism of the 1920s and to accuse him of the kind of aestheticization of politics that Benjamin already criticized in Jünger. The embrace of Jünger is neither a regression into the past nor an attempt to revive the conservative revolution of the 1920s. It is inherently a polemic, perversely and intriguingly waged with the help of Benjamin and Adorno, against the one-sided privileging of left-wing

modernism and its construction of the project of modernity which has become prevalent in the FRG since the 1960s. As such it has great merit in opening up questions shut down or short-circuited by the dominant discourse. But there is another point I want to make here. If indeed Bohrer's view of a new national consciousness, his call for a new culture, informs Schirrmacher's *Nullpunkt*, then it is no *Nullpunkt* at all. It is at best a new stage of a radically aesthetic, romantic, Nietzschean critique of modernity which itself has a long tradition in Germany.

A key question remains: what is the politics of Bohrer's project of an aesthetic anti-modernity which highlights the experience of terror and evil? As soon as the demand to revalidate a certain underprivileged tradition of the national culture is coupled with a politics of unification, as it is in Bohrer's writing, the categorical separation between aesthetics and politics evaporates. It becomes clear that Bohrer does not just adhere to an art-for-art's-sake position. What he wants is a kind of linkage between politics and aesthetics other than that which has prevailed in the FRG.

Bohrer's main political gripe with the FRG rests on the correct observation that the Bonn state lacks a political class similar to that of France, England, or the United States. As a consequence, the sense of national identity is blurred and color-less. The provincialism of Bonn politics is only matched by the provincialism of German cultural and intellectual life. The key element of Bohrer's political elitism is anger about the lack of an elite in Germany. His political writings, collected in the first part of *Nach der Natur*, are purely literary satire in the tradition of Heine rather than that of the conservative revolution of the Weimar years.[34] It is as if the empty space left by the vanishing of a German political class is filled by aesthetics, which becomes a substitute for politics, a mere reversal of the substitution of politics for aesthetics which Bohrer sees as the paralyzing virus affecting contemporary German culture.

Despite its problematic connection with a politics of nostalgic elitism, Bohrer's insistence on the uniqueness of the aesthetic phenomenon and the aesthetic experience must be taken seriously. It is plausible not just in opposition to the kind of moral and political use value imposed on all art and literature in the GDR; it also makes sense as a critique of a literary culture such as West Germany's in which even an artist's outspoken rejection of a political or moral dimension in art is first and foremost determined by the dominant discourse it opposes. Bohrer's focus on what used to be called "the work" is also salutary at a time when the secondary discourses of theory and criticism threaten to dissolve any notion of aesthetic coherence in their incantations about the death of the work and the death of the author. Insistence upon the phenomenality of the art object, on the specificity of aesthetic experience, is necessary at a time when the work is buried under the

rubble of a discourse of textuality that proceeds increasingly according to laws of channel flicking. Bohrer's insistence upon the uniqueness of the aesthetic phenomenon is particularly interesting in that it intelligently avoids the pitfalls of a saccharine resacralization of art which has resurfaced with a vengeance in the past ten years. His attack on the writer as priest in the critical column on Christa Wolf testifies to that. From a literature in a secularized enlightened society Bohrer demands a sharpening of imaginative potency rather than drugs for the oppressed or comfort for the downtrodden. His legitimate polemic against a certain middle-ground of intellectual discourse in Germany, however, makes him forget that quite a few postwar literary works from both parts of Germany fulfill that demand.

It is too early to say whether or not Karl Heinz Bohrer's thinking about a new culture and a new national consciousness will end up shaping a broader discourse in the unified Germany. It certainly has played a major role in the debate about Christa Wolf. Bohrer's will remain an important voice, not the least because of his editorship of the *Merkur*, a German monthly which understands itself as a German journal for European thought and which was founded (ironic coincidence) in 1947. An overblown nationalism should certainly not be pinned on Bohrer, particularly since the course of unification has thoroughly corroborated his analysis of January 1990: postwar Germans East or West have no emphatic sense of national identity nor are they likely to develop it soon. Recent events have made it quite clear, however, that national sovereignty is likely to play a political role in Europe for much longer than the Bonn melting pot mentality anticipates. Bonn's stated desire to dissolve the new found unity into a united Europe seems more out of step with current political realities than Bohrer's insistence on the inevitability of nation.

X

Both in the unification and the literature debate, left intellectuals were on the defensive because of the inherent weakness of long-standing aesthetic views concerning German culture and nation. Even though much of the polemic directed against Christa Wolf or the *Gruppe 47* was vicious and gratuitous, it is ludicrous to fear a nationalist conservative restoration at a time when the only cultural and political vision offered by German conservatives is to build more museums. To me, the failure of German intellectuals lies in their current reluctance to recognize that a radical rethinking has become necessary as a result of the sheer force of historical events.

Ironically, it may be a testimony to the strength of the ties between aesthetic and political discourses in Germany that the collapse of the leftist political consensus

under the pressure of events immediately pulled literature and aesthetics into its orbit. Thus the appearance of Wolf's *Was bleibt* was only the trigger for a debate that was preprogrammed by the logic of political events. This explains why the debate was so massively overdetermined, and why neither the attacks nor the defenses of Wolf, the author and the person, ever rose to the challenge of discussing politics and aesthetics both in their linkage and in their separation.

There is no doubt in my mind that the Wolf debate marks the ending of a literary and critical paradigm. For all the desire for a new beginning, however, I do not believe that there will be a radically new literary departure. As always in the case of historical ruptures, the continuities, in one way or another, will prevail for some time. And yet the history of postwar German culture will have to be read in a different light. The rules of the game have been fundamentally altered. It is now up to the intellectuals—writers and artists, philosophers, social and political thinkers—to adapt themselves to the new terrain and to stop fighting yesterday's battles.

Nation, Race, and Immigration
German Identities After Unification

> **Nationalism today is at once**
>
> **obsolete and current.**
>
> Theodor W. Adorno

The Anti-Nationalist Consensus

Over three decades ago, the existentialist philosopher Karl Jaspers, author of an important and much ignored earlier book about German guilt (*Die Schuldfrage*, 1946), claimed that the history of German nationalism was finished and done with. National unity, he argued, was forever lost as a result of the guilt of the German state, and the demand for reunification to him was nothing but a denial of what had happened during the Third Reich.[1] Jaspers's critique was directed against a then strident conservative discourse of reunification coupled with the bellicose non-recognition of the GDR and the demand, especially by the the organizations of Eastern expellees (*Vertriebenenverbände*), to keep the question of the Eastern borders open. He was the first to articulate an argument against a unified German nation state that has since been widely adopted in Germany, even though at the time Jaspers himself was rejected by the right and largely ignored by the left.

While the division of Germany in 1949 into two states was the political result of the emerging Cold War superpower confrontation and had nothing much to do with retribution for the crimes of the Third Reich, a rhetoric of punishment and retribution regarding the question of national unity became the basis for a

broad left-liberal consensus in the Federal Republic since the 1960s, from Jaspers to Grass and Habermas, and including the vast majority of the cultural and academic establishment. Any proper coming to terms with the past (*Vergangenheitsbewältigung*), it seemed, was predicated on the end of the German nation state. In the 1950s, of course, the Social Democrats had an emphatically affirmative position on national unity, and the building of the Berlin wall stirred up a strong wave of national sentiment. Eventually, however, a strong anti-nationalism took hold, affecting the political and literary culture in fundamental ways. Nation, nation state, and nationalism were short-circuited, and their history in Germany was judged exclusively from the telos they had reached in the Third Reich and in Auschwitz. German nation and unification became non-issues for many. The existence of more than one German state was increasingly accepted across the political spectrum, and some never stopped to point out that in the long wave of German history the unified nation state had only been a brief episode after all. When the question of German nation surfaced at all, it was mostly in a cultural rather than political sense: thus the debate over whether there was only one or whether there were two German literatures and, later, the debate between Grass and Heym about a German *Kulturnation* capable of transcending the political division.

It bears remembering that this anti-nationalist consensus, with its thoroughgoing critique of all those German traditions (and by no means only conservative ones) that opposed German culture to Western civilization and argued for German exceptionalism (*Sonderweg*), was an essential component in the successful Westernization of the Federal Republic: its embrace of liberal life styles, democratic institutions and a political identity based on a constitution. At the same time, there was always a fundamental contradiction. The anti-nationalist consensus clashed head-on with the reunification clause of the Basic Law of 1949 which remained the normative basis of West German politics, even if its realization was pragmatically postponed in the day-to-day life of Ostpolitik from Brandt via Schmidt to Helmut Kohl. In 1989, before the fall of the wall, reunification was not something anybody put great stakes in or even thought possible in the short term. The consensus among all parties in the 1980s was still Brandt's "policy of small steps," designed to ease life for the East Germans and to build a network of inner-German relations that would even outlast any further superpower freezes. When the Greens proposed to do away with the claim to reunification altogether, it was like calling the others' bluff. Of course the proposal was not successful, but in practice the constitutional demand for reunification had been reduced to achieving a modest measure of freedom for the East Germans (e.g., the easing of travel restrictions) through a calibrated politics of rapprochement and interdependency.

Unification itself was left to the incalculable whims of history, and history indeed took care of it.

The Return of Nation

Thus in 1990 the question of German nation returned with a vengeance and took everybody by surprise.[2] After the collapse of the SED regime the East Germans voted for unification with the Federal Republic, and the Basic Law provided the political and legal basis for this process which was achieved with lightning speed. Forty-five years after the end of Hitler's war, Germany was again a sovereign nation state. East and West Germans are united on a territory with stable borders in the East and in the West. The Western part of the country, confiding in the strength of its economy, has shouldered the enormous burden of currency union (against the advice of most economic experts), institutional unification, and reconstruction.

Three years after unification, however, the process has gone into reverse. The abyss between East and West Germans seems larger than ever. The rebuilding of East Germany, accompanied by much Western arrogance, selfishness and insensitivity, has stalled, with unemployment in some parts of East Germany running as high as 40%. Structural economic difficulties have emerged to an extent even unanticipated by the doomsayers of 1990, and the social and psychological integration of the two Germanies is further away than ever. At a time when the progress of European unification has slowed significantly as well, and to a large measure due to economic difficulties with German unification, there is a rise of various nationalist discourses on the right, accompanied by rampant violence against foreigners in both parts of Germany: Hoyerswerda, Rostock, Mölln, Solingen.[3] Often the police are curiously ineffective, the courts indecisive in prosecuting offenders, and the politicians and some of the media less concerned with the victims than with understanding the perpetrators. The slogan "Germany to the Germans" counts its adherents not only on the far right. Indeed, the discourse of nation in Germany has fallen back into a register that's all too well-known from German history.

Nevertheless it would be simplistic to assume that an inherently xenophobic and racist national character is reasserting itself. The numerous candlelight marches against xenophobia demonstrate, in their own problematic ways, that there is at least a strong moral opposition to nationalist xenophobia.[4] But the problem is not a moral one. It is structural and political, and thoroughly of current making. Xenophobia in Germany will continue to run out of control as long as the state refuses, for reasons of short-term electoral gain, to use its monopoly of juridi-

cal and police power against criminal offenders, as it did to great effect against the left terrorists of the 1970s. The nurturing ground of xenophobia can only be dried out through a political process that clearly articulates issues of immigration and citizenship as separate from political asylum and in relation to national interest. Asylum, immigration, and citizenship are the primary discursive terrains on which German national identity is currently being rewritten. The almost exclusive focus on asylum, however, and the general oblivion to issues of citizenship and immigration are reason to worry about the democratic future of Germany. Thus the manipulative and outright demagogic attacks on Germany's extremely liberal and constitutionally grounded political asylum law have resulted in a reprehensible and impractical "compromise" that de facto hollows out the individual right to asylum and may still prove to be unconstitutional. The insidiously exclusive focus on the asylum question nurtures the delusion that "Germany is not an immigration country" and it highlights the absence of an immigration law that would begin to regulate the influx of foreigners who currently must claim political persecution in order to gain legal entry.

The current debate on German nation, with few exceptions, is hardly more promising. It has barely begun to free itself from ingrained argumentative patterns that are inadequate to the current situation of Germany in Europe and the world. In different ways, both the new nationalists and the anti-nationalists are heavily mortgaged to the politics of the past. The nationalists, to the extent that they have an articulated position at all, reproduce delusions of national grandeur of Germany as a Central European power in Bismarckian terms or worse. The adamant post-nationalists and critics of unification remain tied nostalgically to what I would call the post-fascist exceptionalism of the old Federal Republic, thus representing what George Orwell in 1945 called "negative nationalism." Since 1990, these are two sides of the same coin.

It may be significant that so far it has mainly been liberal observers from abroad who see unification as Germany's second chance in this century (Fritz Stern) or as an institutional, constitutional opportunity (Ralf Dahrendorf).[5] Despite worries about the rise of the new nationalism in Germany, linked as it is to the new nationalisms in France and in Eastern Europe, and its damaging effect on European integration, I share Stern's and Dahrendorf's point of view, though not their (perhaps strategic) optimism. At a time when Germany is again a nation state and in desperate need of national reconciliation between East Germans and West Germans, between Germans and their long-time immigrants, the question of German nation must be understood as a key political challenge across the ideological spectrum, a challenge to the democratic parties and institutions as well as

to the anti-nationalist cultural and academic left. Nation and democracy, not its contradiction, nation *and* modernity, not its inherent opposite—that is the field of political contestation that will determine whether Germany continues on the path of Westernization or falls back into an anti-Western, anti-democratic mode increasingly prominent in the right-wing discourse. As some in Germany have begun to argue,[6] the question of nation must not be abandoned to a still marginal right wing that seeks to undermine the democratic consensus and that has been successful so far in exploiting inevitable insecurities and instabilities in the wake of unification. Those who harbor phantasies of a new Bismarckian Reich as the major power in Central Europe called upon to colonize the East and to dominate the European Community threaten a vital political consensus that is based on the two pillars of integration into the West and reconciliation with the East.

Westernization and reconciliation in the broadest sense, while never complete, have functioned as powerful forces of "normalization" in Germany, and it is this kind of normalization, one that recognizes rather than forgets the crimes of the past and remains committed to a constitutional, democratic form of government, that could provide the basis for a more stable and secure sense of German national identity.

National Identity and European Integration

But how does one approach this notoriously shifting concept of national identity?[7] Any discussion of nation and national identity must recognize that it moves on extremely slippery terrain. The concept of nation never functions alone, but in relation to other signifiers in a semantic chain including patriotism and chauvinism, civic spirit and ethnocentrism, democracy and authoritarianism, constitutional rights and xenophobic exclusions. Indeed, as Etienne Balibar has argued, the discourses of race and nation are never very far apart, and racism is not merely a perversion of nationalism but "always a necessary tendency in [its] constitution."[8] In addition, we have come to understand how racism and sexism are linked and how nationalism itself has had a strong impact on codifications of gender and sexuality.[9] The notion of nation is indeed fundamentally ambiguous, a "modern Janus," as Tom Nairn has called it, and its negative constituents may be enough of an incentive for anybody to stick with their anti-nationalist or post-nationalist convictions.[10]

Most critical observers these days agree that nation, like race, is primarily a political construct, not a natural given or essence. Constructs are subject to change over time, can be contested and shaped through political processes. This insight must be consciously exploited by the democratic left today if it does not want to

end up either sidelined or sucked into nationalist sentiment as it was in 1914 and as it was again, on a lesser scale, in the asylum compromise. Clearly the move toward European unification and internationalism in the decades since World War II has greatly benefited from the Cold War. Thus it has been argued that the superpower confrontation put any number of nationalisms into a kind of historical deep-freeze by imposing bloc affiliations, creating international structures, and limiting the field of action of national players. After the collapse of the Soviet Union, we are witnessing an explosive mix of old nationalisms revived, both in Eastern and Western Europe, and we are entering into new power politics nationalisms that threaten to undo the advances made toward supranational structures.

The violent break-up of Yugoslavia is a case in point. It not only illustrates the paralysis of the Europeans when faced with a murderous conflict in Europe, it has also resurrected old allegiances between the Germans and the Croats, the British and the Serbs, thus adding fuel to German-British animosities which pull this war on the geographic margins of Europe right into the center of European politics. The victims are the Bosnian Muslims on whose behalf there has yet to be a single major demonstration in Germany or, for that matter, elsewhere in Western Europe. The drawn-out tragedy of Bosnia represents a breakdown of European integration far more serious than the sudden death of the Maastricht agreement. De facto Europe has accepted ethnic cleansing in an area that once provided a living example for multicultural integration. The difference between Serbian nationalism bent on outward conquest and genocide and a West European populism that calls for internal ethnic cleansing on the basis of a new differentialist racism is only one of degree and direction.

Europe in general, not only its Eastern "liberated" parts, is faced with a resurgence of nationalisms not thought possible only a few years ago. In this situation it would be a serious political abdication for the democratic left not to occupy the question of nation, not to try to make use of its potentially constructive side that builds community, guarantees civil rights, integrates populations. Europeanism or regionalism, two of the alternatives to nation privileged by the post-nationalists, are and have always been not really alternatives at all, but necessary supplements to nation and always implied in it. The emerging internationalism of the European right wing should remind us of the fact that fascism was not just the telos of German nationalism, but itself projected a version of European unification. The decision to opt for a European identity in order to avoid the Germanness in question, so typical of post-war intellectuals, was always a delusion, necessary perhaps in the post-war decades, but politically self-destructive today. Europe was always the privileged space in which modern nationhood took shape.[11] Rather than

representing an alternative to nation, Europe was always its very condition of possibility, just as it enabled empire and colonialism. The mechanisms separating the non-European as barbaric, primitive, and uncivilized were ultimately not that different from the ways in which European nations perceived each other. The traditional national border conflicts that led to inner-European wars have now, it seems, simply been displaced to the outside: Europe, for all its divergent national identities, cultures, and languages, as one meta-nation vis-à-vis the migrations from other continents.[12] Fortress Europe as the contemporary reinscription of 19th-century fictions of national autonomy: this is the danger of a Europe dominated by the right-wing. Bosnia, at any rate, is already "outside."

Thus to prevent further "regression" to a nationalism of megalomania, resentment and aggression in Germany, all those who favor an open society and identify with the democratic, constitutional, and Westernized culture of the Federal Republic might do well to engage in a debate about a potentially alternative and positive notion of nation. A democratic concept of nation would emphasize negotiated heterogeneity rather than an always fictional ethnic or cultural homogeneity. It would acknowledge the abyss between West and East Germans and devise ways to bridge it, including for instance the simple acknowledgment that major mistakes were made in the process of unification itself. It would accept the reality of immigration and devise reasonable ways to control it. Even with Berlin as capital, it would draw on the strong tradition of federalism rather than on centralism, build on the structures and institutions of the old Federal Republic and continue on the now more difficult path toward a multi-national, united Europe.

Blocked Discourses

There is a perverse paradox here. When Germany was divided, the question of German nation had become increasingly theoretical, and, at least in the West, the notion that the nation unified in one state had merely been a short-lived episode in the long wave of German history, was thoroughly accepted and internalized, especially by the post-war generations. East and West Germans came to live with separate identities. They became even somewhat exotic to one another and recognized each other in their differences. One such difference was that the SED regime tried unsuccessfully to instill a class-based sense of a socialist German nation in the East Germans while the West Germans, in the 1980s, indulged in a debate about national identity exclusive of the East Germans. The identity at stake in the FRG after the electoral Wende of 1982 was the left-liberal identity of the Federal Republic which many saw threatened by the conservative government. Bitburg, the historians' debate, Kohl's plan for two German history museums, the

Jenninger affair, the many official memorials held for anniversaries of key events marking the history of the Third Reich (1933/1983, 1945/1985, 1938/1988, 1939/1989) all became issues of national public debate, but the nation was the old Federal Republic.[13] October 3, 1990, the day of unification, which was not celebrated with much nationalist exuberance, let alone jingoism, primarily marks not the happy conclusion of an unhappy national division, but rather the sharpening of the national question, the opening up of new fissures and faultlines in the problematic of nation. Before 1990 there were two German states, but presumably one nation. There is now again one German nation-state, but two national identities, an FRG and a GDR identity within what is supposed to be one nation. If in the pre-1989 debate on national identity the emphasis could be on the word "identity" while "national" remained restricted by political circumstance and featured more of a cultural slant, after 1990 the emphasis inevitably falls on the word "national" in the political sense. But the totally unanticipated, even unthought unification of Germany as a fully sovereign nation state now has the Germans befuddled as to what nation actually might mean under current circumstances. Forty years of understatement, abstention, or outright taboo are claiming their dues, and the absence of political vision among the political elites is fanning the fires of the kind of retrograde nationalism that the Federal Republic thought it had successfully exorcised.

The process of rethinking German nation has barely begun in a conscious way, although it is subterraneously energizing all of the current political debates in Germany, from asylum to military participation in U.N. missions, from social and economic policy to Bosnia and European unification. Any attempt to move beyond the stifling and dangerous current stalemate in the discourse of nation must begin by identifying the blockages to a new approach. Here I would distinguish three major forms of an inability and unwillingness to deal with the question of German nation in a productive way that looks to the future rather than to the past.

The first blockage can be squarely located in the official government discourse itself. Despite the wide-spread and highly significant hesitations regarding the question of whether Bonn or Berlin should be the capital of Germany, official Bonn discourse takes nation and national unity simply for granted as if Germany had just been returned to a natural state of things. That this view is not only held by conservatives is demonstrated by Willy Brandt's understandably euphoric statement in the wake of the falling of the wall: "What belongs together is now growing together." This "naturalist" view forgets or represses that ever since the building of the wall in 1961 the existence of two German states had become second nature and unification was nothing but a nostalgic phantasm, ritualistically conjured up on a

West German national holiday such as June 17 (anniversary of the 1953 uprising in the GDR), but not thought to be in the realm of the possible or even, as far as the younger generations were concerned, the desirable. It is symptomatic that with all the research done on the GDR over the years, there was never a single think-tank developing scenarios of reunification. The term "re-unification" itself which suggests a return to some prior, more natural state is actually symptomatic of this forgetting and of the lack of reflection on what separates the two parts of the country after more than forty years of separate development.

Significantly the identity of the new enlarged nation was first sought in nothing but economic strength and high living standards, exactly that element which primarily defined West German identity before unification and which presumably was all the East Germans wanted. The first things Kohl promised in the euphoria of unification in 1990 were identical salary levels, identical living standards in East and West within a few years with no sacrifices necessary on anybody's part. Three years after unification this discourse of economic national unity has collapsed under the weight of adverse economic conditions: a national debt proportionately larger than that of the United States, increased taxes with further tax hikes on the horizon, dramatically rising unemployment, increasing awareness of an aging infrastructure in the West, and a weakening of the national fetish: the Deutschmark. Many but not all of these problems are a consequence of ill-advised priorities set in stone at the time of unification: the 1:1 exchange rate at currency union, the policy of returning property to former owners rather than compensating them (*Eigentum vor Entschädigung*), the often hasty and counter-productive Treuhand privatizations. In the context of a global recession, which in Germany was only postponed by the unification boomlet, Helmut Kohl's house of cards of easy promises is gone and his failure to make a hard-nosed call for sacrifice and national solidarity—which might have been heeded by a majority in the West in 1989 and 1990—now comes to haunt the political class whose credibility and competence ratings are lower than ever.

The West German chauvinism of prosperity, boosted as it was by the greedy 1980s, can now hide behind the argument that the taxpayer should not be held accountable for the mistakes of the politicians. Economic anxieties about the future are on the rise in the still incredibly wealthy West, and they are heightened by the political instabilities in Central and Eastern Europe. As the image of instant European integration has faded, some reasonable definition of German nation is all the more urgent to prevent further division between East and West Germans, Germans and foreigners living in Germany, East and West German *Länder* (states), communities and the federal government. However strongly bound the

European Community nations still are into the web of supranational organizations such as NATO, the European parliament, the Helsinki accords, the nation state remains a major political force in Europe, and will continue to set the political agenda in the foreseeable future. European unification itself will have to be thoroughly rethought. The Bonn slogan of 1990 about a European Germany does not do justice to the current political constellations.

The second obstacle to a new discourse on German nation is the refusal to address the problematic of nation altogether (except in order to fight the right) and the conviction that the Germans are beyond nation. This mostly liberal and left discourse remains tied by way of simple reversal and similar lack of reflection to the ritualistic national discourse of the conservatives. It simply rejects what they celebrate and thus perpetuates an intellectual stance that made a lot of political sense in the 1950s and 1960s, but has outlived its usefulness in the current political situation. In its strategies of denial and evasion, it could be called the Hallstein doctrine of the left. The Hallstein doctrine of the 1950s and 1960s was a policy of non-recognition of the GDR that had politicians address the other German state as the "so-called GDR" or the "zone" or even "central Germany" suggesting that the Oder-Neiße line would not remain the permanent border with Poland. The current non-recognition of nation as a political challenge again ignores the East Germans and remains tied nostalgically to the identity of the old FRG, except that by now the former rhetoric of punishment for the crimes of the Third Reich has been transmuted into a rhetoric of German superiority. Thus one could argue, meanly, that this Hallstein doctrine of the left is just another version of the claim to German exceptionalism and is comparable to the old conservative *Sonderweg* thesis in that it, too, claims German superiority, in this case over those who still adhere to a self-understanding as nation: the French, the British, the Americans, and many, many others.

This most recent kind of German exceptionalism is located primarily among a middle-aged generation of intellectuals, journalists and professionals whose political identity was defined during the 1950s and 1960s and whose work has contributed significantly to the strength of West German democracy over the years. The lived refutation of traditional conservative notions of Germanness was certainly a prerequisite for the successful Westernization of the FRG. This generation's fierce anti-nationalist stance has been more than successful in that it has denationalized a majority of Germans to the extent that many of them prefer to feel European rather than German, a preference which in its own paradoxical way is of course fiercely peculiar to the Germans.[14]

Jürgen Habermas, one of the main proponents of such a postnational identity,

thus will accept a constitutional patriotism only, and he rejects the earlier predominant notions of a *Volksnation* with its focus on homogeneous ethnicity and *Kulturnation* with its emphasis on the exceptionality of German culture in relation to Western civilization.[15] Understandably wary of amorphous cultural identity politics and historically aware of the dangers of nationalist discourse altogether, Habermas holds out the idea of Europe and the universalist European ideal of constitutional rights as a panacea for the vicissitudes of German national identity. The question here is not whether Habermas is right or wrong. Constitutional rights are indeed non-negotiable as the basis of identity in a democratic society, but it is not negligible that the primary legal authority that can guarantee constitutional rights is still the democratic nation state and its institutions. In the absence of functioning supra-national political units, the nation state is still a fact of life, and it will produce forms of belonging and identity needs that cannot in all instances be satisfied by the abstract-universalist principles of the constitution. In some ways, the very notion of constitutional patriotism, first coined by Dolf Sternberger in 1982, remains tied to the culture of the old Federal Republic with its studied rejection of the national.

Today, at any rate, as the struggle to unify the two parts of the country economically, legally, culturally and psychologically confronts all Germans with extremely difficult tasks, a broader vision of Germany's role in the world is clearly called for, and all of the current debates on the reconstruction of the East, the uses and abuses of the German military, on asylum, on policy toward Bosnia, on European integration and the Deutschmark do indeed define a sense of German nation, whether one wants to admit it or not. Forms of national identity will emerge from those debates and the actions taken or not taken. National identity will be a field of contesting discourses, and as long as the political public sphere, parties, and parliamentary representation are organized primarily on a national basis, it is dangerously short-sighted to keep proclaiming that "we are beyond that," a position that has understandably been accused of "postnational arrogance." Replacing a lost socialist or progressively liberal internationalism by a constitutional universalism combined with a commitment to Europe does not do away with the problem of nation at all. To acknowledge this, however, is not to dismiss the idea of a constitutional patriotism. It merely tries to open it up to a broader field of reference. Patriotic commitment to the German constitution will have to remain a founding element in the redefinition of German identities, but by itself it is not enough to address the hard questions of cultural identity, historical memory, immigration and race.

The third obstacle to a new approach to German nation is the rabidly nationalist

discourse of the new right-wing organizations, the skinheads and other disenfranchised segments of the population, both in the Eastern and the Western *Länder*.[16] With its anti-semitism and racism, its street violence and cowardly night-time fire-bombings, and its phantasm of ethnic autonomy and purity, this is of course the revivalist nationalist discourse that reminds the world of the Nazis and triggers warnings of a Fourth Reich. It is not interested in new approaches to nation, and it is grist for the mill of the post-nationalists whose convictions it reinforces.

The range of potential electoral support for the new "respectable" right-wing parties, who try hard, though not persuasively, to keep their distance from street violence, is far from clear. Their new differentialist racism that acknowledges cultural difference in order to expel it from the national body clearly has wide appeal, and it has its parallels in France, Italy, and England. While the right has scored some electoral successes in state parliaments, recent polls taken after the murders of Turks in Mölln and Solingen indicate that much of that support is soft. The attacks on foreigners, however, have continued unabated in the first half of 1993, and the general dissatisfaction with the traditional parties is undiminished.

Much will depend on how the political, intellectual, and media elites in Germany will shape the discourse about the problems currently facing the unified country. So far the radical right, aided by conservative Bonn politicians like Rühe and Schäuble has scored a major political success in displacing the debate about German nation to the discursive terrain of asylum legislation. It is indeed in the debate over asylum that German nation is being redefined. After all, the rationale for Germany's extremely liberal asylum law was the recognition that political asylum had been the only lifeline for thousands of refugees from Nazi terror. The founders of the Federal Republic wanted to pay back Germany's debt, as it were, with Article 16 of the Basic Law that guarantees unlimited political asylum. Dismantling this law in response to street pressure and populist prejudice fanned by short-term party interests is thus indirectly a denial of Germany's past that plays into the hands of the right-wing revisionists. The new asylum "compromise" which de facto does away with the unlimited right to political asylum clearly is a success for those who claim Germany for the Germans.

Citizenship, Immigration, and Asylum

Perhaps changing the practice of asylum in Germany was unavoidable in light of the expected South-North and East-West migrations and in light of the fact that the extent of the current influx is already larger than that of all other European countries combined. But the practice of asylum could have been changed in a different way. The political pressure could have been taken off the asylum

legislation by separating asylum from immigration and moving toward immigration quotas. While that would not have solved all practical problems, it would have given a clear indication that the Germans are willing to abandon the delusion that "Germany is not a country of immigration," like the old Hallstein doctrine, yet another denial of reality. It would also have required that the country accept a different definition of German citizenship, one that puts the emphasis on length of residency rather than blood lineage and ethnic descent, *ius soli* rather than *ius sanguinis*.[17] It took two years and several thousand attacks on foreigners and dozens of dead and injured for the Bonn government and the media to recognize that maybe the 1913 law that still defines German citizenship via blood lineage should be repealed or modified to permit at least second and third generation foreigners to claim German citizenship if they so desire. It remains to be seen if the current rethinking of citizenship will result in a much needed further Westernization of Germany or if it will produce as foul a "compromise" as the asylum debate has.

Citizenship, asylum, and immigration are key to current redefinitions of German nation and will provide us with a strong measure for judging German politics in years to come. Nation would have to be understood as an ongoing process of negotiating identity and heterogeneity outside of the parameters of the ethnic myth and including all those foreigners who live and work in Germany and have made Germany their second *Heimat* (home, native land). The 1913 law which defines German citizenship on the basis of *ius sanguinis* rather than *ius soli* should be abolished and replaced by a "normalized" law closer to the practice of Western nations like France. This, of course, is the task of a democratic left which is under pressure on this very issue in France itself where not only the National Front wants to make the rules on citizenship closer to the German model. Thus politically progressive action on citizenship and immigration in Germany today may well have significant European implications. At any rate, the absence of a Western type practice of naturalization in Germany is a major political deficit, and it burdens the search for national identity with a heavy mortgage from the past. By defining citizenship via blood lineage and descent, this law not only gives credence to the phantasm of uncontaminated Germanness, but worse, it helps produce this phantasm in the first place. As long as even settled second- and third-generation immigrants, who go to school in Germany, work in Germany, watch German television, and have become part of German culture in a multitude of hybrid ways, can be considered with impunity less German than foreign-born ethnic Germans from the Volga or Rumania who no longer speak the language and whose ideas of Germanness are in a pre-modern time-warp, the fires of xenophobia will continue

to be fanned. Of course, there is no guarantee that changing the rules on citizen-ship will have an immediate effect on the radical right wing. In the short run it might make things worse. One can only hope that the political class will articulate this necessary change in policy in such a way that the majority of Germans will perceive the current situation for what it is: a massive deficit in Westernization.[18]

My political point here is simple. If the radical right has been able to determine the agenda of the debate on Germanness in the asylum debate, it is because litur-gical incantation and an equally ritualistic taboo are still the two major forms the discourse of nation takes in Germany today. But this is exactly where both the anti-nationalist intellectuals and the fumbling politicians in Bonn are in danger of repeating that German history they both ostensibly want to avoid. For as Rainer Lepsius has shown, the problem with German definitions of nation was always the lack of a clearly defined content (contrary to France, England or the United States), and this lack threatens again to lead to grave consequences if the discourse of nation is abandoned to the anti-democratic right where it is energized with racist hatreds, resentment and violence.[19] Paradoxically, it is again (as after 1918) the weakness of a stable sense of national identity and statehood in Germany that energizes the violence against those who do not "belong." The history of German nationalism that has to be overcome is one that always bought national hegemony at the expense of an internal enemy: in the Second Reich it was the working class, later the Jews, today the "foreigners." That is why the "German question" today is the question of asylum and immigration and why there can be no meaningful political discussion of asylum and immigration apart from a discussion of the fissures of German identity and German nation.

The Xenophobic Triangle

If the asylum debate, energized as it was by xenophobia, fire bombings, beatings and German fears of being "foreignized" (*Überfremdung*), in one very obvious sense is about German national identity, it also has an insidious hidden dimen-sion: the growing intensity of resentment between East and West Germans.[20] My hypothesis is that the astonishing levels of real and verbal violence against foreign-ers, including wide-spread populist fellow-travelling in xenophobia, result to a large extent from a complex displacement of an inner-German problematic which right-wing ideologues are successful in exploiting. At stake is not just the scape-goating of foreigners by the East Germans who now experience themselves as second-class citizens, as colonized by the victorious West, or for that matter by the West Germans who fear for their living standard and, like everybody else in Europe, face an uncertain political future. These are important factors, but what

is at stake on a deeper level is rather the displacement onto the non-Germans of forty years of an inner-German hostility where another kind of foreign body was identified as the source of most problems: the other Germany. The whole Ossi/Wessi split, symptomatically expressed in this sort of infantilized language, is not so much a function of objectively separate developments since the late 1940s nor is it only the result of the current problems with unification. Those issues, one would think, could be rationally discussed and dealt with. The unwillingness even to engage in such rational discussions can be attributed to the fact that, on the psycho-social level, the other Germany was always inscribed as the other into one's own sense of being either a West or an East German. The inability or difficulty of a post-war German to belong could always be blamed on that other German: the other German as thief of one's own potential identity.[21] And that bad, other German could be found either on the respective other side of the wall or, through a complex web of political identifications, on one's own side. Thus the West German left was always and without differentiation accused by the conservatives of identifying with the GDR. And dissidents in the GDR could always be accused of being enemies of socialism or agents of Western revanchism: the internal enemy as an agent of an "outside" power which also happened to be German. National identity was always fractured in this way, and it remains to be explored to what extent the success of denationalization in both Germanies was fueled by such subterranean conflicts that destroyed older forms of national identity as much as they added another chapter to the history of German self-hatreds. Unification, of course, dismantled the external form of this mechanism, but it displaced its substance onto another terrain. The new thieves of German identity—thieves of "our" tax money, "our" jobs, "our" homes—are the foreigners. Only this triangulation of foreigners, East Germans and West Germans fully explains the intensity of the escalation in xenophobia since unification.

Such inner-German hostilities show how the historical identity of the GDR is inescapably intertwined with that of the FRG. But the Germans have barely begun to understand that, indulging instead in replays of the blaming game. Thus the West Germans use the Stasi revelations to make the East Germans "other" yet one more time, with the added dimension of using the Stasi to compare the GDR to the Third Reich and thus writing yet another chapter of a displaced coping with the past. The East Germans in turn insist on their GDR identity more than ever and transfer their antagonism from the SED state, which they and not the Bonn government dismantled in the peaceful revolution, to the Bonn republic, democratic institutions, and Americanization. Indeed, one state, but two nations, a potential powderkeg of conflicts and political instability. It is this common

heritage and recent resurrection of Cold War attitudes and patterns of thought on both sides, together with the stubbornly postnational discourse in the West and the lack of vision of the political class, which blocks what is needed most: national reconciliation, integration, and solidarity, all public qualities that the political culture of the 1980s did little to encourage.

If the question of citizenship and immigration is one major discursive terrain on which a new democratic understanding of German national identity may be shaped today, the question of German history and memory is the other one. However, the ideological trench warfare about history and memory is about as stifling as that about nation. The right-wing demand for a positive identification with German traditions that precede the Third Reich seeks to relativize that period of German history, to isolate it, and to redeem a German nationalism untainted by the "perversions" of the Hitler years. This attempt must be opposed with arguments that emphasize linkages between the specific kind of German nineteenth-century ethnic nationalism and the Aryan ideology of the Nazis without collapsing the two. But the call for an identification with tradition and historical memory is not per se a right-wing enterprise. The predominant left response to this question of German traditions remains too enamored of the rituals of anti-fascism which have been recharged by the new right, the latest object of negative desire. The positions of the democratic left on German history are actually much better founded than the apocalyptic tone of the current political debate would lead one to believe. New understandings of German history evolved in the GDR as well as in the FRG, and there is no doubt that Marxist cultural and literary history, with its orthodoxies and even more so with its heterodoxies, has contributed substantially to the emergence of progressive views of German traditions in West Germany since the 1960s. All of the new social movements in Germany, up to and including the opposition movement in the GDR, have reappropriated traditions, constructed alternative memories, searched the national past for materials that would support their political and cultural claims. German unification will be no exception to the rule that all historical upheavals will result in a rewriting of history and tradition. The question is not if, but how and to what extent identificatory memories will be reshaped. It will be interesting to see how eventually an East-West-German dialogue not mired in mutual recriminations will give rise to a new texture of national memory.

Postnationalism and Normalization

As in the nation debate, here too the position of the post-nationalists and constitutional patriots hampers the emergence of such a dialogue. When Jürgen

Habermas argues that citizenship is not conceptually tied to nation, and that "the
nation of citizens does not derive its identity from ethnic or cultural properties, but
from the praxis of citizens who actively exercise their civil rights," he underesti-
mates the legitimate need of East and West Germans to secure a common history
that has a lot to do with cultural properties and national history.[22] Clearly
Habermas has no use (and for good reason) for the old notion of a German
Kulturnation with its anti-Western implications, its class-based notion of high
culture and its populist ethnic, if not racist connotations. But to separate the exer-
cise of civil rights from cultural properties or from the praxis of culture altogether
is not very persuasive. Exercizing one's civil rights will always involve cultural prop-
erties, traditions, memories, language. Memory is indeed central to constitutional
patriotism itself. The very notion of constitutional patriotism gains its political and
moral force because it has drawn political conclusions from the memory of the
uniqueness of the Shoah, and Habermas himself over the years has proven to be
one of the most eloquent critics of those who want to "normalize" German history
by excising the memory of Auschwitz either through relativization or denial.

The emphatic postnationalism on the left is of course fired up by one keyword:
"normalization." It is still haunted by the historians' debate of 1986.[23] But the revi-
sionist history advanced by Ernst Nolte and Andreas Hillgruber clearly did not win
the day.[24] Its absurdities were too blatant, and they were effectively exposed in a
wide-ranging public debate. There is no need to be apocalyptic about "normaliza-
tion." Thus if one increasingly hears these days that Germans should identify with
other, better traditions, that they can't be expected to walk in sack-cloth and ashes
forever (as if they ever had), and that restitution (*Wiedergutmachung*) has been
concluded, this does not mean that the revisionists finally achieved the victory
denied them in 1986. After all, this type of discourse, often coupled with an anti-
semitism of resentment ("The Germans will never forgive the Jews for
Auschwitz"), is not exactly new.[25] That it is being voiced with increased hostility
since unification is not surprising to anybody who is aware of the contorted
history of anti- and philosemitism in the Federal Republic. In order to oppose this
kind of discourse, however, one must admit to notions of national responsibility
and national guilt, as Karl Jaspers already argued in 1946. The discourse of nation
is indispensable here too: the crimes of the Third Reich were not committed "in
the name of Germany," as Bonn-speak all too frequently has it, but by Germans.
The Shoah is ineradicably part of German history and German memory.
Curiously, nobody has made the argument that the denial of German national
identity and the emphatic commitment to Europe could itself be seen as a flight
from this history. The reason, of course, is that the post-nationalists are also those

who insist most adamantly in preserving the memory of German responsibility. And yet, there is an inconsistency here that points to the unbearable nature of a burden too heavy even for those who do acknowledge it.

At the same time, we must not forget that it was in the struggles of the 1960s for a more democratic Germany that Auschwitz became part of German national consciousness, although the fierce anti-nationalism of that critical generation would not have permitted such phrasing at the time. But why resist such a thought now? As international as the movements of the 1960s were in France, the U.S., and Germany, each one did have its own national specifics, and in the FRG the demand to work through the fascist past and the Holocaust were central to the demands for a more democratic Germany in the years of the Great Coalition, the APO (extraparliamentary opposition), and the student movement. However problematic some of the German discussions and treatments of the Shoah may have been at the time, the memory of Auschwitz was indelibly inscribed into German national identity in those years and even the current advocates of forgetting—as long as they are publicly opposed, and they are vociferously—actually reinforce rather than erase the legibility of that inscription.[26] Memory, of course, is a very tenuous and fragile thing, and it needs to be buttressed with the help of institutions of documentation, preservation, and participatory debate. But given the extraordinary intensity of public memory and debate in the 1980s (from the explosive reception of the television series *Holocaust* via Bitburg, the historians' debate, the Third Reich anniversaries all the way to the Wannsee Conference anniversary of 1992 and the media debate about the new Holocaust museum in Washington), I am not so worried that right-wing strategies of denial have had that much of an impact. This is not to say that they should not be fought every step of the way. One strategically productive way of fighting them would be for the democratic left to reoccupy the discursive terrain of nation and to recognize that the democratization of Germany, indissolubly coupled with the recognition of a murderous history, has already given the new Germany a national identity which is worth preserving and building on.

Memories of Utopia

<p style="text-align: right;">

Longing in artworks,

which aims at the reality of the non-existent,

takes the form of remembrance.

Theodor W. Adorno
</p>

I

Like art, utopian thought has always survived its premature burials, and at times it has staged quite spectacular resurrections from the no-places, the no-wheres on the maps of social and cultural life. Survival and rebirth, the desire for the annihilation of death, the longing for another life have always been among the most stubborn impulses to keep utopia alive in adversity. In our century, the discourse of the end of utopia is as endemic to the utopian imagination as its visions of other worlds, other times, or other states of mind.

Utopian thought survived the declarations of its obsolescence in the *Communist Manifesto*, and it survived its withering away in scientific Marxism, only to return with a vengeance within Marxism itself in the twentieth century, in the work of Bloch and Adorno, Benjamin and Marcuse among others. It also survived the dire warnings of Karl Mannheim in *Ideology and Utopia*, which today read like an anticipation of *posthistoire:* "It is possible, therefore, that in the future, in a world in which there is never anything new, in which all is finished and each moment is a repetition of the past, there can exist a condition in which thought will be utterly devoid of all ideological and utopian elements."[1] Claims to the

contrary notwithstanding, we are nowhere near this Mannheimian future. Certainly, one major form of an orthodox and prescriptive utopianism has collapsed with the Soviet Empire. The triumphalism that accompanies this specific end of utopia in the West and that celebrates it as an end to all utopia is oblivious to the ways in which this collapse is already affecting the culture of liberal democracies themselves. For no utopia ever dies alone. It takes its counter-utopia with it. With the demise of the Soviet Union, capitalism itself now lacks a vision of the future, but rather than trying to remedy the problem, it revels in that lack, as if short-term pragmatism were an alternative. The end of utopia, it seems, is our problem as well in a much deeper sense than we would like to admit.

The obsessive attempts to give utopia a bad name remain fundamentally ideological and locked in discursive battle with residual and emerging utopian thinking in the here and now. The strenuousness with which this denunciation of utopian thinking is being pursued years after the Soviet Empire dissolved proves that our age is neither beyond history, nor at the doorstep of some post-utopia. The neoconservative attack on all utopias as inherently and insidiously totalitarian and terroristic—a multiply warmed over argument that counts Carl Schmitt and Hegel among its ancestors—has as its obvious goal the rewriting, if not erasure of the effects of the 1960s, that decade of the recent past which most emphatically rekindled the utopian spirit, from Martin Luther King's "I have a dream" to Herbert Marcuse's call for the realization of utopia to the May '68 graffiti proclaiming *l'imagination au pouvoir* (power to the imagination) It cannot be denied that a certain kind of utopian imagination has indeed ended in a post-1960s enlightened false consciousness, as Peter Sloterdijk has called it in his *Critique of Cynical Reason*.[2] But I do not take it for granted at all that the utopianism of the 1960s led lock-step into the cynicism of the subsequent decades, nor would I consider Sloterdijk's postadolescent *kynicism* an adequate response to the cultural environment of post-1960s disillusionment. Cynicism and utopia, disillusionment and utopia are far from being mutually exclusive, and rather than assuming the end of utopia lock, stock and barrel, it might make more sense to ask whether perhaps the utopian imagination has been transformed in recent decades, reemerging in formerly unpredictable places such as the new social movements of the 1970s and 1980s and being articulated from new and different subject positions.

But the anthropological belief in the indestructability and irrepressibility of the utopian imagination should not blind us to the difficulties—epistemological, political, aesthetic—which utopian thinking faces in the late twentieth century. There was a growing sense, already since the latter 1970s, that somehow utopia, and not just its prescriptive ossifications, was in trouble, and this consensus cannot

be attributed simply to the machinations of the neoconservatives. But if there was something like an end to utopia, it is by no means clear what exactly it is that has ended, and we must take a closer look at the victim.

The discourse of the end of utopia, it seems to me, operates on three levels. Firstly, on a political level alluded to above which simply reflects on post-1968 political developments, on the *Tendenzwende* (turn or shift in politics), the emergence in major Western countries of a new cultural and political conservatism that administers the residues of New Deal liberalism and social democratic reforms. What for some became the long desired *Wende*, turned for others into an often apocalyptic fascination with *das Ende*, especially in the wake of Ronald Reagan's star wars phantasies and loose Pentagon talk about "the European theater." In pragmatic terms, this end of utopia has to do with the crisis of liberalism and the welfare state, with the long agony and final collapse of socialist alternatives (Soviet Union, China, Cuba, Third World), with the heating up of the armament race in the late 1970s and early 1980s, with the rise of structural unemployment in the West and the systemic impoverishment in major parts of the Third World, with the damage to the environment and the generally waning confidence in technological solutions to social problems. Jürgen Habermas, in a 1984 speech entitled "The Crisis of the Welfare State and the Exhaustion of Utopian Energies," analyzed this phenomenon and suggested that at stake was not the exhaustion of utopian energies per se, but rather the end of a certain kind of utopian discourse which, since the late eighteenth century, had cristallized around the liberating potential of labor and production.[3] Habermas addresses this crisis of the utopia of labor, of course, by focusing on communicative action, intersubjectivity and the ideal speech situation. More important for my concerns here, however, is Habermas's rejection of the notion of a radical rupture and his insistence that the coupling of historical and utopian thought, which, as Koselleck has shown in his work on the temporalization of utopia, first emerged on a major scale in the late eighteenth century, is by no means obsolete today. Utopia and time, utopia and history: History as a narrative of emancipation and liberation always points to some future, the Blochian not-yet.[4] On the other hand, history as memory and remembrance is always a narrative concerned with a past, and we all know of those utopian longings directed at a golden age of the past. One does not have to subscribe to Adorno's metaphysical proposition that origin is the goal to acknowledge that the dialectic of remembrance and future projection is the sine qua non of modern utopian thought, simultaneously its strength and often at the root of its all too apparent weaknesses.

Perhaps what we are currently witnessing as the exhaustion of utopian energies

vis-à-vis the future is only the result of a shift within the temporal organization of the utopian imagination from its futuristic pole toward the pole of remembrance, not in the sense of a radical turn, but in the sense of a shift of emphasis. Utopia and the past rather than utopia and the year 2000—that is what moves much of the art and writing that embodies the utopian imagination in our age of an alleged *posthistoire* and post-utopia. Thinking of the work of Alexander Kluge and Christa Wolf, Heiner Müller and Peter Handke, Peter Weiss and Christoph Ransmayr and in the visual arts, Joseph Beuys and Anselm Kiefer, Siegmar Polke and Christian Boltanski, I would say that it is the return to history, the new confrontation of history and fiction, history and representation, history and myth that distinguishes contemporary aesthetic productions from most of the trends that made up the post-1945 neo-avantgardes from absurdism to documentarism and concrete poetry, from the nouveau roman to the Artaud revival in theater, from happenings and pop to minimalism and performance.

In this search for history, the exploration of the no-places, the exclusions, the blind spots on the maps of the past is often invested with utopian energies very much oriented toward the future. The reasons for such a shift from anticipation to remembrance are far from evident, and they may vary from case to case. Nor is it evident what the glance back in time, the search for history may mean in political terms. Given the artists mentioned, however, it should be clear that we are not simply dealing with postmodern pastiche or a waning of affect that Frederic Jameson has identified as a major feature of the postmodern. An analysis such as Jameson's that laments nostalgia trips and the "disappearance of a sense of history" as salient features of the postmodern, seems quite one-sided.[5] It remains hopelessly locked into the futuristic dimension of utopia in its patchworking of a teleological Marxism with a Blochian utopianism.

Against the thesis of loss and disappearance I would rather propose to ask whether contemporary artists are engaged in a project of reconceptualizing, rewriting history in a way that might be as distinct from the Marxist paradigm as it is from the broader modernist one. This reconceptualization which problematizes history and story, memory and representation from any number of differing subject positions, may indeed be imbued with an element of nostalgia. Nostalgia itself, however, is not the opposite of utopia, but, as a form of memory, always implicated, even productive in it. After all, it is the ideology of modernization itself that has given nostalgia its bad name, and we do not need to abide by that judgment. Moreover, the desire for history and memory may also be a cunning form of defense: defense, in Kluge's formulation, against the attack of the present on the rest of time. As Adorno, who can perhaps be seen as the complementary

counter-point to Bloch in the utopia debate, wrote in *Aesthetic Theory*: "Ever since Plato's anamnesis, the not-yet has been dreamt of in remembrance which alone realizes utopia without betraying it to that which merely is the case." [6]

The political *Wende* of the 1970s and early 1980s, with all its implications for culture, should then not just be read as an end to the utopian project of the 1960s. At stake is an understanding of a transformation of that utopianism, a critical displacement of an earlier set of utopian energies at work in Western societies rather than their exhaustion or atrophy. The shift from an exclusive future orientation to the memory pole is perhaps articulated more persuasively in literature and art than in politics, but it is no reason at all to leave the discursive field of utopia to its conservative liquidators.

The discourse of the end of utopia in its second incarnation is related to the triumphalist war on modernity and the master-narratives of the enlightenment, a war waged by several poststructuralist thinkers and their American disciples. But here, too, one could argue that it is only a certain kind of utopia which is pronounced dead on arrival: the utopia of labor and production, of rational transparency of cognition, and of universal emancipation and equality. After all, Baudrillard's potlatsch and symbolic exchange, Lyotard's language games, Derrida's *différance*, Barthes' notion of the writerly text and its pleasure, Kristeva's privileging of the semiotic over the symbolic, Deleuze and Guattari's desiring machines and their notion of a minor literature all may be considered as being themselves utopian, opposed to what these writers would consider the monologic, logocentric, teleological, oedipal and therefore politically totalitarian discourse of enlightened utopianism. But instead of emphasizing the rich utopian dimensions of their project, most poststructuralists, in their intensely post-marxist intellectual mode, will remain starkly opposed to any suggestion of utopianism which they blame for all the evils of modernity. Strange binarism indeed coming from thinkers and critics whose major strategies include the deconstruction of binarisms of all kinds. For only if one collapses all differences between the utopian imagination at the core of the enlightenment and the historical miscarriages perpetrated in the name of rationality, democracy, and freedom, would the poststructuralist critique of utopia have a point.

I think it is fairly obvious that the binary construction at the root of the poststructuralist critique of enlightened rationality has as much to do with French politics of the 1960s and 1970s as it does with any real historical or even philosophical analysis of the enlightenment and its effects. It might therefore be more fruitful to explore the extent to which the various poststructuralist projects actually participate in the suggested transformation of utopian thought in our

time, a transformation which itself can be related to a long tradition of critiques of modernity and of the undeniable downside of enlightened utopianism. After all, there has been for a long time a modernist critique of modernity, sometimes called romantic anti-capitalism, sometimes aesthetic nihilism, of which the surge of French theory of the past twenty and some years would merely be the latest manifestation. This is not to say that we have seen it all before. It rather suggests that a certain set of political and cultural circumstances of the long wave of post-World War II history has pushed an older critique of modernity to a breaking point. The entropy of a certain kind of modern utopian imagination, then, would merely spell the need for its re-writing in a different form.

The third level of the end-of-utopia discourse results from the hypothesis that the culture of enlightened modernity in its postmodern contemporary stage has made reality itself u-topian, a no-place, the site of a vanishing act. This mainly Baudrillardian position, which makes Baudrillard into a theorist of the postmodern rather than only a postmodern theorist, is the exact reversal of Marcuse's call for a realization of utopia. For Baudrillard, utopia is not to be realized, to be transformed from dream and fiction into reality, because it has already been realized in the opposite sense that in the society of the simulacrum reality itself has become u-topian, hyper-real. Postmodern media culture deterritorializes and deconstructs, delocalizes and decodes. It dissolves reality in the simulacrum, makes it vanish behind or rather on the screens of word and image processing machines. What is lost according to this account of a society saturated with images and discourses is not utopia but reality. At stake is the agony of the real, the fading of the senses, the dematerialization of the body, both figuratively and literally. Utopia is no longer needed, or so it is claimed, because all utopias have already fulfilled themselves, and that fulfillment is fatal and catastrophic. Thus goes the argument of Baudrillard's *Les Stratégies Fatales*.

Marx's prediction from the *Communist Manifesto* has come true: All that was solid has melted into air, but instead of a new society we have the simulation of the real, the reappearance of that which was solid as fleeting image on the screen, a kind of apocalyptic reversal of McLuhan's media utopianism of the global village. We are left with the society of the simulacrum and with Baudrillard's iconoclastic promise of implosion and black hole bliss: absorption of all light, no more images, no more meanings, but ultimate density of matter. Baudrillard's astrophysical imagery betrays his hidden desire: it expresses nothing so much as the the desire for the real after the end of television.

The end of utopia, in this account, does not lead to the happy, if often acrimonious reassertion of tradition and value, as it does in the discourse of

neo-conservatism. Nor does it pretend to liberate us from modernity's master-voices by ushering us into a world of nomadic thought or agonistic language games. The end of utopia, it turns out, is the end of the real. We are left with the dystopia of the black hole, the astro-physical no-space in which all distinctions between reality and utopia have been collapsed, and where language itself has ceased to be possible.

But even if one rejects Baudrillard's account of contemporary culture as improperly totalizing and thus still very much tied to the kind of master-narrative it ostensibly rejects, his reversal of the real and the utopian is provocative enough to make us rethink the relation of reality and utopia in our age. For once one switches off the television set—apparently a rare occasion in Baudrillard's universe—the problem of reality as no-place does indeed become a very real problem. When reality can no longer be represented, understood, or conceptualized in terms of a stable episteme, when the modernist problematic of language and representation is no longer limited to the aesthetic realm, but, because of the spread of the media, has become all-pervasive, what are the consequences for utopian thought? After all, it has to ground itself in perceptions and constructions of what is in order to project what might be. But when even the functional understanding of capitalist society, as Brecht attempted to construct it, loses its moorings in a traceable reality and is endlessly displaced by the mere noise of discourses and the mise-en-scène of the visual media, what can a utopian imagination produce except either the promise of apocalyptic deliverance or the artificial paradise of scopophilia here and now?

To sum up this third register of the end-of-utopia discourse: If the dialectic between a given reality and the desire for imagined other worlds is constitutive for utopian thought, then the appearance of reality itself as u-topia, as simulacrum on the screen implies the actual disappearance of reality as we thought we knew it. Together with reality, utopia itself is thrown into a tail-spin. By occupying a no-place, reality itself vanishes, making utopia a practical and theoretical impossibility and delivering us to the infinite recycling of simulacra. On this third, most radical level, the discourse of the end of utopia involves simultaneously the postulate of the end of the real, and the aporia is complete. Baudrillard can be read as postmodern fulfillment of Mannheim's prediction, but his theory of simulation suffers from excessive extrapolation from just one sector of our society, the sector of high-tech cyberspace, to all of our contemporary life-world.

The current claim that utopia has ended is no more plausible than in Mannheim's time, and, like Daniel Bell's argument about the end of ideology in the 1950s, it will be forgotten with the next resurgence of the utopian sensibility.

II

The transformation of temporality in utopian discourse, the shift from anticipation and the future to memory and the past, manifests itself quite strongly in German literary developments since the 1960s. Most recently, however, the political end-of-utopia discourse intervened rather crudely in literary matters.

In the wake of German unification and the Christa Wolf debate of 1990, German post-fascist literature East and West has been vociferously accused in the German media of a misguided, if not insidious, utopian disposition. This last fling of Cold War rhetoric with its typically reductive notion of utopia clearly aimed at rewriting the history of German culture and literature in light of reunification. The multiply layered and generationally complex anti-fascism of so many post-war German writers and intellectuals was now simply dismissed as "belated" and thus allegedly self-serving and suspect, if not outright complicitous in state repression as in the case of some of the most well-known GDR writers. In the feuilletons, the year 1990 came to be something like ground zero for any future literary development,[7] a prerequisite for the kind of reinvention of German literature which, as far as I can see, has so far mainly catapulted the centenarian proto-fascist Ernst Jünger into the limelight—another striking case of the deep past as future, rather than the promised new beginning.

But the end of utopia did not emerge full-blown with the collapse of the GDR. For even though a certain kind of left-liberal and socialist utopianism had come close to being dominant in German literary and intellectual circles, it was always also plagued by self-doubts and subjected to skepticism from within. Against the current revisionism, one has to insist on the fractures and complexities of that allegedly monolithic utopian discourse.

I will not address the broader philosophical question of how to redefine the utopian dimension of art after Adorno,[8] except to insist that the aesthetic dimension is inherently utopian, that severing the link between utopia and literature is cutting the lifeline of literature itself. I will rather focus here on the historical question to what extent the recent end-of-utopia discourse overlaps with an earlier discourse of the end of art, the 1968 German analogue of the postmodern American celebration of the anti-aesthetic. More specifically, I want to ask how the end of utopia relates to the much discussed end of modernism and the exhaustion of avant-gardism since the 1960s.

It has become quite common among literary critics to distinguish the late 1960s' tendency to politicize literature (in the spirit of a Brecht/Benjaminian constructivist production aesthetic) from the rise of the so-called new subjectivity in the 1970s, a literature that presumably abandoned the political and returned to

the folds of the properly literary and aesthetic. Such a simplistic account—from politics to literature, from the objective to the subjective, from enlightenment to irrationality, from history to myth—clearly did not do justice to the complexity of literary developments, but one thing does seem certain: the 1960s' attempt to resurrect the avant-garde project of the inter-war years, whether in its Marxist Brechtian or surrealist Artaudian reincarnation, has either shipwrecked or simply petered out.

In retrospect, the often cited 1968 *Kursbuch* declaration of the death of art and the call for a documentarism of political dossiers, interviews, and reportage reads more like an administrative or bureaucratic decree than like the Marcusean sublation of art into life. And the thought that the Parisian call *"l'imagination au pouvoir"* (power to the imagination) could have succeeded makes not only neocons shudder in retrospect. If indeed the aesthetic dimension inherently holds a *promesse de bonheur* (promise of happiness), even in its most negative modernist forms, then the call for the end of art as well as the demand to bring the imagination to power were simultaneously a call for the end of utopia: the end not as realization, but as elimination. But even when one grants the debate about the death of literature its Marcusean utopian dimension, one would still have to contend with the argument, made already in 1962 by Hans Magnus Enzensberger and again, differently, in the early 1970s by Peter Bürger, that the neo-avantgardist revivalism since the late 1950s was simply deluded rather than utopian.[9] The avant-gardist attack on the institution art had ended once already, but in a sense diametrically opposed to its intentions. Art had already been successfully sublated into life: first by the fascist aestheticization of politics and then by the consumer capitalist aestheticization of the commodity and of the commodity image. Thus art had always already ended, in Bürger's account, and the revolutionary rhetoric of the late 1960s would appear as so much preposterous repetition: utopia as pastiche. But such a global condemnation would not acknowledge the specifics of a historical situation in which, after a close to thirty-year hiatus of repression and amnesia, the rediscovery of the historical avant-garde could indeed generate once more an intensity of utopian energies that were no longer available from the tradition of high modernism (Thomas Mann, Kafka, Benn) at the time. In a curious way, and for different historical reasons, this situation pertained in West Germany as well as in the United States.

And yet, the end-of-art discourse with its bureaucratic decree to politicize all art was always as unsatisfactory to me as the later triumphalist trumpetings about the end of utopia. Here, too, one would want to ask whether it was not a certain kind of art and, equally important, a certain concept of art that had exhausted itself

rather than art per se. In retrospect, at least, it is clear that the call for the end of art was highly ambivalent. It was still part of an avant-gardist mindset that was convinced it had full knowledge of where the cutting edge of history and aesthetics was; it also, less knowingly perhaps, gave expression to the very crisis of that avant-gardist/modernist mindset. Thus it helped prepare the ground paradoxically, for the reemergence in the 1970s of the kind of art and literature that the '68 *Kursbuch* writers would have considered to be even more affirmative and regressive than the works of the 1960s for which they were writing their ironic obituaries. There seems to be a law of modern culture: the more emphatic the obituary, the sooner the resurrection.

Of course, it was neither art nor literature that died in the late 1960s. What did end was the double-track aesthetic utopia of modernism and the historical avant-garde, a utopia in which art saw itself functioning both as an essential element of radical social transformation and as an agency of salvation and redemption. The last stage of the avant-garde's project of politicizing the aesthetic, of sublating art into life, was reached in the Federal Republic with the 1968 demand to politicize art, a demand that actually resulted in an epistemologically and aesthetically impoverished documentarism rather than in any empowerment of the imagination. I do not mean to denigrate here the political usefulness and timeliness of documentarism in the German context where it helped bring into public view political issues such as Auschwitz and the Third Reich as well as the struggles of decolonization. But one can easily reject that documentarism's claim to be the ultimate aesthetic avant-garde. By anybody's critical account, the union of the political with the aesthetic, postulated by Benjamin in "The Author as Producer" and enthusiastically taken up by the proponents of the end of art, did not take place. This specific politicization of art ended in aesthetic entropy and thus anticipates by some twenty-five years the current ossification of the anti-aesthetic into a dogma of political correctness.

Similar problems, however, emerged in what one might describe as modernism's last stance in the 1960s. The final stage of modernism's concern with the politics of language and self-referentiality was reached in those same years in the language experiments of the Vienna Group, especially in the seminal work of Oswald Wiener, in concrete poetry (Gomringer, Jandl, Mohn) and in Heissenbüttel's language laboratory. As in the case of *Tel Quel* in France, the major thrust of much of this language experimentation was to reveal the inherent oppressiveness of the symbolic order and to create alternative, non-hegemonic codes by exploiting the playfulness and anarchy inherent in language once it is uncoupled from the instrumental need to signify. At the time in Germany, these

two trends of political documentarism and language experimentation were seen as radical opposites, and each one certainly held the other in contempt. Only in retrospect does their proximity emerge in full view. For despite their radically different epistemology and writing strategies, both trends follow the modernist logic of raising consciousness, of creating alternative and counter-hegemonic knowledge, and, through the medium of literature, of destroying illusions: illusions about the real and illusions about language.

Today this logic of disillusionment is exhausted, tied as it is to the denial of the aesthetic as mere affirmation and to a radical modernism of negativity. Attuned as he was to the temporality of art in society, Adorno argued in the 1950s that the negation of the affirmative cannot be sustained indefinitely without becoming another dogma. Inevitably the question will arise: what comes next? The logic of disillusionment will have to yield to some new affirmation. Nietzsche rings true when he says: "That the destruction of an illusion does not produce truth but only one more piece of ignorance, an extension of our 'empty space,' an increase of our 'desert.'"[10]

When looking at literary and artistic developments since the 1960s, it is clear that neither documentarism, radical language experiments nor minimal and concept art would give us a key to the major works of the 1970s and 1980s: neither to Handke nor to Strauss, neither to Wolf nor to Jelinek, neither to Ottinger nor to Valie Export, neither to Kluge nor to Weiss, neither to Fassbinder nor to Syberberg, neither to Polke nor to Kiefer. If the end of an aesthetic avant-gardism was reached in a certain sense with the famous Kursbuch issue that pronounced literature dead, it was sealed in another sense with Peter Handke's two-front attack on the Brechtian paradigm of avant-gardism and on the mainstream modernist writing practices of prominent members of the *Gruppe 47* which Handke labelled "an impotent literature of description." And when Handke provocatively took up residence in the notorious ivory tower *(Ich bin ein Bewohner des Elfenbeinturms)*, thus rejecting all literary rituals of disillusionment, it became clear that his position was as distinct from that of the ideologues of documentarism as it was from that of the language experimentalists. His play *Kaspar* of 1968 is the perhaps the most striking proof of that.

Kaspar consists of an endless chain of pattern sentences being drilled into the protagonist thus demonstrating the oppressiveness of language as it functions in socialization. But at the same time, Handke does not shy away from retelling a very old story—that of the nineteenth-century foundling Kaspar Hauser, who has to be taught how to speak—in a curiously abstract and yet moving way that plays on the urge of the audience to identify. Brechtian *Verfremdung* (estrangement) is

undercut as much as the experimental rejection of narrative. As an experimentalist political melodrama, *Kaspar* was perhaps the most successful theater event of May '68, a time when language had become a central political issue. Of course, the date of its premiere was a mere coincidence, but a fortuitous one. For *Kaspar* showed that *"la prise de la parole"* was as fraught with difficulties as any *"prise du pouvoir"* could expect to be. With hindsight, *Kaspar,* a play that few will remember today, can be read as an uncanny commentary on that other theatrical event everybody remembers from that year: the occupation of the Odéon theater in Paris at the height of the rebellion. For me, both events together mark a turning point in the fate of aesthetic and political utopia in European culture: not the end of art, but the end of a certain utopian aesthetic umbilically linked with the age of classical modernity.

III

Reflecting on the question of utopia in post-1960s German literature and art may give us some clues as to what has changed since that time. These reflections, tentative as they have to be, follow from the consensus that this more recent work can no longer be measured by the criteria of language experimentalism or the logic of abstraction or minimalism. Nor can the left avant-gardist paradigm make strong claims in an age in which the promise of socialist alternatives to a market culture has withered into oblivion. These various older aesthetic practices still do exist as residual avant-gardisms, and at times quite powerfully and persuasively so. But the structure of temporality that underwrote the historical avant-garde's futurist claims is no longer the same. Aesthetic practices with strong links to the historical avant-garde have for some time now existed in cohabitation with new kinds of narrative texts and with new types of figurative painting. The situation, as Habermas has suggested and everyone seems to agree, is *unübersichtlich,* confusing and opaque, but that may be precisely its strength.

There is no longer one single measuring stick called avant-gardism for all artistic production. The reason for this development, however, is not, as Bürger would have it, that the avant-garde's attack on the institution art has failed and that therefore older and newer forms of artistic expression can coexist in pluralist happiness, all equally co-optable and co-opted by the institution and the market. Clearly, the anything goes approach, even in this ambitious theoretical version, is not satisfactory, and we have to begin to make other kinds of distinctions among a growing body of works and artistic practices that position themselves quite critically and pointedly in contemporary culture, in terms of their relation to the market and the institutions, their specific aesthetic strategies, and their claims on different groups of readers and spectators.

One such criterion of distinction is the extent to which post-1960s works, in their own aesthetic strategies, still offer reflections or rather intertextual traces of the project of modernist and avant-gardist aesthetics rather than simply forgetting what Adorno, however problematically, used to call the most advanced state of the artistic material. The difficulty, of course, is that much of the literary production of recent vintage is accurately described and criticized as merely a regression to narrative, subjectivity, identity, self-expression: the forgetting of modernism reigns supreme, in literary texts as much as in the simple-minded desire for experience, identity, authenticity. Much of the *Neue Innerlichkeit* (new inwardness) and penchant for autobiography, the so-called *Erfahrungstexte* (experienced-based texts) and *Verständigungstexte* (autobiographical and confessional texts) that swamped the literary market until recent years is flawed aesthetically by this kind of forgetting. The best texts of the 1970s and 1980s, however, reflect on their own difference vis-à-vis modernism and the avant-garde, and they do so textually in very different ways. Some examples, which I can only name here, would be Kluge's *Neue Geschichten,* Peter Weiss's *Ästhetik des Widerstands,* Christa Wolf's *Kein Ort. Nirgends,* Peter Handke's *Die linkshändige Frau* or *Die Lehre der St. Victoire,* Christoph Ransmayr's *Die letzte Welt.* Examples in the visual arts are Anselm Kiefer's history paintings of the early to mid-1980s and Christian Boltanski's work on memory in photography or his installations such as the "Missing House" in Berlin's *Scheunenviertel,* a formerly Jewish neighborhood.

I do not intend to lump these artists together as postmoderns, and any student of contemporary German culture is aware of the major political and aesthetic discrepancies between Kluge, Weiss, and Kiefer, Handke and Wolf. Weiss and Kluge's production goes back to the early 1960s, Handke and Kiefer only emerged on the scene in the late 60s, Handke with a big splash at the Princeton meeting of the *Gruppe 47* in 1966, Kiefer rather unsuccessfully at first a few years later. Wolf occupies a special place both as a woman writer and as a writer from an East European country in which the modernism problematic has been shaped by literary and political forces very different from those in the West. A common view is to separate Weiss and Kluge as the leftist political writers, grounded in the 1960s, from the apolitical *Neue Innerlichkeit* of Handke and from the even more dubious narcissistic fascination with fascism of Kiefer or Syberberg. Such readings, however, rely on a weak contextualism and a deficient sense of aesthetic issues. They fail to recognize that Peter Weiss was not just writing for a nostalgic left when he wrote *Ästhetik des Widerstands,* but taking up issues of subjectivity and gender, history and myth in powerful new ways; that Kiefer's treatment of fascist iconography was not just a fascination with fascism, but emerged from the need to work

through a heritage of national icons that was as much repressed in the visual arts as in the left-liberal public sphere of the Federal Republic; that from early on, Kluge's literary project was as distinct from the realism claims of documentarism as Handke's was from the *Neue Innerlichkeit*. And it is no coincidence that the complex narrative work of Ingeborg Bachmann, her *Todesarten* cycle, was only "discovered" after the Karin Struck/Verena Stefan phase of women's writing had run its course.

Perhaps the question of utopia will permit an alternate approach to these writers and artists. Surely, my earlier observation that contemporary art and literature have lost confidence in the future and no longer uphold the mystique of avant-gardism, turning instead to the past and to history, to memory and remembrance, cannot suffice here if the aim is to define the posteriority of contemporary art and literature, its *Nachträglichkeit* (belatedness) in relationship to modernism. History and remembrance were after all central aspects of modernism itself (as is evident in the work of Nietzsche, Freud, Proust, Thomas Mann, Döblin, and Broch), and the very problem of memory was constitutive of modernist narrative strategies. But if one tries to identify the utopian element in modernism and the historical avant-garde, then one can find what distinguishes contemporary works from their predecessors and what distinguishes the recent turn to history, memory, and the past from the ways the modernists dealt with temporality.

I would, somewhat schematically, identify three registers of the utopian imagination in the art and literature of the earlier twentieth century: the utopia of sublating art into life, the utopia of radical textuality, the utopia of aesthetic transcendence.

The utopia of sublating art into life, as Peter Bürger has argued, was of course first articulated within the orbit of the historical avant-garde, from Dada to French surrealism. This dimension which was theoretically rearticulated in the 1960s by Marcuse and others is over and done with. It is finished, not only because it led, as Marcuse himself was the first to argue, to a regressive dissolution of the aesthetic dimension (his "repressive desublimation") nor, as Adorno argued, because it betrayed the fragile truth of art to a reified world. More importantly, it is no longer viable because the avant-gardist paradigm to which it was tied has lost its persuasiveness both in the political and the aesthetic fields. The emphatic claim that art has a major role in changing life and society has revealed itself as a dangerous illusion, especially if one remembers the fascist aestheticization of politics. But the proposition is also theoretically not tenable. If modernity, as Max Weber has persuasively argued, is characterized by an accelerating differentiation of spheres, no one single sphere can be charged with bringing about radical social change by itself, least of all the aesthetic sphere. The argument about the sublation of art into

life, it seems to me, was fundamentally tied to a post-revolutionary situation after 1917, and it drew its energies from the political promise of a breakthrough into a radically new society. Today such claims make no sense at all.

Second, there is the utopia of the radically new and modern text that as text retains its separateness from life while allying itself and its effects with a radical political movement—Brecht on the left, Ernst Jünger and Gottfried Benn on the right. This utopia was predicated on the notion of a transcendence of middle-class society and culture which both fascism and communism promised in different ways. It was also built on the conviction that new modes of aesthetic representation had a major role to play in this process of social and political transformation. This latter belief is not held by many today, nor is it viable any longer; it is as if the limits-of-growth argument had finally also undermined the aesthetic conviction "the more modernist the better." After a century of experiments with narration, language, medium, and form, the notion of yet another avant-gardist breakthrough into new forms of representation is hard to sustain. Our age is not one of emphatic breakthroughs and new frontiers, nor would we even want to subscribe today to Rimbaud's "*il faut être absolument moderne*" (we must be absolutely modern). The belief in the transformative powers of art belongs to an age in which art's redemptive promises had not been eroded by consumer culture and by a political history that should make us cringe at any absolutist demand to politicize art.

The exhaustion of these first two paradigms of utopia is largely due to the same reasons: political demands have overloaded art's circuits. Their major difference is that the first advocates *Aufhebung* (sublation), while the second insists on the continuation of the aesthetic project in its own right. But both do take the nexus between aesthetic and political revolution for granted.

Third, there is the utopia of aesthetic transcendence, the discovery of that other language which Rilke phantasized about, that other music which Gregor Samsa in Kafka's *Metamorphosis* desires to hear, or that purity of vision which only abstract art has been said to be able to even aspire to. While the first register of utopia does away entirely with the work of art qua work, the second retains the work, but very much in the service of advancing a political project. Only this third dimension would depend entirely and emphatically on the special aesthetic status of the work and its effects on experience. The work preserves and embodies the utopian moment in an otherwise totally reified culture. Central to this project is the modernist art of epiphany, a temporal experience outside of the regular flow of time and only attainable as aesthetic experience.[11] In short, one might call this the utopia of high modernism, which is uncoupled from the claims of social transformation as much as from the claim that the work of art speaks some political truth about its time.

It seems evident that in the past two decades we have witnessed a withering away of the first two forms of utopian energy that fueled modernism and the avant-garde. What has been relegitimized, often but not always in uncritical and regressive forms, is the special status of the art work as carrier of a utopian dimension. The aesthetic and utopian dimensions of literature and art have reasserted themselves against the dogma of the anti-aesthetic. But the nature of that utopian dimension has changed. The belief in the attainability of pure vision is gone, only the desire is left: Anselm Kiefer's crashing palettes. In Kiefer's attempt to work through the image world of German fascism, politics and history have caught up with a metaphysics of a purity of vision. In Peter Weiss, the hope for the radical transformation of a world of violence and oppression, a goal to be achieved with the sustaining help of the aesthetic, has been suspended in the future subjunctive of the ending of *Die Ästhetik des Widerstands (The Aesthetics of Resistance)*.[12] Kluge's earlier confidence in the emergence of a counter-public sphere has been muted to the notion that being a writer today is like being "a guardian of the last residues of the grammar of time," of the difference between present, future and past, and that writing in the age of the new media is like sending a *Flaschenpost*, putting a message into a bottle and tossing it into the ocean. With that image, used by Adorno decades ago to position Critical Theory, Kluge meets Adorno in the postmodern.

It is in this context of a loss of confidence in the utopian powers of art to either conjure up, approximate, or embody a utopian plenitude—in life, in the text, or in transcendence—that the contemporary turn to history, memory, and the past assumes its full significance. What is at stake in Weiss, Kiefer, Wolf, Müller, and Kluge is not the creation of the utopian epiphany so central for modernism, nor is it the reverse, the aesthetics of terror and violence that scar so much modernist literature and art. Both modes are fundamentally tied to modernism's belief in momentary transcendence, the puncturing of the oppressive continuity of time, redemptive disruption, and ultimately some radical alterity in another life. But this other life was always opposed to an everyday present that seemed mired in oppressive traditional values, in pain and prejudice, and in reification on every level. When this present itself, however, has become progressively unmoored from tradition, when media saturation wipes out spatial and temporal difference, by making every place, every time available to instant replay, then the turn to history and memory can also be read as an attempt to find a new mooring. The reliance on memory in the social sphere marks the desire to resist the delimiting of subjectivity and the disintegration of social cohesion. The art of memory counters aesthetic desublimation and the ideology of the anti-aesthetic. But ultimately our culture as a whole is haunted by the implosion of temporality in the expanding synchronicity of our media world.

It is no coincidence that "the work of art" has come back in this age of unlimited reproduction, dissemination, and simulation. The desire for history, for the original work of art, the original museal object is parallel, I think, to the desire for the real at a time when reality eludes us more than ever. The old opposition reality/utopia has lost its simple binary structure because we acknowledge that reality is not just simply out there, but is also always the site of some construction, just as utopia is and yet different from it. At the same time in literature, the old dichotomy between history and fiction no longer holds. Not in the sense that there is no difference, but on the contrary in the sense that historical fiction can give us a hold on the world, on the real, however fictional that hold may turn out to be.

By working through rather than cynically performing this problematic of utopia/reality, such literature can actually help maintain the tension between fiction and reality, aesthetic representation and history. It is in the attempt to maintain that tension, that dialectic, against the lure of the simulacrum that I see utopian energies at work in literature today. There is a utopian intertextuality with the past in many of the texts mentioned here that attempts to ground the reader in temporality going beyond facile quoting and superficial, arbitrary citation.

There can be no utopia in cyberspace, because there is no there there from which a utopia could emerge. In an age of an unlimited proliferation of images, discourses, simulacra, the search for the real itself has become utopian, and this search is fundamentally invested in a desire for temporality. In that sense, then, the obsessions with memory and history, as we witness them in contemporary literature and art, are not regressive or simply escapist. In cultural politics today, they occupy a utopian position vis-à-vis a chic and cynical postmodern nihilism on the one hand and a neo-conservative world view on the other that desires what cannot be had: stable histories, a stable canon, a stable reality.

Part Two

Media and Culture

The Fragmented Body in Rilke's
Notebooks of Malte Laurids Brigge

Modernity is the transient, the fleeting, the contingent;

it is one half of art, the other being the eternal and the immovable.

Charles Baudelaire

The psychological basis of the metropolitan type of individuality

consists in the intensification of nervous stimulation which results

from the swift and uninterrupted change of outer and inner stimuli.

Georg Simmel

I

If ever there was a German poet said to embody the essence of high modernism, it surely must be Rainer Maria Rilke. And if literary modernism found its ultimate manifestation in lyric poetry, then Rilke's *Sonette an Orpheus* and his *Duineser Elegien* had to be full-fledged embodiments of this privileged art form of the twentieth century. The poetry of the mature Rilke certainly seemed to fulfill the stringent requirements traditionally made of modernist poetry, such as originality of voice, the work as hermetically closed to the outside world, self-sufficiency, and purity of vision and language, all of which would guarantee the work's timelessness and transcendence.

But in recent years such codifications of modernism have increasingly come under attack for being too narrow, and we have come to understand them as themselves historically contingent—related to the post-1945 revival of the autonomy aesthetic—rather than expressing some ultimate truth about modernism. In German literary criticism, this kind of codification of modernist literature first emerged in the mid-1950s in the work of Hugo Friedrich and Wilhelm Emrich, and it fast made its way into Rilke scholarship. Characteristic of this account of

modernism and typical of German intellectual life at the time was the oblivious-
ness to the major debates about modernism, expressionism, and realism that had
taken place in the 1930s involving Brecht, Lukács and Bloch, Benjamin and
Adorno. And yet, the periodization of this postwar account of modernism roughly
corresponds to that of the earlier debate—like Benjamin or, very differently,
Lukács, Hugo Friedrich posits a rupture with Baudelaire in the middle of the nine-
teenth century. The criteria for this periodization, however, are now intrinsically
literary and structural, if not metaphysical, rather than historical, contextual, or
sociopolitical. The separateness of the literary from the social and political was
central to this theory of modernist literature, which used symbolist poetry as its
paradigm. So was its claim that there is an unbridgeable gap between the feeling
and experiencing *I* that expresses itself in romantic poetry and the modern poetic
subject that operates analytically, cerebrally, constructively, and that ultimately
succeeds in purifying itself and achieving a kind of poetic transcendence.
Specifically Friedrich's account of the trajectory of poetry from Baudelaire to
surrealism revolves around the notion that modernist poetry can no longer be
understood in terms of the experience or self-conception of the poet.[1] Categories
such as depersonalization, self-abandonment, or dehumanization provide the
basis for the claim that the poetic subject is forever separate from the empirical,
feeling, and experiencing subject of the author, or, for that matter, the reader.
Already this account of modernism was a discourse of loss and absence, loss of
subjectivity as well as loss of authorship in the traditional sense. It was a discourse
of negativity that aimed at salvaging the transcendence of poetic word and vision
by jettisoning traditional romantic concepts of poetic subjectivity, expression, and
authorial intention that the experience of modernity itself had vaporized.

Rilke scholarship shifted easily into this kind of discourse. It seemed more
appropriately modern and literary after the preceding hagiographic Rilke cult or
the existentialist readings that continued to co-exist in uneasy tension with what I
am calling in shorthand the high modernist readings.[2] With the emphasis increas-
ingly on Rilke's hermetic late poetry, rather than on his more accessible early verse
or on the popular *Geschichten vom lieben Gott* or the *Cornet*, a Rilke image took
hold that valorized Rilke primarily as a representative of what I would call the cold
stream of modernism, a modernism of disembodied subjectivity, metaphysical
negativity, and textual closure, the classicism of the twentieth century.

How, then, does Rilke's novel, *The Notebooks of Malte Laurids Brigge*, fit into
all of this? It hardly comes as a surprise that the high modernist readings of Rilke
pay scant attention to *Malte*, an unabashedly personal and experiential, though
carefully constructed text, whereas existentialist critics see the novel as a

breakthrough to Rilke's most mature work, as an existentially necessary text in which Rilke laid the foundations for his late poetry.[3] It is easy to see how *Malte* had to cause the high modernist critic considerable theoretical embarrassment, since nowhere are the autobiographic and psychological roots of Rilke's writing more evident than in this novel, key passages of which are lifted almost without alteration from the poet's correspondence. Indeed, the closeness of the empirical subject Rainer Maria Rilke to his fictional protagonist Malte Laurids Brigge has been amply documented, and Rilke's letters show how what one might call his "Malte complex" never ceased to play a major role in his life and writings, even after the novel was published.[4] But the dialectic of blindness and insight prevented high modernist critics from actually reading this constellation. Even the existentialist critics who did focus on the pivotal role of *Malte* in Rilke's writing life often lost sight of the text by subjecting their reading to one or another version of existentialist metaphysics. And yet, as the construction of high modernism took hold in criticism, some readers have attempted to pull the text into the orbit of the high modernist canon. Thus critics have read *Malte* as a kind of modernist *Künstlerroman*—the portrait of the alienated artist in crisis, who eventually learns to overcome alienation in his writing[5] and moves from a merely subjective to a more properly objective narrative;[6] or they have argued for some level of fundamental coherence of this extremely fragmented text, a coherence, even closure, that was said to result from the "law of complementarity"[7] structuring the text or from the "closed world of a limited subjectivity" determining the text via the three interweaving clusters of Malte's learning how to see, his remembrances, and his attempts to narrate.[8]

While many of those readings are quite insightful and compelling in their attempts to secure a place for Rilke's text in the canon of the modernist novel, they almost invariably lack an interest in reading Malte's experiences and remembrances psychoanalytically, let alone historically. Given the methodological premises of high modernist criticism, or, for that matter, of existentialist criticism, it comes as no surprise that psychoanalytic readings of Rilke stand almost totally apart from the rest of Rilke scholarship and that the insights of psychoanalysis have by and large been shunned by Rilke scholars as irrelevant for the literary and aesthetic assessment of the novel.[9] Such methodological abstinence is no longer plausible since the theoretical turn in recent literary criticism has radically changed the ways in which we conceptualize the relationship of psychoanalysis to writing and reading. Once we begin to understand subjectivity as social construct, mediated through language, family structure, gender positioning, and historical experience, we can attempt to develop alternative forms of psychoanalytic readings,

readings that are no longer divorced—as psychoanalytic interpretations often used to be—either from aesthetic considerations or from historical-political questions.

II

Thus the aim of this essay is not to provide a more updated psychoanalytic reading of *Malte* in the narrow sense, nor simply to recouple Malte with his author whose symptoms the text would display and displace in narrative form. The aim of the essay is a larger one. By focusing on the overwhelmingly powerful, even haunting imagery of the fragmented body in *Malte,* I want to inquire into the relationship between Malte's childhood experiences, so vividly remembered during his stay in Paris, and his perceptions of the modern city that recent research has shown to be quite representative for the literature of the early twentieth century.[10] My hypothesis is that the relevance of Rilke's novel for an expanded understanding of literary modernism has something to do with the way in which the text suggests connections between aspects of early childhood experience and the disrupting, fragmenting experience of the modern city. If such a reading can be sustained, then it should also be possible to map *Malte* onto a discourse that, from Baudelaire via Georg Simmel to Walter Benjamin, has attempted to define the parameters of the experience of modernity as rendered by the literary text via a theory of perceptions of city life, perceptions as much determined by outside stimuli as they are dependent on psychic processes. But before we get to the larger issue of how to read in *Malte* the dialectic of what Simmel described as the tragic split between objective and subjective culture, let me first focus on the nature of Malte's experiences as Rilke renders them in the text.

Critics have always emphasized that the basic experience of Malte, the 28-year-old aristocratic Dane who comes to Paris with artistic and intellectual aspirations and begins to record his life crisis in his notebooks, is one of ego-loss, deindividualization, and alienation. Often this disintegration of the ego is attributed to Malte's city experiences alone, and his childhood, which also features dissolutions of self, is said merely to foreshadow, to anticipate the later experiences. Not only is such a narra-teleological account not tenable, oblivious as it is to the much more complex narrative structure of the novel and to the always problematic "inmixture" of past and present in narration, but the very thesis of disintegration of self, of *Ent-ichung,* actually presupposes a stable self, a structured ego, a personality in the sense of bourgeois culture and ego psychology that could then show symptoms of disintegration under the impact of the experience of the modern city.[11] What if Malte had never fully developed such a stable ego? What if, to put it in Freudian terms, the id/ego/superego structure, which after all is not a natural

given but contingent on historical change, had never fully taken hold in Malte so that all the talk of its disintegration was simply beside the point? What if the fixation on the ego, which the late Freud has in common with traditional non-psychoanalytic notions of self, identity, and subjectivity, was simply not applicable to *Malte*? What if Malte represented a figuration of subjectivity that eludes Freud's theory of the structure of the psychic apparatus and that cannot be subsumed under Freud's account of the oedipal? Perhaps we need an entirely different psychoanalytic account for what has usually been described as disintegration of self and loss of ego in Rilke's novel.

It is particularly the haunting imagery of the body—Malte's own body and the bodies of the *Fortgeworfenen*, the members of the Paris underclass as they collide with Malte in the streets—that can give us a clue here. The text is obsessively littered with descriptions of body parts (the hand, the abscess, the torn-off face of the poor woman, the second head, the big thing) and of bodily sensations. Such images of threatening body fragments, which take on a life of their own, are paralleled by descriptions of people (the patients at the Salpetrière hospital, the woman on the streetcar) that focus almost fetishistically on separate body organs. In every case the imaginary unity of the body surface is disrupted: from his glance at the rash on the baby's forehead on the first page to his close-up perceptions of the Salpetrière patients' eyes, legs, throats, hands, Malte does not see holistically. Rather he perceives fragments, and this bodily fragmentation causes his anxieties, anxieties of bodily organs growing out of bounds, exploding inside the body, swelling the body beyond recognition and altering or destroying its surface unity. Clearly, these are not primarily anxieties of loss in the sense of the Freudian account of castration anxiety; they are rather anxieties of excess, of flowing over, of unstable bodily boundaries. Significantly, these anxieties are often followed by a sensation of a total dissolution of boundaries, a merging of inside and outside that is also experienced by Malte as threatening and invasive.

Indeed, it is important to insist that these experiences of excess are not to be misread as positive expansions of self, as a dynamic of liberated flows of desire in the mode of Deleuze and Guattari's schizo body, or as a pleasurable symbiotic merger of self and other, along the lines, say, of Freud's notion of the oceanic self. Rilke's constant use of the imagery of disease and filth, aggression and death clearly points in a different direction. Indeed, we face the paradox that these visions of bodily excess are simultaneously experiences of loss. But it is not the localizable loss of the Freudian account that is at stake here; it is a more totalizing loss, a wiping out of identity, a voiding of a sense of self, as in the often-quoted passage:

How ridiculous. I sit here in my little room, I, Brigge, who am twenty-eight years old and completely unknown. I sit here and am nothing. And yet this nothing begins to think . . .[12]

Or, perhaps less abstractly, after his experience with the epileptic on the Pont Neuf:

What sense would there have been in going anywhere now; I was empty. Like a blank piece of paper, I drifted along past the houses, up the boulevard again. (71)

The nothing that begins to think, the blank piece of paper that, it seems, is waiting to be written on—obviously a connection is suggested here between the voiding of self and writing, and I will come back to that later.

But first let me stay with the way in which Rilke presents such dissolutions of the boundaries of the self. Already at the beginning of the novel there is a description of such a crisis of boundaries, limited here, it seems, to the specifics of auditory perception. Malte describes his sensations while lying in bed with the window open:

Electric trolleys speed clattering through my room. Cars drive over me. A door slams. Somewhere a window pane shatters on the pavement: I can hear its large fragments laugh and its small ones giggle. (4)

But the breakdown of the inside/outside boundary is not limited to auditory perception. In the famous passage in which Malte describes the horrifying, almost hallucinatory recognition of the residual inside wall of a demolished house as outside wall of the adjacent building, revealing an inside that is no longer there, the loss of boundary is clearly described in a visual dimension. And the wall of the apartments thus exposed is described in a language that again approximates the human body, just as throughout the novel the dissolution of boundaries affects the boundary between the body and things, the animate and the inanimate:

It was, so to speak, not the first wall of the existing houses, . . . but the last of the ones that were no longer there. You could see its inside. You could see, at its various stories, bedroom walls with wallpaper still sticking to them; and here and there a piece of floor or ceiling. Near these bedroom walls there remained, along the entire length of the outer wall, a dirty-white space through which, in unspeakably nauseating, worm-soft digestive movements, the open, rust-spotted channel of the toilet pipe crawled. The gaslight jets had left dusty gray traces at the edges of the ceiling; they bent here and there, abruptly, ran along the walls, and plunged into a black, gaping hole that had been torn there. (46, translation modified)

And the passage ends with Malte's terror:

I swear I began to run as soon as I recognized this wall. For that's what is horrible—that I did recognize it. I recognize everything here, and that's why it passes right into me: it is at home inside me. (48)

Indeed, the experience of horror cannot be attributed to the city alone, which, as it were, would overwhelm an overly sensitive but, deep-down, authentic subject. True, the horror passes right into him, outside to inside, but it also is already at home in him. Thus even if Malte may initially hope to get some relief by remembering his childhood, it very soon becomes clear that his childhood itself is packed with very similar experiences of the horrifying and the uncanny: the experience of being voided in the dinner hall at Urnekloster ("it sucked all images out of you") (26); the terror of the appearances of the ghosts of Christine Brahe and Maman's sister Ingeborg; the experience of the fragmented body with the hand coming out of the wall toward Malte while he is groping for a pencil in the dark under the table; the childhood diseases and hallucinatory anxieties; and, above all, the mirror scene. It is true that his first reflections about his childhood suggest a fundamental difference between now and then, the city and the country, the factory-produced death in the big city hospital as opposed to the individual death of the old days: / When I think back to my home, where there is no one left now, it always seems to me that things must have been different back then" (10). But already here the reader should get suspicious. For despite its ostensible gesture as statement of fact, this phrasing rather expresses desire ("must have been") and hesitation ("it seems to me"). And while the following reminiscences of grandfather Brigge's death at the estate may indeed be a good example of what Malte means by a death of one's own, the description of the chamberlain's body growing larger and larger and swelling out of the dark blue uniform as a result of his deadly disease already contains the same images of uncontrollable body growth and violent deformation that haunt Malte in his various Paris encounters with the man in the crémerie, the epileptic, the patients in the hospital. Malte's loneliness in Paris makes him want to escape into the past: "If at least you had your memories. But who has them? If childhood were there: it is as though it had been buried. Perhaps you must be old before you can reach all that. I think it must be good to be old" (17). But then Malte's childhood resurfaces with a vengeance, and soon enough he recognizes that rather than providing relief, his memories compound the crisis of his life in Paris: "I prayed to rediscover my childhood, and it has come back, and I feel that it is just as heavy as it used to be, and that growing older has served no purpose at all" (64, translation modified).

In a first attempt to read the basic similarities between Malte's childhood and his Paris experiences, one might suggest, following Freud, that we are facing here

a kind of repetition compulsion. In *Das Unheimliche,* Freud argues that the uncanny is "that class of the terrifying which leads back to something long known to us, once very familiar."[13] Freud also points out that the uncanny experience comes about "when repressed infantile complexes have been revived by some impression or when the primitive beliefs we have surmounted seem once more to be confirmed."[14] Of course, there is a difference. Malte does not just "experience" the uncanny in Paris. He also describes it, writes about it, tries to work through it, and in yet another register, of course, it is Rilke himself who is engaged in working through his Paris/childhood experiences by having Malte write about them in a fictional voice. Since the publication of Lou Andreas-Salomé's book about Rilke (1928)[15] and the publication of the first volumes of Rilke's letters (1929 ff.), a rigorous separation of Malte from his author, as if we could have Malte without Rilke's childhood anxieties, is as ludicrous as a total identification of Malte with Rilke would be.[16] Rilke himself put it succinctly enough: "Er [Malte] war mein Ich und war ein anderer" ("He was myself and was an other").[17]

But my primary interest at this stage of the argument does not concern the relationship between Malte and Rilke, which has been documented fairly well. It rather concerns the question to what extent the "impression" of the city triggers the repetition compulsion. Is this a mere coincidence? Could Malte's childhood memories have broken loose with equal force in any other circumstances? Is the external stimulus even necessary for the repetition compulsion to surface? Freud after all goes so far as to claim that "where the uncanny comes from infantile complexes the question of material reality is quite irrelevant; its place is taken by psychical reality."[18] But in opposition to Freud, I want to suggest that it is actually Malte's particular experience of the city that triggers the resurfacing of childhood disturbances and confronts Rilke/Malte with the necessity of working through them: the city, as it were, functioning, in a very un-Proustian spirit, as the Proustian Madeleine for all the childhood anxieties related to the phantasm of the fragmented body. But before broaching the relationship between modernization and figurations of subjectivity directly, we must still try to understand the origins of Malte's phantasms of the fragmented body, a task that the text itself does not engage in, but rather complicates through a constant shifting between authorial subject and fictional subject.

At this juncture it should be noted that Freud's text also draws our attention to the uncanniness of severed limbs as they appear in literary texts such as E.T.A. Hoffmann's *Der Sandmann* or Wilhelm Hauff's *Die Geschichte von der abgehaue-nen Hand.* Of course, Freud interprets these phenomena in terms of his theory of castration anxiety which, as I shall argue, is not really applicable in the case of

Malte. Only as an afterthought, which is not further elaborated, does Freud mention the uncanny fear of, and fascination with, the idea of being buried alive, a "phantasy of inter-uterine existence."[19] Here indeed Freud comes very close to the problematic that is articulated in the novel, and it is interesting to note that we know from Lou Andreas-Salomé's accounts that Rilke himself did have one such dream.[20] Ultimately, however, Freud's interpretation of the uncanny is only pertinent to a reading of Rilke's novel in that it emphasizes the phenomenon of repetition compulsion in uncanny experiences. In order to understand the specifics of this repetition compulsion, however, one needs a different framework, one that is not locked into the oedipal mode.

III

Such an expanded account of the uncanny in phantasy life, I think, is present in the work of post-Freudian psychoanalysts such as Melanie Klein, Margaret Mahler, Michael Balint, and others, all of whom have focused on what commonly is called the "preoedipal" phase of child development, the phase of symbiotic unity of child and mother and the painful process of separation of the child from the mother.[21] It is no news to Rilke readers that Malte's relationship to his mother, and later to his mother's youngest sister Abelone, is far more important in the narrative than his relation to his father. Malte's key childhood experiences revolve around the realm of the Brahes, his mother's family, rather than the Brigges, the family of his father. Ghosts in Malte's Denmark, which one would expect to be male and mouthpieces for the law of the father, are invariably female in this novel: Christine Brahe and Ingeborg, both of whom furthermore belong to the mother's side of the family. And then there is Malte's powerful and deeply problematic identification with femininity, first as a little boy when he pretends to be his own sister Sophie and dresses up in girl's clothes in order to relish his emotional identification with his mother in scenes of secret intimacy that one might read as attempts at a secondary symbiosis; later as an adult and a fledgling writer in Paris when his anxiety-ridden identification with the *Fortgeworfenen,* the Paris street people, is displaced by his joyful identification with *die grossen Liebenden,* the abandoned women in love, from Sappho via Gaspara Stampa, Mariana Alcoforado, and Louise Labé to Bettina Brentano. Significantly, in both cases the autobiographic parallels of these identifications with the feminine are well documented.[22] Once again Malte serves as a screen for Rilke's projections.

The dominance of the mother's sphere in Rilke's novel is so overwhelming that even Freudian readers like Erich Simenauer have had to concede that there is remarkably little oedipal repression going on here. Indeed, I would claim that the

Notebooks have to be read primarily in terms of the dyadic relationship between Malte and Maman rather than in terms of the oedipal triangle, not to be sure in the sense of an either/or, but certainly in the sense emphasized by post-Freudian psychoanalysis that the dyadic relationship with the mother that precedes the oedipal triangle can produce psychic disturbances of its own when the transition from symbiosis to object relations is not made successfully. Among these disturbances, murderous phantasies of the violent, fragmented body, anxieties of fragmentation, of objects that enter the body or grow inside it, fear of merger and dissolution are paramount, as Melanie Klein and others have shown in their work with very small children and in analyses of psychotics. In such patients hallucinatory, ecstasy-like states abound, intensities of affect that are not worked over by consciousness, and that even in analysis remain impenetrable to narrative articulation. The conclusion researchers have drawn is that such patients either lack the Freudian instance of the ego or that its development has been fundamentally disturbed in the transition from the symbiotic to the postsymbiotic phase.

It seems evident that Malte's hallucinatory perceptions of dissolution and his phantasms of the fragmented body, either in childhood or in Paris, can be well accounted for by such psychoanalytic work. The puzzling question, however, remains why the adult Malte should suffer at all from such early childhood traumas. After all, his relationship with Maman is presented as successfully "symbiotic" throughout, as thoroughly nurturing, so that the typical roots of later disturbances do not seem to pertain. In other words, neither is Maman the harsh and unnurturing mother who rejects her child too early or never really accepts it; nor is she the over protective mother who does not allow the child to perceive himself as object separate from the mother. One answer to this question, I would suggest, can emerge if we superimpose what we know of Rilke's childhood onto the childhood of the novel's protagonist. As has been amply documented, Phia Rilke was the harsh mother who was both unaccepting of her son ("guilty" of being second-born to a girl who had lived only a few weeks after birth) *and* overprotective and all-embracing. Or, rather, she alternated between these two states either by withdrawing from baby René, who, in his first year of life, had twenty-four different wet-nurses and caretakers, or by showering him with attention when she paraded him in little girl's clothes in front of her friends.[23] The anger and hatred that Rilke harbored for his mother is well known, but it is not matched by anything in the novel. It is as if Rilke, by writing the novel, created an ideal mother image for himself, the mother he always desired, but could not have. The psychic necessity of this fictional creation becomes evident if one considers the guilt feelings that accompanied his relationship to Phia all his life: guilt feelings

not of an oedipal kind of desiring union with the mother but rather of hating the person he most desired and who, given her character and psychic dispositions, continually withdrew from that desire. The results of that powerful and never resolved double bind in Rilke's life are Malte's phantasms of the fragmented body, his anxieties of dissolution of boundaries, and a fundamental lack in ego development and object relations as they appear in the novel. The contradiction constitutive of the narrative, then, is that Rilke creates the figure of an ideal mother (Malte's), but that the real mother (Rilke's) is inscribed into the text via Malte's psychic disturbances, which have to be read as narratively displaced from the real subject to the fictional subject.

IV

Once we have read the hallucinatory perceptions of Malte as being rooted in the phantasm of the fragmented body rather than simply as susceptibility to Scandinavian spiritism, his fear of fragmentation, of breaking to pieces, and of shattering stands out even more starkly. Here, another dimension of fragmentation comes into focus: his fearful identification with shattering objects, a displacement of traumatic symptoms from subject to objects unsurprising in someone who is fundamentally unsure of the boundaries of his body, the boundaries between himself and the world.

From the very beginning the theme of fragmentation is related to the fear of death. Thus when the dying chamberlain Brigge desires to be carried into the room in which his mother had died a long time ago and people and dogs burst into this room nobody had set foot in for twenty-three years, the breaking of things is described with emotional sympathy, as if they were animate:

> Yes, it was a terrible time for these drowsy, absentminded things. Down out of books which some careless hand had clumsily opened, rose leaves fluttered to the floor and were trampled underfoot; small, fragile objects were seized and, instantly broken, were quickly put back in place; others, dented or bent out of shape, were thrust beneath the curtains or even thrown behind the golden net of the fire-screen. And from time to time something fell, fell with a muffled sound onto the rug, fell with a clear sound onto the hard parquet floor, but breaking here and there, with a sharp crack or almost soundlessly; for these things, pampered as they were, could not endure a fall. (11f.)

Later on in the novel, when Malte falls sick in Paris, the lost fears of his childhood resurface, impressing on the reader that the fear of going to pieces is nothing experientially new in his life:

All the lost fears are here again. The fear that a small woolen thread sticking out of the hem of my blanket may be hard, hard and sharp as a steel needle; the fear that this little button on my night-shirt may be bigger than my head, bigger and heavier; the fear that the bread crumb which just dropped off my bed may turn into glass, and shatter when it hits the floor, and the sickening worry that when it does, everything will be broken, forever. (64)

The imagery of shattering objects is finally woven back into that of the fragmented body in a crucial passage where Malte describes his anxiety of separation as fear of death and then conjures up an image of apocalypse in writing and language that might bring his pains to an end:

But the day will come when my hand will be distant, and if I tell it to write, it will write words that are not mine. The time of that other interpretation will dawn, when there shall not be left one word upon another, and every meaning will dissolve like a cloud and fall down like rain . . . this time, I will be written. I am the impression that will transform itself. (52 f.)

This of course would be the moment of the modernist epiphany, the transcendence into a realm of writing that would leave all contingency behind and achieve some ultimate truth and coherence. However, Malte recognizes that he cannot take the step "to understand all this and assent to it" because "I have fallen and I can't pick myself up because I am shattered to pieces" (53).[24] Prerequisite for taking that step, for turning misery into bliss, as Malte puts it, seems to be some notion of a self that remains outside of Malte's reach, a nonshattered, even nondifferentiated self that would be symbiotically all-encompassing and whose writing would achieve transcendence in that other "glorious language" (257). What Malte expresses here is the intense modernist longing for another kind of language that would, in psychoanalytic and ontogenetic terms, correspond to a phase preceding the development of language, which is after all constituted quintessentially as differentiation. But the desire for such a fluid language before differentiation is accompanied by Malte's equally strong acknowledgment (at least at this point in the novel, though perhaps not at its very end) that such a language cannot be attained, that the desire for it is an impossible, even dangerous desire. Consequently he turns back to writing another's, not *the* other, language. He copies others' texts into his novel, texts that serve him as prayers. A Baudelairean prose poem and a passage from the Bible are collaged here into the narrative, proving how distant Malte is from the "time of that other interpretation." Malte's discourse, indeed, is not the authentic, transcendent discourse of modernism that provides, in Wilhelm Emrich's phrasing, "unendliche Sinnfülle," an unlimited

plenitude of meaning; his discourse remains rather the discourse of various others: that of Baudelaire and the Bible as well as that of Rilke's letters and a variety of other historical texts. Most important, though, it is Rilke's unconscious that speaks with a vengeance in this novel. I am tempted to say that it is Rilke who is being written already while Malte is still waiting for this to happen, but if that is so, then it must also be said that Rilke's being written is an entirely different kind from the one Malte imagines and prophesies. Finally, the fear of shattering, when tied to the lack of an imaginary unity of self, ego, or identity, as well as to the desire and fear of symbiotic fusion, culminates in the famous mirror scene, that childhood experience which, as Lou Andreas-Salomé has pointed out, Rilke transplanted from his own life into Malte's.[25] Malte's mirror scene, however, produces the exact opposite of what Lacan has described in his seminal work on the mirror stage.[26] Where in Lacan an anticipatory sense of identity and unity of the subject is first constituted when the toddler jubilantly discovers his or her full bodily reflection in the mirror, precisely the failure of such imaginary unity to come about via the mirror image characterizes Malte's experience.[27] Important for my argument here is not the fact that Lacan analyzes this anticipatory self-recognition as a misrecognition, in the sense that the mirror image *is not* the self, but remains outside the self, serves as its reflection, is in the position of the other to the self. What is important for a reading of Rilke's novel is the fact that Malte never even reaches the stage of imaginary identification of self with the mirror image, which functions like a visual representation of the unitary, fully differentiated, and fortified ego. On the contrary, the mirror experience in the novel is not one of pleasurable confirmation of an identity, even an imaginary one, but an experience of total shattering, of being overwhelmed and wiped out. Of course, another difference between Lacan's and Rilke's mirror scene is that Malte is not just looking at his plain self, but is actually playing dress-up in front of the mirror, which adds yet another level of complication, the conscious play with identity.[28]

Let us now take a closer look at how the mirror stage is symbolically reenacted and remembered in the novel. First of all, it is important to note that the horrors of the scene, which resurface with full force in Malte's account, cannot be attributed to feverish hallucinations. Traumatic anxiety is not brought forth here by disease and "the world of these fevers" (100), but it emerges when Malte inadvertently oversteps the boundaries of the world of normal, taken-for-granted identities:

> But when you played by yourself, as always, it could happen that you inadvertently stepped out of this agreed-upon, generally harmless world, and found yourself in circumstances that were completely different, and unimaginable *(gar nicht abzusehen)*. (101)

Malte plays dress-up in the out-of-the-way attic guest-rooms at Ulsgaard, puts on old costumes and ancestral clothes, and then takes pleasure at seeing himself in the mirror. He loves these disguises because they heighten his contradictory feelings about himself, but as a result of his ego-weakness they can also become quite overpowering:

> It was then that I first came to know the influence that can emanate from a particular costume. Hardly had I put on one of them when I had to admit that it had me in its power; that it dictated my movements, my facial expression, even my thoughts. (103)

But Malte maintains conscious and playful control of the *mise-en-scène*. He remains aware of the fact that he is both subject and object of the look, and he maintains a sense of identity through all of his disguises:

> These disguises, though, never went so far as to make me feel a stranger to myself; on the contrary, the more complete my transformation, the more convinced I was of my own identity. I grew bolder and bolder; flung myself higher and higher; for my skill at catching myself again was beyond all doubt. (103 f.)

That security of playing with images of self in disguise, the pleasure of seeing himself seeing himself—as Lacan puts it with reference to Valéry's *La Jeune Parque*—is disrupted when Malte discovers an armoire full of paraphernalia for masquerades, gets transported into a kind of intoxication in which he randomly dresses himself in scarves, shawls, veils, and spacious cloaks, and then steps in front of the mirror in order to seek his magnificent image. While turning around in front of the mirror in order "to find out what I actually was," he knocks over, owing to his limited vision behind the mask, a small table carrying a number of fragile objects that now shatter and break on the floor. (106) The aesthetic play with mirror images and identities turns into existential disaster:

> The two useless, green-violet porcelain parrots were of course shattered, each in a different, malign way. A small bowl had spilled out its pieces of candy, which looked like insects in their silk cocoons, and had tossed its cover far away—only half of it was visible, the other half had completely disappeared. But the most annoying sight of all was a perfume bottle that had broken into a thousand tiny fragments, from which the remnant of some ancient essence had spurted out, that now formed a stain with a very repulsive physiognomy on the light rug. (106)

Malte quickly tries to clean up the mess, but, hampered both in vision and in movement, he is unsuccessful and is caught by a violent rage against his "absurd situation." Desperately he tries to free himself from his costume in front of the mirror, but he only succeeds in entangling himself further. And then something happens to Malte that cannot be accounted for by the theory of the mirror stage at all. His desire to see and to learn how to see—later in life his stated Paris project—is stopped cold; the gaze becomes fundamentally problematic, split, as it were, between seeing and being seen:

> Hot and furious, I rushed to the mirror and with difficulty watched, through my mask, the frantic movements of my hands. But the mirror had been waiting for just this. Its moment of revenge had come. While I, with a boundlessly growing anguish, kept trying to somehow squeeze out of my disguise, it forced me, I don't know how, to look up, and dictated to me an image, no, a reality, a strange, incomprehensible, monstrous reality that permeated me against my will: for now it was the stronger one, and I was the mirror. I stared at this large, terrifying stranger in front of me, and felt appalled to be alone with him. But at the very moment I thought this, the worst thing happened: I lost all sense of myself, I simply ceased to exist. For one second, I felt an indescribable, piercing, futile longing for myself, then only *he* remained: there was nothing except him. (107)

It is clear that Malte's traumatic fear about the image turning into a real *Doppelgänger* and reducing the real self to an illusion explodes not at the sight of the strange creature in the mirror alone but rather at the point when he knocks over the table and breaks the perfume bottle. The experience of shattering objects, combined with the heavy and pervasive vapor of the spilled perfume, suddenly ruptures his ability to play at disguise and masquerades. A total loss of self, abandonment to an absurd and unrecognizable mirror image, is the result. But the conjunction of mirror image and fragmentation is even further emphasized by the text. Even the mirror surface isn't whole, nor does it have the usual transparency of reflection:

> I . . . ran to the nearest guest-room, in front of the tall, narrow mirror, which was made up of irregular pieces of green glass. Ah, how I trembled to be there, and how thrilling when I was: when something approached out of the cloudy depths, more slowly than myself, for the mirror hardly believed it and, sleepy as it was, didn't want to promptly repeat what I had recited to it. But in the end it had to, of course. (103)

Given its peculiar makeup, this mirror itself is incapable of providing the imaginary identity and unity of the body. It conspires, as it were, in Malte's fragmentation.

The mirror voids him, sucks all images of self out of him, and leaves him, at the end of the scene, lying on the floor "just like a piece of cloth," reduced to a stage of infantile motor incoordination (108).

This variant of the Lacanian mirror scene is so crucial for an understanding of the *Notebooks* not just because it confirms Malte's ego deficiency but because it opens up the problematic of seeing and being seen. We must remember here, first, that vision is central for Rilke's experience of the city and for the construction of his aesthetic, and, second, that Malte describes his own life crisis with the words: "I am learning to see" (5, 6). But as the mirror scene shows, there is no seeing without being seen. This basic split in the organization of the scopic field of course played a major role in Sartre's *Being and Nothingness,* and it also appears in Lacan's later essay "The Split Between the Eye and the Gaze." In this essay Lacan goes beyond the argument of the mirror stage and distinguishes the narcissistic *méconnaissance* of the specular image—Malte seeing himself seeing himself—from a scopic situation marked by what Lacan calls the "pre-existence to the seen of a given-to-be-seen."[29] The gaze is always deeply implicated in processes of desire, and for Rilke this fact cannot appear as anything but a basic contamination of vision. The passage in *Malte* could then be read as a breaking open of the initial narcissistic identification with the specular image, a disruption of narcissistic satisfaction by the recognition that there is no purity, no oneness of vision, but that the scopic field is always already split. Malte's childhood experience with the mirror thus contains already his relationship to the Paris outcasts whose gaze pursues him everywhere in his wanderings through the city. His learning to see is consistently disrupted and spoilt by the fact that he is being seen, an object of the gaze rather than its privileged subject. It is here, then, that Malte's childhood experiences mesh with his experiences of the modern city for which Simmel and Benjamin have emphasized the prevalence of vision over hearing.[30] It is perhaps primarily this concern with the problematics of vision that places Rilke's novel squarely within the culture of early twentieth-century modernism.

But this is also the place where a fundamental contradiction emerges, a contradiction that may well be paradigmatic for a certain constellation in modernism in general. Just as Rilke's modernism successfully articulates the problematics of vision as a central experience of metropolitan modernity, it also constructs an aesthetic designed to evade the very problem that gave rise to it in the first place. Thus Malte's whole project in the second part of the novel can be read as an attempt to elude the gaze, to undo the split between the eye and the gaze, and to restore some imaginary purity of vision and of writing via the myth of the "women in love" and the parable of the prodigal son with which the novel

ends. It is difficult to think that Malte's project was not close to Rilke's own heart, even though Rilke has Malte fail in his attempt to learn how to see and to create that other language. That failure, I think, is all but inevitable. The text itself shows why the desire to get out of the structures of desire and temporality and to enter into a realm of purity of language and vision is a dead end, both theoretically and aesthetically. Rilke may still identify with Malte's project, but, as I will argue, by the end of the novel that project reveals itself to be hopelessly vitiated.

V

Let me turn now to the broader question of metropolitan experience and the mechanisms of perception. I have shown how, in the process of writing his Paris diary, Malte himself becomes increasingly aware that his country childhood was actually haunted by the same kinds of phantasms that make life miserable for him in the big city, and he senses that it is the city itself that makes his childhood resurface. As I am not satisfied with a mechanical Freudian reading of this repetition compulsion, which would put all the emphasis on the early childhood experience alone, I still want to explore further why it is the city that not only triggers the repetition compulsion but also compels the effort to work it through, to displace it into fictional discourse. The question is whether there is not some more substantial link between Malte's psychological constitution and the experience of modernity as produced by urban life in the late nineteenth and early twentieth centuries. Perhaps the constellation of city experience and the early childhood trauma of the fragmented body can tell us something about modernist subjectivity that may not only be paradigmatic for a certain kind of modernist male artist but also have broader implications.

One of the major accounts of perceptions of modern city life and their psychic implications since the mid-nineteenth century was elaborated aesthetically by Baudelaire, critically by Georg Simmel and Walter Benjamin.[31] At first sight, Malte seems quite distant from the central concerns of these writers. As an artist, he certainly has nothing much in common with Baudelaire's painter of modern life, except perhaps that vision is as central to Baudelaire's work as it is to Rilke's. If the experience of modernity, as described by Baudelaire, Simmel, and Benjamin, has centrally to do with the relationship of the artist to the metropolitan crowd, then Rilke's Malte seems a rather atypical protagonist. Sure, the crowd is there in *Malte,* as "a hidden figure" (Benjamin's term for the crowd in Baudelaire's poetry) rather than as a described reality, something like a screen onto which Malte projects his phantasms of the fragmented body and from which he then escapes into the solitude of his rented room. But moving through the crowds does not energize Malte

as it energizes Baudelaire. Baudelaire describes the crowd as an "immense source of enjoyment," as "an enormous reservoir of electricity" in which the man of genius finds inspiration, even ecstasy.[32] In this sense Malte clearly is not a man of the crowd, nor is he a flaneur or dandy, nor is he ever concerned with fashion as a key element of modernity. The issues of exchange, commodification, and emerging consumerism, which are so powerfully worked out by Simmel and Benjamin, are all but absent from Rilke's novel. And Benjamin's concern with the impact of a newspaper and information culture on the structure of experience appears in Rilke at best as part of a vague and fairly unoriginal critique of the superficiality of modern civilization against which he posits the project of modernist writing.

The point of comparison is elsewhere. It is in the theory of perception, shock, and shock defenses that, according to Simmel and Benjamin, transformed the basic structures of human experience in the nineteenth century. In his essay "The Metropolis and Mental Life," Simmel has argued that the metropolis creates psychological conditions having to do with the "rapid crowding of changing images, the sharp discontinuity in the grasp of a single glance, and the unexpectedness of on-rushing impressions."[33] Against the threats of an ever-changing environment metropolitan man develops a protective organ that Simmel describes thus:

> The reaction to metropolitan phenomena is shifted to that organ which is least sensitive and quite remote from the depth of the personality. Intellectuality is thus seen to preserve subjective life against the overwhelming power of metropolitan life.[34]

Simmel then goes on to link that protective intellectuality with the matter-of-factness of the money economy and describes blaséness, reserve, indifference, and a general blunting of discrimination as key features of metropolitan psychic life. The same pattern of interpretation appears in Benjamin's 1939 essay "Some Motifs in Baudelaire." Simmel's binary opposition of subjective versus objective culture reappears in Benjamin in the psychoanalytically complex opposition between *Erfahrung* (experience) and *Erlebnis* (event), *Erinnerung* (memory) and *Gedächtnis* (remembrance). Benjamin uses Freud's thesis from *Beyond the Pleasure Principle* that consciousness plays a major role in the protection against stimuli *(Reizschutz)* and that becoming conscious and the inscription of memory traces are mutually exclusive. What Simmel and Benjamin have in common is the notion that consciousness neutralizes the shock experiences of metropolitan life and that this neutralization is essential for self-preservation, even if the price for such self-preservation is an impoverishment of experience in the emphatic sense, an atrophy of subjectivity.

At this point, we run up against a problem we had encountered earlier in a different context. In relying on the strength of consciousness to provide *Reizschutz* against a traumatic breakdown, protection against the stimuli, shocks, and accidents of street life in the city, Benjamin and Simmel implicitly assume a psychic instance in control, the conscious ego. What else is this consciousness but part of the armor of the fortified ego, which, in Lacan's account, achieves its first imaginary shape during the mirror stage, and which proves itself in fending off the shocks and assaults of city life on human perception. That, for Benjamin, was the essence of Baudelaire's "heroism of modern life." Here it becomes clear that the Simmel-Freud-Benjamin account of the psychic processes triggered by the modern city experience does not apply to Malte. The main problem Malte has in his encounters with the city is precisely his *inability* to protect himself against the chaos of stimuli and shocks. This inability is of course rooted in his psychic constitution, in his childhood past. By juxtaposing past and present, Rilke actually focuses on a dimension of experience that Simmel and Benjamin fail to incorporate into their reflections.[35] Malte experiences the city very differently from, say, Benjamin's Baudelaire. Rather than parrying the shocks of modern life with his poetic imagination—an image that Benjamin took from Baudelaire's "Le Soleil"—Malte is totally defenseless against the shocks of the city, which penetrate right down to the deepest layers of unconscious memory traces, hurling themselves, as it were, like shells into the quarry of Malte's unconscious childhood memories, breaking loose large chunks that then float up to the surface as fragments in the narrative. Ironically, the effect the city has on Malte is precisely the effect Rilke feared from psychoanalytic treatment. Rilke's statement about psychoanalysis—"Es ist furchtbar, die Kindheit so in Brocken von sich zu geben" ("It is terrifying to spit out one's childhood like that in bits and pieces")—has often been used by critics to keep psychoanalysis at bay in their readings.[36] Little did they notice that spitting out his childhood in bits and pieces is precisely what Rilke does in his novel, even though he does so in an aesthetically highly controlled way. Forced by his experience with the shocks and assaults of the modern city, Malte reproduces fragment upon fragment of his past, fragments that lack, to be sure, the unifying intervention of the analyst or, for that matter, of the traditional narrator who would impose a linear order of representation and perspective onto the seemingly chaotic material. In Rilke's case, the modernist narrative with its tortured subjectivity, its experimental ruptures and discontinuities, emerges out of the constellation of a childhood trauma of the fragmented body with the shattering and unavoidably fragmentary experience of the metropolis. The absence of an adequate *Reizschutz,* resulting from a deficiently developed ego, characterizes

Malte Laurids Brigge and determines the course of the narrative, thus making the Paris/childhood constellation central to any reading of the novel.

The broader question remains as to what extent Malte may be a paradigmatic case of male subjectivity within modernity. If the ways in which Malte reacts to city experience cannot be grasped with Simmel's or Benjamin's account of the experience of modernity, perhaps these accounts are deficient, or at least not generalizable. Malte might be quite representative for another psychic disposition produced, or at least exacerbated, by modernization, and characterized by ego deficiency, phantasms of fragmentation anxiety, and lack of defensive mechanisms against the assault of modernization on the senses and the psyche. Already in Freud's days this disposition must have been much more common among men than the disposition Freud theorized, with its emphasis on ego, consciousness, and sublimation. At least that is strongly suggested by the investigations of Klaus Theweleit in *Male Fantasies,* which construct the imagination of the fascist male in ways very different from Freud or, for that matter, the Frankfurt School.[37] It is indeed striking to see—and one is at first reluctant to admit it—that Malte shares quite a number of traits with the "fascist male" as analyzed by Theweleit: basic psychic disturbances going back to an unsuccessful separation from the symbiotic stage, vacillations between paranoia (Malte's constant fear of being seen) and phantasms of omnipotence (the creation of the new language), narcissistic disturbances, idealization of the mother combined with an inability to form lasting relationships with women, fears of being overwhelmed, engulfed, reduced to nothingness. This said, we must immediately backtrack. Of course, Malte is anything but the fascist male. Where Theweleit's Freikorps men, out of unresolved symbiosis, develop fantasies of violence and destructive rage and direct this aggression outward against anything that connotes femininity, Malte actually identifies with the feminine, and his violent phantasies are invariably and masochistically directed against himself only. Where the Freikorps man forges his male identity out of a fear of the feminine and develops an image of the male body as armored terror machine, simultaneously longing and fearing to explode on the battlefield, Malte deals with the ambivalence between desire for fusion and the fear of it in a non-aggressive way. Rather than turning to violent action against the feminine, he appropriates the feminine and uses it to create the modernist aesthetic, the phantasmagoria of a magnificent new language that will speak to him, but that has never yet been heard, a language that would transcend, or rather precede, language as we know it, precede the mirror phase, as it were, and fulfill the narcissistic desires of omnipotence and fusion.

It is easy enough to interpret Malte's reflections on the divine, on transcendent

love, on the necessity of loving rather than being loved, on the prodigal son's relation to God as Malte's way of overcoming fragmentation and working toward fusion, symbiosis, reconciliation of everything that is split or shattered. There is also no need to elaborate how his concern with narrative and temporality, his attempt to create a narrative in which time would be suspended, his projective identifications with figures of the distant historical past all aim in the same direction. It is also easy to see that Malte's identification with femininity, his praise of intransitive love, a love without object, is in itself highly problematic, a paradigmatic case of a male-imagined femininity. While this aspect of the novel, strongly foregrounded only in the second part, may be read as a critique of the property inscriptions and the violence of male possessiveness in the bourgeois institutions of love and marriage, Malte's reflections on Gaspara Stampa, Mariana Alcoforado, Louise Labé, Bettina Brentano, and finally Sappho also reproduce typical bourgeois idealizations of female selflessness and renunciation. Any ambivalence is lost, however, when the identification with the feminine is narratively retracted at the very end of the novel. The woman writer as *die große Liebende* (the woman in love) no longer provides the model for Malte. After all, it was commonly held at the turn of the century that the male artist can appropriate femininity while the woman with artistic aspirations does violence to her nature.[38] With his rewriting of the biblical parable of the prodigal son as the one who loves but does not want to be loved, the one who will be written and is longing for the modernist epiphany of that other language, Rilke redelivers the project of writing back to a male authorial voice. The novel ends with a retraction of that breaking of the patriarchal chain—"Today Brigge and nevermore" (159)—that seemed so central to Malte's life and writing project. The identification with femininity has fulfilled its function: it has allowed Malte to escape from city terror and childhood trauma into reconciliation. But this reconciliation is achieved on the basis of a problematic male appropriation of the feminine that ultimately serves only to solve the crisis of male creativity, to help Malte move closer to that ever elusive purity of vision and of language.

Rather than providing a solution, the ending of *Malte* strikes me as the culmination of a series of evasions of the splits and tensions that tear the protagonist apart, evasions also of the experiential reality of modern city life. Rather than read the second part of the novel as an achievement of narrative coherence, I see it as obsessive evasion in every sense, existential as well as aesthetic. I also cannot read the ending as tragic failure; the novel just comes to the end of a dead end. Despite this failure, Rilke's greatness perhaps lies in the fact that he does not attempt to transform Malte's failure into an epiphany, not even into a negative epiphany.

Rilke had great difficulty with the ending of the novel, and he knew it. What Rilke had to offer modernist prose, I would argue, is all in the first part, which focuses radically and uncompromisingly on the truth of an unreconciled and antagonistic present. One only needs to follow the trajectory of Malte's identificatory strategies from his pained and paranoid identification with the Paris street people, to an imaginary and bodiless femininity of the "women in love," to the mystificatory use of the biblical story of the prodigal son to note the progressive dematerialization, the flight from the reality of his experiences and his subjectivity. The city recedes as the novel goes on and the concrete memories of childhood are soon overtaken by mere phantasms of wish fulfillment. It is no coincidence that the new glorious language will speak *through* Malte rather than being spoken *by* him. The modernist aesthetic of transcendence and epiphany constructs itself here as a simultaneous voiding of subjectivity, which is more an avoiding of an unanchored and threatening subjectivity that has become too hard to bear. In Rilke's novel, the dream of another language, central to the modernist aesthetic at the turn of the century, is just another projection, another imaginary, another mirror image in which the trauma of the fragmented body and that of an unavoidably fragmentary and multiply split language is finally dissolved, the experience of modernity transcended. The best that can be said about the end of *Malte* is that reconciliation is only anticipated, not realized. But reconciliation is nevertheless false, just as delusory in its promise of an anticipated narcissistic fusion in and with a kind of fluid, nondifferentiated language as the Lacanian mirror image is delusory in its anticipation of the unity of the subject. Rilke's *Notebooks of Malte Laurids Brigge* is both a powerful articulation of a crisis of subjectivity under the pressures of modernization and an equally powerful evasion of the problem. It projects the very real and yet impossible desire for fusion and symbiosis into the aesthetic realm, the realm of language where it cannot be fulfilled any more easily than in reality. If Rilke's work embodies one of the most persuasive instances of high modernism, then the *Notebooks* represents that moment in his work in which he himself calls that project into question in the very process of articulating it. The novel is a case of high modernism against itself. That is what makes it such fascinating reading in a postmodern age.

Fortifying the Heart—Totally

Ernst Jünger's Armored Texts

> **O doctor, please help me, I'm damaged.**
> **There's a pain where there once was a heart.**
>
> Rolling Stones

I

The catalogue of the 1993 Venice Biennale kicked off with a prognosis for the twenty-first century. It was entitled *Gestaltwandel* (metamorphosis of gestalt). Its author, Ernst Jünger, who as title and text amply demonstrate, is still and stubbornly waiting for his planetarian machine prophecies of the new age of the worker to come true.[1] Except that what was unambiguously fascist in texts like *Totale Mobilmachung* (1930) or *Der Arbeiter* (1932) is now couched in a jumble of mythic images about nature and technology, Titans and gods that appeal to a certain kind of contemporary Germanic mindset that thrives on a frenzy of ecological apocalypse and immerses itself in a melancholic rehash of romantic nature philosophy and depraved philosophies of history.[2] All of it, of course, in the spirit of posthistoire and the postmodern. Jünger has always been more of a chameleon than seismograph of the times.

The fact that political and metaphysical mush such as Jünger's musings about the world-state, the increasing spiritualization of the earth, the interim age of the titans, and the need for gods to sustain a culture has moved center stage and finds an audience beyond Germany's borders, is proof only of the fact that political and

social crises such as the current European ones raise the spiritual need for sublime distractions and new age prophecies to compensate for the dissatisfactions with extant belief systems and exhausted political ideologies. In Germany, the feuilletons of major papers and weeklies continue to heap praise on Jünger as master stylist and representative of twentieth-century German literature. All of this occurs in the midst of the crisis of the left-liberal consensus that provided the basis for a politics of culture in West Germany since the 1960s and only three years after the wholesale attack on four decades of East and West German literature in the wake of unification.[3] But the concern here will not be Jünger's surprising postmodern and postunification resurrection. The point is rather the lack of *Gestaltwandel* in Jünger's earlier work, the obsessive return to the same experiential material from World War I which is rewritten time and again, seamlessly coded and frozen in rhetorical armor that is the opposite of what I take to be literary modernism. All of which makes him a very suspect representative of modern German literature.

What interests me in particular are the ways in which *Das abenteuerliche Herz,* the key text of 1929 that grounds the claim of Jünger as a major modernist, is linked to the war diaries and the right-wing political pamphlets of the 1920s and early 1930s, a link that advocates of Jünger as a canonical modernist either ignore, underplay, or deny.[4] Central to my reading of Jünger is the question of the relationship between fascism and modernism, a familiar topic that has returned in this country in the new context of studies of violence, gender, and sexuality in modernist texts.

My basic assumption is that two positions have to be avoided as unsatisfactory. The separation of modernism as an aesthetic phenomenon from its multiple entanglements with fascism that grounded the Cold War ideology of modernism as the free art of the West is as suspect, theoretically and politically, as the reductionist collapsing of modernism and fascism as it was first advanced in the expressionism and popular front debates of the 1930s, and as it is currently resurfacing in indiscriminate condemnations of modernism and modernity as totalitarian and oppressive, imperialist and racist, Eurocentric and phallocratic. Of course there are elements in modernist art, writing, and thought that have affinities to fascism. Fascism as cultural synthesis, despite the anti-modernist *Entartete Kunst* bonanza of 1937, did incorporate elements of modernism just as it incorporated and restructured key elements of modernity with its use of media, technology, and functionalism. Fascism *and* modernism is as urgent and legitimate a topic as fascism *and* modernity. That Ernst Jünger is no modernist, therefore, does not imply that there is no fascist modernism in literature. Céline might

be a case in point. But the criteria by which one establishes the fascist character of a modernist text, apart from the political opinions of its author, are still exceedingly fuzzy.[5] We need to put more pressure on the concept of modernism as a literary practice, on the aesthetic specificities of what constitutes modernism in a strong sense. Otherwise we run the danger of arriving at the meaningless conclusion that every artist whose work articulates certain aporias of modernity, as Jünger does, and whose imagination partakes in modernity's phantasmatic constructions is thereby a modernist. It is not enough to distinguish different political forms of modernism unless such an analysis is accompanied by sustained attention to strategies and techniques of representation, language and imagery, metaphors of the social and textual constructions of subjectivity.

II

Ernst Jünger, born in 1895 and one of the last surviving members of the generation of 1914, has been alternately celebrated as a modernist and condemned as a fascist, held up as a guardian of style and perfection in writing and vilified as elitist modernist. If Jünger was celebrated in the 1950s in West Germany as an exemplary modern author, he was subsequently written out of the canon during the 1960s and early 1970s as a right-wing propagandist, tainted by the fascist "aestheticization of politics" (Benjamin). Since the late 1970s, however, Jünger, who has always had a strong following in France, found new and provocatively intelligent defenders in Germany (including Alfred Andersch and Hans Magnus Enzensberger), received several prestigious literary prizes (including the Goethe prize in the year of the conservative Wende 1982), and was courted by Helmut Kohl and François Mitterand for their ceremonious reconciliation at the battlegrounds of Verdun. The storm-troop officer of World War I, the nationalist ideologue of the 1920s, the officer in the Wehrmacht occupation forces in Paris in the early 1940s is now a prophet of Franco-German reconciliation and European unification. It is all the more important to focus on Jünger's writings of the 1920s and 1930s which established his fame as a writer and whose success he has never been able to match in later years.

Jünger as fascist, Jünger as modernist, Jünger as stylist: my answers to these propositions will be comparatively simple. If modernism in literature, despite its wide scope and variants, is understood as the attempt to problematize the apparent stability and transparency of representation and narrative, or language and subjectivity (as in Kafka or Joyce, Proust or Woolf, Brecht or Döblin), then Jünger is no modernist. For rather than grappling in his texts with the crisis of representation and language, he fends it off by producing what can be called the

armored text.[6] If fascism is defined not in the narrow sense of close adherence to the racist and völkisch blood and soil doctrines of the 1930s (which Jünger did reject), but rather as a broad anti-democratic post-World War I political culture that validated aggression, death, and violence as ultimate meaning, feeding into the cultural synthesis that made Nazism attractive and successful as a mass movement, then Jünger is indeed a fascist, notwithstanding his studied aristocratic distance from the Nazis both before and after 1933. If modernist writing is consistent experimentation in search of a new language, the invention of new modes of narrative, the aesthetic articulation of the conditions of representation within representation itself, then Jünger with his often pretentious overwriting, murky and pompous philosophizing, and persistent lapses into the jargon of the officer's mess is a highly defective stylist, often closer to late nineteenth-century B-literature than to Flaubert, Baudelaire, or Kafka.

Defenders of Jünger, the stylist, have referred to him as a seismograph of the crisis of his times. The metaphor is not necessarily in Jünger's favor. Contrary to currently popular claims, his literary recordings are anything but a reliable guide to the events of the twentieth century. After all, the seismograph will indiscriminately record any discourse within its parameters, and the language of the seismograph itself follows a restricted code in that it cannot possibly offer any insight into the origins or effects of the earthquake it records. The shortcomings of Jünger's language were documented in detail decades ago by the British Germanist J.P. Stern who spoke maliciously of "the style of a drill-sergeant with a taste for philosophy."[7] However, the continuing fascination with Jünger's writing (by no means only among conservative readers) does not permit us to dismiss him too easily. The question of fascism and modernism, after all, is not just a question of style.

III

As a writer, Ernst Jünger became famous in the 1920s as the author of several books dealing with his experiences in World War I—which he joined at the age of nineteen, fought to the war's end as a storm-troop officer despite being wounded multiple times, and ended by receiving the award of the highest military order, the Pour le Mérite, just a week before the signing of the armistice. His diary from the war, entitled *The Storm of Steel,* first published in 1920 and amended multiple times in later editions, became a key text in the construction of what George Mosse has called the myth of the war experience and the central counter-point to Remarque's anti-war novel *All Quiet on the Western Front.* There were fourteen editions published by 1934 with approximately a quarter

million copies sold. Jünger never duplicated the success of this book, but the war remained central to most of his writings during the 1920s. Long essays on *Combat as Inner Experience* (1922), *Fire and Blood* (1926), *Total Mobilization* (1930), *The Worker* (1932), and *On Pain* (1934) constructed an ontology of combat and war as models for a new hierarchically ordered community, beyond democracy and the despised culture of bourgeois security, ennui, and philistinism. This new nationalist vision of an emerging global culture was built around the metaphysically coded Gestalt of the warrior-worker with the warrior's body constructed as the ultimate armored fighting machine. Jünger's description of the blood of youth confronting deadly matter on the battlefield and the phantasy of their interpenetration in "streams of liquid metal" provides us with a genealogy of the T 1000 cyborg from *Terminator II*: the big white killer male, invincible and beyond organic death.[8] Jünger was thus not only posthistoire, but even and already then post-Schwarzenegger whose role in the film is that of an all too human machine.

The experience of World War I and the subsequent mythification of war also overdetermines Jünger's understanding of metropolitan modernity in the 1920s. The discursive linkage of war, modernity, and metropolis is not unique to Jünger in the Weimar Republic, but he articulates it with unmatched enthusiasm, however cold and detached his observations may appear.[9] In the essay "Großstadt und Land" from 1926 we read:

> We must penetrate the forces of the metropolis, which are the real powers of our time: the machine, the masses, the worker. For here lies the potential energy from which will arise the new nation of tomorrow; and every European people is now at work trying to harness this potential. . . . The Great War itself is a good example of the way that the essence of the city has begun to take possession of the whole range of modern life. The generation of the trenches went forth expecting a joyous war in the old style, a field campaign. But just as the landscape of this battlefield proved to be no natural landscape but a technological landscape, so was the spirit that animated it an urban spirit. Urban, too, was the 'battle of materials' and still more the mechanized 'battle of movement' that developed from it. Today any kind of revolt that does not begin in the urban centers is doomed from the start to failure.[10]

Jünger thus embraced the inevitability of catastrophic destruction in what he described as global civil war as a precondition for the emergence of a new fully technological age, with its joyously anticipated synthesis of flesh and steel, brain and camera, body and machine. When Siegfried Kracauer reviewed Jünger's

perhaps most notorious book of those years, *The Worker*, he judged it "anything but a political construction," and regarding one of Jünger's several photographic books of those years, entitled *The Transformed World*, he said that "this gestalt-show opens up not so much a path into politics as a line of flight leading away from politics"—a line of flight, we might add with hindsight, leading into cyborg science fiction.[11] The problem is that this kind of techno-fiction was profoundly political in those years, nurturing the kinds of fantasies of power and violence from which the Nazis built much of their mass support.

In light of recent debates on the psycho-social make-up of the proto-fascist warrior, I would want to suggest that Jünger's megalomaniac and narcissistic fantasies of power, combined with a cult of hardness and invulnerability, resulted from the traumatic experience of emasculation in the lost war. This traumatic experiential dimension is not sufficiently acknowledged by those who link Jünger to fascism via Benjamin's famous and imprecise phrase of the "aestheticization of politics." Nor is it acknowledged by Klaus Theweleit who grounds the imaginary of the fascist warrior and the armored body in early childhood developments more than in specific historical experience.[12] However, it is the experience of the war that marks the difference between Jünger's actual war diaries and Marinetti's pre-war Futurist Manifesto with its glorification of machine warfare and scorn for woman. Yet it is also clear that Jünger's imaginary remasculinization with its attack on democracy as weak, feminine, and un-German fed directly into Nazi ideology, as did his phantasmatic armoring of the male body in the Gestalt of the worker. Jünger's active political participation in various rabid anti-democratic organizations of the conservative revolution of the late 1920s, including the National Bolsheviks around Ernst Niekisch, and his writing for a number of right-wing political magazines has been amply documented. It serves to show that his rejection of the Nazis did not result from their radicalism but rather from their participation in electoral politics which made them, in his eyes, not radical enough. His own radicalism, in the 1920s and later in the 1930s, was that of the aristocrat of German culture, the prophet of a new technological age, who, against all evidence, believed in his privileged distance from the plebeian Nazi rabble. Political and aesthetic aristocratism and pace Karl-Heinz Bohrer, however, is not enough to ground an advanced modernist writing practice.

At the same time, Jünger's *The Storm of Steel* is far from a simple glorification of war; nor is it simply the opposite of Remarque's famous anti-war novel. The horror of trench warfare is not only fully acknowledged by Jünger, but his writing can be said to emerge from the conflict between the clearly perceived lack of meaning in the mass slaughter on the fully mechanized battlefields and the

attempt to find meaning at any cost in this shattering experience. Jünger used to say: "What is important is not what we fight for, but how we fight."[13] But rather than expressing the professional soldier's sense of fairness in battle, Jünger's "how we fight" is loaded with a metaphysics of combat as pure transcendent event, a transcendence, to be sure, which is emphatically gendered when combat is described as "the male form of procreation."[14] In his essay "Der Wille," published in the journal *Standarte* (May 6, 1926), Jünger recapitulated:

> We asked for the meaning of our experience and were able to determine only one thing: this meaning had to be totally different from the one we attributed to events at that time. . . . We must believe in a higher meaning than the one we were able to give to events, and we must believe in a higher destiny within which that which we believe we determine is being fulfilled. . . . We *must* believe that everything is meaningfully ordered, otherwise we shipwreck with the masses of the inwardly oppressed, the disillusioned, or the do-gooders, or we live in suffering like animals from day to day.[15]

The passive mode where meaning fulfills itself rather than being produced through human agency is part and parcel of Jünger's decisionism and his metaphysics of combat: decisionism as a desperate attempt to hide that there are no decisions to be made. It is as if Jünger is *being spoken*, like a ventriloquist's dummy, when he writes in another programmatic essay entitled "Der Geist" (1927):

> The spirit's nature is masculine and gives direction, it does not want to dissolve itself into the world; it rather wants to gain control of it. It wants the world to be its world, to be like itself. The spirit needs the blood because it is embedded into life, but it can do without consciousness. . . . Under the mechanism of surfaces it searches for deeper meaning. Rather than theorize it wants to create. Rather than decompose [*zersetzen*] it wants to generate.[16]

The discovery that it speaks, that one is *being spoken*, that one's life is being lived, as it were, is one of the most terrifying and irritating discoveries articulated time and again in modernist literature and thought, in Rilke and Döblin, in Musil and Joyce, in Nietzsche already and in Freud. Jünger, however, as his phrasing shows, simply ignores the dilemma: instead the dummy usurps the speaking space of the puppet master himself, without the least bit of reflection, irony or self-doubt. The spirit's calling, after all, is grand vision, "das Schauen der großen Bilder," and this is what emerges as Jünger's own artistic ambition as he moves from his war diaries to *Das abenteuerliche Herz* and *Auf den Marmorklippen*. The escape from language,[17] however, results in its reification as soon as this visionary

turns writer. Jünger's escape from language into vision is only matched by his flight from a modernity that threatens his need for order, hierarchy and patriarchal control into an equally reified metaphysics.[18]

Reading Jünger's essays "Der Wille" oder "Der Geist" or his essays on combat as an inner experience, one feels reminded of Benjamin's observation in his 1936 essay "The Storyteller" that men returned from the battlefield "not richer but poorer in communicable experience." Except, of course, that Jünger had not grown silent, but rather produced an accelerating torrent of language from the early 1920s on that moved ever further away from what one might call with Benjamin "communicable experience." Benjamin continues with the following observations:

> For never has experience been contradicted more thoroughly than strategic experience by tactical warfare, economic experience by inflation, bodily experience by mechanical warfare, moral experience by those in power. A generation that had gone to school on a horse-drawn streetcar now stood under the open sky in a countryside in which nothing remained unchanged but the clouds, and beneath these clouds, in a force field of destructive torrents and explosions, was the tiny, fragile human body.[19]

This is where one major difference between Jünger and Benjamin emerges (and it is by no means the only one). Jünger denies what Benjamin acknowledges. All of Jünger's writing of the 1920s, including the revisions of *The Storm of Steel*, are marked by the attempt to forget that tiny, fragile human body, or rather to equip it with an impenetrable armor protecting it against the memory of the traumatic experience of the trenches. Forgetting is for Jünger an obsessive rewrite project, with each additional layer of text another repression, another exorcism, another piece of the armor. The horror of war rather than horror as literary tradition and decadence remains the hidden source of energy of Jünger's writing, but with the years it is increasingly aestheticized, and thus ever further removed from lived experience. An aestheticization it is, but not one of politics which remained remarkably absent from the war diaries to begin with. The fact that this aestheticization yields a politics in the end is an entirely different matter, the logic of which will be traced here.

If the root of horror in Jünger was the mechanized battlefield of the war, then his texts, with their increasing fascination with the transformative powers of technology and their obsessive coding of the male body as machine can be regarded as expressing the identification with the aggressor which Jünger himself described as "total mobilization down to the innermost core." Indeed, Benjamin may well

have been thinking of Jünger when he commented on the loss of communicable experience in "The Storyteller," for in his earlier review of Jünger in 1930 he had already noted the phantasmatic qualities, the lack of realism and the metaphysical abstraction from lived experience in Jünger's writing. I would suggest that this identification with the destructive forces of modernity that had overwhelmed Jünger on the battlefield is a traumatic reaction formation, resulting in a compulsive repudiation of his own body as organic and vulnerable as well as generating a literary repetition compulsion which makes Jünger's texts of the 1920s so very similar to each other. Time and again he returns to the same events, keeping the threat at bay through a strategy of aestheticizing horror and its memories. Aesthetic perception is already present in the early versions of the war diary, as for instance in the following passage taken from the chapter "The Great Offensive" which describes the March offensive of 1918:

> Then a whistle of another shell high in the air. Everybody had the clutching feeling: 'It's coming over!' There was a terrific stupefying crash . . . the shell had burst in the midst of us. . . .
>
> I picked myself up half-unconscious. The machine-gun ammunition in the large shell-hole, set alight by the explosion, was burning with an intense pink glow. It illumined the rising fumes of the shell-burst, in which there writhed a heap of black bodies and the shadowy forms of the survivors, who were rushing from the scene in all directions. At the same time rose a multitudinous tumult of pain and cries for help.
>
> I will make no secret of it that after a moment's blank horror I took to my heels like the rest and ran aimlessly into the night.[20]

The focus on the moment of intense shell shock is further aestheticized in a 1934 insert to this just quoted passage: "Like a dream image from hell, the rolling movement of the dark mass in the depths of the smoking and glowing cauldron rent open for a second the uttermost abyss of pain."[21] In a yet later version "the uttermost abyss of pain" which after all describes the sufferings of his injured men becomes the "utmost abyss of horror"[22] which moves the center of attention back to the perceiving subject, Jünger himself. And in *Feuer und Blut*, another text from the 1920s, in which Jünger comes back to the same event, he compares the "throng of bodies" with "writhing amphibians in a boiling lake," and finally, with the "damned in a Dantesque vision."[23] While these metaphors are not implausible, they certainly do not add to the descriptive power of the original passage. Their function, I would suggest, is to control the memory of horror, to naturalize and familiarize it via literary allusion. This aestheticization of the experience of horror is just the other side of Jünger's machine fantasies and his embrace of

destruction for the sake of a brave new world. Where aestheticization provides an armor to consciousness, shielding it from the direct impact of memory, the Gestalt of the worker-warrior does the same for the body. Neither provides, as Bohrer claims, an "immense increase in aesthetic perception."[24] The effect is rather aesthetic reification: the armored text corresponds directly to the fascist phantasy of the invincible armored body, whether it be that of the male, the Party or the nation.

IV

I have dwelt in some detail on Jünger's war-related writings (which have never been claimed as modernist) because they are inseparably linked to his prose texts of the late 1920s, gathered in the slim volume *The Adventurous Heart* (1929, 1938), a collection of capriccios in prose which have become the textual basis for the reading of Jünger as modernist.

At first sight, indeed, we are dealing here with a very different species of texts. Two aspects mark the difference: experiences of horror, while still paramount, are completely severed from the context of war, and most are framed in dream-like surreal sequences. But dream is not the other of the war experience. On the contrary: a dream-like reality has often been described as an experiential dimension of trench warfare. Thus in a passage of *The Storm of Steel* that must have been added around 1924, Jünger writes about his first experience of horror and death on the battlefields:

> Time and again we had to stare at these things that we had never seen without being able to grasp their meaning—they were totally unfamiliar to us. As if in a dream, in a garden full of strange plants, we walked this ground littered with dead bodies with dislocated limbs, distorted faces and the horrifying colors of decomposition.[25]

Secondly, there is the language of nature study, descriptions of flowers, plants, and animals, erudite entomological notations combined with lusciously erotic color schemes and flower fantasies. One can hardly be further removed, it seems, from the realm of horror, mutilation, destruction and war. Unless, of course, one remembers Octave Mirbeau's *Jardin des Supplices* which posits a close affinity of exotic flowers to sexuality, mutilation, and death. Furthermore, the realm of nature, while serving as a safe haven to Jünger, especially in his allegedly anti-Nazi novel *The Marble Cliffs*, actually provides the basic metaphors for human and social life as struggle and war, birth and decay. Jünger persistently metaphorizes war as a natural phenomenon with phrases such as "storm of steel," "hurricanes

of fire," "hails of shells." In his writings, steel helmets become "iron seed," fighter planes are "vultures" or "birds of prey."

But the linkage between the language of combat and the language of nature study can be established in a much less metaphorical way as well, a way that has to do with Jünger's strategies of observation and perception. Much indeed can be made of Jünger's obsessive concern with perception, his claim to a "second, colder consciousness" that is endowed with the "ability to see oneself as object."[26] The telescopic nature of this gaze is located for him outside of the realm of feeling, emotion, pain. Its medium is photography—photography as weapon—seeing as an act of attack.[27] Jünger's gaze is that of an armored eye that tries to wrench order and control from chaos, confusion and terror. A passage in *Fire and Blood* shows this, at first sight, implausible linkage between combat and vision on the one hand, and Jünger's preoccupation with nature study on the other:

> Yes, now I too can see them, immediately in front of us, the upper part of their bodies half leaning out of the trench, feverishly loading and firing their rifles. And now I am seized by an unconquerable rage. It makes me do something quite senseless. I throw away my rifle and jump with one leap down into the middle of the road. And though everything has gone well with me so far, not even the greatest of luck, which I have come to take for granted, will now keep me out of harm's way. While my knees are still bent from the impact of the jump, I receive a hard blow against my chest, which in a second makes me sober. In the midst of the tumult, between both raging parties, I stop and recollect myself. It was the left side, just on the heart, not much one can do about that. In a moment I shall fall full length as I have seen so many fall. Now it's all over. Curious, this: while I stare at the ground I see the stones on the yellowish soil of the path, black chips of flint and white, polished pebbles. In this terrible confusion I see each one of them sharply, separately, and the pattern they make is imprinted in my mind as if this were now the most important thing of all.[28]

The objectively recording gaze at nature is here codified as the gaze in the moment of anticipated death, the transition from an organic to an inorganic state, Freud's death drive at work. Nature, rather than providing a harmonious alternative to violence and death, remains inseparably linked with it. Without being able to fully elaborate the point here, I would suggest that Jünger's texts about birds and insects, snakes and flowers have the same function as the increasingly aestheticized descriptions of his war experience and the fantasies of the armored, machine-like body with its petrified camera-like gaze. At stake in all of this is the shoring up of a deeply injured male subjectivity, the acceptance of violence and mutilation as a natural and metaphysical given combined with the

attempt to keep the horror at bay by employing strategies of replay and control. In Freudian terms, these texts can be read as embodying strategies of *Reizschutz*, protection against the power of traumatic memories, perhaps even against survivor guilt. Jünger's fantasies of his own invulnerability, which have often been taken simply as a sign of his arrogance and aristocratism, seem to point in that direction.

V

The strong linkage between *The Adventurous Heart* and the war related writings, which I have argued is key to an understanding of the politics of horror in Jünger's work, is basically denied in Karl Heinz Bohrer's fascinating study of Jünger entitled *The Aesthetics of Horror* (1978). Rather than emphasizing the primary importance of the war experience for Jünger, the writer, Bohrer dwells on Jünger's indebtedness to a whole literary tradition of decadence, aestheticism, and horror from Sade, Poe, and Baudelaire to Huysmans, Mirbeau and Lautréamont, and to the surrealists of which Jünger himself has indeed claimed to be a part. The war, in this view, is only relevant as facilitating an "immense increase in aesthetic perception" of horror. Jünger's knowledge of the early modernist, aestheticist and decadent traditions of the nineteenth century becomes central in the attempt to downplay the psychosomatics of horror in the war diaries and their relation to the *politics* of horror in Jünger's war related writings and right-wing pamphleteering of the 1920s. For Bohrer the category of horror points to the "paradox of archaic regression and a most acute consciousness of the epochal moment,"[30] a paradox that is said to embody the crisis of bourgeois literature and to establish the autonomous realm of the aesthetic against all pressures of ideology and historical contingency. In the experience of horror, according to Bohrer, we are liberated from the confinements of the symbolic order and achieve a higher modernist consciousness. The negative epiphany of horror, as it were, is thus celebrated as the dark side of the canonized modernist epiphanies in Proust, Rilke or Virginia Woolf. Bohrer ignores that Jünger's archaic regression and his privileging of the atavistic, the elemental, the pure event, far from being a return to the origins of time and the elemental depths of human life, is rather an immersion in the contemporary archives of a popularized social darwinism and vitalism, the right-wing heroic myth of the undefeated German soldier and the dream-worlds of male fantasies of power through violence.

And yet, the experience of horror to which the "adventurous heart" exposes itself is indeed different from that of the war books. To support my argument that

Jünger's armored texts cannot be considered modernist in any strong sense of the word, I would like to comment briefly on two striking horror capriccios from *The Adventurous Heart.* The first is contained (with minor variations) in both editions and is entitled "The Black Knight"; the second, a text added to the 1938 edition and entitled "Violet Endives."[31]

While the narrator of the capriccios that make up *Das abenteuerliche Herz* is invariably in a position of mastery vis-à-vis discourse, narration, and style, there is one capriccio of nightmarish horror where the narrator's armor is of no use, his *désinvolture* (off-handedness, claim to distance; favorite term of Jünger's in the 1930s and subject itself of one of the prose pieces of this collection) crumbles and he takes to his heels just as he did in the shellshock passage from *The Storm of Steel* quoted above. Given this stunning parallel of the narrator's breakdown and given the fact that "Der schwarze Ritter" is the only text in the collection in which a heart figures prominently as registrar of horror, though in a rather allegorical way, one might ask whether this text represents an unmediated return to the trauma of shellshock, whether it ruptures and breaks through the effects of aestheticization and linguistic armor which Jünger constructed around his trauma. If we map the narrator's dream experience of torture and mutilation in the satanic castle onto the first version of the shell-shock episode (Jünger in the position of observer in both texts, bodies reduced to a single bloody wound, the aestheticizing values of red and black, the glowing metal, the dream-like quality of battlefield scenes, etc.), we are led to an immediate conclusion: the horror of the war experience is rewritten here in terms of the male's horror of the female genitals as threatening wound, the fear of the destruction of the male body in war displaced to the female body. From Theweleit and others we know that male fears of the vagina, connected as they are with castration anxiety and the fear of emasculation, figure prominently in the imaginary of the fascist warrior, and emasculation as a historical problem after the lost war was indeed a key problem for male identity in Weimar Germany. Jünger's texts, however, are not usually rich in explicit sexual imagery. Why then this exception? Why the breakdown of the narrator's cool self-control which is maintained in all of the other horror texts of *Das abenteuerliche Herz*? Is it a symptom of the original trauma, an acknowledgment of that tiny fragile human body of Benjamin's text, or is it rather another *Reizschutz* text, another aestheticization, another piece of the self-protective armor? I would argue the latter, except that this time the protection of memory sought by aestheticization fails. For the displacement itself overdetermines the memory of battlefield horror, thus generating the intensity of the narrator's reaction. While the displacement simultaneously produces a condensation of war

wounds and female sexual organs as the ultimate threat to the integrity of the
male body, there is also a displacement from the memory of the unbearable
horror of the trenches onto a familiar literary trope of torture and mutilation of
female bodies which Jünger knows from the literary tradition that includes de
Sade and Mirbeau. In this literary context, the phantasm of the threatening
female genitals is already a literary trope and therefore less threatening to Jünger
than the war trauma. But the attempted distancing is not successful. It does not
secure a position of mastery for the black knight, who buckles under the paradox
of a narrative displacement and condensation functioning in two opposite ways
simultaneously. A familiar literary trope is used to bring memory under control,
but the very same trope overdetermines and exacerbates the fear unleashed by the
original memory. It is no wonder that the black knight runs from the scene.

But before it comes to that, the evocation of physical pain is veiled by another
displacement—a displacement of horror from the body to the level of conscious-
ness. For what terrifies the narrator most is neither the act of torturing, nor the
pain of the tortured woman which is drowned in silence and dream-like slow
motion. Nor is it the view of the bloody wound itself. What makes him flee is the
effect of the scene on the tortured girl's mother: the large heart cut out of red
paper that covers her entire chest turning snow-white, like glowing iron, at every
stab of the nail that pierces the girl's body. It is the mother's experience of horror
that shatters the psychic armor of the black knight. The narrator's fascination
with satanic violence and torture is always in the service of their effects on the
imagination. In this instance he admits that it is too much to bear and that he has
failed what, in typical self-absorption, he takes to be a test designed to probe his
endurance. Fascination and desire form a unit with repression and fear in all of
Jünger's horror scenarios. While the original version of "The Black Knight" ends
with the narrator's hasty retreat and a comment on the endless tortures being
inflicted in this satanic castle, the second version significantly reverts to the narra-
tor's fortified ego by concluding: "I have penetrated the secret castle of pain, but
the first of its offerings was already too much for me." Denial reigns supreme.
Narrator and reader can put it all behind them and go on happily to other scenes
of torture, cannibalism, and gratuitous violence of which there are plenty in *Das
abenteuerliche Herz*.

The other horror texts of *Das abenteuerliche Herz*, however, do not need any
form of denial. Torture is triumphantly embraced when the narrator, strolling
leisurely in the magnificent *Jardins des Supplices* of Octave Mirbeau's, observes
Chinese torturers whose activities "awaken the heart with vital feelings of
unknown force." Identification with the perpetrator goes hand in hand with

désinvolture as the sadism of the distanced gaze. Jünger calls it "higher life" and celebrates this "vital feeling of unknown force."[32] Sometimes, however, this higher life that flows from the observation of torture, cannibalism, and mutilation reveals its barbaric and sadistic nature, especially in parts where Jünger is not in control of his narrative language. Witnessing a slaughter scene where a man's body has already been scalded and shaved for cooking, with the severed bearded head swimming in a steaming kettle, the narrator comments: "The beard adds a beastial dimension; it calls forth something like the feeling: My, this must have been a really exhausting slaughter of the kind where one must serve liquor liberally." This is the language of beer hall-*Gemütlichkeit,* and it does not require much imagination to link it with the SS and the Eastern Front in World War II.

Contrary to the "Black Knight" where the protagonist/narrator himself is overwhelmed by the effect of horror, "Violet Endives" pursues a strategy of maximizing the horror of the reader by avoiding any display of horror by the narrator. The narrator's *désinvolture,* the absence of moral judgment and his cold, matter-of-fact interest in the face of a modern regression to the archaic and the atavistic, gets its poignancy from the narrator's ironic comment on cannibalism as an advancement of civilization. Or is it ironic? How are we to read this sentence: "I did not realize that civilization had come so far in this city." Is it, as Bohrer claims, a metaphor critical of fascist rule, a metaphor which gives way to the "explicit representation of the emerging SS-world" in the description of Köppels-Bleek in the *Marblecliffs?*[33] Reading Jünger as a literary modernist obviously increases the pressure to validate his texts as anti-fascist, and here Bohrer's desire to separate the aesthetic from the political is caught in a performative contradiction. His frequent references to Adorno even raise the question whether "Violet Endives" could be read as anticipating Adorno and Horkheimer's critique of the fateful and fatal dialectic of enlightenment and barbarism. The archaic—the barbaric—is always already inscribed into a commodified modernity and set free in fascism. Or does it rather express conscious acquiescence to cannibalism as an advancement of civilization, an acquiescence that does not, to be sure, participate actively in the cannibalistic hunt, but that takes it as an unavoidable fate. How adequate is this metaphor of cannibalism as a critique of fascist modernity, if that's what it is?

Bohrer's reading is intriguing. I would grant that it may very well have been Jünger's intention to distance himself from the fascist world of violence and murder, as is no doubt true of that other alleged conversion-text of the late 1930s—*On the Marble Cliffs.* But Jünger's narrative strategies, textually manifest in the apparently distant and sovereign subject position of his narrator, speak a

different language. They betray his continuing fascination with and affinity for that heart of darkness in the midst of European civilization. Several phrasings reveal that the narrator's *désinvolture* is a sham. Underlying it is a dialectic of fascination and distance, participation and *désinvolture*, desire and repression in which the latter terms (distance, *désinvolture*, repression) are fully constituted by and dependent on the former (fascination, participation, desire). In true Mirbeau-like fashion, the visual lure of the violet endives is explained by the fact that the narrator had already had some dark inkling that this delicacy should be accompanied by human flesh. Thus he knew all along in which direction civilization was progressing. The narrator's psychic involvement in cannibalism is further highlighted by the fact that he engages the salesman in a long conversation about how to prepare the meat. The reader is not privy to that conversation, but again the narrator's desires are at stake when he descends with the salesman to the refrigerated storage rooms where he sees "the people hanging from the walls like hares in front of a game-butcher's." In this middle section of the text, Jünger's ostensible critique of commodification (hands, feet, and heads set out in special bowls with little price tags on them) clashes quite dramatically with his privileging of the hunt. Remembering that the hunt is always presented in Jünger as a somehow more original, more vital and elemental form of life, that in his war books combat scenes are described in terms of hunt and British and French soldiers are hunted down like game during a battue, then the eruption of the archaic form of a cannibalistic hunt in the midst of a modern commodified culture reads less as a critique of a fascist modernity than as another glorification of violence and the archaic. What seems like critique, critique developed through shock effects, is really the expression of ultimate satisfaction with the progress of civilization and its literal incorporation of the atavistic. The last sentence clearly indicates that some symbolic exchange is concluded between the salesman and the narrator: while the narrator buys neither endives nor human flesh, the salesman gives him a receipt *(quittiert)* with an obliging smile anyway. The narrator buys not human flesh, but he does buy into the experience of cannibalism. The lure of the archaic, of violence and horror, is irresistible to Jünger, and the progress of civilization toward barbarism is inevitable. But by 1938 he has succeeded in completing his armor against the real memories of horror by turning horror into literature. Its representation points no longer to the trenches of the war, but to late nineteenth-century decadence and the texts of Octave Mirbeau. With the second version of *Das abenteuerliche Herz*, Jünger's armored texts have reached their therapeutic goal, and Jünger can start writing war diaries afresh. This time the diaries are of his days as an officer with the Nazi occupation forces in Paris.

Philosophers like Adorno and Horkheimer—to whom we owe one of the more compelling critical articulations of the linkage between enlightenment and barbarism, rationality and myth, modernity and sacrifice—always maintained the notion of some other rationality of civilization, the image of a social order without violence, repression, and domination. Jünger's celebrated *désinvolture*, however, his telescopic gaze at the archaic within modernity is nothing but an internalized form of domination which remains caught in the compulsive cycle of having to conjure up the lure of horror, physical torture, and mutilation in order to reestablish the safe boundaries of an aristocratic, stoical self. *The Dialectic of Enlightenment* aimed at breaking the spell of mythic horror inside modernity, but Jünger fully succumbed to that spell. Accepting aggression and victimization as the ontological basis of all human life, his only act of resistance was an aristocratic stoicism in the face of the unavoidable which took power in Germany in 1933.

CODA

Some might argue that the obsession with violence, techno-fantasies and male identity is so widespread in modernism and the historical avant-garde that it is questionable to deny Jünger the status of modernist. To that criticism I would respond by saying that everything depends not *if*, but rather *how* a text responds to the phenomena constituting the dark side of modernity. One only needs to think of Kafka's narratives of horror and his very different positioning of narrator and protagonists as in *The Penal Colony* (which also takes its cues from Mirbeau's *Torture Garden*) or the whipper episode in *The Trial* and compare them with "Violet Endives" or with "The Black Knight" to know the difference between a compelling and complex modernist treatment of horror and the B-literature of fascinating fascism.[34] In Kafka, horror is never merely staged for the gaze of a master. Indeed, there is no master's gaze, nor is there, despite Kafka's control of his literary means, a language of mastery. Kafka's stories display none of Jünger's pre-modernist narrative omniscience which provides the representational prerequisite for his celebrated *désinvolture*, second consciousness, and telescopic gaze. Where Jünger claims *Haltung* (self-control) and distance, the subject in Kafka, both narrator and protagonist, is always sucked into the unfolding spectacle. The role of Kafka's narrator is ambiguous, and the effect on the reader is one of irritation and insecurity. Kafka writes out of the abyss of modernity while Jünger is comfortably installed in the Grand Hotel Horror at the abyss's edge. That is why we now have a postmodern Jünger whereas a postmodern Kafka would be an impossible contradiction.

Alexander Kluge

An Analytic Storyteller in the Course of Time

All real beauty is analytic.

Edgar Allan Poe

We do not have too much reason and too little soul;

we rather have too little reason in matters of the soul.

Robert Musil

In a *Spiegel* review of Kluge's 1977 *Neue Geschichten (New Stories)*, his most volu-
minous and ambitious collection of stories to date, Hans Magnus Enzensberger said
something that still has the ring of truth: "Among well-known German authors
Kluge is the least well-known."[1] Least well-known in this case means well-known,
but not widely read. It seems that Kluge's unique versatility as filmmaker and film
politician, social theorist and storyteller has hampered rather than enhanced the
reception of his literary works. Many people will have seen one or the other of Kluge's
many films, and there is a lively and growing debate about formal and political
aspects of his filmmaking. For the past twenty years, his theoretical works, coau-
thored with Oskar Negt, have played an important role in the German discourse of
social and cultural theory. But comparatively little serious work has been done on his
storytelling.[2] Many of the early reviews of his stories betrayed, more than anything
else, the perplexity and helplessness of the critical establishment, and there seems to
be a shared assumption that Kluge's "primary" medium is cinema. Surely, the resis-
tance to Kluge's literary texts has something to do with the ways in which these texts
consistently and programmatically disappoint readers' expectations. But it also

reflects the simple fact that even people interested in contemporary cultural production are more likely to submit themselves to the demands of a ninety-minute Kluge film than to spend several days working through hundreds of pages of seemingly unconnected, discontinuous stories which systematically prevent reader identification and frustrate the pleasures of literariness. Despite the studied simplicity of style, the demands Kluge's stories make on the reader are no less intense than those his films make on their spectator. It is not only that Kluge's filmic or literary texts resemble construction sites, as has often been said. The very structure of his writing is designed to transform the reader's head into a construction site. Occasional resistance to such a demand is understandable and cannot be blamed only on the insidious impact of consumer culture and its ready-made commodities.

The basic paradox and difficulty of these texts by Kluge is that they rely on knowledges, abilities, and desires which, according to his own theoretical analyses of contemporary mass media culture, are on the wane because of the pervasive growth during the period of late capitalism of what he and Negt describe in *Öffentlichkeit und Erfahrung (The Public Sphere and Experience)* as the public spheres of production. But even if the reader's ability to produce new social experience is not blocked, even if the reader brings along enough basic knowledge of political economy, social theory, and psychoanalysis to decipher Kluge's stenographic, dialectical constructions of aesthetic image and theoretical concept, the first reaction to the labyrinths of Kluge's story collections, particularly those published during the 1970s, is likely to be frustration and irritation. All traditional notions of narration—plot, character, and action—are suspended, and one has great difficulty orienting oneself. The stories move in a very fast, shorthand style, and the figures are often just as much in a hurry, heading into either dead ends or disaster. Since authorial commentary is absent and endings often remain inconclusive, the reader never knows whether or with what to identify, which is, of course, exactly what Kluge intends. Many stories focus on events and situations in the lives of individuals, but instead of traditional heroes or modernist anti-heroes, Kluge offers what looks at first sight like narrative chaos, a series of unrelated accounts of events as one might find them on the local news page of the daily paper.

Finally, the fact that Kluge is both acknowledged and ignored as a major contemporary writer results from the density and consistency of his literary project, which was never out of touch with German social and cultural reality, yet never in tune with major literary developments in postwar Germany. His stubborn consistency and independence from the mood swings of the literary scene cost him readers even as it established his reputation as a writer. Still, it is understandable that Kluge was primarily thought of as a filmmaker, rather than a writer. While many of his films

were prizewinners from early on, his literary reputation was officially acknowledged only relatively recently, with the Fontane prize in 1979 and, more important, the Kleist prize in 1985.

Reading Kluge's stories produces strange effects. Given their sheer number and the shortness of many, it is inevitable that the reader will forget a lot of them quickly. But eventually one feels the cumulative impact of his kind of storytelling, which operates on a paradigmatic rather than a syntagmatic level. And then there emerge those stories that begin to work in one's head. The gaps and fissures left by Kluge's minimalist narrative strategy beg to be filled in. The reader is hooked.

Even if not all of the stories are successful as stories, they nevertheless provide an immense reservoir of aesthetic, political, and theoretical insight that has yet to be fully tapped. In film circles, especially in Germany, Kluge is and has always been a mythical figure. Perhaps now that the celebrated New German Cinema appears to be moribund (if not already dead), and German literature has lapsed into the privatism of such prophetic or apocalyptic ruminations as characterize the later works of Handke and Bernhard, the time has come to reassess the work of Kluge as a whole and to make it effective for contemporary cultural discourse. The unique mix of film, literature, and theory, image, trope, and concept certainly makes Kluge's overall project one of the most interesting around: Kluge as owl of Minerva for a post-Hegelian, post-avant-garde dusk in which the classical divisions between philosophy and art, theory and aesthetic practice, film and literature have been, at least tentatively, abandoned, but in which the media-specific differences between film, literature, and theory are not elided to produce that proverbial night in which all cows are gray.

One way of approaching Kluge's literary oeuvre is to position it in relation to some of the major literary trends in postwar Germany, especially the documentarism of the 1960s and the literature of the so-called new subjectivity of the 1970s. West German literature was still under the sway of absurdism and relished timeless parables of totalitarianism (Dürrenmatt, Frisch, Walser, et al.) when Kluge made his literary debut in 1962 with a collection of stories which, because of their concrete imagination and the merciless precision of their apparently documentary detail, puzzled most of their readers. These *Lebensläufe* (case histories), life stories of mainly middle- and upper-class Germans during and after the Third Reich (victimizers, fellow travelers, victims), read like a series of short-circuited and condensed *anti-Bildungsromane*. If the *Bildungsroman* whose invariable focus was the spiritual or educational trajectory of its hero's life—functioned in German literature as a textual machine in which and through which bourgeois subjectivity constituted itself in history, then Kluge's stories matter-of-factly demonstrate how that subjectivity has been stunted and mutilated under the impact of modernization in general, and

fascism in particular. From the very beginning of his literary experiments, Kluge rethinks the parameters and functions of subjectivity rather than abandoning it altogether. He writes stories in which the subjective dimension has been overlaid by anonymous structures, structures of discourse as much as of social behavior.

Already in this first volume of stories, the impact of Frankfurt School theory on Kluge makes its aesthetic and political mark. Kluge takes Adorno's observations about the waning of subjectivity since the liberal age and translates them into new literary form. But he does it differently from classical modernists such as Thomas Mann, Kafka, Rilke, or Benn, who expressed the loss of subjectivity, alienation, and reification in a highly individualized and therefore always recognizable, "personal" style. There is no trace of lament or mourning, no decrying of self-alienation in Kluge, as there is in so many modernist narratives. Nor does Kluge bear comparison with Samual Beckett, who, in Adorno's aesthetic thought, had become a gauge for measuring the objective decay of subjectivity in a post-Auschwitz age. Kluge does not have a style *qua* individual, authorial language. Rather, he mimics the frozen languages of factual reportage and bureaucracy, of the protocol, the document, the official letter, the legal deposition, the chronicle, and so forth, and modifies them for his purposes, often through methods of logical extrapolation, ironic distance, satire, or humor. His purpose is always to engage the reader in the project of a new kind of enlightenment, one that has worked through the catastrophic failures of its own tradition and that is concerned not only with the fate of human rationality, but also with the historical determinations of the senses, perceptions, and emotions. Kluge's whole project, whether in film, theory, or literature, questions the classical oppositions between the rational and the irrational, the analytic and the emotional, the real and the unreal, and it attempts to unravel their dialectical reversals and mutual, often opaque, implications.

From a literary point of view, a number of questions pose themselves to Kluge, who is not only steeped in Adorno's modernist aesthetic, but also attempts to draw conclusions from Benjamin's reflections on storytelling, memory, and experience. What can the storyteller do once reality evades representation and most representations of reality are no more than simulacra? How do the modern media affect memory? How does the author construct the text/reader relationship in an age of atrophied experience? How does one narrate when reality has become functional, as Brecht already pointed out when he suggested that a simple representation of reality, say a photograph of the Krupp works, no longer grasps that reality? Indeed, Kluge's method of storytelling is very Brechtian. With Brecht he shares the technique of the estranging glance, the method of historicization, and the notion of the social gest as it manifests itself in language, attitudes, and behavior. One of Kluge's basic narrative

strategies, in an age in which traditional narration is no longer adequate to capture the increasingly complex and abstract structures of contemporary reality, is to render the various language games that constitute social and political reality recognizable as such, to unfold their implications for domination and repression, and to explore their potential for protest and resistance. His is a mode of writing in which these languages seem to swallow up the subjectivity of the individuals whose lives are being narrated by an author who is present not as voice, but in bricolage, in a method of constructing layers of discourse, of slipping in and out of the discursive mind sets of the figures described.

It is as if modernization speaks itself as a machinery of discourses in whose grids individual subjectivities are simultaneously constituted and imprisoned, even stunted and mutilated. All of the discourses Kluge cites have their own history, their traditions, their genealogy, and many of them are related to the history of German bureaucracy and the Prussian State: the police, the judiciary, the educational system. In Foucault's terms, it is the German archive, its structures and its histories, which Kluge draws on and activates in his storytelling. But if in Foucault subjects are entirely produced by the archive, a process which actually tends to erase subjectivity altogether, Kluge's stories spin themselves out of the residues of subjectivity, distorted subjectivity, stunted subjectivity, subjectivities which can never be separated from the objective determinations of the archive, but which are nevertheless not identical to them. Taken together, Kluge said, his *Lebensläufe* pose the question of tradition and make up a sad story *(eine traurige Geschichte)*.[3] "Story" here should be taken in the double sense of tale and history, the history of a people whose language and culture is German, and who share a tradition which, according to Kluge, has always excelled in producing catastrophes: from the mythic tragedy of the Nibelungen via the peasant wars of the early sixteenth century to the winter battle of Stalingrad, arguably the decisive turning point of World War II and certainly one of its most stubborn myths. Where Foucault, as historian and scientist, isolates the structures of the various discourses that make up the archive, Kluge, as storyteller in a structuralist age, translates the archive back into individual life stories or, rather, shows how the archive permeates individual modes of speech, behavior, and action. Thus *Lebensläufe* provide a paradigm for his storytelling which will later be expanded and elaborated, but never fundamentally changed or abandoned.

One of the stories from *Lebensläufe*, the story of Anita G., served as the basis for Kluge's first full-length feature film, *Yesterday Girl*. When this film premiered in 1966, West Germany was in the throes of a fascination with the documentary, which *Lebensläufe* and Kluge's subsequent painstaking documentary reconstruction of the battle of Stalingrad—entitled *Schlachtbeschreibung* (*The Battle*, first version 1964)—

had anticipated some years earlier. But the reception of Kluge's work did not bene-
fit from this literary new wave, represented primarily by the theater (Hochhuth,
Kipphardt, Peter Weiss) and by various attempts to rekindle the Weimar tradition of
a working-class literature. More important, perhaps, Kluge was already beyond
certain aesthetic and political propositions on which much of the documentary wave
was based. For instance, he did not make a categorical distinction between fiction
and document, as so many of the documentarists did. He did not believe in the myth
of the real, the myth of authenticity, which the document suggested to many at that
time. He was skeptical of the claim that the document as used in the literary texts was
closer to reality than to fiction, that only real documents could serve as the basis for
a new realism, for a reinvigorated effectiveness of literature in the public sphere.
Already in his first text he had liberally mixed documentation and invention, stating
laconically in the foreword that his *Lebensläufe* were partly invented, partly not. The
notion of an invented document is no contradiction in terms for an author who is
interested in the structure and paradigms of documentary discourses rather than in
their claims to empirical truth or factual accuracy. Thus many of Kluge's stories read
like documentary texts, even if they are totally fictional: see, for example, his viciously
satirical science fiction tales in *Lernprozesse mit tödlichem Ausgang (Learning Processes
with Deadly Consequences,* 1973), in which capitalism races through space in a state
of permanent civil war, leaping from one galactic system to the next, always in search
of raw materials, labor power, and the maximization of profit.

In retrospect, I would claim that with very few exceptions—Peter Weiss's
Investigation among them—Kluge's best documentary writing has more to offer
aesthetically and politically than most of the documentarism of the 1960s. The
reason for this is quite simple. Much of 1960s documentarism treated literature and
the stage as moral institutions designed to provide enlightenment. The Schillerian
dramaturgy of Rolf Hochhuth's plays (e.g., *The Deputy)* may serve as the most
obvious example of this trend, which, at least implicitly, took the structures of a
traditional bourgeois public sphere for granted. Kluge's writing in turn operated on
a level of aesthetic reflection and analytic savvy that had learned its lessons from the
experiments of the Weimar avant-garde, especially Brecht and the montage tradi-
tion. His project was also deeply influenced by the thought of both Benjamin and
Adorno.[4] It took several more books and a number of films to reveal that, among
contemporary German writers and artists, Kluge is perhaps the most important
and creative heir to those still vibrant traditions. If one examines Kluge's literary
and theoretical positions, one sees how the well-known dichotomies—Brecht vs.
Adorno, Adorno vs. Benjamin, or political writing vs. high modernism, mass
culture as tool of domination vs. media as agents of emancipation—are taken apart

in his writing practice and give way to methods of remixing, constructing, and collaging that set those well-known positions productively back into motion. Of course, what I am claiming here for Kluge's storytelling is equally true for his filmmaking and his theoretical analyses of the public sphere, experience, and the history of labor power, the project of his and Oskar Negt's last gigantic cooperative venture, *Geschichte und Eigensinn (History and Obstinacy)*.

To return to the German literary context of Kluge's writing: it is no surprise that the 1968 radical student attack on all forms of art and literature as "bourgeois culture" put Kluge and other *Autorenfilmer* (auteur directors) on the defensive. He was not willing simply to dump his project of developing and nurturing a New German Cinema both as filmmaker and film politician, nor was he willing to embrace the abstract choice between literature and politics, to abandon literature for politics as the radical rhetoric of the times demanded. His response to the student movement's challenge to art, literature, and film was articulated in the film *Artists Under the Big Top Perplexed,* a complex reflection on the crisis of art as institution in a historical pressure cooker. For a while, then, Kluge withdrew into his work at the Institut für Filmgestaltung in Ulm, where he began to develop a project of science fiction films, a kind of "flight from reality," as he himself described it later on. But it was also in those years that he deepened his understanding of social theory and political economy in the first cooperative work with Negt, published in 1972 as *Öffentlichkeit und Erfahrung.* One year later he published his second major collection of stories, *Lernprozesse mit tödlichem Ausgang* (1973), which reflects his modified theoretical outlook. If the Stalingrad book was primarily concerned with the question of the organization of a disaster, *Lernprozesse* picks up on the model *of Lebensläufe,* except that it now presents life histories in their relation to the sphere of capitalist production. The principles of industrial production, as analyzed by Marxism, are shown to determine not just the sphere of production in the narrow sense, but also the social production of emotional experience, social cooperation, love and death, crime and justice, morality and personal relations. Kluge writes stories about learning processes that result in death, with the obvious hope that a different type of learning can be realized by the reader. He tells of events and situations whose meaning is somehow not accessible to the participants. The learning processes described take place in various areas of social life: industrial labor, leisure time, organized crime, personal relations, and, finally, the extrapolated development of imperialism after the nuclear holocaust—a science fiction story as only Kluge could have written it. All of these learning processes end badly because they invariably consist of fragmentary or partial actions which cannot be meaningfully connected; they are based on

false exclusions, abstract divisions, forced separations; their protagonists are intensely in search of an overarching meaning of life, which is always missed and perhaps forever elusive. What Kluge calls "hunger for meaning" *(Hunger nach Sinn)* is the unifying element in all of these stories, but the social situation in the twentieth century and beyond is characterized by *Sinnentzug,* a withdrawal of meaning.[5] In the foreword, Kluge writes: "Withdrawal of meaning. A social situation in which the collective life program of human beings falls apart faster than new life programs can be produced."[6]

When Kluge published these stories in 1973, German literature had just recovered from the 1968 assault on its legitimacy and begun its ambivalent journey into what came to be called "the new subjectivity" or "new inwardness" *(neue Innerlichkeit).* Again Kluge was and was not part of this literary direction. Since he had never bought into the latent objectivism of the documentary and political waves, he did not need to rediscover the problem of subjectivity, which from early on had been central to his literary and aesthetic investigations. The promises of immediacy and authenticity—whether in the form of the document or the personal, the emotional, the subjective—had no appeal for him. From Kluge's perspective, the enthusiasm with which the new subjectivity was embraced had to be read as yet another expression of the indomitable desire for meaning. And the learning processes initiated by this literary reaction against the objectivism of the previous years were all too often based on the same sorts of exclusions and oppositions his own writing was designed to question. Ironically, while some critics had taken *Lebensläufe* to task for not being documentary enough, for focusing on individual lives and bourgeois individuals, in the 1970s Kluge was criticized for not being subjective enough, for hiding in his texts, for not coping adequately with the problem of subjectivity, either his own or that of his figures.

I suspect that either these specific critiques or the general cultural climate that nurtured subjective expression and reflections on subjectivity led Kluge to insert his own authorial self more forcefully into his later texts. Certainly there are signs of this in Kluge's trilogy from the late 1970s. Kluge's own obsessions—the obsession with Stalingrad and military strategy, the obsession with his own experience of aerial bombardment, the obsession with the functional and the technocratic, and the obsession with the dead of history—come more to the fore than ever in his collection of stories, the *Neue Geschichten, Hefte 1-18: "Unheimlichkeit der Zeit"* (1977), as well as in one of his most important and most widely discussed films of those years, *Die Patriotin (The Female Patriot).* The theoretical centerpiece of the trilogy is *Geschichte und Eigensinn,* written with Negt over the space of three years and published in 1981.

It would be futile to try to describe, in toto, the *Neue Geschichten*. They are too diverse, too heterogeneous to be captured in a coherent description. There are 149 stories, some shorter, some longer, sometimes narrated in organized sequences, sometimes not. Some of the eighteen notebooks have titles ("Images from My Home Town," "Inside the Brain of the Metropolis"), most do not. Illustrations are liberally interspersed: photos, including family snapshots, graphics, drawings, sketches, maps, musical scores, paintings, and so forth, but their relation to the text often remains opaque.[7] The stories focus on administered human life during the Third Reich and the war, in the Federal Republic, in the German Democratic Republic. They are always precise and obsessed with quantifiable detail, but they also remain fragmentary and strangely decentered. In opposition to the homogenizing stories fabricated in the public media, Kluge focuses on the particular without immediately making it representative of something other than itself. But he does this in such a way that the particular, the nonidentical is not paralyzed in isolation, not cut off from the larger context in which it is embedded. On the contrary, the glance of radical particularization opens up questions of mediation, coherence, *Sinn* (meaning). The multiplicity of stories, voices, events prevents any individual event or life story from becoming representative. It is precisely the precision with which each particular is presented that points to the nonrepresentability of the social whole.

And yet the *Neue Geschichten* offer something of an encyclopedia—incomplete to be sure—of contemporary German life from the Third Reich to the present. Critics have isolated thematic clusters: cuts from various workplaces, the state apparatuses, the private sphere; individual life stories or fragments thereof; the military-industrial complex and the academy; 1968, the student movement, the work of the Institute for Social Research in Frankfurt, and so on. Time and again Kluge focuses on the energy and *Eigensinn* (obstinacy) with which individuals pursue their goals. Many stories revolve around the destiny of the senses, memory, childhood, revenge, happiness. Kluge is especially successful in capturing the functionalist mindset of the compulsively neurotic technocrat, and the stories present a variety of them: bomber pilots and administrators, technical planners and academic researchers.

The ostensible lack of unity intends, of course, to approximate the lack of coherence both in reality and in the experience of it. Even to say, as some critics have, that the subtitle *Unheimlichkeit der Zeit* provides a unifying element is not exactly to say much, since the subtitle is itself quite ambiguous. It can be translated with equal justification as "the uncanniness of time" or as "uncanny times," and the latter may refer to the present or to the past. Both translations, of course, apply. Kluge himself calls *Neue Geschichten* stories without an overarching concept and claims not always to understand their overall connections. But in this volume as in earlier ones, the basic

aesthetic *gestus* of Kluge's mode of writing is still "antifictional," as some critics have called it.[8] Mise-en-scène and the counterfeiting of documentary materials result in an antifictionalization of narration which, as Stefanie Carp says in her superb study, is directed "against the cultural fictions that mythicize or deny the abstraction of human life"[9] in contemporary culture. Kluge himself says much the same when he describes his project as writing realistic counter-(hi)stories against the reality-fiction of history *(gegen den Real-Roman der Geschichte);* these stories are aesthetically and structurally adequate to contemporary reality's high degree of complexity and at the same time make available, in the form of art, those possibilities of experience and consciousness which are blocked by the reality-fiction of history.[10] I cannot develop here Kluge's complex aesthetic of realism, which permeates all of his texts, stories, films, theory, and essays.[11] Clearly, his stubbornness in holding onto one of the most prostituted terms in the vocabulary of modern aesthetics has to do with his affinity with Brecht as well as with his desire to deconstruct what Adorno called the "universal context of delusion" produced by late capitalism. "The motive for realism," he writes in his essay on reality's ideological claims to be realistic, "is not affirmation of reality, but protest."[12] The protest of Kluge's realism is not so much directed against the literary realism of the nineteenth century—one of the main targets of modernist fiction and theory—rather, it is directed against the homogenized realism *(Einheitsrealismus)* propagated by the mass media. In this sense Kluge's project is not narrowly aesthetic, but informed by a desire to open up spaces for the production of what he and Negt called counter-public spheres.

And yet, the realism, or, depending on the position from which one speaks, antirealism of Kluge's stories is emphatically an *aesthetics* of resistance, constructed to resist homogenization, centralization, and administration from above. But rather than privileging heterogeneity as romanticized other, it shows in concrete terms how heterogeneity and difference are themselves internally split: on the one hand, the heterogeneity of resistance, which Kluge captures with the notion of *Eigensinn* (obstinacy) and self-regulation, on the other hand, the heterogeneity and difference produced by the homogenizing system itself, the heterogeneity which results from the processes of specialization, division, separation that make up the modern world.

The difference between *Neue Geschichten,* on the one hand, and *Die Patriotin* and *Geschichte und Eigensinn,* on the other, is perhaps that the stories, particularly in their powerful reconstruction of the aerial bombardment of his home town in April 1945, focus more on what Kluge describes as the "strategy from above."[13] The aerial bombardment which Kluge experienced as a child becomes a spatial and structural metaphor for the terror of reality, the power of oppression, the deadly dialectic of production and destruction which is modern capitalism. On the other

hand, the film and the theoretical text focus on the potential for resisting strategies from above by means of strategies from below. In these latter works, particularly in their notions of history, labor power, and *Eigensinn, a* number of romantic motifs and tropes appear which bring Kluge, the analytic storyteller, into conflict with Kluge, the theoretician, who remains tempted by the ultimately aesthetic notions of redemption, reconciliation, even a resurrection of the dead—notions which the aesthetic and analytic structures of his literary texts ultimately deny. The extent to which this apparent turn in Kluge's work has to do with the politics of national identity and German traditions as they have emerged since the early 1980s in the public discourse remains to be analyzed.

In one of his more recent essays, the speech he gave when receiving the Kleist prize in 1985, Kluge had harsh words for those who remain enamored of the repetition compulsions of tragic theater experiences; against the fake romanticism of nineteenth-century opera he posited once again the ideal of analytic writing. One may wonder, however, if the continuing fascination of the theoretician with the utopian promise of aesthetic reconciliation and redemption in and of history is not part of that very same culture that produced opera as a powerhouse of emotions. Certainly the notion of an aesthetic redemption of history, no matter how tempting and intriguing it must be for a writer in the tradition of Benjamin and Adorno, does not mesh well with the methods of analytic writing.

Whether and how Kluge's romantic projections will manifest themselves in his storytelling remains to be seen. A sequel to *Neue Geschichten* has been announced and is long awaited. That Kluge has not, however, abandoned his analytic bent is clearly indicated in the Kleist speech of 1985. Poe, Musil, and Kleist are acknowledged as precursors in the project of analytic writing. In this speech, Kluge is not overly optimistic about the possibilities for opposition and resistance, let alone redemption, through literature. He returns to a pessimistic Adornean trope in which he describes his literary project as a kind of writing in bottles. He ends his Kleist speech by saying:

> In the age of the new media, I do not fear what they can do; I rather fear their inability, the destructive power of which fills our heads. In this age we writers of texts are the guardians of the last residues of grammar, the grammar of time, i.e., the difference between present, future, and past, guardians of difference. [14]

But even the *Flaschenpost,* the message in the bottle written by the guardian of difference, assumes it will find its reader, and Kluge's struggle with and against the media continues, if not in his storytelling, then certainly in his most recent intense engagement with private television. But that is another episode of the Kluge story.

Postenlightened Cynicism
Diogenes as Postmodern Intellectual

The entire kynical mode of life adopted by Diogenes was nothing more or less than a product of Athenian social life, and what determined it was the way of thinking against which his whole manner protested. Hence it was not independent of social conditions but simply their result; it was itself a rude product of luxury.

Hegel, *Elements of the Philosophy of Right, sec. 195*

For the happiness of the animal, that thorough kynic, is the living proof of the truth of kynicism.

Nietzsche, *Untimely Observations 2, sec. 1*

Reduced to his smallest dimension, the thinker survived the storm.

Brecht, *Das Badener Lehrstück vom Einverständnis*

I

Some two hundred years after the publication of Immanuel Kant's *Critique of Pure Reason* (1781), a polemically written philosophical essay of nearly one thousand pages, disrespectfully entitled *Critique of Cynical Reason,* captured the imagination and the passions of readers in Germany. Contrary to Kant's philosophical treatise, which, over a hundred years after its appearance, still made Musil's Törless sweat with fear and nausea, Peter Sloterdijk's treatise became an immediate success offering German intellectuals a master lesson in the pleasures of the text. Within only a few months over forty thousand copies had been sold, and the liberal feuilletons outdid each other in heaping praise on the author by comparing him to Nietzsche, Spengler, and Schopenhauer. Since much of this praise focused on Sloterdijk's critique of the Enlightenment, popular in West Germany since the conservative turn (*Tendenzwende*) of the 1970s, the left responded by trying to relegate Sloterdijk's essay to the dustbin of history, as a rotten ware of late capitalist decline. Both readings sucked Sloterdijk's text back into the ideological and political confrontations of contemporary West German culture that Sloterdijk actually proposed to sidestep, and thus they missed important aspects

of the book's challenge to the status quo. Ironically, many of the negative responses were reminiscent of an earlier conservative German *Kulturkritik* that held that anything successful could not possibly be any good and required ponderous seriousness of anything to be taken seriously. Thus the tongue-in-cheek reference to Kant in the title was predictably turned against the *Critique of Cynical Reason,* and it was attacked as simplistic, faddish, and pretentious, antitheoretical, regressively irrational, and politically reactionary. There was controversy, and controversy, as any cynical observer of the culture industry will be quick to note, is the sine qua non of critical success.

But the success of Sloterdijk's essay has deeper roots. It has a lot to do with the fact that despite the recent revival of conservatism in Western countries, the old dichotomies of Left versus Right, progress versus reaction, and rationality versus irrationality have lost much of their explanatory power, moral appeal, and political persuasiveness. In its focus on a new type of postenlightened schizocynicism that remains immune to traditional forms of ideology critique, Sloterdijk's book articulates the pervasive malaise and discontent in contemporary culture that despite differences in local traditions and politics, is as much a reality today in the United States as in West Germany or, for that matter, in France. First and foremost, the *Critique of Cynical Reason* should therefore be read as an attempt to theorize a central aspect of that culture we have come to call postmodern, as an intervention in the present aimed at opening up a new space for a cultural and political discourse.

What then is Sloterdijk's project? The dismissive comparison with Kant, voiced by some German critics, is as much beside the point as the facile elevation of Sloterdijk to a Nietzsche of the late twentieth century. While he is strongly indebted to a Nietzschean kind of *Kulturkritik* that focuses on the nexus of knowledge and power, he is not ready to forget the affinity between Nietzsche's subtle "cynicism of self-disinhibition"[1] and the brutal politics of imperialism, later fascism. Neither does he share Kant's intention to subject reason to critique in order to open up the way toward the final goal of all rational speculation, the advancement of science, progress, and emancipation. If anything, his posture is anti-Kantian in that it rejects all master narratives (with a Brechtian twist, Sloterdijk calls them *Grosstheorien)* of reason of which Kant's idealism and metaphysics is certainly a major example. The title's reference to the Kantian critiques makes sense only as a critical gesture.

However, there is another sense of the Kantian project that Michel Foucault has emphasized in an attempt to posit Kant against the Cartesian tradition, and which might describe Sloterdijk's project quite accurately. In his essay "The

Subject and Power," Foucault had this to say about Kant:

> When in 1784 Kant asked, *Was heisst Aufklärung?*, he meant, What's going on right now? What's happening to us? What is this world, this period, this precise moment in which we are living?
>
> Or in other words: What are we? as *Aufklärer* as part of the Enlightenment? Compare this with the Cartesian question: Who am I? I, as a unique but universal and unhistorical subject? I, for Descartes, is everyone, anywhere at any moment? But Kant asks something else: What are we? in a very precise moment of history. Kant's question appears as an analysis of both us and our present.[2]

I think that we may read Sloterdijk with maximum benefit if we read him in the same way Foucault read Kant's programmatic essay. What is at stake in the *Critique of Cynical Reason* is not a universal history of cynicism (as such the book would be seriously flawed), but rather a more limited investigation of the role of cynicism and its antagonist kynicism for contemporary critical intellectuals. Sloterdijk sees cynicism as the dominant operating mode in contemporary culture, both on the personal and institutional levels, and he suggests reviving the tradition of kynicism, from Diogenes to Schweik, as a counterstrategy, as the only form of subversive reason left after the failures and broken promises of ideology critique in the tradition of Western Marxism. By focusing on cynicism as a central feature of the postmodern condition in the 1970s and 1980s and by searching for strategies to resist it, Sloterdijk attempts to theorize that which has often remained submerged in the recent debate about modernity and post-modernity: the pervasive sense of political disillusionment in the wake of the 1960s and the pained feeling of a lack of political and social alternatives in Western societies today. After all, the 1960s in West Germany—against the arguments of Adorno and Horkheimer's *Dialectic of Enlightenment*—were once labeled a second expanded enlightenment that seemed to promise a major and long-lasting realignment in the country's political culture based on what Sloterdijk calls, with a sense of loss, the "public dispute about true living" (xxxv). In the German context where illiberalism and reaction are usually perceived to be responsible for the march into fascist barbarism, the notion of *Aufklärung* (enlightenment) carried a great potential of utopian hopes and illusions with it at that time, both in relation to radical social and cultural change anticipated for the future and with regard to Germany's attempts to come to terms with its fascist past. Cynicism and resignation are therefore indeed dangers for a generation that had its formative political experiences in the 1960s and that has since then seen its hopes not so much dashed as crumble and fade away. The situation

is even worse for the subsequent generation, the nofuture kids and dropouts *(Aussteiger)* of the 1970s who were too young then to feel anything but contempt for the 1960s nostalgia of their elders who have the jobs, while they face diminished opportunities and an increasingly bleak labor market. While Sloterdijk's analysis is rooted in his perceptions of German culture, it seems fairly clear that the German case of political disillusionment, cynicism, and an atrophied trust in the future has parallels in other Western countries today. In a certain sense, the growth of cynicism during the 1970s actually provided the cultural soil for the revival of the ideological conservatism of the 1980s, which has, filled the void left by the post-1960s disillusionment with a simulacrum of homely old values.

Thus Sloterdijk perceives a universal, diffuse cynicism as the predominant mindset of the post-1960s era, and he takes the cynic not as the exception but rather as an average social character, fundamentally asocial, but fully integrated into the work-a-day world. Psychologically he defines him as a borderline melancholic able to channel the flow of depressive symptoms and to continue functioning in society despite constant nagging doubts about his pursuits. I suspect that Sloterdijk's cynicism is less widespread than he might want to claim. But as an analysis of the prevailing mindset of a generation of middle-aged male professionals and intellectuals, now in their mid-forties and in increasingly influential positions, Sloterdijk's observations are perceptive and to the point. And who could resist the brilliance of an aphorism such as the following, which pinpoints this new unhappy sensibility:

> Cynicism is *enlightened false consciousness.* It is that modernized, unhappy consciousness, on which enlightenment has labored both successfully and unsuccessfully. It has learned its lessons in enlightenment, but it has not, and probably was not able to, put them into practice. Well-off and miserable at the same time, this consciousness no longer feels affected by any critique of ideology: its falseness is already reflexively buffered.(5)

Given this modernization of false consciousness, the old strategies of the enlightenment—from the public exposure of lies to the benign correction of error to the triumphant unveiling of a structurally necessary false consciousness by ideology critique—will no longer do. They will no longer do not only because the false consciousness they attack is already reflexively buffered, nor simply because ideology critique in the Marxian tradition, that once most radical heir to the Enlightenment, has mutated into a theory of political legitimation in the Soviet bloc. Even more objectionable to Sloterdijk is the subjective side of ideology critique, which always rests on a problematic reification and depersonalization of

the opponent in the first place: enlightenment as a war of consciousness aimed at annihilating the opponent. Thus the focus on the place of subjectivity in ideology critique reveals how the dialectic of domination and exclusion was always already inscribed into the enlightenment, vitiating its claims to universal emancipation. In this far-reaching critique of the deadly mechanisms of ideology critique, Sloterdijk actually continues in an important tradition of Western Marxism that reaches back to Marx himself: the critique of reification. However, he gives it a Nietzschean twist by focusing not on reification through the commodity form (which he accepts in a weaker, nontotalizing version), but on reification of self and other in presumably enlightened discourse practices.

One of the consequences of Sloterdijk's concern with the subjective effects of cynical reason is that he attempts to address the creeping political disillusionment of the post-1960s era on an existential, subjective level rather than disembodying it into the realm of universal norms or agonistic, free-floating language games without subjects. One need not be fully convinced of Sloterdijk's somatic strategies for overcoming this enlightened false consciousness to see that his analysis of the post-1960s intellectual works as a productive irritant both against the defenders of a Habermasian modernity and against the advocates of a Nietzschean schizo-post-modernity. By addressing the problem of cynical disillusionment head-on and by articulating the basic intellectual problem of our time as that of an "enlightened false consciousness" rather than attacking or defending enlightened rationality, Sloterdijk's essay cuts across the false oppositions, accusations, and counteraccusations that have marred the modernity-postmodernity debate, pushing it ever deeper into a cul-de-sac. From an American perspective one might say that Sloterdijk offers us a sustained polemical reflection on a modernity gone sour and a postmodernity unable to stand on its own feet without constant groping back to what it ostensibly opposes. Rather than seeing enlightenment as the source of all evil in a perspective which became prevalent in France in the post-1968 era or condemning the poststructuralist critique of reason as inescapably irrationalist and conservative, Sloterdijk engages the hostile camps in a dizzying dance in which frozen positions are productively set in motion and in which a new figuration of postmodernity emerges, a figuration that seems both more promising and less exclusive than most of the current accounts would seem to permit.

Sloterdijk's questions would then read something like this: How can intellectuals be *Aufklärer* at this precise moment in history? What has happened to enlightenment, to the ideal of rational discourse since the 1960s, and how do we evaluate the strong antirationalist impulse visible in all Western countries today? How does the political and cultural experience of the 1960s stack up against the catastrophic

history of the earlier twentieth century? Was the New Left's belief in a regeneration of the enlightenment perhaps naive in the first place? How and in what form can the values of the Enlightenment tradition be sustained in an age that has become more and more disillusioned with the project of enlightened modernity? What forces do we have at hand against the power of instrumental reason and against the cynical reasoning of institutionalized power? How do we define the subject of *Aufklärung* today? How can one remain an *Aufklärer* if the Enlightenment project of disenchanting the world and freeing it from myth and superstition must indeed be turned against enlightened rationality itself? How can we reframe the problems of ideology critique and of subjectivity, falling neither for the armored ego of Kant's epistemological subject nor for the schizosubjectivity without identity, the free flow of libidinal energies proposed by Deleuze and Guattari? Where in history do we find examples that would anticipate our intellectual dilemma? How can historical memory help us resist the spread of cynical amnesia that generates the simulacrum side of postmodern culture? How can we avoid paralysis, the feeling of history at a standstill that comes with Critical Theory's negative dialectic as much as with the positing of a carceral continuum that occupies central space in recent French accounts of *posthistoire?*

No doubt, Sloterdijk wants to be an *Aufklärer.* He advocates a type of enlightenment that is enlightened about itself. He rejects the new fundamentalism of conservatives and neoconservatives, *and* he criticizes the universalist claims of the classical Enlightenment. Thus he accepts certain important tenets of the poststructuralist critique of the Enlightenment, especially in its Foucauldian version. But he never falls for the facile and fashionable collapsing of reason and totalitarianism, nor for the obsessive French focus, since the 1970s, on incarceration and *le monde concentrationnaire,* the world as concentration camp. (In a curious way this concern of French intellectuals displays the same fixation on the past of which they accuse German Left intellectuals whose obsession with fascism allegedly blinds them to the threat posed by the Soviet Union and the world of the Gulag.) Just as Sloterdijk rejects the timeworn Lukácsian argument that all the roads of irrationality lead into fascism, he also disagrees with "the French position." He refuses to accept the surreptitiously teleological notion that all enlightenment ends in the Gulag or in a concentration camp, which is itself nothing but the reverse of the myth of revolution and emancipation that prevailed in the self-understanding of French intellectuals from Zola to Sartre. To the German critic who was nurtured on Adorno, Horkheimer, and Marcuse in the 1960s, such a one-dimensional proposition could only appear as the dialectic of enlightenment revisited—except that contrary to much of the French Nietzscheanism of the 1970s, Horkheimer

and Adorno always held on to a substantive notion of reason and truth that remained, in Kantian terms, the condition of possibility of Critical Theory itself.

While Sloterdijk takes freely from both Critical Theory and poststructuralism, his position remains crucially ambivalent in that he has as much trouble with the truth of Critical Theory as with the total dissolution of truth, reason, and subjectivity in certain radical forms of poststructuralism. His text oscillates provocatively between Frankfurt and Paris. At times it appears to blend Critical Theory with poststructuralism; at others it rather seems to operate like a collage of various theoretical *objets trouvés*. At any rate, Sloterdijk's intention is to move beyond the propositions of the *Dialectic of Enlightenment,* and to evade the post-Nietzschean compulsion to collapse knowledge and power. In that aim—and *only* in the aim—he might be said to approach Habermas, whose model of consensus and free dialogue he accepts as a "heeling fiction" (14) but rejects as an adequate description of the post-1960s status quo. In an era of widespread diffuse cynicism in which the traditional subject of critical knowledge and all central perspectives of critique seem to have been pulverized, Sloterdijk constructs a new model of localized conflict that seeks literally to embody another reason, another enlightenment, another subjectivity. He proposes to turn the disillusionment with enlightened modernity away from melancholy and cynicism and to make lost illusions productive for an enlightened thought on another level. He wants to achieve this goal by reclaiming a tradition of rationality from which the modern scientific enlightenment, much to its detriment, has cut itself loose: the tradition of kynicism, embodied in Diogenes, who privileged satirical laughter, sensuality, the politics of the body, and a pleasure-oriented life as forms of resistance to the master narratives of Platonic idealism, the values of the polis, and the imperial claims of Alexander the Great.

II

Nevertheless, Sloterdijk's starting point remains Adorno and Horkheimer's pessimistic work and its radical critique of instrumental reason and identity metaphysics. The *Critique of Cynical Reason* could indeed be read as a postmodern pastiche of the *Dialectic of Enlightenment,* a pastiche, however, that retains the memory of the pain and anger of Adorno's melancholy science and that sympathizes with the rejection of a patriarchal world in which reason has become a strategic tool for the domination of inner and outer nature. If it is pastiche, however, it is not so in the sense that Jameson has defined as one of the major modes of postmodern cultural production.[3] Jameson sees pastiche as imitating a peculiar mask, as speech in a dead language, as a neutral prac-

tice of mimicry that has abandoned the satirical impulse still inherent in parody, that major stylistic strategy of modernism out of which pastiche is said to evolve. And he goes on to claim that producers of culture today "have nowhere to turn but to the past: the imitation of dead styles, speech through all the masks and voices stored up in the imaginary museum of a now global culture.[4] Jameson clearly sees postmodern pastiche negatively as a "random cannibalization of all styles of the past," and much of postmodernism can indeed be described in this way. In fact, even Sloterdijk could be said to cannibalize a number of different styles and modes of expression—the polished aphorism, the anecdote, the suggestive style of the feuilleton, satire, serious philosophical discourse, the discourses of literary and intellectual history—mixing them in a kind of patchwork that prevents the emergence of a unitary style in the traditional modernist sense and that evades the requirements of a rigorous philosophical discourse.

But this is also the point where Sloterdijk's pastiche is no longer grasped by Jameson's characterizations. The *Critique of Cynical Reason* is not "blank parody, a statue with blind eyeballs."[5] Sloterdijk's pastiche is endowed, from the very beginning, with a combative impulse, and his text asserts a notion of an embodied subjectivity. Memory and amnesia keep it from going blind, and the kynical impulse of *Frechheit* (impudence) makes this pastiche come alive as self-assertive body. It is a philosophical pastiche that remains self-consciously satirical and never denies its substantive ties to the tradition of literary modernism and the historical avant-garde. Rather than postmodern in Jameson's sense, suspended, as it were, in the gap between signifier and signified, Sloterdijk's relationship to the discourses of various disciplines and media is Brechtian (though without Brecht's Leninist politics), in that it has definite purposes, makes contingent arguments, and uses traditions critically to its own advantage. In this sense, Sloterdijk's work could be claimed for a critical and adversarial postmodernism, a postmodernism of resistance, as some critics have called it.

At the same time, Sloterdijk's text is postmodern in yet another sense. The *Critique of Cynical Reason* lacks the metaphysical backlighting that still hovers on the horizon of Adorno's critique of the metaphysics of reason, and that in general haunts much of literary and philosophical modernism. Thus in the *Dialectic of Enlightenment,* that central text of philosophical high modernism, the struggle of reason against mythic nature that brings about the inescapably fatal reversal of reason into myth, of self-preservation into self-denial, is itself a metaphysical figure. Adorno's relation to metaphysics as the pretext of his critical work is as emphatically strong as Derrida's two decades later. Both Critical

Theory and deconstruction, primarily through their readings of Nietzsche, actually ground a whole philosophy of history in their ideas about the rise and fall of metaphysics. But as Sloterdijk says, this notion of a breakdown, of a collapse, is today inadequate: "Metaphysical systems do not 'fall,' but fade, seep away, stagnate, become boring, old hat, unimportant, and improbable" (356).

Instead of a totalizing unraveling of enlightenment and Western metaphysics (interpreted along the lines, say, of "phallogocentrism") or of an equally onesided normative defense of enlightened modernity (interpreted along the lines of communicative reason), Sloterdijk gives us an account of the operations of enlightened reason in history as a series of combative constellations without ground, without beginning and without telos: enlightenment as the eternal return of the same. As he tries to avoid any teleological account of the history of enlightenment, he presents us with the ineradicable return of the struggle between opposing consciousnesses: the cynicism of power and its institutions (in the realms of politics, the military, religion, knowledge, sexuality, and medicine) versus the kynical revolt from below, which responds to the cynicism of domination with satirical laughter, defiant body action, or strategic silence. Sloterdijk's description of cynicism and kynicism, repression and resistance, as a constant of history can be criticized as lacking historical specificity, but given the parameters of the recent debate on postmodernity it has the advantage of making the fear of total closure suddenly appear to be as delusive and irrelevant as the hope for total emancipation, the first actually being nothing so much as a binary reversal of the latter, a reversal of the messianic millenarianisms of the early twentieth century into the catastrophic dystopias of our own time. Sloterdijk would be the last to forget the experiences of twentieth-century totalitarianisms: after all, his thought is grounded in the tortured insights of Critical Theory and cannot be accused of amnesia. But he does refuse the metaphysics of totality that still characterizes so much of contemporary European thought, even if in the form of radical negation. He refuses it in order to salvage the discourse of emancipation, shorn of its universalist claims and brought down to a localizable human dimension. With Adorno, Sloterdijk insists that one of the main problems with the Enlightenment was its inability to include the body and the senses in its project of emancipation. He therefore attempts to reconstitute *Aufklärung* on the limited basis of what he calls physiognomic thought, embodied thought, arguing for enlightenment as *Selbsterfahrung* (self-experience) rather than self-denial. The mythic model for the kind of somatic anarchism he advocates is the Greek kynic Diogenes, the plebeian outsider inside the walls of the city who challenged state and community through loud satirical laughter and who lived an animalist philosophy of survival and happy refusal.

But let's make no mistake. We are not just facing a return of the tired existentialist notion of the individual versus society, the outsider versus the group, the margin versus the center. Nor is Sloterdijk's resurrection of Diogenes merely a nostalgia for the protest strategies of the 1960s shorn of their collective dimension and reduced to a kind of Stirnerian philosophy of the individual, self-identical body. Sloterdijk fully grasps the dialectic of exclusion and inclusion, outside and inside, body and power, and the reproach often leveled against him, that he constructs a merely binary opposition between cynicism and kynicism simply misses the mark. After all, the cynic as disillusioned and pessimistic rationalist is as far beyond the belief in idealism, stable values, and human emancipation as the kynic is. Thus rather than positing a binary opposition of cynicism versus kynicism, Sloterdijk postulates the split within the cynical phenomenon itself, which pits the cynical reason of domination and self-domination against the kynic revolt of self-assertion and self-realization. He mobilizes the kynical potential of the Diogenes tradition against a prevailing cynicism that successfully combines enlightenment with resignation and apathy. But it is precisely the moment of a disillusioned enlightenment in cynicism itself that—and this must be Sloterdijk's hope—might make it susceptible to the temptation of kynical self-assertion. Here it becomes clear that Sloterdijk's Diogenes strategy is directed primarily at those who still suffer, however subliminally, from enlightened false consciousness, not at the real cynics of domination or at those leaders of the contemporary world who mistake their own cynical politics for a return to old values, a form of unenlightened cynicism to which Sloterdijk pays scant attention. Sloterdijk is right in reminding us that the domination through instrumental or cynical reason can never be total and that the masochism of refusal or the melancholy about an irrevocable loss of happiness, that double heritage of Critical Theory, has today lost its offensive potential and reinforces the enlightened false consciousness it should help to dismantle.

Thus Sloterdijk answers Adorno's melancholy science with a kind of *Erheiterungsarbeit,* a "work that cheers up and is based on what he calls the "embodying of reason" (xxxiv, xxxvii). He carnivalizes the frozen landscape of negative dialectics, and mobilizes the kynical body of Diogenes against the cunning of Odysseus, that master-cynic of the *Dialectic of Enlightenment* who pays the price of self-denial in order to survive in his struggles with the mythic powers, the Cyclops and the Sirens. Where Adorno's Odysseus embodies what Sloterdijk calls "self-splitting in repression," the ultimately unhappy consciousness of the modern cynic, Diogenes comes to represent the "self-embodiment in resistance," an enlightened affirmation of a laughing, excreting, and masturbating body that

actually undercuts the modern notion of a stable identity, attacks the armored, self-preserving, and rationalizing ego of capitalist culture, and dissolves its strict separations of inside and outside, private and public, self and other (218).

On one level Sloterdijk's return to the kynic body may appear as a merely adolescent and regressive gesture whose potential for effective resistance is a priori contained and even vitiated by the way in which sexuality, the body, the corporeal have been deployed, instrumentalized, and co-opted by the contemporary culture industry. If, as Sloterdijk would have to be the first to admit, the body itself is a historical construct, how can the mere impudence of the postmodern Diogenes hope to break through the layers of reification and power inscriptions which Norbert Elias and Michel Foucault have so cogently analyzed? And how would Sloterdijk counter a Foucauldean claim that the resistance of the self-conscious body is produced by the culture of cynicism itself as a regenerating and legitimating device? It is indeed questionable to what extent Diogenesian protest gestures could be more effective politically than traditional ideology critique combined with organized mass protests and group politics. Unless, of course, Diogenes's aim were to create a "counterpublic sphere," a kind of *Gegenöffentlichkeit* as Oskar Negt and Alexander Kluge have theorized it. Precisely this broader dimension is absent from Diogenes's politics.

But the return to the body in Sloterdijk is never an end in itself, and we may have to look for its politics on another level. Enlightenment as *Selbsterfahrung* (self-experience) through the body tries to unearth a register of subjectivity buried in the civilizing process that produced the Western self-identical subject over the centuries. To that rational male subject, whose ultimate manifestation for Sloterdijk is the nuclear bomb and its identity of self-preservation and self-destruction, Sloterdijk opposes an alternative subjectivity, a vision of an actual softening and liquefying of subjects:

> Our true self-experience in original Nobodiness remains in this world buried under taboo and panic. Basically, however, no life has a name. The self-conscious Nobody in us—who acquires names and identities only through its social birth—remains the living source of freedom. The living Nobody, in spite of the horror of socialization, remembers the energetic paradises beneath the personalities. Its life soil is the mentally alert body, which we should call not *nobody* but *yesbody* and which is able to develop in the course of individuation from an areflexive "narcissism" to a reflected "self-discovery in the world-cosmos." In this Nobody, the last enlightenment, as critique of the illusion of privacy and egoism, comes to an end. (73 f.)

It is in the discussion of this self-conscious nobody that both Sloterdijk's

closeness to and distance from Adorno become emblematically visible. He rein-
terprets the famous passage in Homer's *Odyssey* where Odysseus, in a lightning
flash of foresight, answers the Cyclops's request for his name by saying: "Nobody
is my name." This ruse saves Odysseus's and his companions' lives because the
blinded Cyclops fails to get help from his peers when he tells them: "Friends,
nobody slays me with cunning," thus causing them to walk away laughing and to
ignore his predicament.

For Adorno, it is all in the name. In the struggle of reason against the mythic
powers of nature, the very act of physical self-preservation implies the sacrifice of
the self. Identity appears as based on self-denial, an argument Adorno makes even
more powerfully in his reading of the Siren episode in the *Odyssey*. For Sloterdijk,
on the other hand, it is all in the conscious body. Rather than seeing Odysseus's
denial of his identity as a fatal first step in the constitution of Western subjectivity,
Sloterdijk emphasizes the positive aspect of physical survival, and in a Brechtian
move he praises the discovery of nobodiness in the moment of danger as a
welcome expansion of subjectivity: "The utopia of conscious life was and remains
a world in which we all have the right to be Odysseus and to let that Nobody live"
(74). In emphasizing the importance of experiencing preindividual emptiness, the
nobody, Sloterdijk moves toward a realm of non-Western mysticism that would
have been quite foreign to Adorno's historically-rooted reflection. At the same
time it is significant that Sloterdijk does want to rescue Odysseus, that prototype
of Western rationality, for the kind of alternative enlightenment that he has in
mind. He advocates the expansion of the rational self into the body and through
the body to a state of nondifferentiation that would, however, remain in constant
tension with kynical self-assertion. Contrary to Buddhist asceticism, which aims at
a transcendence of the individual body, contrary also to a Nietzschean negation of
individuation, Sloterdijk maintains an affirmation of the body as "yesbody," and it
is the permanent oscillation, as it were, between yesbody and nobody that under-
mines the pathology of identity and guarantees the expansion of the boundaries
of subjectivity, Sloterdijk's central concern.

Sloterdijk's concept of a new, kynical subjectivity aims at nothing less than a
new, postindustrial reality principle that contrary to the Deleuzian scheme of the
schizobody would acknowledge the necessary and productive contradiction
between a unified physical body and processes of psychic deterritorialization. In an
age in which traditional rationality has revealed itself as the principle of self-
preservation gone wild" (324) and the political pathology of overkill presents itself
as realism, Sloterdijk sees the only chance for survival in a reversal of the civilizing
process itself, which has created the dominant Western mindset of hard subjects,

hard facts, hard politics, and hard business" (325). To the privileging of distance and objectification in the culture of modernity, Sloterdijk's physiognomic thought opposes a sense of warmth and intimacy, convivial knowledge, and a "libidinous closeness to the world that compensates for the objectifying drive toward the domination of things" (140). Here it becomes clear that his approach shares much common ground with critiques of Western rationality and patriarchy as they have been articulated in ecological, psychoanalytic, and feminist discourse. But this is also where a number of problems emerge. When Sloterdijk claims that *we* are the bomb, the fulfillment of the Western subject, he clearly has the reified, rational male subject in mind. The question of women's subjectivity and its relationship to the cynicism-kynicism constellation is never really explored, and the presentation of Phyllis and Xanthippe as female kynics is, to put it mildly, disappointing. What *are* women to do while Diogenes "pisses against the idealist wind," and how do they participate in or counteract the cynicism of domination? Is kynicism really the only visible way of acting and speaking in a different voice? I think Sloterdijk could have strengthened his case by focusing more thoroughly on the problem of gender and by asking himself to what extent his critique of male identity pathology might actually be indebted to feminist perspectives. A politics of a new subjectivity today makes sense only if gender difference is explored and theorized. Otherwise one runs the danger of reproducing the exclusionary strategies of the Enlightenment yet another time. Important as the argument for a new politics of subjectivity is, Sloterdijk's male kynicism remains ultimately unsatisfactory.

But then one might want to go further and ask whether the cynicism-kynicism constellation is not itself the problem. The very strength of Sloterdijk's construction—the fact that he avoids a merely binary opposition—may also imply a weakness. I am not only referring here to the fact that the kynical attack on the cynicism of domination itself has to rely inevitably on a heavy dose of cynicism. Such cynicism of the kynic is, of course, not in the service of domination. It nevertheless depends on the logic of hostility that the new reality principle of a softened, flexible subjectivity is supposed to overcome. It is difficult for me to imagine a nonhostile, nonobjectifying satirical laughter, and Sloterdijk never really addresses the question of what kynics actually do to the persons they laugh at. The question here would be whether Sloterdijk's immanent dialectic of cynicism-kynicism does not ultimately hold him captive to what he wants to overcome.

If that were the case, the possibility emerges that the kynic may himself be simply a cynic in disguise. Throughout his book, Sloterdijk describes Diogenes as something of a loner, and when he talks about his new physiognomic thought he praises the conviviality with things rather than that with human beings. The

whole spectrum of what the Germans call *Beziehungsprobleme* (the politics of the personal), which has occupied so much space in the psychopolitics of the 1970s, seems strangely blocked out. What about cynicism and ways of overcoming it in the relations between lovers and friends, husbands and wives, children and parents? What about relations at the workplace, in institutions, in leisure activities? Instead of a plausible focus on intersubjective relations, the ultimate testing ground of any new subjectivity, we get Sloterdijk's odd suggestion that we should take the bomb as the Buddha of the West, the source of negative illuminations, of enlightening *Selbsterfahrung* (self-experience). What the Cyclops was for Odysseus, so it seems, the bomb is for us: the moment of danger in which we find our own nobodiness, in which we understand what it would be like "to explode into the cosmos with a complete dissolution of the self"(132). Here Sloterdijk's constructive project to transform the reality principle itself by abandoning the "armed subjectivity of our rationality of induration" and by creating a new subjectivity, a new reason, veers off into a well-known male fascination with the machinery of technological destruction (325). Sloterdijk's meditations on the bomb, which to him are pivotal to achieving the desired breakthrough to the new horizon of another enlightenment, turn the movement of his own thought back into the cold current of cynicism he had set out to escape, and he comes dangerously close to rewriting the romantic death wish in its postmodern form. When Sloterdijk approximates Diogenes's satirical laughter to the mocking smile of the bomb and talks about the "pandemonium and laughter . . . at the core of the igniting explosive mass," the kynic can no longer be distinguished from the cynic (132). Is Sloterdijk displaying kynical strategies or cynical attitudes? It is anybody's guess.

If indeed the cosmic laughter of the nuclear holocaust were the ultimate chance for realizing the kynical nobody, then one might want to rely after all and against better insight on the precarious rationality of overkill and madness as a strategy of survival. Perhaps there was always already too much rather than too little nobodiness in the dominant Western forms of rationality and subjectivity. Perhaps Adorno was right after all when his terrified gaze saw nothing but destructive self-denial in Odysseus's tricksterism.

III

The *Critique of Cynical Reason* does not simply invalidate itself here as an effective critique of contemporary culture. Its analysis of postenlightened cynicism penetrates to the core of the contemporary malaise, and the new "gay science" Sloterdijk proposes is never so gay as to make us forget the wounds and

vulnerabilities from which it springs. Certainly, the critique of postmodern cynicism as enlightened false consciousness can stand apart from the somatic strategies of Diogenes' new gay science. It is striking though to see how Sloterdijk's text oscillates strangely between an apocalyptic sensibility and a metaphysics of disaster on the one hand and the hope for self-realization in a new enlightenment, a philosophy of survival, on the other. In that oscillation Sloterdijk's text yields to the pressures of the German culture of the missile crisis, the *Aussteiger* (dropouts), and the anti-nuke movement of the early 1980s, a culture of an apocalyptic consciousness which is quite reminiscent of certain apocalyptic trends in Weimar culture and which, in typically German ways, takes Baudrillard at his word when he claims that the real nuclear event has already taken place.[6]

Although the Diogenes in Sloterdijk ultimately keeps him from embracing a postmodern aesthetics of collective suicide as the last chance of self-realization, his views on history come problematically close to the German prophecy of apocalypse.[7] This is true not only for his meditations on the bomb and the speculations about the promises of the nobody but more importantly for the ways in which he interprets Weimar as the *Gründerzeit* (founding period) of modern cynicism and strategically places this "Historical Main Text," which comprises almost one-fourth of the total work, at the very end of his book.

Ostensibly, Sloterdijk returns to Weimar because it was in those fourteen years between the humiliations of a lost war resulting in Versailles and Hitler's ascent to power that the cynical structure first emerged as culturally dominant. While today's cynicism is bureaucratic and apathetic, anesthetized, as it were, to its own pains, the culture of Weimar is still fully conscious of the losses and sufferings that come with modernization. Nevertheless Sloterdijk speaks emphatically of a "reconstructed proximity of experience" between Weimar and the present and he argues that it needed the cynicism of our own time to read Weimar culture as representing a "summit of cynical structure" (389 f.). Sloterdijk rejects both the nostalgic archaeological approach to Weimar culture, which played such a large role in the cultural constitution of the New Left in Germany, and the apologetic political approach, which sees Weimar only as a temporal prefascism, an "augury of political ethics," only good to teach FRG and GDR "Democrats" how to avoid the mistakes of the past (388). While Sloterdijk sees those views of Weimar as projections, "images in a historical gallery of mirrors," he claims to offer a historically more adequate account of Weimar culture (388). I agree by and large with his critique of accounts of Weimar as nostalgia and apologia, and I find his focus on Weimar cynicism fascinating, novel in its insistence on the centrality of the phenomenon, and often brilliant. It is hard to forget Sloterdijk's analyses of

Heidegger's "Man" (Anyone) or of the ambivalences of Dada and its semantic cynicism, his descriptions of the historical and physical contingencies of Weimar subjectivities, the trauma of the trenches and the reality of prostheses, the "cubist mentality" and the "cosmetic realism" of the emerging *Angestelltenkultur* (white-collar culture) as Kracauer has called it. Weimar cynicism appears here as the result of a fundamental crisis of male identity after defeat, and Sloterdijk is certainly right in presenting (not unlike Klaus Theweleit) the major front formations on the Right and on the Left as attempts to restore masculinity, to shore up a sense of identity and boundaries, both psychologically and politically. He never discusses how Weimar women figure in this struggle, but for once the masculine inscriptions in cynicism and kynicism (e.g., the section on Brecht and sexual cynicism) are made quite explicit in the Weimar sections of the book.

And yet, one may want to ask whether there is not a hidden agenda to Sloterdijk's account of Weimar as well, whether we have not just entered another room in the same historical gallery of mirrors from which Sloterdijk wants us to escape. That in itself would not be a criticism so much as an acknowledgment that no historical narrative will ever be entirely free from the interests and pressures of the present. But it is the nature of the pressures that makes me skeptical about Sloterdijk's account. If indeed there is a tension in his writing between catastrophism and hope, which many of us would probably share in our own perceptions of the contemporary world, then this crucial chapter on Weimar cynicism would actually tend to obliterate that tension and lock us into the catastrophic mentality, abolishing all ambivalence and ultimately closing down the space for kynical resistance. Sloterdijk analyzes Weimar cynicism cogently as a symptom of cultural pathology, representative of times of declining class domination, of the "decadence and indiscriminate disinhibition of the ruling strata." Even if one does not espouse a teleological view of history, it is difficult to forget that Weimar cynicism *did* end in fascism and the holocaust. Sloterdijk himself is the first to admit that the cynical disposition of a whole culture is typically found in prewar periods in which neither intelligence nor good intentions may be enough to stop the race toward disaster. What good, then, can Diogenes do today? How would his satirical laughter differ from that hellish laughter of the apocalypse, the chilling effects of which Thomas Mann invoked in *Doktor Faustus?* Is Sloterdijk not again flirting with catastrophe? If Weimar were indeed the model for the present would that not make our fate just as inescapable as the prophets of nuclear disaster in Germany liked to proclaim in the 1980s? After all, the holocaust already took place.

It seems to me that Sloterdijk's fascination with Weimar cynicism, to which we owe some of the best writing about Weimar in recent years, locks him into a

teleological view of contemporary developments despite himself. Since he never elaborates in any detail on the implied historical comparison between Weimar and contemporary culture, it is difficult for the reader to escape the conclusion that our fate has already been sealed, with or without Diogenes. Only such a comparison could dispel the temptation of cultural despair and give us some indication whether Sloterdijk's critique of identity pathology and his project of developing a new reality principle is more than wishful thinking. But it is precisely this project that poses a significant challenge to contemporary thought and politics in which the very real deconstructions of multinational capitalism and French theory face off with conservative attempts to reconstruct the basics in education, social life, and international politics. Unless critical intellectuals understand the *new* appeal of old values as new, rather than simply as a continuation of "bourgeois" identity formation and ideology, the genuine insights of poststructuralist theory will come to naught. The challenge posed by the *Critique of Cynical Reason* to deconstructionists and reconstructionists alike has been well put by Leslie Adelson in a very perceptive review of Sloterdijk's book. The central question is "how to relinquish the obsession with a fixed identity opposed to all Others *without* abandoning whatever identity is needed, first to perceive and then to end very real and institutionalized forms of oppression."[8] Sloterdijk hopes to achieve this with the help of Diogenes and a regeneration of the kynical impulse, a solution that may fall short of the forbidding complexities of the task. But however limited one may hold the Diogenes strategy to be in a broader political sense, Sloterdijk is not a renegade of the Enlightenment, and he does not simply advocate carnival on the volcano. In his concluding pages, he finally does reject the temptation of apocalypse, and he denounces the boom in disaster prophecies itself as an outflow of cynicism. It is here that he returns unabashedly to the Kant of "Was ist Aufklärung?" (What is Enlightenment?) of 1784: "*Sapere aude!* (dare to know) remains the motto of an enlightenment that, even in the twilight of the most recent dangers, resists intimidation by catastrophe. Only out of its courage can a future still unfold that would be more than the expanded reproduction of the worst in the past" (546). This minimalism of hope in the face of maximal possible catastrophe renders an aspect of our postmodernity that it is as important to recognize and to nurture as it is to criticize that enlightened false consciousness that Sloterdijk impels us to acknowledge as one of the most dangerous symptoms of our culture. The historical truth content of Sloterdijk's book lies precisely in the tensions and oscillations between apocalypse and hope that the text refuses to reconcile.

Some years ago there was an event at the Whitney Museum of American Art in New York City. It came at the tail-end of a David Salle exhibition, a major retrospective (1979-1986) of an artist who, only a decade earlier, was doing lay-out and graphics for a pornographic magazine, an artist who has had one of the fastest rises to painterly stardom in an art market bent on overtaking itself. The event I am referring to was announced on a huge poster: JEAN BAUDRILLARD. SOLD OUT. "Sold out" was written in big block letters diagonally across the surface. And then, again horizontally: TOPIC TO BE ANNOUNCED. Clearly, we live in an age of fast art and speedy theory. The day may come, say in 1999, when the museum will announce a new show: RETROSPECTIVE—WORKS FROM 1999 TO 2001. ARTIST TO BE ANNOUNCED.

I do not know what Baudrillard spoke about at the Whitney, and ultimately it matters very little. The point is that what happened here perfectly illustrates one of Baudrillard's own arguments, namely that simulation has replaced production at the center of our social system, that contemporary culture has gone beyond the classical Marxist use value/exchange value distinction—a distinction still at the

heart of Adorno's frozen dialectic of modernism and mass culture—and operates on the basis of sign value writ large. Sign value in this case—the case of theory, the case of Baudrillard at the Whitney—obviously functioning as name value, as the signifier/signified unit that attracts the audience: no need to give a topic. We already know what we will get. Retrogressive from a theoretical point of view, at least in a Baudrillardian perspective, the referent would still have to appear in person, would have to walk through the doors of the museum and get up in front of his audience to deliver the goods. In the scheme of simulation, of course, the body as referent becomes so much refuse: "The real itself appears as a large useless body."[1] At best, it could be seen as residue supporting the system's need to simulate the real. So if Baudrillard shows up at the Whitney, does that make him complicitous in late capitalism's scheme to simulate the real where there "really" is no real left? Or does Baudrillard's theory of simulation express the post-1968 despair of the leftist French intellectual that there is no real Left left? Or could it be that Baudrillard's lecture never took place, that "sold out" was inscribed on the poster from the start, and that therefore nobody ever came to buy a ticket? And yet the annals of the museum would now record: lecture by Jean Baudrillard, such and such a day, 1987. This scenario would clearly work better with the theory of simulation, of the map preceding the territory rather than representing it. But this is still America, the country famous for its obsession with "the real thing," and there still is a political economy of culture, deeply implicated to be sure, in processes of signification and simulation, but not, I think, reducible to them. To see the entanglements of the real as no more than simulations designed by the system to feign that something is there, a presence, a referent, a real, is a form of ontologizing simulation that betrays, perhaps, nothing so much as a desire for the real, a nostalgia of loss. And yet the theory of simulation, which has at its center what in France is called la *télématique* (neologism formed from *télévision* and *informatique* [data processing]), exerts an understandable fascination since it seems to account for certain very "real" tendencies of contemporary culture, extrapolates them polemically, and grounds them in the recent evolution of telecommunications.

Of course, Baudrillard's theory of simulation and of the simulacrum, as elaborated in a series of writings from the "Requiem for the Media" in *For a Critique of the Political Economy of the Sign* (1972) via *L'Echange Symbolique et la Mort* (1976) to *In the Shadow of the Silent Majorities* and *Simulations* (both 1978) is primarily a media theory. As such, its reception is by no means limited to artists and the contemporary art scene, even though that is where it seems to have had its strongest effects in the 1980s. It is precisely the notion of simulation in all its breadth and implications that accounts for Baudrillard's cult following in New

York, on the West Coast, in Australia, in Berlin and even in Frankfurt, where his writings can be perceived as being true to the spirit of Adorno's evil-eyed critique of mass culture. And it is exactly Baudrillard's status as a cult figure on the fringes of the academy and plain outside it that makes him comparable to another prophet of the media in the United States at an earlier time, Marshall McLuhan. Granted, the parallel is not quite persuasive in purely quantitative terms. McLuhan's *Understanding Media* sold well over 100,000 copies, a figure of which Semiotext(e) and Telos Press, the two American publishers of Baudrillard's work, could only dream; moreover, Baudrillard would still have to appear in *Time, Newsweek, Vogue, Esquire, Fortune, Playboy*, and the *New York Times Magazine*, all of which seems highly unlikely. And yet . . .

In this essay, I would like to explore the hidden referent of Baudrillard's media theory, which in its political and social implications is always much more than a theory of images and image perception. To be sure, the textual referent of Baudrillard's writing may be less hidden than simply forgotten. After all, Baudrillard's texts are full of references to McLuhan's work. Much less clear, however, is what this appropriation of McLuhan for the 1980s actually means and what kind of appropriation it is. Is the theory of simulation a recycling of McLuhan for the present in which his writings are largely forgotten and his name for most conjures up no more than a few slogans such as "the medium is the message, or the massage," or the happy formula of the global village? Does Baudrillard, in other words, merely offer a theoretical pastiche based on amnesia? Or does his continuing fascination with McLuhan suggest that what was prophecy in McLuhan has become reality some twenty years later? Or is something else at stake altogether?

Of course it would be too easy to speak simply of a return of McLuhan in the guise of French theory and then to use the timeworn arsenal of ideology critique against both. The critique of McLuhan from the vantage point of Western Marxism and Critical Theory, as admirably articulated in John Fekete's study of the New Critics, was surely important in a period when McLuhan advised the federal government of Canada and moved liberally through the executive suites of Bell Telephone, IBM, and General Motors, and when a veritable McLuhan cult swept the major mass circulation magazines, radio programs, and television talk shows.[2] His unbounded optimism about the effects of electronic communications on human community and his blindness to the relationship between the media and economic and political power could only be read as affirmative culture, as an apology for ruthless technological modernization or, at best, as naive politics. At the same time, the effects that McLuhan's theorizing of the media had on the political strategies of the 1960s counterculture were anything but merely affirmative.

Today, however, McLuhanism (or: McLuhanacy, as some have called it) is no longer a major force in public discourse, and media cynicism (both affirmative and critical) seems to have thoroughly displaced the cosmic media optimism so typical of a certain communications euphoria in the 1960s. In this new discursive context, the ideology critique of McLuhan's work, though not invalid, seems less immediately pressing; casting aside McLuhan's social prophecies that the electric age is said to entail, we can focus again on what McLuhan actually argued about different media, media reception, and media effects. In *The Medium is the Massage: An Inventory of Effects*, McLuhan wrote quite persuasively:

> All media work us over completely. They are so pervasive in their personal, political, economic, aesthetic, psychological, moral, ethical, and social consequences that they leave no part of us untouched, inaffected, unaltered.
> The medium is the massage. Any understanding of social and cultural change is impossible without a knowledge of the way media work as environments.[3]

Understanding how that massage works, how it operates in socialization and perception, in the construction of gender and subjectivity; how it inscribes its message into the body by disembodying the real; and how it embodies an apparatus of power relations, affecting social practices and institutionalized discourses—these are the concerns that arise from a reading of McLuhan today, and they remain central to any study of the media in the contemporary world. And it is to Baudrillard's credit that apart from the Roland Barthes of *Mythologies*, he is one of the very few major figures in French post-Marxism and post-structuralism who has made the media central to his theorizing. Here, however, one must voice a basic reservation about Baudrillard. While McLuhan's media analysis may still serve as a relevant reference point, at least to the historically minded, for further media studies, the very structure of Baudrillard's theorizing is ultimately unproductive in its *reductio ad absurdum* of the power of the image. His notion of the silent mass of spectators disables any analysis of heterogeneous subject positions in the act of reception. Any economic or institutional analysis of the apparatuses of image production, including national differences even within Western mass media societies, is rendered obsolete by Baudrillard's notion of an almost self-generating and monolithic machinery of image dissemination. The history of the media is reduced, as I will show, to stages of the image, an approach that seems to have more to do with Platonic and Christian traditions than with any historical understanding of the media, modern or premodern. Any ideology critique of representations of gender or race, of the politics of imaging the various worlds of this world is disabled because ideology critique, even when truth and the real

have become unstable, must continue to rely on some distinction between representations as well as to analyze their varying relationship to domination and subjection, their inscriptions of power, interest, and desire. Baudrillard's society of simulation does not allow for such distinctions, nor, for that matter, for the viability of any ideology critique. If the 1950s gave us the "end of ideology," the 1980s have given us the alleged end of ideology critique. To put the shoe on the proper foot, an ideology critique of Baudrillard's theorizing is urgent precisely because the theory of simulation offers nothing but the solace of instant intellectual gratification to those who are uninterested in understanding media or in analyzing them as vehicles for ideology. Simulation, after all, may simply be the latest version of the ideology of the end of all ideology.

Even if Baudrillard's texts were nothing but simulations—an argument made by playfully cynical defenders of his work—one would have to conclude that as simulations these texts participate affirmatively in the operation of a system that, as Baudrillard claims, merely simulates the real to maintain the status quo. But then Baudrillard is the cynical defender of what is the case merely because it is the case. If simulation had already become total, this would seem the only possible position left to the critic, though lacking ground from which to proclaim "what is the case." If an outside of simulation is no longer possible, then the question of the real becomes like the question of God or the question of truth: not provable, but also not to be disproven, or not representable, therefore in desperate need to be simulated to conceal the truth that there is none. God and truth: Is it a coincidence that Baudrillard begins "The Precession of Simulacra," the lead essay of *Simulations* and perhaps his most influential piece, with a quote from Ecclesiastes, to proceed, a few pages later, with a discussion of the death of God? It is the simulacrum of God which suggests that "ultimately there has never been any God, that only the simulacrum exists, indeed that God himself has only ever been his own simulacrum."[4] Baudrillard goes on to use the iconoclasts' rage against images to elucidate the pomp and power of fascination exerted by simulacra through the ages. But it seems that even now the critic, though this should be theoretically impossible, is still involved in an act of secular demystification: where capital simulates the real to hide the truth that there is none, the critic operates out of the consciousness of the total collapse of any distinction between the real and the simulated, essence and appearance, truth and lie. After all, how are we to read Baudrillard's texts if not as demystifications of Marxism and psychoanalysis, as a debunking of cherished concepts such as labor and use value, desire and the unconscious, the real and the imaginary, the social, the political, communications, information, and so on. We have here a logical

aporia, but logical aporias have never yet prevented theories from having strong effects, or, for that matter, from grasping something important. Thus, alternatively, we might read these texts as claiming that the most recent order of simulacra is indeed part of our "reality," and represents, as it were, central aspects of the current state of affairs, the result of a cultural transformation that separates what is often called the postmodern condition from an earlier age of media, mass culture, and commodification. Although this reading would reject Baudrillard's basic claim that the simulacrum has become total, I find such an approach more appropriate and fruitful precisely because it does not give up at the outset any notion of the real. Against a certain kind of hyper-Nietzscheanism, it maintains the tension between simulacrum and representation, a sine qua non for critical media studies. Nor does it blindly accept Baudrillard's dictum, abusively derived from Benjamin, that "the real is not only what can be reproduced, but that which is always already reproduced. The hyperreal . . . is entirely in simulation."[5]

I do not intend to read Baudrillard against the grain. The strategy of this essay is rather to show how some of the most questionable patterns of McLuhan's media theory resurface in Baudrillard's work, though in a substantially altered form. The purpose of this exercise is less to prove that Baudrillard plundered McLuhan than to posit a trajectory from the affirmative media optimism of the 1960s to an equally affirmative media cynicism of the 1980s, a cynicism that has cut its links to an enlightened modernity and indulges in a search of apocalyptic bliss. I take the theory of simulation to be a strategic point of articulation of that cynicism, an enlightened false consciousness, which Peter Sloterdijk has cogently analyzed as a dominant mindset in the post-1960s era.[6]

To begin with, it might be useful to remember that McLuhan originally came out of literary criticism. He was a professor of English literature in Toronto. Indeed his method of reading social phenomena and the history of media technology, as John Fekete has pointed out, is strongly informed by the trajectory of New Criticism from Richards and Eliot to Ransom and Frye and shares with it an emphatic foregrounding of myth.[7] Baudrillard, when faced with new forms of consumer and media culture in the 1960s, attacked the discourse of classical Western Marxism, up to and including Guy Debord's situationism, with the help of structural linguistics and theories of signification. Likewise, McLuhan attacked the hostility of traditional humanists to media and modernization and insisted that the humanists' task was more than just the narrow literary study of classical or modern texts, that it was no longer possible "to adopt the aloof and dissociated role of the literate Westerner."[8] What linguistic theory was for Baudrillard's

sociology, popular culture and the media were for McLuhan's cultural criticism:
a means to attack the hegemonic discourse of their respective disciplines. Where
Baudrillard announced the end of classical political economy, McLuhan claimed
that the age of literacy, the Gutenberg galaxy, was coming to an end in the elec-
tronic age. Where Baudrillard focused on the importance of processes of signifi-
cation in language and image in order first to expand the classical Marxist
critique of reification and commodification and ultimately to dump it, McLuhan
carried cultural criticism into the realm of popular culture, abandoned literature
altogether, and yet remained true to his new critical heritage in privileging the
medium over the message.

McLuhan recognized correctly that humanist critiques of technology and
media more often than not came out of fearful resentment as well as total iden-
tification with high culture. His basic project in the late 1950s and early 1960s
was to understand the media rather than to dismiss them. The media never
represented a threat to him, and in that he differed from conservative critics as
well as from neo-Marxists such as Adorno. Not to understand the media: that
was the only threat, the only danger for Marshall McLuhan. But then, from the
beginning, his kind of understanding could hardly be distinguished from adver-
tising. His message—beyond that of the medium—was simple: feel good, forget
your anxieties, surrender to the media, stay cool, and everything will be alright.
In the *Playboy* interview of 1969 he said:

> It's inevitable that the whirlpool of electronic information movement will
> toss us all about like corks on a stormy sea, but if we keep our cool during
> the descent into the Maelstrom, studying the process as it happens to us and
> what we can do about it, we can come through.[9]

With Baudrillard we are not being tossed about like corks on a stormy sea;
conditions have worsened, and we are being swallowed up by the notorious
black hole, implosion being the astrophysical equivalent of engulfment in the
Nietzschean discourse of mass culture that is perceived as feminine threat to
"real" culture.[10] The millenarian "coming through" has been replaced in
Baudrillard by an apocalyptic vanishing act. But the images and metaphors of
natural disaster and astrophysics abound both in McLuhan and Baudrillard.

Indeed, many of the key terms of Baudrillard's rhetoric appear on the first
page of McLuhan's perhaps major work, *Understanding Media*:

> After three thousand years of explosion, by means of fragmentary and
> mechanical technologies, the Western World is imploding. During the

mechanical ages we had extended our bodies in space. Today . . . we have extended our central nervous system itself in a global embrace, abolishing both space and time as far as our planet is concerned. Rapidly we approach the final phase of the extensions of man—the technological simulation of consciousness. . . . [11]

The notion that technology is an extension of the human body is familiar from anthropology and the history of technology. What is new in McLuhan is the claim that we are witnessing a world-wide paradigm shift from extension and explosion to implosion, from outward expansion to a pulverizing, bursting inward. This paradigm shift is said to result from the shift from mechanical technologies to electric technologies. McLuhan proceeds, further, to link the shift in technologies to another binarism, that between hot and cool media, a distinction that immediately conjures up the Levi-Straussian distinction between hot and cool (modern/primitive) societies. Hot and cool oppose each other like print and speech, radio and the telephone, film and television. The rationale for these distinctions is often eccentric and contradictory, leading Daniel Bell to claim in anti-hedonist despair that reading McLuhan is like a Turkish bath of the mind. [12]

But things are not quite as steamy and unsettling in McLuhan after all. What emerges quite clearly is that the two sets of binarisms (explosion/implosion, hot/cool) lead up to a large-scale historical periodization of cultural stages which McLuhan claims are effected, even determined, by changes in communications technology. The anthropological notion of culture as a system of communication is rewritten in terms of communications technology, and it results in a kind of technological *Geistesgeschichte*, a pattern that will reappear in Baudrillard. McLuhan isolates four stages of cultural history: a "primitive," tribal society, a cool audile culture with an oral technology of speech; second, a hot visual culture with a technology of phonetic writing; third, an even hotter visual culture with the mechanical technology of print (the Gutenberg galaxy); and finally, a return to a cool culture on a higher level, an audile-tactile culture with an electric technology of television and the computer.

The persistent issue in this scheme is the rise and decline of visuality, and McLuhan associates visuality with linear continuity, uniformity, abstraction, and individualization. This culture of visuality is characterized by separation, distance, alienation, and the dissociation of sensibility—reification, as the early Baudrillard would call it with Lukács and Debord. This culture of visuality, modernity in other words, is about to be superseded by a culture of instantaneous inclusiveness, a mythical and integral culture in which "electric speed [brings together] all social and political functions in a sudden implosion" and in which "the electrically

contracted globe is no more than a village."[13] Obvious difficulties arise in following McLuhan's claim that television somehow initiates the promised land of an audile-tactile, post-visual culture. One could claim, as Jonathan Crary has done, that McLuhan's 1960s definition of television as cool, was founded on features of a medium still in its infancy: the low definition of its image and the image's small size, features that would no longer pertain in an age of high-resolution television and of large home screens.[14] But another factor must be considered here that has to do with reception. Contrary to film, which, according to McLuhan, isolates the spectator, television has the power to create community; it retribalizes the world. Features that were attributed to film by Brecht and Benjamin under the name of collectivizing reception resurface in McLuhan's scheme in relation to television, except that the socialist vision of collective reception is replaced by an idea of television as tribal drum. There is a constant sliding of categories from the technological to the social and vice versa which produces implausibilities and contradictions galore. But then, what is at stake here is not really history, neither a history of the media nor a history of human culture. What is at stake is a mythic pattern of fall and salvation. Ultimately the four stages of cultural history can be reduced to three, once we collapse the two middle phases of visual culture (the phonetic and the Gutenberg phase) into one: the age of literacy. We end up with a trinity of tribalism (cool), detribalization (visual, hot), and retribalization (cool). Television ushers us into the age of post-literacy. The Gutenberg Galaxy is superseded by the electric age. Implosion and feedback loops replace explosion and linearity. Integration replaces fragmentation. The culture of Western humanism, which after all is a culture of literacy, has disappeared, and McLuhan is happy about it: it is a technocratic version of anti-humanism, which, however, differs greatly from the structuralist "death of man." Thus in the introduction to *Understanding Media* we read that:

> The aspiration of our time for wholeness, empathy and depth of awareness is a natural adjunct of electric technology.... We are suddenly eager to have things and people declare their beings totally. There is a deep faith to be found in this new attitude—a faith that concerns the ultimate harmony of all being. Such is the faith in which this book has been written.[15]

Indeed the mythic pattern of fall and salvation must be taken at its most catholic. Try an experiment in reading: for electricity substitute the Holy Spirit, for medium read God, and the global village of the screen becomes the planet united under Rome. Rather than offering a media theory McLuhan offers a media theology in its most technocratic and reified form. God is the ultimate aim of implosion. The question becomes: what about Baudrillard?

Baudrillard's engagement with McLuhan's work began as far back as 1967, when he reviewed the French translation of *Understanding Media* in the left journal *L'Homme et la société*. This review is interesting because it not only contains a scathing critique of McLuhan's media idealism from the vantage point of Marxism and historical sociology, it already displays signs of Baudrillard's later fascination with McLuhan's central propositions. This fascination comes through in Baudrillard's style and rhetorical strategies rather than in the argument itself, and it shows up in the ways he makes McLuhan speak out against the "generally morose prophecies" of European mass medialogues, a put-down which is certainly not exclusively directed against conservative laments about the decline of culture, but equally against monolithic media theories on the Left. On the level of explicit argument, however, Baudrillard's critique of McLuhan is uncompromising and relentless:

> Evidently, there is a simple reason for this [McLuhan's] optimism: it is founded on the total failure to understand history, more precisely to understand the social history of the media.[16]

By focusing exclusively on the infrastructural revolutions of the media, McLuhan ignores, according to Baudrillard,

> all those historical convulsions, ideologies, and the remarkable persistence (even resurgence) of political imperialisms, nationalisms, and bureaucratic feudalisms in this era of accelerated communication and participation.[17]

The question here, of course, is whether this pre-1968 critique of McLuhan cannot be raised against Baudrillard's own writings on the media, whether in *Simulations* or in *In the Shadow of the Silent Majorities* he himself has not capitulated to what he called in 1967 "this most passionate and most dangerous paradox" of McLuhan's work: the notion that the medium is the message.

After all, Baudrillard's whole critique of the Marxist production paradigm presupposes the emergence of television as a culturally dominant apparatus. His analysis of consumption—consumption of objects as well as of significations—as a system of communication through which a repressive code is continuously and seamlessly reproduced; his thesis that the sphere of signification is formally identical to the sphere of exchange (with the signified anchoring the signifier in a referent just as use value is held to anchor exchange value in classical Marxism); his concomitant discovery of what he calls the political economy of the sign (with its proposition that the commodity form is no longer at the center of the social system, but that the structure of the sign resides at the very heart of the commod-

ity form); up to his theory of simulation that announces the end of all and any political economy, the end of the referent, the real, the political, the social—all of this theorizing is unthinkable without the impact of television as an apparatus of simulation that integrates the flows of signification and information with that of commodities, that drains the real out of commodities and events, reducing them to so many images that refer only to other images. Certainly, if there is technological determinism, media determinism, in Baudrillard, it is more sophisticated than McLuhan's in that it does not simply ignore the discourses of social theory and political economy, but claims to have worked through them and to have used them up. Another major difference is apparent: from early on, Baudrillard replaces McLuhan's unbridled media optimism with a dystopian vision similar to that of the situationists and, by way of extension, to that of Adorno's critique of the culture industry:

> In short, there comes into being a manifold universe of media that are homogeneous in their capacity as media and which mutually signify each other and refer back to each other. Each one is reciprocally the content of another; indeed, this ultimately is their message—the totalitarian message of a consumer society. . . . This technological complex, nevertheless, does convey a certain kind of imperious message: message of consumption of the message, of spectacularization, of autonomization and valorization of information as a commodity, of glorification of the content treated as sign. (In this regard, advertising is the contemporary medium par excellence.)[18]

Baudrillard's later theory of simulation can indeed be read as a logical extension, an extension into vertigo, of the situationist proposition, as articulated in Guy Debord's *Society of the Spectacle*, that when reality is systematically turned into a spectacle, the spectacle itself becomes reality. But one major difference between the situationists and Baudrillard's early work on the one hand, and the later theory of simulation on the other might be worth pointing out. In the late 1960s, Baudrillard, like the situationists, still relied on concepts such as reification and alienation as they had been developed in the work of Lukács and Henri Lefebvre, among others. In his review of *Understanding Media*, for instance, Baudrillard calls McLuhan's slogan "the medium is the message" "the very formula of alienation in a technological society."[19] Concepts such as reification and alienation, of course, suggest a state of the non-reified, the non-commodified, the non-alienated that could provide the desired space for political and symbolic resistance. While it has become fashionable in recent years to simply dismiss such concepts as essentialist and conceptually retrogressive, this does not do justice to the ways in which the critique of reification and alienation operated in the late 1960s. The non-reified,

the non-alienated would precisely not be sought in some abstract and universal essence of man, beyond and outside of social and historical determinations and contingencies. Resistance would rather come from those groups that were under-represented, as it were, by the code, excluded from representation, marginalized, and reduced to degree zero of the hegemonic code where their speech simply did not count or was never really heard. Such social groups (youth and students, women, blacks) would not just clamor for more representation in the code; they would attack the code itself, or so it was hoped. A kind of "semiological banditry" by the "damned of the code" was invested with hopes for rebellion, authenticity, and political opposition.[20] That's what the *prise de la parole* of May 1968 was all about. With these hopes crushed and the political restoration of the 1970s making great strides, Baudrillard became increasingly critical of the discourse of margin-ality and alienation, and he came to interpret the marginal as a mere simulation of resistance, produced actually by the master code itself. Thus in *In the Shadow of the Silent Majorities* he rejects the notion that a new source of revolutionary energy can be found in "micro-desires, small differences, unconscious practices, anony-mous marginalities." In a sweeping gesture he accuses intellectuals of a "final somersault . . . to exalt insignificance, to promote non-sense into the order of sense," and he denounces this strategy as "one more trick of the 'liberationists.'"[21] The targets of Baudrillard's critique are primarily Deleuze, Guattari and Foucault. But while he rejects political theories of the marginal and the liberation of desire, he remains ambiguous in his treatment of the marginality's other, the mass: as silent majority, as recipient and object of the media, as object of surveys, polls, tests, and referenda, in sum, the mass as a projective screen of the discourse of power. The text vacillates strangely between cynicism and approval of the silent majority's silence. But, as a close reading will reveal, Baudrillard still invests the silence of the masses with emphatic notions of refusal and resistance. The masses are to him pagan, anti-transcendence, anti-faith, anti-God. He glorifies their refusal of meaning as a refusal of indoctrination by the media. Their desire for spectacle instead of meaning is described as "the positive brutality of indiffer-ence."[22] Silence is a refusal of the fiction of any real exchange, a protest based on the acknowledgment that the modern media per se inhibit and prevent exchange, response, and participation.[23]

The rationale for Baudrillard's paradoxical validation of the silence of the masses and of their defiance of meaning is most clearly spelled out in the brief essay "Implosion of Meaning in the Media," where Baudrillard talks about the "double bind" in our relation to media culture, comparing it to the double strategies

children use in relation to conflicting adult demands, on the one hand, that they be autonomous subjects and, on the other, that they obey:

> The resistance as subject is today unilaterally valorized, held as positive—just as in the political sphere only the practices of liberation, emancipation, expression, and constitution as a political subject are taken to be valuable and subversive. But this is to ignore the equal or perhaps even superior impact, of all the practices-as-object—the renunciation of the position of subject and of meaning—exactly the practices of the masses—which we bury and forget under the contemptuous terms of alienation and passivity. The liberating practices respond to *one* of the aspects of the system, to the constant ultimatum to make of ourselves pure objects, but they don't respond at all to the other demand, which is to constitute ourselves as subjects, to liberate ourselves, to express ourselves at any price, to vote, produce, decide, speak, participate, play the game—a form of blackmail and ultimatum just as serious as the other, probably even more serious today. To a system whose argument is oppression and repression, the strategic resistance is the liberating claim of subjecthood. But this reflects rather the system's previous phase, and even if we are still confronted with it, it is no longer the strategic terrain: the system's current argument is the maximization of the word and the maximal production of meaning. Thus the strategic resistance is that of a refusal of meaning and a refusal of the word—or the hyperconformist simulation of the very mechanisms of the system, which is a form of refusal and of non-reception.[24]

While this passage is quite persuasive in its outline of the double bind and its political implications, it becomes problematic when it ventures into a theory of history, a theory of subsequent stages of the system. And even if we agree with Baudrillard's critique of a certain prominent romanticization of marginality or otherness, it seems that he can and should be criticized for romanticizing mass refusal as hyperconformism, a kind of Marcuseanism for an age of diminished expectations.

Of course, Baudrillard is fairly far from McLuhan when he ascribes to the masses a full understanding of McLuhan's basic proposition about the media and, simultaneously, a conscious resistance to the media, but then he did not stick with this position for very long. Certainly, with "The Precession of Simulacra," the lead essay of *Simulations*, any notion of resistance has disappeared, and we are left with a monolithic vision of contemporary culture that seems more like a binary reversal of McLuhan, but McLuhan nevertheless. And in *Les Stratégies fatales*, McLuhan's "euphoria" comes back as the "ecstasy of communication" a blend of Dionysian chaos with American "more is better."[25] Technological determinism runs amok, transforming itself into a phantasmagoria of the screen. One brief quote from *Les Stratégies Fatales*:

Something has changed, and the Faustian, Promethean (perhaps Oedipal) period of production and consumption gives way to the "proteinic" era of networks, to the narcissistic and protean era of connections, contact, contiguity, feedback and generalized interface that goes with the universe of communication. With the television image . . . our own body and the whole surrounding universe become a control screen. 26

One might say here that Baudrillard enacts what he preaches: the age of the simulacrum, of the map preceding the territory. Rather than representing reality, his text simulates what is still to come. But even then it recycles what once was: namely, the terms of McLuhan's grand-scale periodizing and his notion of the world of communications as a tactile world of contact, connections, and feedback, rather than a visual world of (in Baudrillard's terms) the scene/seen or the mirror.

It is indeed striking to see how McLuhan's grand historical scheme is reworked in Baudrillard from the mid-1970s on. In his 1967 review of McLuhan, Baudrillard still had this to say about the Canadian:

> Every ten years American cultural sociology secretes grand directional schemes in which a diagonal analysis of all civilization ends up circling back to contemporary American reality as implicit telos and model of the future.[27]

Ten years later, this kind of American cultural sociology has evidently caught up with Baudrillard himself, and the European phantasmagoria "America" dominates the Baudrillardian discourse. From his discussions of Disneyland and Watergate via the Twin Towers of the World Trade Center to *Apocalypse Now* and to *Amérique* (1986) his provocative evocation of the United States as the only primitive society in modern times, the ultimate referent of Baudrillard's discursive simulations is the United States, or rather, an imaginary United States. America is paradigm and telos for the theory of simulation as it was paradigm and telos in McLuhan's theory of the electric age. But the parallel goes further. Already in *L'Echange symbolique et la mort* (1976) and then again five years later in *Simulacres et simulation* (1981), Baudrillard reads history in terms of the successive stages of the simulacrum, just as McLuhan read history as a function of changes in media technology. What is interesting here is the fact that his 1976 periodization of simulacra is still linked to the discourse of value while in the later text the successive phases of the image are discussed in theological terms—yet another rapprochement with McLuhan.

Let me briefly lay out the two schemes. The chapter on "The Orders of Simulacra" in *L'Echange symbolique et la mort* is introduced in the following way:

Three orders of the simulacrum, parallel to the mutations of the law of value, have followed one another since the Renaissance:

—Counterfeit is the dominant scheme of the "classical" period, from the Renaissance to the industrial revolution;

—Production is the dominant scheme of the industrial era;

—Simulation is the reigning scheme of the current phase that is controlled by the code.[28]

These three phases of the simulacrum correspond to three phases in the history of the law of value: first, the precapitalist phase in which land is the carrier of the law of value; second, the capitalist law of value described by Marx, in which the exchange value of the commodity comes to dominate its use value; and third, the phase that Baudrillard calls the structural law of value in which capital, in a kind of linguistic combination of signs, begins to float freely, swallowing up all the earlier determinations of value, be they nature, use value, production, meaning, purpose, or truth. What remains is a world of universal simulation in which capital functions as a gigantic machinery of devaluation. But values do not simply disappear, they survive as simulacra, centrally on television. Baudrillard's theory of simulation as a theory of the latest stage in the development of capital is of course a theory of catastrophe and of nihilism, a Nietzschean nihilism come into its own with the help of technology: the television screen and the computer.

This may all sound very unlike McLuhan, until we remember that implosion for Baudrillard is not catastrophic in the usual secular sense of the word, but suggests something like redemption, redemption in hyperreality.[29] And the rapprochement with McLuhan continues in the second scheme of the order of simulacra. As I indicated before, there is a discursive shift in Baudrillard's theory of simulation. The categories of political economy, even the political economy of the sign, vanish and are replaced by the language of theology, most visibly in "The Precession of Simulacra." He still pretends to offer a history of the image in the following scheme. The image is "the reflection of a basic reality" (that is, representation; the sign and the real are somehow equivalent); it "masks and perverts a basic reality" (Marx's notion of ideology as false consciousness); it "masks the *absence* of a basic reality" (Nietzsche's attack on truth, metaphysics, and representation); it "bears no relation to any reality whatever: it is its own pure simulacrum" (the image on the electronic screen).

So far, so good. I suppose here one could still argue that Baudrillard's interest in this scheme is less historical than systematic. But then suddenly history reenters with a vengeance via the death of God, the last judgment and resurrection. First Baudrillard names the four orders of the image—the order of the sacrament, the

order of malefice, the order of sorcery, and the order of simulation—and he distinguishes between signs that dissimulate that there is something (the first two) and signs that dissimulate that there is nothing (the last two). This distinction for him marks a major historical turning point, clearly localizable with Nietzsche:

> The first [reflection of a basic reality] implies a theology of truth and secrecy (to which the notion of ideology still belongs). The second inaugurates an age of simulacra and simulation, in which there is no longer any God to recognize his own, nor any last judgment to separate true from false, the real from its artificial resurrection, since everything is already dead and risen in advance.[31]

Here Baudrillard's discourse leaves the realm of history and contemporary culture and somersaults into a kind of catastrophic theology that will leave us forever, I presume, with simulation, the hyperreal, and capital as a system of floating signifiers unchained from any referent whatsoever. Simulation, indeed. A melancholy fixation on the loss of the real flips over into the desire to get beyond the real, beyond the body, beyond history. It is a religious desire, a desire for ultimate transcendence, achieved in Baudrillard, as in McLuhan, through the media. So what are we to find at the end of implosion, inside the black hole about which Baudrillard keeps phantasizing? Perhaps a postmodern potlatch in a global village. But we will never know, since the black hole will have absorbed all light, all images, all simulations. Iconoclasm writ large will have won the day, or rather: the night when television has finally gone off the air.

one of the sparks for european f.-activities was the

encounter of american lack of style and european

fatigue with style, american bricolage and european

phantasy, american insouciance and european logic ...

tomas schmit

Fluxus is still needed, in a world of pretension and

falseness, grandiosity and humorlessness.

Dick Higgins

Beginnings

Fluxus was a groundbreaking and idiosyncratically imaginative avant-garde of the early 1960s with a prehistory of experimental music and concrete poetry of the 1950s and a post-history of conceptual minimalism, conceptual art, and performance art of the 1960s and 1970s.

While the boundaries of Fluxus as an avant-garde are as porous in terms of origins as they are in terms of membership at any given time, the consensus is that Fluxus "began" with a series of concerts organized by Lithuanian-born George Maciunas in his A/G Gallery in New York in 1961 and with the plans to publish a journal called Fluxus. But instead of a publishing venture in the United States, Fluxus first became something like an improvisational clearinghouse for artistic events and activities in Western Europe, a kind of on-the-road and in-time production of concerts and performance pieces, many of which were never recorded. Fluxus gained momentum when George Maciunas, its obsessive and dedicated impresario, left New York and went to live in Germany. There he began to organize a series of concerts that started in Wiesbaden in September 1962 and moved on to Paris, Copenhagen, and Düsseldorf. These concerts, though rarely

well-advertised and poorly attended were seminal to the emergence of a whole new art scene in the 1960s.

Thus the German-American connection seems crucial for the rise of Fluxus in the early 1960s. The New York-Wiesbaden constellation provided a frame within which a loose association of artists from Korea, Japan, Denmark, France, Germany and other countries began to play their Fluxus parts. At a time when dominant art movements were still tied to a place (the New York School, l'Ecole de Paris), Fluxus was international and not easily containable geographically. It never even came close to being a "school."

One may be tempted to say that Fluxus is not, nor has it ever been an art movement in the traditional sense. Somehow it failed, but its very failure turns out to have been a success of almost mythic proportions. For if the worst that can happen to an avant-garde is to be co-opted, collected, and musealized, then Fluxus, (until recently) was a resounding success precisely because, unlike Pop, it failed to be successful. Apart from a small coterie of aficionados, it even managed—almost— to be forgotten, a fact that guaranteed its long afterlife in artistic practices and provides excitement for its current rediscovery. Conversely, if the best that can happen to an avant-garde is that it creates a vital tradition while escaping the fate of dogmatic ossification, then Fluxus has been extremely successful in that many of its early practitioners embarked on new Fluxus-inspired projects and that it left significant traces in many subsequent aesthetic practices as well as in the work of any number of individual artists.

Some have even claimed that none of the art movements of the 1960s and 1970s would have been possible without the initiating spark of Fluxus. But if one then proceeds to pin down a certain artist or a certain work as Fluxus-related, standards of purity and exclusion are brought to bear by interested former participants that make the phenomenon elusive to the vanishing point. Thus Dick Higgins has listed nine criteria for Fluxus work that are so broad as to practically include (or, for that matter, exclude) everything postmodern under the sun, depending on how one interprets these criteria, and Robert Watts has cynically suggested that "the most important thing about Fluxus is that nobody knows what it is."[1] But then Fluxus is either the master-code of postmodernism or the ultimately unrepresentable art movement—as it were, postmodernism's sublime. Neither of these two views is really satisfactory.

Fluxus as Neo-Dada

The paradox today is that Fluxus at age 30 is being defined. The traces it has left are being recovered. Fluxus is being collected and validated as an avant-garde. It

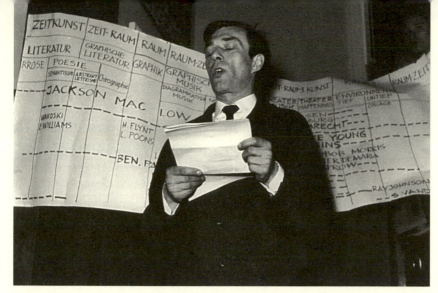

Arthus C. Caspari read-
ing George Maciunas's
manifesto "Neo-Dada
in Music, Theater,
Poetry, Art" at Kleines
Sommerfest: Après
John Cage, Wuppertal
(June 1962).
*Photo Rolf Jährling.
Courtesy of The Gilbert
and Lila Silverman Fluxus
Collection.*

is becoming successful in market and museum terms, and it is beginning to share
the fate that has befallen all other earlier avant-garde movements: codification
through archive, museum, and scholarship. It will not even help much to remem-
ber that Fluxus's spiritus rector and would-be dictator, George Maciunas, once
emphatically rejected the notion of Fluxus as an avant-garde and described the
sparse, minimalist Fluxus event in relationship to Allan Kaprow's much more
theatrical happenings as a rear-guard practice.[2] After all, rear-guardism itself has
become quite a privileged strategy in an age when the ethos of avant-gardism no
longer has the same claim on art that it used to have, even in that earlier post-
World War II period. And Maciunas himself was of course perfectly aware of
Dada as predecessor in 1962 when, in one of his earliest programmatic state-
ments, he described Fluxus as "Neo-Dada in Music, Theater, Poetry and Art."[3]
The avant-garde then, already was inevitably rear-guard in that it had itself
become tradition and thus self-contradictory: the tradition of the new, as Harold
Rosenberg disparagingly called it;[4] a mere repetition, if not a fraud or a self-delu-
sion, as Enzensberger claimed in his perceptive piece of 1962 entitled "The
Aporias of the Avant-garde."[5]

And yet, rather than a belated, regressive repetition, there was a difference in
these new avant-gardes. The anger and contempt about Neo-Dada, Nouveau
Réalisme and Pop voiced by former Dadaists such as Raoul Hausmann, Richard
Hülsenbeck, Hans Richter and Marcel Duchamp testifies to that difference as much
as the outrage that Fluxus and other more or less simultaneous phenomena of the
late 1950s and early 1960s (the provocations of the Vienna Group, the group Spur
in Munich or Alan Ginsberg and the Beats) generated among the genteel guardians
of culture on both sides of the Atlantic.

This difference can be described in aesthetic terms as well as in broader histori-
cal and political terms. Fluxus emerged from a unique constellation that in the early

1960s had been years in the making and at the core of which was something like a chance montage of European-American incompatibilities and approximations.

In both Germany and the United States the emergence of Fluxus marks the end of a period of restoration and conservativism that accompanied a shift to a new politics and a new culture. With Kennedy's election in 1960, the prematurely celebrated affluent society of the staid, stable Eisenhower years gave way to exuberant optimism but ended in political crises, assassinations, campus turmoil, and protests. In Germany the smugness and self-satisfaction of the "economic miracle" of the Adenauer years was increasingly destabilized, beginning with the 1961 elections that eventually, after student movement and extraparliamentary opposition, led to the election of a social democratic government by the end of the decade.

Despite George Maciunas's ambition to create something like a Left front of the arts on the model of the LEF group in the Soviet Union of the 1920s, Fluxus in general did not place itself in the tradition of political avant-gardism of the 1920s. Thus the relationship to the new politics of the 1960s remains tenuous at best. To establish a direct link between Fluxus events and the protest politics of the 1960s would be to falsify the historical record; however, the anarcho-cultural sensibility articulated in Fluxus concerts did affect the arts in the same way that cultural protest infiltrated the public sphere. But by the time the student movement exploded in Berkeley in 1964 and in Europe shortly thereafter, Fluxus had already entered its second, less productive phase. An event such as Maciunas's and Henry Flynt's public protest at Karlheinz Stockhausen's New York concert in 1964 (Stockhausen was accused of continuing to produce high art) demonstrates that their attempt to politicize Fluxus in the name of an ill-defined Marxism had actually failed. Major figures in the Fluxus group participated in Stockhausen's concert despite the protest of their Fluxus leader.

This failure was symptomatic of Fluxus's overall closeness to the non-political, allegedly non-ideological 1950s. Of course, abstention from politics and ideology in art after the McCarthy years was itself deeply ideological. After all, the very notion of the "end of ideology" was one of the major ideological weapons in cold war anti-communism. It is significant to a historical understanding of Fluxus that end-of-ideology politics held sway in the two front-line countries of the cold war—the Federal Republic of Germany and the United States—much more strongly than it did in France or England, where the political and intellectual Left was still a palpable presence. This would explain why Fluxus had its major force-fields in the United States and Germany, whereas Sartre's existentialist Marxism and the Situationist International's radical critique of consumerism and the society of the spectacle dominated in France, and England produced an early Pop

culture whose political edge was always more pronounced than that of Pop art in the United States.[6]

Aesthetically, however, it was the rediscovery of Dada on both sides of the Atlantic in the 1950s that provided the key to further developments in the arts. This rediscovery was not just an archeological phenomenon. Dada was immediately reinscribed in the cultural politics of the 1950s as an antidote to an increasingly canonized modernism in poetry, narrative, and painting. In the United States, Robert Motherwell's 1951 documentation *The Dada Painters and Poets* was as influential as the 1956 Schwitters retrospective in Hanover's Kestner Gesellschaft and the Düsseldorf Dada exhibition of 1958. In both countries, this rediscovery had the aura of the new. In Germany the repression and persecution of avant-gardism in the Third Reich had produced a generational amnesia; in the United States it was only since the 1950s that a Dadaist attack on art as institution ("high art" as canonized by museum, gallery, scholarship and criticism) made any sense at all. Prevailing Anglo-American understanding of modernism did not pay heed to Dada or surrealism until the 1961 MOMA show The Art of Assemblage incorporated at least the formal aspects of Dada into the modernist canon.

Perhaps the post-war reception of Dada in Europe was more emphatically coded by the literature of absurdism (Beckett, Ionesco) and by the shadow that Auschwitz cast over any cultural enterprise after 1945. The reception of Dada in the United States was more playful, provocative, less weighted down with metaphysical residues, and simply oblivious to those memories of political terror and the holocaust. So the cultural environment for this repetition of Dada, a repetition with a difference, is not the same, but the Dada effect was quite similar.

Like Dada but certainly unlike Pop, Fluxus worked out of an aesthetic of negation: negation of the art market, of the notion of the great individual creator, of the artist as hero or redeemer, of the art object as reified commodity, and of traditionally defined boundaries between music, literature and the visual arts. But this was also the negation of an emphatically subjective aesthetic of negation, of existentialist suffering and alienation as it characterized late modernist music, painting and literature in the 1950s. It was, finally, a rejection of the privileging of deep meaning and learned interpretation as Susan Sontag attacked it in her seminal piece of 1964 "Against Interpretation."[7]

Fluxus is part of that avant-gardist tradition of anti-art, but from its first American manifestations, eagerly absorbed especially in Germany, Fluxus also expounded an affirmative aesthetic: affirmation of the emphatic intermedia event; of audience and performers' enjoyment against the sublime seriousness of high modernism; of the simple, habitual events of everyday life and their inherent

relation to art; of the concrete, and minimalist object-event intended to loosen up the ingrained mechanism of Western high-culture like a bad tooth, as Benjamin once said of the surrealist privileging of dreams.[8] Susan Sontag understood this new practice in the arts when she called for a new audience response: "We must learn to see more, to hear more, to feel more."[9] But the political naiveté of this affirmative aesthetic is nowhere more visible than in Dick Higgins's claim in *Something Else Newsletter* of February 1966:

> However, the social problems that characterize our time . . . no longer allow
> a compartmentalized approach. We are approaching the dawn of a classless
> society, to which separation into rigid categories is absolutely irrelevant.[10]

While this leap from intermedia experimentation in the arts to the delusion about a classless America is perhaps best forgotten, in their aesthetic practices Fluxus artists were indeed working on the threshold between art and its negation without, however, simply reviving the Dadaist semiotic disruption of traditional bourgeois art forms. The Futurists and Dadaists had attacked the shallow forms of an Arnoldian or Wilhelminian high culture, the class culture of the belle époque which (for good reason) had not survived World War I. Even if an attack on institutionalized culture was again plausible in the late 1950s, it had to face two difficulties: the Dadaist forms of attack were themselves being canonized as legitimate art during the 1950s and the institutionalization of art in post-war Western societies seemed less immediately class-bound, operating more on the level of cultural administration. The proverbial *épater le bourgeois*, which only the philistines held to be the central concern of the avant-garde, was no longer pertinent in an age of mass cultural consumption and musealized avant-gardism.

If Dada questioned the status of art, genius, and art object as they had informed 19th-century bourgeois culture, that critique was by no means obsolete after 1945, when traditional notions of culture were happily being reconstructed: in the United States a notion of high culture took root for the first time on a broader basis and in war-ravaged Europe conservative notions of culture had their last fling, both in terms of a turn to national traditions and a conservative codification of modernism itself. Thus versions of Neo-Dada were perhaps not a major advance in the sense of the formal development of artistic strategies, but they certainly played a part in expressing the rebellion of a new generation of artists against the administered culture of the 1950s, in which a moderate, domesticated modernism served as ideological prop to the Cold War. But as the major Neo-Dada phenomenon in that transitional period, Fluxus also attempted to put something new in the place of the rejected old.

What, then, is that new element that distinguishes Neo-Dada from Dada, and what are its central aesthetic aspects? Fluxus was a tendency, an attitude, a way of life: Fluxfests, Fluxweddings, and Fluxfoods were as important as Fluxconcerts, Fluxevents and Fluxboxes. This attempt to bridge the gap between art and life would seem to relate Fluxus again and quite explicitly to the art/life problematic of the historical avant-garde embodied in Futurism, Dada, Surrealism, and the Soviet avant-garde of the 1920s, a relationship Maciunas went to great and often absurd lengths to chart, label, and administer. But while the earlier Dada played itself out in close proximity *and* antagonism to political vangardism—just think of the proximity of Dada's Cabaret Voltaire to Lenin's hideout in Swiss exile in Zurich's Spiegelgasse—the almost obsessive and fetishistic emphasis on redoing everything under the sun in the name of Fluxus seems rather like an anticipation of the lifestyle obsessions of later decades. The difference is that life according to Fluxus was not supposed to be commercialized at all. It actually resisted commodification quite consciously, but in retrospect the absence of a political radicalism rooted in reality was both an aesthetic weakness and a sign of political insight at a time when the Left cultural politics of the 1920s no longer offered any solutions.

Perhaps nothing else, nothing more radical, was possible around 1960. The superpower confrontation of the 1950s had severely limited the space in which a novel, productive encounter between aesthetics and politics could have emerged. A major aesthetic and political rupture of representational strategies had occurred in the arts in the earlier twentieth century. Such breaks cannot simply be willed into existence at a time when the great utopian visions of a socialist or communist

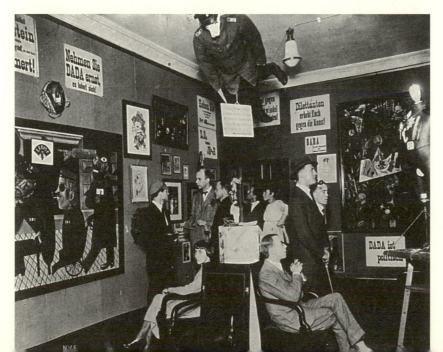

Opening of the Erste Internationale Dada-Messe (First International Dada Fair), Berlin (July 1920).
Photo courtesy Bildarchiv Preussischer Kulturbesitz. Berlin.

society were no longer believable, when totalitarian cultural politics had made the incompatibility of political vanguardism and aesthetic avant-gardism more than clear. The target of an avant-garde in the 1950s could no longer be a fairly coherent system of representation and culture. At best, an avant-garde could challenge the ways in which the ruptures with that system were being domesticated, institutionalized and commodified in a general climate of restoration in the age of Eisenhower, Adenauer, and de Gaulle. Fluxus thus offers a symptomatic case of what separates the post-war avant-gardes from their predecessors in the age of heroic vanguardism.

An Avant-garde Born Out of the Spirit of Music

The archeology of Fluxus gives us a striking picture of its beginnings. At a time when the CIA secretly funded cultural activities in Western Europe, including the importation of American-style modernism (the New York School) in order to stem the paranoically feared influence of Soviet cultural politics on America's allies, a couple of American artists unconspiratorially used the bases of the American military forces in Germany to undermine the domination of the modernism which Cold War cultural politics was promoting as the proper free art of the West. Emmett Williams, based in Darmstadt, worked for the American army paper *Stars and Stripes,* and George Maciunas made a living doing design and signs for the American PX stores at the Wiesbaden base.

The beginnings of Fluxus are marked by a yet larger constellation that explains the explosive energy released by the group. In 1962, a United States avant-garde met a European avant-garde, and the locale of the meeting was a totally unimportant but now historical provincial museum in Wiesbaden, where the first of a series of Fluxus festivals was staged. The sequence of events leading to Wiesbaden is well-known. It led from the Black Mountain College where composer John Cage did the first happening-like performances in 1952, working with Charles Olson, Robert Rauschenberg, Merce Cunningham, David Tudor, and others, to New York where Cage taught at the New School for Social Research in the late 1950s providing the intellectual center for a fast forming group of artists including LaMonte Young, Dick Higgins, George Maciunas, George Brecht, Jackson MacLow, Al Hansen, and Allan Kaprow, most of whom were to play major roles in Fluxus.

The link to Cage is significant because, for the first time in the twentieth century, music played the leading part in an avant-garde movement that encompassed a variety of artistic media and strategies. Of course, there had been a musical avant-garde earlier in the twentieth century, and the sound experiments of Luigi Russolo, Eric Satie, and Edgar Varèse were being rediscovered in the 1950s

THERE'S MUSIC—AND EGGS—IN THE AIR!

By RICHARD O'REGAN, AP Staff Writer

RAW EGGS glided gently through the air and squashed to rest on the audience.

Pebbles flew about the room, cracked and bounced off the floor. A flurry of propaganda leaflets followed. "Strike for Peace," they announced.

"Keep your seats," somebody cried.

This wasn't a barroom brawl. It wasn't a political rally. It was a concert of "very new music and anti-music" in Wiesbaden's dignified art museum.

Germany has become a leading center for experimental music in the postwar world. One of the world's top laboratories for electronic music is in Cologne, Germany's modern music festivals have become a tradition.

Every year young musicians, composers, beatniks, curious and serious from all over the world congregate at Kranichstein and Donaueschingen.

They perform or listen to performances on bottles, pots and pans and doctored violins; they beat on pianos with fists, elbows and hammers; they fill the instruments with cutlery to encourage new sounds, or else produce unearthly combinations of whining vibrations from electronic contraptions.

They write scores that can be read forwards, backwards, upsidedown and inside out all at the same time. They perform visible music and music that can't be heard.

"But" wrote a critic in the Frankfurter Neue Presse, this first International Festival of Very New Music and Anti-Music "put all the others in the shadow."

"It made the other festivals seem like classical chamber music societies in comparison," said another critic.

When the festival opened in early September, it began with weird electronic compositions and performances such as that of the Italian Sylvano Bussotti who danced glass, plastic boxes, brushes and paper balls on the strings of a piano.

It progressed through tape recordings of sounds, strung together in what is called concrete music, to the 10th of 14 concerts. That evening there was NO music at all.

The opening work that night was "Danger Music No. 2" by a New Yorker, Dick Higgins.

Higgins entered and took a bow. He sat himself beside a bucket. His wife, Alison Knowles, appeared with a pair of scissors. She began to cut his hair. Higgins looked content.

After 15 minutes, the audience grew restless. Paper airplanes circled from the back row. Conversation took over.

"I'm sure I don't know what it is all about or what it is supposed to mean," commented one of Germany's well-known abstract painters.

"I tell you Higgins is performing a rare work," said Emmett Williams, a partime performer and composer of this Very New Music living in Germany. "He could play a Chopin etude every night. But Higgins can't give another performance like this for six months, until his hair grows back."

"But there is *no* music," we protested naively. "Is this parody or protest?"

"You have to understand," said George Maciunas, the American promoter of the festival, "that in new music the audible and the visible overlap. This is what is called action music."

"Ah ha," we answered, politely and uncomprehending.

At this moment, Higgins sprang from his barber's seat and seized two pounds of butter and a container of a dozen eggs. (This was "Danger Music No. 15.") He smashed some of the eggs over his now completely shaven head.

He tossed eggs into the air, onto the floor, and gently into the audience. Those in the know nonchalantly unfurled umbrellas.

One egg dripped sadly from the wall. Higgins mixed butter and eggs and advanced toward the audience. An elegantly dressed lady fled through an exit expecting the mess to be hurled into the air. Instead, Higgins placed it tenderly in the hands of several members of the audience.

Three elderly English ladies departed rapidly in confusion, asking what streetcar went where when.

"Well, the advertisements clearly say this is Very New Music. What else do they want?" said the man at the entrance.

"Maybe they expected to hear some music," we suggested.

AMID enthusiastic applause, Higgins withdrew to give way for Nam June Paik of South Korea. Paik covered himself with shaving foam, scattered rice and pebbles on the floor and into the audience and lamented over a roll of cheap paper. Then abandoning his whimpering he took a running, screaming dive into an antique bathtub full of water.

Sad, contrite and very wet, he retired to a corner to play snatches of a child's nursery rhyme on an old-fashioned horn gramophone. Finally, he left sucking one of his socks to the wild applause of the audience.

As the final work that night, a group of young composers viciously attacked a grand piano, somewhat the worse for wear after being pummeled, jumped upon and beaten in previous festival performances.

With crowbars, saws, hammers and their bare hands, they ripped the protesting instrument apart and offered the pieces to the audience for pennies. The concert concluded with further applause.

"We don't understand at all," we said to Maciunas. "The only music we heard all evening was the nursery rhyme."

MACIUNAS is a 30-year-old New Yorker who, while he composes, makes his living as an architect in Germany.

"This is a festival," he replied, "organized by a loose group of young musicians, artists, writers and poets from the United States, Europe, Japan and Korea.

"Naturally, nobody can make his living with this sort of Very New Music, because it is not accepted. But Germany is very sympathetic to all forms of new musical expression and the Wiesbaden Buergermeister put this museum at our disposal.

"In previous performances in this festival there has been much electronic music and concrete music. What you saw tonight was action music, happenings and anti-music. Particularly the destruction of the piano was anti-music.

"Anti-music is, in fact, a protest. Art is artificial. Just by definition," he explained. "What is more, it dulls the hearer or viewer to the beauty of reality.

"For example, the sound of rainfall, the babble of a crowd, a sneeze, the flight of a butterfly.

"If one did away with art, people would be able to appreciate real things to their fullest again. Besides, all the people now engaged in senseless artistic professions could become useful members of society like mathematicians, window washers — something constructive and real."

"Why did you tear the piano apart?"

"We had to get rid of it. It was worn out and it is difficult to carry away. So you see the composition was beautiful in its practicality."

Maciunas said he was taking the group to Copenhagen in November, to Paris in December and to elsewhere in Europe before going on to the United States.

"Be sure you clean that egg off the wall before you go," came a cool, stern voice behind us. It belonged to the museum superintendent.

Sunday, October 21, 1962 — THE STARS AND STRIPES — Page 11

together with Dada in both poetry and the visual arts. Concrete poetry, with its concern with graphics, and concrete music were two developments of the 1950s that entered into Maciunas's notion of the concrete, mono-morphic Fluxus event. The Vienna School, on the other hand, had remained bound to one medium, and the multi-media collaborations between Bertolt Brecht and Kurt Weill or Hanns Eisler had remained isolated instances, cut short, like so many other aesthetic experiments of the Weimar Republic, by Hitler's rise to power.

Richard O'Regan, "There's Music—and Eggs—in the Air," *Stars and Stripes,* October 21, 1962. Review of the Fluxus Internationale Festspiele Neuester Musik, Wiesbaden (1962).

Photo courtesy Walker Art Center. The Gilbert and Lila Silverman Fluxus Collection.

The beat movement which was rattling American culture in the late 1950s from the West Coast with its own brand of attack on high modernist seriousness played no major role in the beginnings of Fluxus. On the contrary, the beats' predilection for unmediated, spontaneous, and expressive subjectivity in their poetry and prose was explicitly shunned by the New York disciples of John Cage. The followers of Cage defined their project as expanding the boundaries of art in relation to the waning forces of abstract expressionism in painting and the crisis of serialism in music, both of which they rejected emphatically. And yet it is easy to see the link between action painting and action performance in their shared emphasis on the concrete materiality of the medium as a logical step that moved

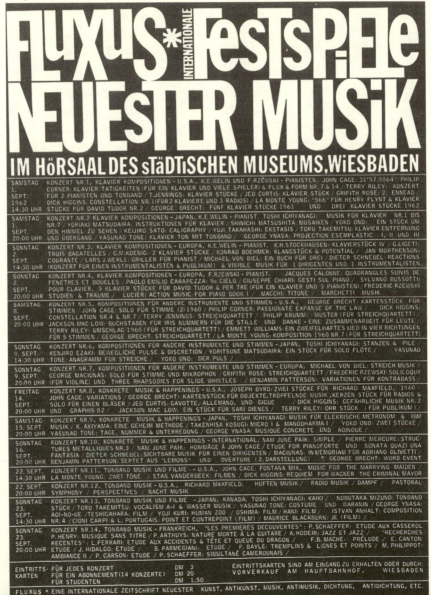

George Maciunas, Poster for Fluxus Internationale Festspiele Neuester Musik, Wiesbaden (1962). Offset on paper, 23 ¹/₄ x 16 ¹/₂

Photo courtesy Walker Art Center.

The Gilbert and Lila Silverman Fluxus Collection.

art decisively beyond the canvas and away from the notion of the finished work.

Abstract expressionism had by then become institutionalized and commanded considerable prices on the art market. It also exercised enormous influence in Europe where 1950s abstraction and its variations such as Informel or "tachisme" were seen as the culmination of the modernist trajectory that had begun with Kandinsky's first abstract paintings in 1910. With the New York School, America had proven its ability to win on the battlefields of culture as well, and New York succeeded in displacing Paris as the center of the modernist arts. For the Fluxus rebellion to take shape, however, the New York scene alone did not provide enough energy. Something else was necessary, and Cage provided it. With Cage, who had been strongly affected by Duchamp since the early 1940s, we have a linkage to European music, namely that to Arnold Schoenberg, who had fled the Nazis and subsequently taught Cage in California before Cage moved East. In the United States, however, Cage's musical experiments lacked the background and environment of a vibrant modernist music culture. There simply was very little Schoenberg or dodecaphonic music to be heard in the concert halls. Musical modernism was hardly even known, while modernism in architecture and painting had become the dominant artistic expression of the post-war era.

This is where Germany became central to the growth of Fluxus as an avant-garde emerging from the music scene. Contrary to the United States, there was practically no indigenous new painting in Germany throughout the 1950s. Instead, the Federal Republic witnessed the exhilarating rediscovery of the modernism the Nazis had so spectacularly banned with their notorious 1937 exhibit of Entartete Kunst.[11] That art, forbidden during the Third Reich, had a major revival with the first Documenta in Kassel in 1955, and it was followed by the introduction of American-style abstract expressionism with the second Documenta in 1959. But as far as new production was concerned, the visual field was exhausted; the visual imagination in Germany was depleted after the visual orgies of Nazi festivities, the light domes of Albert Speer, and the general experience of war and burning cities. The revulsion against radical forms of modernism, however, which Nazi cultural politics had so cleverly exploited, seemed to linger way beyond the downfall of the regime itself. Even more importantly, the documentary footage from the concentration camps, as it began to be ever more frequently shown in Germany in the mid-1950s (e.g., Alain Resnais' *Night and Fog)* had a paralyzing effect on the visual imagination of a whole generation. Auschwitz cast an image prohibition over any form of visual and literary representation, and artists were fundamentally unsure as to which traditions were still usable, which aesthetic strategies were not contaminated by Nazi abuse.

Only music, an inherently non-representational medium, was unaffected by these doubts. In its many music and opera festivals and its lively concert culture, Germany escaped from the pressures of the present and the memory of the Nazi years by affirming a cultural heritage presumably not tainted by Nazism, even though many of the Third Reich's musical stars and directors continued to perform in the limelight. They stood for an unbroken tradition of a fundamentally conservative musical culture that was thought to be free from the fetters of politics.

A result of this apologetic continuation of "the best of German culture," however, is that the center of avant-gardism in Germany in the 1950s was neither in literature nor in the visual arts, but in music experiment in what was then called the new music, musica nuova. The key location was Darmstadt. At the famous annual Ferienkurse für neue Musik (Vacation Courses for New Music), musical experiment went from an intense appropriation of Schoenberg, who had, in the early 1950s, replaced Hindemith, Stravinsky, and Bartok as the key paradigm of musical modernism, to a Webernian phase and the espousal of serialism by the mid-1950s. Luigi Nono, Pierre Boulez, and Karlheinz Stockhausen were some of the leading new composers at the time, and most of the major figures of the European music scene taught or performed in Darmstadt. However, increasing abstraction and a kind of technocratic formalism, experienced by many as the formal expression of a decadent capitalist system, eventually led to a dead end. Already in 1955, Adorno, one of the most astute observers of modernism in music, spoke of the aging of the new music, its loss of inner tension and creative force, and its incorporation into an affirmative administered culture.

In the meantime, electronic experiment had found its laboratory in the radio studios of the Westdeutscher Rundfunk in Cologne. Working there, Stockhausen and Nam June Paik developed a new music aesthetic which pushed beyond the natural sound boundaries of traditional instruments. Just as the Cologne WDR supported musical experiment, the Darmstadt scene was co-sponsored by the Hessian radio. Radio was still the major mass medium of the time and serious music commanded considerable air time.

It was in this Darmstadt environment of advanced musical experimentation, at which Adorno was a frequent observer, that Cage caused a major sensation in 1958 with his Zen inspired challenge to the extreme rationalization of the musical material in the serialist enterprise. Against Western musical rationalism, which Max Weber had already analyzed and Adorno had made into a theoretical pillar of his music philosophy, Cage demanded to free the pure materiality of sound and emancipate noise from its oppressive exclusion in the realm of music. For sound to emerge, music had to be silent (thus the title of Cage's seminal book

of 1961: *Silence).* The avant-garde's demand to abolish the boundaries between art and life finally and boldly entered the realm of the most advanced music.

The famous Fluxus concerts of the early 1960s are inextricably bound to this development of an aleatoric post-serialism. Not only did Emmett Williams spend decisive years in Darmstadt, but both Nam June Paik and LaMonte Young first met Cage there, an encounter that significantly reoriented their work. The double impact of Cage in New York and Cage in Darmstadt created the critical mass out of which Fluxus emerged as an intermedia avant-garde born from the spirit of experimental music.

It was indeed plausible that a new radicalism, a Neo-Dada should emanate from music, a field which lacked the kind of avantgardist dismantling of its institutional frame and inherent structures, which was ripe for the expansion of its sound material into what always had been considered simply non-musical. In Schoenberg's dodecaphonic compositions, as well as in Webern and serialism, Western culture's movement toward rationalization had continued unabated through World War II. The constructivist logic of this brand of modernism could be read as a protest against a totally rationalized world which radiated disaster (Adorno) or as a kind of high cultural reproduction of the oppressive structures of a rationalizing modernity. The latter view made a radical anarchic attack on

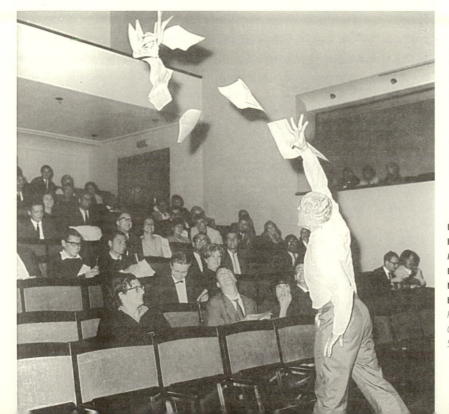

Dick Higgins performing his *Danger Music Number Two* at Fluxus Internationale Festspiele Neuester Musik. Wiesbaden (1962).
Photo Helmut Rekort.
Courtesy Archiv Sohm. Staatsgalerie Stuttgart.

serialism almost inevitable, an attack that posited the principles of indeterminacy and chance against a rigidly administered and rationalized musical material.

On a pragmatic level, it had also become evident that a totally determined and rationalized music could no longer be distinguished from a completely undetermined and random music by listening alone. Only the reading of the musical score would expose the difference. Indeed, to some sophisticated professionals the reading of the score became more important than actual listening or performing. To a critical ear, however, it is precisely this inability to distinguish indeterminacy from excessive overdetermination that also reveals how close chance and indeterminacy are to the very oppressiveness of rationalization they ostensibly want to overcome. Excessive determination itself had already opened the door to chance in the works of Stockhausen and Boulez, and Cage, it can be said, simply drew the conclusions of what was latent in serialism itself. At the same time, his Zen-inspired focus on the sounds and noises of everyday life offered a striking contrast in sensibility to the post-Webernian European music scene.

Actually, Cage's uncritical celebration of chance and the I Ching recall Walter Benjamin's paradoxical comments on the structural proximity of assembly line work and gambling in his Baudelaire essay.[12] The insidious dialectic of mere accident and total rational control is perhaps nowhere as evident as in the ultimate Fluxus event of the 1950s, one performed millions of times over, but never by a Fluxus artist: schoolchildren lined up, arms covering their heads, in nuclear war drills. Nuclear war was, after all, the trauma of the 1950s generation: the possibility of MAD (mutually assured destruction) revealed the inherent absurdity and danger of technological progress and the politics of deterrence, or, in aesthetically coded terms, the dialectical closeness of chance and determination.

Lining up for the apocalypse. School kids learn how to "beat the bomb." Official Civil Defense Photo (circa 1958). Used in the film *The Atomic Café* (1982). *Photo courtesy Museum of Modern Art/Film Stills Archive.*

Thus, while Cage's aesthetic of musical silence that permitted the chance sounds of everyday life to penetrate the field of music represented an unavoidable move in music aesthetics, it was far less liberating or at least more ambivalent than it imagined itself to be. Much the same can be said of the Fluxus pieces and events that followed on the heels of Cage's project. Total rational control and the status quo may be exploded by chance, but chance in the 1950s always had two sides: a life affirming side with its focus on the simple acts and events of everyday life and its cutting critique of an oppressive logic of modernization and consumerism, and the apocalyptic side, the nuclear accident that would destroy the world and generate a silence beyond art and life.

The turn to Zen Buddhism, so central to Cage and much of the counter-culture of the 1960s, is significant in that it functioned as the oriental veneer over some alternate meaning, an intellectual other that breathed new life into the world of Dr. Strangelove. It provided the illusion of spirituality that had been drained from Western civilization. But the paradoxical celebration of chance as a constructive principle of the new art would reach its own dead end very soon; after the elimination of author, work, and conscious aesthetic construction, randomness itself had to sink into the muck of an unadulterated materiality of everyday life and its ultimate lack of meaning. Here it is important to note that Fluxus, in general, did not follow Cage's road to Zen and, in its practice of performing pieces and events, carefully maintained the boundary between art event and the heterogeneous reality of everyday life, never lapsing into that participatory aesthetic ethos that emerged as one of the major utopian delusions of the 1960s in various artistic media.

Clearly, Cage's experiments articulated an important critique of excessive rationalization in contemporary Western music, which it revealed as oppressive and confining. His critique of technocratic modes of composition also manifested itself in his attempt to move music away from modern technology and media back into everyday life. Electronic experiment had expanded the realm of sound in a different way, but in Cage's perspective this was another wrong avenue to pursue. Most of the Fluxus artists shared this rather purist anti-technological attitude which would soon have to contend with a new media triumphalism under the spell of Marshall McLuhan.

Cage and Fluxus share the project of doing away with art. This is the genuine Dadaist moment of Fluxus. But even in this rebellion, in its incorporation of everyday events into art, Fluxus remained bound to art, expanding the realm of expression and material development in highly charged and consequential ways. The high modernist notion of individualized artistic expression based on transcendent vision was replaced by a focus on the expressiveness of the world. But this

typical avant-gardist move was caught in a paradox: the expressiveness of the world still needed the artist to stage and perform it. Fluxus as Neo-Dada thus had its own inherent logic which did not permit the final abolition of art—a performative contradiction that did not seem to bother anyone at the time.

Intermedia and *Verfransung*

Historically, Fluxus was located on the threshold between an older type of European avant-gardism, with which it shared many basic assumptions, and a beginning postmodernism which it anticipated in its emphasis on performance, event, and the indeterminacy of medium. This historical boundary was marked by the tension between the European critical, negatory side of Fluxus (best embodied in George Maciunas himself and in his arch-rival in Germany, Wolf Vostell) and the affirming, expanding—though by no means uncritical—aspects transmitted to Fluxus primarily through John Cage and the emerging American avant-garde scene.

Fluxus also was a boundary phenomenon in that it located its experiments between different arts and media, between music and poetry, design and poetry, music and graphics, music performance and theater performance, vaudeville and high art, art and life. Higgins coined the fortuitous formula of "intermedia" which he wanted clearly distinguished from multimedia. Multimedia resulted from addition and juxtaposition while intermedia focused on the heretofore empty spaces between rigidly separated and defined arts. The guiding principles of intermedia were subtraction and reduction (rather than addition) in that the intermedia event also tended to be, in Maciunas's words, concrete, mono-morphic, untheatrical, and, especially in the laconic pieces of George Brecht, minimalist.

The Fluxus utopian space between media is meaningful only as long as existing or formerly dominant boundaries are still respected or recognizable. The implicit dependence on a traditionally structured system of the arts, which is put under erasure by the Fluxus event, is perhaps best expressed in what Adorno, in a key essay of 1966, called the increasing *Verfransung der Künste*.[13] This notion of *Verfransung* (fraying, entangling, blurring of boundaries), while close to Dick Higgins's celebrated formula of "intermedia," is perhaps theoretically more perceptive in that it includes the sense of an evolving dissolution, of aesthetic entropy—a reciprocal emptying out of traditions, a loss of form and truth content. Adorno, in his characteristically European mode, makes a strong point for the logic of the material development in the arts that pushes the arts toward a degree zero of meaning and transcendence which is absent from Higgins's simple, non-metaphysical discourse. Where Higgins assumes optimistically that

each Fluxus event will create its own inherent and natural medium, Adorno sees entropy and a process in which the arts, given their inability to redeem in the post-Auschwitz age, simply consume each other. Neither Higgins nor Adorno ever aim at a unification of the arts in a kind of a postmodern Gesamtkunstwerk (total work of art). The terms intermedia and *Verfransung* insist on differentiation and thus reproduce theoretically what the American-European encounter produced in Fluxus practices: ways to rethink and transform the different arts in that crucial fluid space between modernism and postmodernism.

Looking back at Fluxus thirty years after its beginnings, one may well want to ask whether Adorno's or Higgins's analyses have been borne out by subsequent developments in the arts. The movement toward entropy eventually proved a dead end in theory and in artistic practice, and so it is no surprise that traditional forms of artistic expression that had been declared dead many times have returned with a vengeance. Neither Adorno nor Higgins would be pleased even though this development confirms at least Adorno's belief that art has to insist on remaining separate from and heterogeneous to life. The process of *Verfransung* was actually stopped in its tracks, and one might say that today's postmodern culture is teeming with the promiscuity of hybrids which Adorno saw emerging in the early 1960s. But such hybrid forms and media now exist in their own right, and *Verfransung* as hybridization has been recognized as a productive tendency rather than as entropy. Contrary to original Fluxus practices, intermedia now also includes technological and electronic gadgetry. Traditional and non-traditional forms of art exist side by side, and Higgins's distinction between multimedia and intermedia is no longer relevant. On the other hand, Higgins was right in that intermedia art ultimately legitimized itself as a medium in its own right. Fluxus as a threshold phenomenon, in a temporal and aesthetic sense, has become historical indeed.

If Fluxus is indeed symptomatic for major and groundbreaking changes in the arts, why did it take so long to recognize its importance as an art movement? For contrary to Pop, minimalism, ZERO, or concept, Fluxus has indeed managed to be (almost) forgotten not only as a "movement," but even as a tendency or an attitude. Remarkably few of the historical accounts of the arts of the 1960s have much to say about Fluxus. And yet, as soon as one begins to study Fluxus as a phenomenon of the late 1950s and early 1960s, one begins to see its traces everywhere in the artistic movements that followed in the 1960s and 1970s, from minimalism and concept to performance art, video, mail art, and correspondence art.

Since the major twentieth-anniversary celebration of Fluxus in Wiesbaden in 1982, Fluxus has been awakened from the slumber of oblivion. From the hidden

corners of its often quite vital after-life it is being pulled into the open public sphere through publications, exhibits, and a new kind of collector interest. This recent interest in Fluxus may prove to be as elusive as the Fluxus phenomenon itself. But what motivates this new interest in Fluxus? Are we looking for the lost purity and innocence of an artistic ethos at a time when the commodification of art has reached a feverish pitch and the hopes for a postmodernism of resistance have dashed? Or are we searching for some hidden origin of that phenomenon called postmodernism, a prehistory of the postmodern? Is the current fascination with movements of the 1950s and 1960s such as Lettrism, Cobra, Situationism, Viennese actionism and others the result of our fatigue with the churning of the current art markets, the instantaneous commodification of the latest artistic genius? Is it merely avant-garde nostalgia or is it a cultural move to challenge the blatant cultural conservatism of our own time? Is the aim to construct Fluxus as the forgotten and hidden, perhaps even betrayed origin of later art movements that preyed upon it without acknowledgment? The master-code, as it were, of what has come to be called postmodernism? Is that what motivates the recent interest of museums and collectors in the Fluxus phenomenon, despite the well-known and almost insuperable difficulties in collecting objects from a movement that was centered around performances and events, in presenting a non-movement that by definition eludes museal presentation or re-presentation?

Whatever the answers to such queries may be, Fluxus has returned from oblivion, even though its new life is now in the museum, the archive, the academy. But then the museum today is no longer a bastion of high culture only, but, at its best, a space for cultural encounters that do not betray the spirit of the movement while representing it. For if Fluxus has become historical, it may also be true, as Emmett Williams suggested years ago, that it has not yet been invented.

The Terror of History, the Temptation of Myth

More than any other recent painter's work, Anselm Kiefer's painterly post-painterly project has called forth ruminations about national identity. American critics in particular have gone to great length in praising his Germanness, the authentic ways in which he deals in his painting with the ghosts of the fatherland, especially with the terror of recent German history. The use of profound allegory, the multiple references to Germanic myth, the play with the archetypal—all of this is held to be typically German, and yet, by the power of art, it is said somehow to transcend its origins and give expression to the spiritual plight of humanity in the late twentieth century.[1] The temptation is great to dismiss such stereotype-driven appreciations of national essence as a marketing strategy of the Reagan age. Pride in national identity is in. Even the Germans benefit from it since Ronald Reagan's visit to the Bitburg cemetery gave its blessing to Helmut Kohl's political agenda of forgetting the fascist past and renewing national pride in the name of "normalization." In an international art market in which the boundaries between national cultures become increasingly irrelevant, the appeal of the national functions like a sign of recognition, a trademark. What has been

characteristic of the movie industry for a long time (witness the successions of the French cinema, the Italian cinema, the new German cinema, the Australian cinema, etc.) now seems to be catching up with the art world as well: the new German painting. Let me quote, perhaps unfairly, a brief passage from a 1983 article that addresses the Germanness in question:

> Kiefer's use of paint is like the use of fire to cremate the bodies of dead, however dubious, heroes, in the expectation of their phoenixlike resurrection in another form. The new German painters perform an extraordinary service for the German people. They lay to rest the ghosts—profound as only the monstrous can be—of German style, culture, and history, so that the people can be authentically new. . . . They can be freed of a past identity by artistically reliving it.[2]

Remembering that it was in fact the Nazis who promised authentic national renewal, a resurrection of the German *Volk* from the ashes of defeat, remembering also that it was the Nazis who practiced mass cremation not for resurrection, but for total elimination of their victims, memory, and all this kind of rhetoric simply makes my hair stand on end. To me, a German of Kiefer's generation, the reference to laying to rest the ghosts of the past reads like a Bitburg of art criticism, if not worse, and I would claim that it fundamentally misrepresents the problematic of national identity in Kiefer's work. Kiefer's painting—in its forms, its materials, and its subject matter—is emphatically about memory, not about forgetting, and if flight is one of its organizing pictorial metaphors, it is not the flight of the phoenix, but the doomed flight of Icarus and the melancholic flight of the mutilated and murderously vengeful Wayland, the master smith of the classic book of Norse myth, the Edda. Kiefer's wings, after all, are made of lead.

The purpose of this essay, then, will be to free our understanding of Kiefer's complex and captivating work from the stereotypes of Germanness and from the cliché that names him Anselm Angst and worships his flight into the transcendence of art and the universally human. I propose to place Kiefer's aesthetic project in its specific cultural and political context, the context of German culture after Auschwitz out of which it grew and to which it gives aesthetic form, which energized it during long years of little recognition, and to which, I would argue against facile claims of transcendence and universality, it ultimately remains bound—in its strengths, in its weaknesses, and most of all in its ambiguities.

Even a first and casual look at Kiefer's work will tell us that it is obsessively concerned with images of myth and history. Immersed in the exploration (and exploitation) of the power of mythic images, this work has given rise to the mystification that somehow myth transcends history, that it can redeem us from

history, and that art, especially painting, is the high road toward redemption.
Indeed, Kiefer himself—to the extent that we hear his voice through the para-
phrases of art criticism (including Mark Rosenthal's problematic attempts at
ventriloquism in the catalogue of the 1987 American exhibition of Kiefer's work
that was shown in Chicago, Philadelphia, Los Angeles, and New York)—is not
innocent in provoking such responses. But ultimately his work is also informed by
a gesture of self-questioning, by an awareness of the questionable nature of his
undertaking, and by a pictorial self-consciousness that belies such mystifications.
I take his work—and this will be one of my basic arguments to be about the ulti-
mate inseparability of myth and history. Rather than merely illustrating myth or
history, Kiefer's work can be read as a sustained reflection on how mythic images
function in history, how myth can never escape history, and how history in turn
has to rely on mythic images. While much of Kiefer's mythic painting seems ener-
gized by a longing to transcend the terrors of recent German history, the point,
driven home relentlessly by subject matter and aesthetic execution, is that this
longing will not, cannot be fulfilled.

One way to discuss context (Kiefer's and our own) is to relate Kiefer to three
West German cultural phenomena that have captured the attention of American
audiences in recent years. First there was the international success of the new
German cinema with the work of Fassbinder, Herzog, Wenders, Schloendorff,
Kluge, Sanders-Brahms, von Trotta, Ottinger and many others. Much of that
work was driven by questions of German identity—personal, political, cultural,
sexual. All of this work was ultimately rooted in the acknowledgment that the
fascist past and the postwar democratic present are inescapably chained together
(examples are Fassbinder's films about the 1950s, Kluge's films from *Yesterday Girl*
to *The Patriot,* and the various films on German terrorism and its relationship to
the Nazi past). There are especially striking parallels between Kiefer's treatment of
fascist imagery and Syberberg's major films, and it is no accident that both artists
have been accused of sympathizing with fascism.

Then there was the rise to instant stardom of a group of painters, many of them
from Berlin, who had been painting for almost twenty years—during the heyday
of late abstraction, minimalism, conceptualism, and performance art—but who
were recognized and marketed as a group only in the early 1980s: *die neuen
Wilden,* the neoexpressionists, as they were most commonly called because of
their return to the pictorial strategies of that pivotal movement of German
modernism. Just as German expressionism had given rise to one of the most far-
ranging debates about the aesthetics and politics of modernism in the 1930s,[3]
neoexpressionism immediately sparked a debate about the legitimacy of a return

to figuration after abstraction, minimalism, and concept art.[4]

Thirdly and most recently, there was the so-called *Historikerstreit* in Germany, the historians' debate over the German responsibility for the holocaust, the alleged need to "historicize" the fascist past, and the problem of a German national identity. Indeed, as philosopher Jürgen Habermas observed, the historian's debate about the German past was in truth a debate about the self-understanding of the Federal Republic today. In that debate of 1986, a number of right-wing historians took it upon themselves to "normalize" German history, and one of them went so far as to put the blame for the holocaust, by some perverted logic of the priority of the Soviet Gulag, on the Bolsheviks.[5] The *Historikerstreit,* outrageous as it was in this latter aspect, did make the pages of the *New York Times.* What did not become clear from the reporting, however, is the fact that underlying the whole debate was the conservative turn in German politics since the early 1980s, the Bitburg syndrome, the public debate about proposals to erect national monuments and national history museums in Bonn and in Berlin. All of this happened in a cultural and political climate in which issues of national identity had resurfaced for the first time since the war. The various factions of German conservatism are in search of a "usable past." Their aim is to "normalize" German history and to free German nationalism from the shadows of fascism—a kind of laundering of the German past for the benefit of the conservative ideological agenda.

All three phenomena—the new German cinema, neoexpressionist painting, and the historian's debate—show in different ways how West German culture remains haunted by the past. It is haunted by images which in turn produce haunting images—in cinema as well as in painting. Anselm Kiefer, despite his seclusion in a remote village of the Odenwald, is very much a part of that culture.

Within West Germany, critics have been much more skeptical of the idea that Kiefer succeeds in dealing with and exorcising the ghosts of the German past in his painting. Criticism first emerged publicly on a broad scale when Kiefer and Baselitz represented the Federal Republic at the 1980 Venice Biennale, and Kiefer was accused in the feuilletons of flaunting his Germanness with his embarrassingly nationalist motifs. Some American commentators have dismissed such criticisms as bizarre, crudely censorious, and cognitively inferior.[6] I believe that this is a serious mistake born of an ignorance of Kiefer's context that ultimately disables the reading of the paintings themselves. The nationalism/fascism problematic in Kiefer's work deserves serious attention, and Kiefer himself would be the first to insist on that. The American desire finally to have another major contemporary

painter, after Picasso and Jackson Pollock, may indeed be overwhelming, but we don't give Kiefer the recognition he deserves by avoiding problematically German aspects of his work and by making him into an "art pathfinder for the twenty-first century," as one recent headline had it. [7] Certainly I do not want to see Kiefer identified with an international postmodern triumphalism which has at least some of the critics in ecstatic rapture. Consider the following preposterous statement by Rudi Fuchs, Dutch art historian and museum director and organizer of the 1982 postmodern art bonanza at Kassel, Documenta 7: "Painting is salvation. It presents freedom of thought of which it is the triumphant expression. . . . The painter is a guardian-angel carrying the palette in blessing over the world. Maybe the painter is the darling of the gods."[8] This is art theology, not art criticism. Kiefer has to be defended against such regressive and mystifying appropriations. He is not in the business of salvation triumphant nor in the cultural trafficking in guardian angels that has become increasingly popular in the 1980s—witness the Wenders/Handke film *Wings of Desire*. Neither is Kiefer simply into resurrecting the German past, as some of his German critics complain. But, in a country like West Germany, where definitions of national and cultural identity all too often have led to the temptation of relegitimizing the Third Reich, any attempt by an artist to deal with the major icons of fascism will understandably cause public worries. Fortunately so.

What is it, then, that has Kiefer's countrymen up in arms? With what seems to be an incredible naiveté and insouciance, Kiefer is drawn time and again to those icons, motifs, themes of the German cultural and political tradition which, a generation earlier, had energized the fascist cultural synthesis that resulted in the worst disaster of German history. Kiefer provocatively reenacts the Hitler salute in one of his earliest photo works; he turns to the myth of the Nibelungen, which in its medieval and Wagnerian versions has always functioned as a cultural prop of German militarism; he revives the tree and forest mythology so dear to the heart of German nationalism; he indulges in reverential gestures toward Hitler's ultimate culture hero, Richard Wagner; he suggests a pantheon of German luminaries in philosophy, art, literature, and the military, including Fichte, Klopstock, Clausewitz, and Heidegger, most of whom have been tainted with the sins of German nationalism and certainly put to good use by the Nazi propaganda machine; he reenacts the Nazi book burnings; he paints Albert Speer's megalomaniac architectural structures as ruins and allegories of power; he conjures up historical spaces loaded with the history of German-Prussian nationalism and fascist chauvinism such as Nuremberg, the Märkische Heide, or the Teuteburg forest; and he creates allegories of some of Hitler's major military ventures. Of

course, one has to point out here that some of these icons are treated with subtle irony and multi-layered ambiguity, occasionally even with satirical bite (e.g., *Operation Seelion),* but clearly there are as many others that are not. At any rate, the issue is not whether Kiefer intentionally identifies with or glorifies the fascist iconography he chooses for his paintings. I think it is clear that he does not. But that does not let him off the hook. The problem is in the very usage of those icons, in the fact that Kiefer's images violate a taboo, transgress a boundary that had been carefully guarded, and not for bad reasons, by the postwar cultural consensus in West Germany: abstention from the image-world of fascism, condemnation of any cultural iconography even remotely reminiscent of those barbaric years. This self-imposed abstention, after all, was at the heart of Germany's postwar reemergence as a relatively stable democratic culture in a Western mode.

Why, then, does Kiefer insist on working with such a controversial body of icons? At stake in Kiefer's paintings is not just the opening of wounds, as one often hears, as if they had ever been healed. Nor is it the confrontation between the artist, whose painting conjures up uncomfortable truths, and his countrymen, who want to forget the fascist past. The Bitburg Germans will forget it. They are determined to forget—Kiefer or no Kiefer. They want to normalize; Kiefer does not. The issue, in other words, is not whether to forget or to remember, but rather how to remember and how to handle representations of the remembered past at a time when most of us, over forty years after the war, only know that past through images, films, photographs, representations. It is in the working through of this problem, aesthetically and politically, that I see Kiefer's strength, a strength that simultaneously and unavoidably must make him controversial and deeply problematic. To say it in yet another way, Kiefer's hunted images, burnt and violated as they are, do not challenge the repressions of those who refuse to face the terror of the past; rather they challenge the repressions of those who do remember and who do accept the burden of fascism on German national identity.

One of the reasons why Kiefer's work—and not only the fascism and history paintings, but also the work from the mid-1980s that focuses on alchemy, biblical and Jewish themes, and a variety of non-German myths—is so ambiguous and difficult to read is that it seems to lack any moorings in contemporary reality. Despite this ostensible lack of direct reference to the present in his work, Kiefer's beginnings are firmly embedded in the German protest culture of the 1960s. He was simply wrong, forgetful, or disingenuous when he recently said, "In '69, when I began, no one dared talk about these things."[9] He might have been right had he said "no one painted these things." But talk about fascism, German history, guilt, and the holocaust was the order of the day at a time when

a whole social movement—that of the extra-parliamentary opposition and the New Left inside and outside the academy—had swept the country with its agenda of *Vergangenheitsbewältigung,* the coping or coming-to-terms with the past. Large-scale generational conflict erupted precisely on the issue of what parents had done or not done between 1933 and 1945 and whether former members of the Nazi party were acceptable as high-level political leaders. The German theaters performed scores of documentary plays about fascism and the holocaust (Rolf Hochhuth's *Deputy* [1963] and Peter Weiss's *Investigation* [1965] being the best-known), and scores of television programs addressed the question of fascism. After all, 1969 was the year in which Willy Brandt, a refugee from the Nazis and an active member of the Norwegian underground during the war, became chancellor and initiated a policy of détente with the East which was based on the public acknowledgment of "those things."

And yet, in a certain sense Kiefer is not entirely wrong. His approach to understanding and representing the past differed significantly from what I would call, in shorthand, the liberal and social-democratic antifascist consensus of those years. Let us take one of Kiefer's early works, the series of photographs entitled *Besetzungen (Occupations)* from 1969, as an example to discuss a central issue which governs much of his painting throughout the 1970s. The work consists of a series of photographs taken at various locations all over Europe—historical spaces, landscapes—all of which feature the artist himself performing, citing, embodying the Sieg Heil gesture. As the catalogue suggests, the artist seems to have assumed the identity of the conquering National Socialist who occupies Europe.[10] The first reaction to this kind of work must be shock and dismay, and the work anticipates that. A taboo has been violated. But when one looks again, multiple ironies begin to appear. In almost all of the photos the Sieg Heil figure is miniscule, dwarfed by the surroundings; the shots are taken from afar. In one of the photos the figure stands in a bathtub as if walking on water and is seen against a backlit window. There are no jubilant masses, marching soldiers, nor any other emblems of power and imperialism that we know from historical footage from the Nazi era. The artist does not identify with the gesture of Nazi occupation, he ridicules it, satirizes it. He is properly critical. But even this consideration does not lay to rest our fundamental uneasiness. Are irony and satire really the appropriate mode for dealing with fascist terror? Doesn't this series of photographs belittle the very real terror which the Sieg Heil gesture conjures up for a historically informed memory? There just seems no way out of the deeply problematic nature of Kiefer's "occupations," this one as well as those that were to follow in the 1970s, paintings that occupied the equally shunned icons and spaces of German national history and myth.

Anselm Kiefer
Page from *Occupations*
1969

There is another dimension, however, to this work, a dimension of self-conscious mise-en-scène that is at its conceptual core. Rather than seeing this series of photos only as representing the artist occupying Europe with the fascist gesture of conquest, we may, in another register, see the artist occupying various framed image-spaces: landscapes, historical buildings, interiors, precisely the image-spaces of most of Kiefer's later paintings. But why then the Sieg Heil gesture? I would suggest that it be read as a conceptual gesture reminding us that indeed Nazi culture had most effectively occupied, exploited, and abused the power of the visual, especially the power of massive monumentalism and of a

Anselm Kiefer
Page from *Occupations*
1969

confining, even disciplining, central-point perspective. Fascism had furthermore perverted, abused, and sucked up whole territories of a German image-world, turning national iconic and literary traditions into mere ornaments of power and thereby leaving post-1945 culture with a tabula rasa that was bound to cause a smoldering crisis of identity. After twelve years of an image orgy without precedent in the modern world, which included everything from torch marches to political mass spectacles, from the mammoth staging of the 1936 Olympics to the ceaseless productions of the Nazi film industry deep into the war years, from Albert Speer's floodlight operas in the night sky to the fireworks of antiaircraft flak

over burning cities, the country's need for images seemed exhausted. Apart from imported American films and the cult of foreign royalty in illustrated magazines, postwar Germany was a country without images, a landscape of rubble and ruins that quickly and efficiently turned itself into the gray of concrete reconstruction, lightened up only by the iconography of commercial advertising and the fake imagery of the *Heimatfilm*. The country that had produced the Weimar cinema and a wealth of avant-garde art in the 1920s and that would produce the new German cinema beginning in the late 1960s was by and large image-dead for about twenty years: hardly any new departures in film, no painting worth talking about, a kind of enforced minimalism, ground zero of a visual amnesia.

I am reminded here of something Werner Herzog once stated in a somewhat different context. In an interview about his films he said, "We live in a society that has no adequate images anymore, and, if we do not find adequate images and an adequate language for our civilization with which to express them, we will die out like the dinosaurs. It's as simple as that.[11] The absence of adequate images in postwar Germany and the need to invent, to create images to go on living also seems to propel Kiefer's project. He insists that the burden of fascism on images has to be reflected and worked through by any postwar German artist worth his or her salt. From that perspective indeed most postwar German art had to be seen as so much evasion. During the 1950s, it mainly offered derivations from abstract expressionism, *tachism, informel,* and other internationally sanctioned movements. As opposed to literature and film, media in which the confrontation with the fascist past had become an overriding concern during the 1960s, the art scene in West Germany was dominated by the light experiments of the Gruppe Zero, the situationist-related Fluxus movement, and a number of experiments with figuration in the work of Sigmar Polke and Gerhard Richter. The focus of most of these artists, whether or not they wanted their art to be socially critical, was the present: consumer capitalism in the age of America and television. In this context Kiefer's occupations of the fascist image-space and of other nationalist iconography were as much a new departure for German art as they were a political provocation, except, of course, that this provocation was not widely recognized during the 1970s.

In that decade, Kiefer's work on myth, especially German myth and the national tradition, could still be seen as an art of individual mythology, as it was called at Documenta V in 1972. It was only during the conservative 1980s, when the issue of national identity had become a major obsession in West Germany, that Kiefer's choice of medium and the political content of his painting got the critics buzzing. Anselm Kiefer—painter of the new Right! But it would be a

mistake to collapse Kiefer's development as an artist with the political turn toward conservatism in the 1980s. After all, the whole issue of national identity first emerged in the 1970s on the intellectual Left and within the orbit of the ecology and peace movements before it became grist for the mills of the new Right. Kiefer's focus on Germanic iconography in the 1970s still had a critical edge, attempting to articulate what the liberal and social democratic cultural consensus had sealed behind a *cordon sanitaire* of proper coping with the past. And his choice of medium, his experimentations on the threshold between painting, photography, and the sculptural, also had a critical edge in the refusal to bow to the pieties of a teleologically constructed modernism that saw even remotely representational painting only as a form of regression. Representation in Kiefer is, after all, not just a facile return to a premodernist tradition. It is rather the attempt to make certain traditions (high-horizon landscape painting, romantic painting) productive for a kind of painterly project that represents, without, however, being grounded in the ideology of representation, a kind of painting that places itself quite self-consciously after conceptualism and minimalism. The often-heard reproach against Kiefer's being figurative and representational misses his extraordinary sensitivity to materials such as straw, sand, lead, ashes, burnt logs, ferns, and copper wire, all of which are incorporated imaginatively into his canvases and more often than not work against the grain of figuration and representation.

While Kiefer's material and aesthetic employment of figuration does not give me ideological headaches, I think it is legitimate to ask whether Kiefer indulges the contemporary fascination with fascism, with terror, and with death. Fascinating fascism, as Susan Sontag called it in her discussion of Leni Riefenstahl, has been part of the international cultural landscape since the 1970s. In his book *Reflections of Nazism: An Essay on Kitsch and Death* (1984), the historian Saul Friedlander has analyzed it in scores of cinematic and literary works from the 1970s, ranging from Syberberg's *Our Hitler* to Liliana Cavani's *The Night Porter* and Fassbinder's *Lili Marleen*, from Alain Tournier's *The Ogre* to George Steiner's *The Portage to San Cristobal of A H.* In addition, we have witnessed the rediscovery, often celebratory, of right-wing modernist writers such as Céline and Ernst Jünger. How does Kiefer fit into this phenomenon, which is by no means only German? To what extent might it explain his success outside his native Germany? Such questions are all the more urgent because, I would argue, Kiefer's own treatment of fascist icons seems to go from satire and irony in the 1970s to melancholy devoid of irony in the early 1980s.

Central for a discussion of fascinating fascism in Kiefer are three series of

paintings from the early 1980s: the paintings of fascist architecture; the March Heath works, which hover between landscape painting, history painting, and an allegorization of art and artist in German history; and the Margarete/Shulamite series, which contains Kiefer's highly abstract and mediated treatment of the holocaust. Together with the Meistersinger/Nuremberg series, this trilogy of works best embodies those aspects of his art that I am addressing in this essay.

Let me first turn to the watercolors and oil paintings of fascist architectural structures: the two watercolors entitled *To the Unknown Painter* (1980, 1982) and the two large oil paintings of fascist architectural structures entitled *The Stairs* (1982–1983) and *Interior* (1981). These works exude an overwhelming statism, a monumental melancholy, and an intense aesthetic appeal of color, texture, and layering of painterly materials that can induce a deeply meditative, if not paralyzing state in the viewer. I would like to describe my own very conflicting reactions

Anselm Kiefer
To the Unknown
Painter
Watercolors on paper
1980

Anselm Kiefer
Interior
Oil, Acrylic, emulsion,
shellack, straw, woodcut
fragments on canvas
1981

to them, with the caveat that what I will sketch as a sequence of three stages of response and reflection was much more blurred in my mind when I first saw the Kiefer retrospective at the Museum of Modern Art in New York.

Stage one was fascination—fascination with the visual pleasure Kiefer brings to the subject matter of fascist architecture. If seen in photographs, such buildings will most likely provoke only the Pavlovian reaction of condemnation: everybody knows what fascist architecture is and what it represents. Being confronted with Kiefer's rendering of the interior of Albert Speer's Reichschancellery was therefore like seeing it for the first time, precisely because "it" was neither Speer's famous building nor a "realistic" representation of it. And what I saw was ruins, images of ruins, the ruins of fascism in the mode of allegory that seemed to hold the promise of a beyond, to suggest an as yet absent reconciliation. True, there is the almost overbearing monumentalism of size and subject matter of these paintings, with

central point perspective driven to its most insidious extreme. But then this monumentalism of central perspective itself seems to be undermined by the claims the multiply layered surfaces make on the viewer, by the fragility and transitoriness of the materials Kiefer uses in his compositions, by the eerie effects he achieves in his use of photography overlaid by thick oil paint, emulsion, shellac, and straw. Dark and somber as they are, these paintings assume a ghostlike luminosity and immateriality that belies their monumentality. They appear like dream images, architectural structures that seem intact, but are intriguingly made to appear as ruins: the resurrected ruin of fascism as simulacrum, as the painterly realization of a contemporary state of mind.

At this point I became skeptical of my own first reaction. Stage two was a pervasive feeling of having been had, having been lured into that fascinating fascism, having fallen for an aestheticization of fascism which today complements fascism's own strategies, so eloquently analyzed by Walter Benjamin over fifty years ago, of turning politics into aesthetic spectacle. I remembered the romantic appeal of ruins and the inherent ambivalence of the ruin as celebration of the past, of nostalgia and feelings of loss. And I recalled the real ruins left by fascism, the ruins of bombed-out cities and the destruction left in the wake of fascist invasion and retreat. Where, I asked myself, do these paintings reflect on this historical reality? Even as images of fascist ruins, they are still monuments to the demagogic representation of power, and they affirm, in their overwhelming monumentalism and relentless use of central-point perspective, the power of representation that modernism has done so much to question and to reflect critically. The question became: Is this fascist painting at one remove? And if it is, how do I save myself from being sucked into these gigantic spacial voids, from being paralyzed by melancholy, from becoming complicit in a vision that seems to prevent mourning and stifle political reflection?

Finally, my initial thoughts about Kiefer's "occupations" asserted themselves again. What if Kiefer, here too, intended to confront us with our own repressions of the fascist image-sphere? Perhaps his project was precisely to counter the by now often hallow litany about the fascist aestheticization of politics, to counter the merely rational explanations of fascist terror by recreating the aesthetic lure of fascism for the present and thus forcing us to confront the possibility that we ourselves are not immune to what we so rationally condemn and dismiss. Steeped in a melancholy fascination with the past, Kiefer's work makes visible a psychic disposition dominant in postwar Germany that has been described as the inability to mourn. If mourning implies an active working through of a loss, then melancholy is characterized by an inability to overcome that loss and in some

instances even a continuing identification with the lost object of love. This is the
cultural context in which Kiefer's reworking of a regressive, even reactionary
painterly vocabulary assumes its politically and aesthetically meaningful dimen-
sion. How else but through obsessive quotation could he conjure up the lure of
what once enthralled Germany and has not been acknowledged, let alone prop-
erly worked through? How else but through painterly melancholy and nightmar-
ish evocation could he confront the blockages in the contemporary German
psyche? At the same time, the risk of confronting contemporary German culture
with representations of a collective lost object of love is equally evident: it may
strengthen the static and melancholy disposition toward fascism rather than
overcome it.

Here, then, is the dilemma: whether to read these paintings as a melancholy
fixation on the dreamlike ruins of fascism that locks the viewer into complicity,
or, instead, as a critique of the spectator, who is caught up in a complex web of
melancholy, fascination, and repression.

Even the two elements common to several of the paintings and watercolors in
this series—the inscription "to the unknown painter" and the dead center posi-
tioning of a palette on a black pole—will not help us out of this dilemma. Surely,
as a double reference to the unknown soldier and to art, these linguistic and
conceptual inscriptions in the midst of these fascist architectural monuments
tend to break the spell of the image as pure and unmediated and to produce an
estrangement effect. Here as elsewhere Kiefer relies on linguistic inscription and
encoding as methods of undermining the false immediacy of visual representa-
tion. His images have to be both seen and read.

But how estranging are these inscriptions ultimately? If one remembers the
classical topos of paralleling the heroism of the warrior with the heroism of the
genial artist, then Kiefer's recourse to the trivial romantic motif of the monument
to the unknown soldier could be read as a slightly displaced critique of the myth
of artistic genius.[12] Such a reading, however, seems a bit forced. After all, the
notions of the unknown soldier and of the unknown, unrecognized genius are
themselves integral to the myths of warrior heroism and aesthetic genius that have
been major props of middle-class culture since romanticism. A potentially critical
strategy of breaking visual immediacy through linguistic markers and conceptu-
ally estranging signs on the work's surface ultimately serves only to reinforce the
myth it ostensibly undermines. Furthermore, the undocumented heroism of the
unknown soldier is displaced here into the heroism of that very well-known
painter Anselm K., who may himself have fallen for the lure he had set out to
combat. Much the same, by the way, can be said of Kiefer's earlier attempts to

construct German genealogies in paintings such as *Germany's Spiritual Heroes* (1973), *Icarus* (1976), and *Ways of Worldly Wisdom* (1976–1977). Kiefer's need to position himself effectively at the end of a genealogy of German art and thought gets in the way of whatever critical intentions he might have had. To be sure, in *To the Unknown Painter* Kiefer does not celebrate the link between aesthetics and war as the Italian futurists or the right-wing modernists of the Weimar Republic did. Instead of an aesthetics of terror, one might say, we get melancholy and narcissism, the narcissism of a postfascist German painter whose frozen gaze is directed at two imaginary lost objects: the ruins of fascism (buildings, landscapes, mindscapes) and the ruins, as it were, of the house of painting itself. These two sets of ruins are pictorially equated. Kiefer ends up collapsing the difference between the myth of the end of painting and the defeat of fascism. This is a conceit that seems to draw in highly problematic ways on the phantasmagoria that fascism itself is the ultimate Gesamtkunstwerk, requiring a world historical Götterdämmerung at its end: Berlin 1945 as the last act of Hitler's infatuation with Richard Wagner and Kiefer's work as a memorial to that fatal linkage between art and violence. *Nero Paints*—indeed.

But such a negative reading of the architecture paintings is contradicted by the Margarete/Shulamite series, a series of paintings based on Paul Celan's famous "Death Fugue," a poem that captures the horror of Auschwitz in a sequence of highly structured mythic images. In these paintings, where Kiefer turns to the victims of fascism, the melancholy gaze at the past, dominant in the architecture paintings, is transformed into a genuine sense of mourning. And Kiefer's seemingly self-indulgent and narcissistic obsession with the fate of painting reveals itself here in its broader historical and political dimension. In the German context, Kiefer's turning to Paul Celan, the Jewish poet who survived a Nazi concentration camp, has deep resonance. In the 1950s, Theodor Adorno had claimed that after Auschwitz lyric poetry was no longer possible. The unimaginable horrors of the holocaust had irretrievably pushed poetic language, especially that written in German, to the edges of silence. But Celan demonstrated that this ultimate crisis of poetic language could still be articulated within language itself when he confronted the challenge of writing a poem about the very event that seemed to have made all language incommensurate.[13] I would suggest that in the Margarete/Shulamite series, especially with *Your Golden Hair, Margarete* (1981) and *Shulamite* (1983), Kiefer succeeds in doing for painting what Celan did for poetry more than forty years ago. In this context Kiefer's equation of fascism with the end of painting takes on a different connotation. For him, too, as for Celan and Adorno, it is indeed fascism that has brought about the ultimate crisis of art

Anselm Kiefer
Your Golden Hair,
Margarete
Oil, acrylic, emulsion,
charcoal, straw on burlap
1981

in this century. Fascism has not only revealed the extent to which poetry and painting can never be commensurate to the world of historical violence. It has also demonstrated how politics can ruthlessly exploit the aesthetic dimension and harness it in the service of violence and destruction.

The Margarete/Shulamite paintings, which draw on the refrain of Celan's poem "your golden hair Margarete, your ashen hair Shulamith," avoid figuration or any other direct representation of fascist violence. In conceptualist fashion, *Your Golden Hair, Margarete* conjures up the curvature of the German woman's hair with a bow of straw imposed on the center of a barren, high-horizon landscape. A painted black curve echoing the shape of Margarete's hair evokes Shulamite, and the title of the painting is inscribed in black above both. In this painting, the black of Shulamite's hair becomes one with the black markings of the land—again an indication that Kiefer's dark ground colors refer primarily to death in history rather than to mythic renewal, as is so often claimed. And the combination of real straw with black paint furthermore points to the Nuremberg and Meistersinger paintings from the early 1980s, paintings that use the same colors and materials in order to evoke the conjunction of Nuremberg as site of

Wagner's *Meistersinger* and of the spectacular Nazi party conventions filmed by Leni Riefenstahl in *Triumph of the Will*.

But perhaps the most powerful painting in the series inspired by Paul Celan is the one entitled *Shulamite*, in which Kiefer transforms Wilhelm Kreis's fascist design for the Funeral Hall for the Great German Soldier in the Berlin Hall of Soldiers (c. 1939) into a haunting memorial to the victims of the holocaust. The cavernous space, blackened by the fires of cremation, clearly reminds us of a

gigantic brick oven, threatening in its very proportions, which are exacerbated by Kiefer's use of an extremely low-level perspective. No crude representation of gassing or cremation, only the residues of human suffering are shown. Almost hidden in the depth of this huge empty space we see the seven tiny flames of a memorial candelabra dwarfed by the horror of this murderous space. Kiefer succeeds here in avoiding all the ambiguity that haunted his other paintings of fascist architecture. And he is successful because he evokes the terror perpetrated by Germans on their victims, thus opening a space for mourning, a dimension that is absent from the paintings I discussed earlier. By transforming a fascist architectural space, dedicated to the death cult of the Nazis, into a memorial for Nazism's victims, he creates an effect of genuine critical *Umfunktionierung,* as Brecht would have called it, an effect that reveals fascism's genocidal telos in its own celebratory memorial spaces.

Let me conclude these reflections on Kiefer by coming back to my theme of myth, painting, and history as it is articulated in one of Kiefer's most powerful works, the painting entitled *Icarus—March Sand* (1981). This painting expresses

Anselm Kiefer
Icarus—Sand of the
Brandenburg March
1981

paradigmatically how Kiefer's best work derives its strength from the at times unbearable tension between the terror of German history and the intense longing to get beyond it with the help of myth. *Icarus—March Sand* combines Greek myth with the image of a Prussian, then East German, landscape that, to a West German, is as legendary and mythic as the story of Icarus's fall. The painting does not articulate a passionate scream of horror and suffering that we might associate with expressionism. Instead we get the voiceless crashing of the two charred wings of Icarus in the mythic landscape of the Brandenburger Heide, the March Heath, site of so many battles in Prussian military history. Kiefer's Icarus is not the Icarus of classical antiquity, son of an engineer whose hubris was chastized by the gods when the sun melted his wings as he soared upward. Kiefer's Icarus is the modern painter, the palette with its thumbhole replacing the head. Icarus has become an allegory of painting, another version of Kiefer's many flying palettes, and he crashes not because of the sun's heat above, but because of the fires burning beneath him in the Prussian landscape. Only a distantly luminous glow on the high plane of the painting suggests the presence of the sun. It is a setting sun, and nightfall seems imminent. Icarus is not soaring toward the infinite; he is, as it were, being pulled down to the ground. It is history, German history, that stunts the painterly flight toward transcendence. Painting crashes. Redemption through painting is no longer possible. Mythic vision itself is fundamentally contaminated, polluted, violated by history. The stronger the stranglehold of history, the more intense the impossible desire to escape into myth. But then myth reveals itself as chained to history rather than as history's transcendent other. The desire for renewal, rebirth, and reconciliation that speaks to us from these paintings may be overwhelming. But Kiefer's work also knows that this desire will not be fulfilled, is beyond human grasp. The potential for rebirth and renewal that fire, mythic fire, may hold for the earth does not extend to human life. Kiefer's fires are the fires of history, and they light a vision that is indeed apocalyptic, but one that raises the hope of redemption only to foreclose it.

Kiefer in Berlin

The Anselm Kiefer
exhibition at the Berlin
Nationalgalerie.
Installation photo.
1991

German newspapers have never tired of pointing out that Anselm Kiefer's reputation as the most successful German artist since Beuys was made in the U.S.A., and there, it is intimated, by a mysteriously homogeneous group of "Jewish-American collectors." Those misguided souls—this is the subtext—bought Kiefer at a time when the German critical establishment knew for sure that this artist, with his teutonic image worlds, his Wagnerian monumentalism, and his nebulous disposition toward myth and catastrophe, was an irrationalist and a reactionary, if not a proto-fascist. Kiefer and Syberberg, according to the consensus, were the twin evils of an otherwise reputable culture. Even today, German critics often reproach the American Kiefer reception *in toto* for its lack of critical awareness and pictorial skepticism toward an art that is said to rely on facile fascination and bombastic mise-en-scène.[14] America is said to have given in to the lure of morbid images of an aestheticized apocalypse and to the hype about the artist as a redeemer. German and American views stand in a strange reciprocity: while the Germans believe that Kiefer's problematic "Germanness" has (undeservedly) enhanced his reputation in the United States, the American Kiefer triumphalists have embraced Kiefer as an artist who for political reasons is not properly appreciated in his home country.[15] While there is some truth to both propositions, such judgments betray mainly projective needs and the temptation of scandal: Whose Kiefer is it? and How German is he? And they block the more interesting question of how this Germanness functions differently in the United States from the way it does in Germany. When American critics praise Kiefer as the lone artist-hero who struggles against the repression of the fascist past in his own country, they simply betray an ignorance of the fact that the coming to terms with the past, *Vergangenheitsbewältigung,* has been the dominant ethos in West German intellectual life for the past thirty years. To accuse a predominantly left-liberal German culture of the repression of fascism is ludicrous. For German critics the issue was rather how Kiefer went about dealing with this past. To them, Kiefer's deliberate strategy of opening the Pandora's box of fascist and nationalist imagery amounted to a kind of original sin of the post-Auschwitz era. Yes, in his earlier work Kiefer was indeed fighting repression. However, it was not Germany's unconscious repression of guilt that his work tried to blow open. It was rather the deliberate and conscious repression of fascist image worlds on which the left-liberal consensus of *Vergangenheitsbewältigung* was built. But the difference in registers of repression was not recognized by either side in this transatlantic non-dialogue: America wanted the artist as lone ranger; Germany wanted to maintain the comfort and good conscience of its anti-fascist taboo zone.

There is reason to believe that the major German Kiefer exhibition, which ran

from March 9 to May 20, 1991 at the *Nationalgalerie* in Berlin, has helped move
the debate about Kiefer's work away from such questions of national identity and
projections of his ultimate greatness. As images of fascist architecture and nine-
teenth-century nationalist traditions have given way in Kiefer's more recent work
to clusters of images related to the Kabbalah, the Old Testament, and to Greek
and Oriental mythology, the fascism reproach has receded, but the specter of the
"Jewish-American collector" and the made-in-America reputation still haunts
the critics and serves as a loaded cipher for their continuing discomfort with the
artist's work.[16] As the reviews of the show demonstrate, the reasons for this
discomfort were increasingly, if tentatively, articulated in properly aesthetic
terms, but feuilleton reactions to the exhibit still suffered from an overload of
expectations and the after-shocks of the earlier controversy. The Syberberg-Kiefer
parallel, at any rate, has fortunately been dropped from the gammut of criticism,
an indication perhaps that German reactions to Kiefer's work are now shifting.

Here it is important to remember that with one exception (Düsseldorf 1984)
all the major Kiefer exhibitions had taken place abroad, and knowledge of the big
American retrospective of 1987–1988 had only come to Germany in bits and
pieces. All the more intense were the expectations at the opening of the extensive
Berlin exhibition installed by the artist himself and a team of assistants in four
weeks of hard physical labor. The timing could hardly have been better: Kiefer
comes to Berlin, the political and cultural capital of the new, reunited Germany.
And he comes massively: with fifty-eight paintings, graphic works, and sculptures,
most of them huge and heavy, only eight of which predate 1985. Most of the
Nationalgalerie exhibition halls were emptied for the show. Ceilings were rein-
forced to carry the immense weight of the lead sculptures. The considerable cost
of the exhibit was born by the Association of Friends of the *Nationalgalerie*. This
was to be the biggest Kiefer exhibit in Germany yet, and the pre-opening advertis-
ing made sure everybody knew it. Would it be the triumphalist homecoming of
the painter-hero whose earlier work might now look like a prophecy of nation and
unification? Or would his recent work confirm the fears of German intellectuals
about a Fourth Reich waiting in the wings? Of course, such questions would have
been even more pertinent had the show opened, as originally planned, during
unity celebrations in the fall of 1990 before the long and painful slide of the Eastern
provinces into economic and social disaster, not to mention the German triumph
of the will to total peace during the gulf war. By the time the show opened in early
March, the euphoria of unification had gone flat; Germany rather than George
Bush was the wimp; and Berlin could not even be sure whether it would become
the seat of government or remain the capital for representational functions only.

Kiefer in Berlin: for certain expectations, based on the earlier Kiefer controversy, nothing seemed to work. But if the anticipated scenario never got off the ground, it was as much due to the protean nature of Kiefer's work itself as it was to the sheer force of political contingencies.

When I visited Kiefer in the summer of 1990 in his studio-factory in Buchen to discuss the upcoming exhibit in Berlin, I was struck by the fact that the national imagery of his earlier work had all but disappeared from the recent projects. The then imminent unification of Germany did not elicit any kind of emphatic response from him. More significant was the care and attention to detail with which he was preparing for the Berlin exhibition: an on-scale model of the exhibition space at the *Nationalgalerie* occupied the center of the expansive factory hall. Miniature versions of the sculptures and paintings (based mostly on like-sized photographs) could be positioned and repositioned in the various halls, and Kiefer seemed quietly obsessed with the planning for the show. Nothing, it seemed, was being left to chance.

When asked at a 1991 press conference why he had been interested in exhibiting in Berlin, Kiefer dryly replied: "This impossible building." And impossible it is, this museum, built by Mies van der Rohe in 1968, with its flat-roof, black steel and glass construction and mighty green marble pillars that make the main exhibition hall look like an up-scale gigantic automobile show room. But Kiefer's preparations paid off. The show was extremely well hung and the use of space and light beautifully made to group and highlight works from different stages of production. The exhibit was organized not in chronological order, but in an attempt to strike sparks from the juxtapositions and oppositions that allowed the spectator to trace a dense web of related motifs, pictorial strategies, and material techniques. Contrary to the show that had been on display in Philadelphia, Chicago and New York, it was not a retrospective, but with about six works from 1990 and another six from 1991, some of them not yet finished, it was more like a work-in-progress exhibition.

The huge hall on the main floor held mainly the most recent sculptural work—five lead airplanes and a rocket (most from 1989 and 1990) as well as three huge book sculptures, one of which had been shown at Anthony d'Offay in London (*High Priestess*, or *Zweistromland*), and another at Marian Goodman's in New York (*Breaking of the Vessels*). Elevated iron ramps were constructed around the hall's two rectangular pillars to permit spectators an aerial view on these strange melancholic birds that are forever earthbound just as the lead books are

too heavy to be taken off their shelves. These stranded sculptures on the ground floor were combined with thematically related paintings. The compartmentalized show-rooms on the lower level displayed the typically gigantic paintings and a number of large-size graphic works behind glass that resemble sketches, even drawings, though they are primarily made of worked-over photographs, lead sheets, and paper. The hanging was sparse; it avoided overcrowding, and moved the spectator rhythmically through the exhibition. Rarely have I seen an exhibition at the *Nationalgalerie* that worked as well as this one, which was prepared with the help of Mark Rosenthal, curator of the American show, and Angela Schneider, curator at the *Nationalgalerie*.

If one asks what is new in Kiefer's work from the late 1980s, apart from the abandonment of Germanic themes in favor of motifs taken from Jewish mysticism, Greek and Oriental mythology, there are three immediate answers: the use of Saturnian lead as a magically subtle, visually rich and conceptually loaded lead material; the attempt to leave the image routine and move into sculpture, with the lead airplanes and libraries as well as with an expansion of the sculptural elements on the paintings; and a new experimentation with perspective which is more complex and fragmented in the recent work than it was in the central-perspective high-horizon paintings of the 1970s. Rather than speaking of a new departure, however, it would be more appropriate to speak of a thematic and formal expansion in concentric circles. The concern with basic and mythic materials was always there—lead now replaces straw and clay. The making of books also goes back to Kiefer's early years. Thus the three massive and weighty lead libraries (*Zweistromland, 60 Millionen Erbsen, Bruch der Gefäße*) only represent the move from the artist's book to large-scale sculpture. Similarly the lead airplanes can be seen as a conceptual expansion of the flying palettes of the earlier work. Just as the palette was always an emblem of the act of painting and seeing, the recent airplanes are conceptually connected with the shift to aerial views, the gaze from above, in much of the more recent work.

Also new is Kiefer's willingness to abandon his former seclusion, to give interviews, and to have some of his projects presented photographically in newspapers.[17] Such interviews have made it clear that Kiefer sees his work in dialogue with Warhol and Beuys, Duchamp and Pollock, as well as Informel and Concept Art rather than simply as a contemporary revival of Northern romanticism à la Caspar David Friedrich or as a postmodern break with the experiments of post-1945 avant-gardism. While he does not share Joseph Beuys's provocative view

that everybody is an artist, he has gone to great length to reject the mystification of the individual artist as genius so often attributed to him by the Kiefer triumphalists. Whether his own stated view of the artist as medium is ultimately further from traditional concepts of a privileged aesthetic creativity than the radical experiments of Beuys and Warhol is certainly open to debate. But even if it were not, that in itself would not necessarily vitiate Kiefer's project of picture making. The ethos of an aesthetic democratism, so characteristic of certain 1960s avant-garde practices and revived in recent years in the name of multiculturalism, is itself a complex mix of laudable political intentions, conceptual confusion, and empty rhetoric that holds no absolute claim on truth.

Kiefer has also countered the pretentiousness of many learned explanations of his use of mythical themes, names, and materials. He particularly rejects the role of learned allegorist, emphasizing instead the banal everyday character of objects, materials, and words as initial impetus for aesthetic discoveries. He simply points to the fact that certain names and concepts have been overlaid with inexhaustible layers of meaning which in turn have created a kind of aura around names such as Lilith, Jason and Medea, Isis and Osiris. Even names from recent poetry—Celan's Margarete and Shulamite or Ingeborg Bachmann's *Karfunkelfee* can be carriers of the kind of a poetic aura that often serves as initial impetus for Kiefer's work. The tension between word and image, operative in most of Kiefer's work, is so strong that one may be tempted to see him as a poète manqué, a writer who cannot resist the pull of the image and somehow ends up in the wrong medium. At any rate, his rejection of the *pictor doctus* (erudite painter) role should give pause to those bent on creating more learned commentaries on Kiefer's use of the Kabbalah, on the alchemists' fascination with lead, or on his views on the myths of creation. It is the layered and fragmented complexity of the mythic materials, names, and symbols that he wants to capture in visual sedimentations. No learned exegesis will ever put all the fragments back together again.

Thus even as Kiefer relies on the spectator's ability to conjure up some of the auratic qualities of names, places, and materials, the spectator is not required to be a member of an educated elite. On the contrary, Kiefer knows too well that the educated bourgeoisie of old has disappeared and cannot be resurrected. But that leaves him in the dilemma of having to explain how spectators can gain access to the mythic materials around which he weaves his images. His solution to the problem lies in something like the Jungian archetypes. "Our memory," he said in an interview, "is not just formed when we are being born; it comes from far away, has stored basic experiences and attitudes that have gathered in thousands of years."[18] This reliance on collective memory is of course as problematic today as

it was when Walter Benjamin resorted to Jung to read the myth worlds of nineteenth-century modernity. But then Kiefer does not pretend to give a scientifically cogent explanation. One can also argue that in the processes of acculturation, mythical materials from the distant past are still being recycled today to the extent that many viewers' imagination will be set in motion when they are confronted with Jason and the golden fleece, Siegfried and Brünhilde, Lilith and the myths of creation. If one considers that many of the myths central to Kiefer's work do not primarily come to us from the depths of the past, but from knowledge of the Bible or from memories of the late nineteenth century (Wagner and the Nibelungen), the whole issue of some mystical collective memory can be laid to rest. Ultimately, it depends on the individual spectator to what extent he or she wants to engage with the writing and inscriptions, how far he or she wants to follow the thread of the mythic stories Kiefer simultaneously alludes to, conjures up, and erases. Just as Kiefer has described the material process of his picture making as a kind of reverse archeology, the viewer, too, is free to add layers of allusion and meaning. The spectator's guilt about lack of knowledge, which reappears as resentment in the critics' complaint about Kiefer's reliance on distant bodies of knowledge, may say more about the state of contemporary culture than about Kiefer's paintings. For even if one wants to give oneself over to the visual imagery alone, immerse oneself in the sedimentations of photography, paint, ashes, emulsions, shellac and lead, and ignore the complex layers of naming, titling, and inscribing, the aesthetic experience will still be richly textured. The popular success of the Berlin show testifies to that. One of the characteristics of Kiefer's work is that it is both easily accessible and subtly hermetic. Hermetic not in the sense of a body of hidden knowledge, but in the sense of an elusiveness which prevents seeing and interpreting from ever coming to rest.

The interest in the newer work lies precisely in the inability to decide whether Kiefer works as a painter or a story teller. He constantly crosses the line between them. He loads his images with words, and transforms names into powerful images. It is as if he perpetually reenacts the historical iconoclasm controversy trying to, at the same time, validate both sides of the issue: sometimes with words against images, sometimes with images against words. At best, the inscriptions, still typically in childlike handwriting, can function to break the lure of immediacy, thereby opening the painting up to multiple layers of reading; and the images in turn can force a visual eruption in the imagination, for example in the gorgeous but unfinished Lilith painting of 1990 in which a mane of black hair

forms the center of a whirl of ashes invading a painted-over cityscape seen obliquely from above. In this Lilith painting, Kiefer conjures up the story of Adam's legendary first wife, the non-Eve whose identity has always been coded as demonic and insubordinate and whose independence was rooted in the fact that she was not formed from Adam's rib. The old story of Lilith meeting the demon in the ruins merges with visions of cities in ruins, urban decay, the haze of pollution. The violent whirl of ashes conjures up the Brechtian poetic topos

Anselm Kiefer
Lilith
1990

"Von den Städten wird bleiben: der durch sie hindurchging, der Wind!" (Of those cities will remain: what passed through them, the wind!) The age-old topos of equating the metropolitan body with the female body (the great whore Babylon) is deliberately restated as myth and retracted by the double disembodiment of Lilith, who appears in the form of hair and language only. Of course, the story is never fully told by a single picture. Other Lilith paintings take up other parts of the legend (*Lilith's Daughters*), and the greyish little dresses, encrusted with ashes and attached to the canvas will appear as well in other paintings that have nothing much to do with the persona of Lilith (e.g., *Jason and Medea*) thus

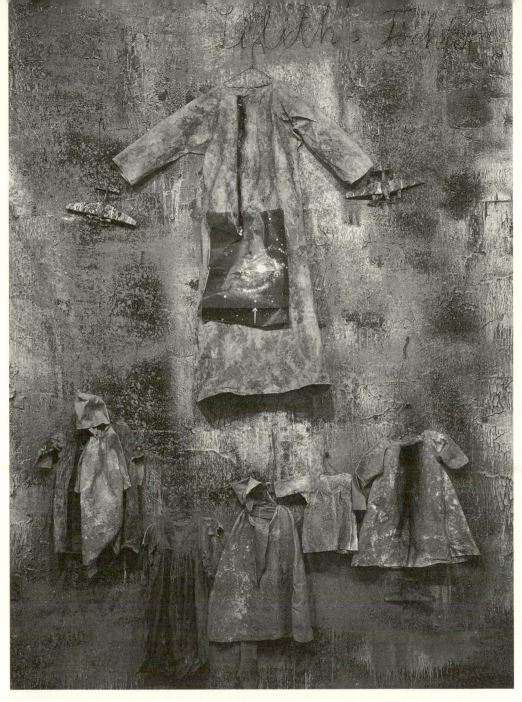

displacing us from one narrative nexus to another. All we get are fragments from a memory that lies in ruins itself. Words and image combine to form material *Denkbilder*, thought-images in which narrative and conceptual, material and pictorial elements remain in a permanent fluctuation that eludes any attempt to pin them down. The same names and words appear on different pictures thereby

Anselm Kiefer
Lilith's Daughters
1991

complicating the web of narrative and pictorial elements. The mythic repetition employed here does not provide a stable ground, however. The disparate narrative elements never amount to some meta-narrative. Even the small mythic stories such as those of Jason or Lilith appear only in fragmentary form in which memory ruins of the past are overlaid by the debris of the present. Whether Kiefer's work on myth ultimately aims at some great synthesis, at some "*grand recit*" is hard to tell. Whatever he himself may say in interviews, his work is asking the questions rather than pretending to give answers. If anything, the space of the "*grand recit*" is postulated as an absence, non-representable and forever elusive, around which Kiefer's pictures circle in futile, but beautiful motion.

It has often been said that Kiefer's work on myth derives from the work of Joseph Beuys, but despite certain similarities (the critique of modern science and progress, the rediscovery of aura, the rejection of symbol and allegory in a traditional sense), Kiefer handles myth very differently. The use of writing as opposed to Beuys's oral performances is the key difference here. Contrary to Beuys, from whom Kiefer learned much in the 1970s, Kiefer is not the latter-day shaman whose use of materials and performance strategies comes out of an existential experience and gains its utopian healing power from that framework. Kiefer works more like a secular bricoleur, with a Gargantuan appetite for mythic stories and references, but also with an acute consciousness of loss and an insight into the impossibility of attaining some ultimate reconciliation. Beuys's fat and felt embodied an emphatic vision of healing and nurturing. Kiefer's lead remains fundamentally ambivalent: it may turn into the alchemist's gold, but it remains poisonous. It protects against radiation, but it absorbs all light. It is grey, dead matter, but begins to shine when subjected to processes of erosion and oxydation. It is associated with Saturn (the least lit planet in our solar system), with darkness, black gall, and melancholy, but then melancholy has always been considered central to the artistic imagination. For Kiefer, myth itself is neither some primary reality, nor a guarantee of an unquestioned origin. It is rather an attempt to construct meaning and reality through storytelling in images.

Kiefer's work as bricoleur of images, names, stories, materials, and concepts involves taking risks. The main risks are those of unchecked repetition, illustration and overcoding. Nowhere are these risks more visible than in the airplane sculptures. The very fact that so many critics felt obliged to make some trite reference to mesopotamian bombers and the gulf war (the land of Euphrates and Tigris plays an important role in Kiefer's recent imagery) shows that something

here didn't work, and the blame is not entirely the critics'. Material and conceptual execution fall apart when the plane entitled *Jason* features little show-cases in the wings that display human teeth (referring to the teeth of the dragon which, seeded, produced the warriors Jason had to fight). Other such display windows feature lumps of earth in a rocket (*Resurrexit*), snakeskin in a cockpit (the snake and the eagle), and a woman's hair in the wing of a plane entitled *Berenice*—the mythical figure who sacrificed her hair which then turned into a constellation in the skies. One plane, entitled *Melancholy*, carries Dürer's polyhedron filled with dust and debris from the studio floor on its wing. Such literalness, which is matched by the literalness of the critics' babbling about the gulf war, is at best whimsical. The step from the sublime to the ridiculous can be a small one, but it is to Kiefer's credit that he risks taking it without safety nets.

Indeed, the exploration of the tension between banality and sublimity may be as central to Kiefer's work as the Baudelairean dialectic of the eternal and the fugitive was to modernism. That tension is persuasively maintained in the book sculptures, but not in the airplanes. To my mind, the planes function well aesthetically only on a conceptual level. They work conceptually as carriers of ideas, transporters of stories, vehicles of a gaze. The problem, sensed by Kiefer—that as sculptures they remain quite redundant—is not solved by their narrative inscriptions. As soon as these planes are loaded with particular stories (*Jason, Berenice*), they crash as art works, and fail as sculpture.

There is, however, one exception: *Mohn und Gedächtnis* (Poppy and Memory) which refers to Paul Celan's first book of poetry of 1952. It is a low hanging plane with four jets under the wings and two additional ones on the oversized tail. More than any of the others it looks like a stranded bird, with the cockpit window as an eye and the welding of the nose barely hinting at a beak. Like a Baudelairean albatros, emblem of stifled creativity, it was the first work visible upon entering the museum. The wings are weighted down with oversize lead books whose pages ooze out dried poppy flowers in the direction of flight, suggesting a future already forgotten. The rumpled and bumpy lead surfaces of the plane display a supernatural white shine, as if the material was in the process of turning into silver. Emblem of time and forgetting, the impossible desire to fly, the burden of knowledge and the necessity to forget in order to remember, this sculpture works as a richly figurative conceptual work. It was already once exhibited at the Galerie Paul Maenz in Cologne in a show entitled "The Angel of History," a reference to the famous image in Benjamin's "Theses on the Philosophy of History," of the angel looking backward at the ever growing piles of ruins of the past as he is helplessly propelled into the future by a storm from paradise that catches his wings. Here the

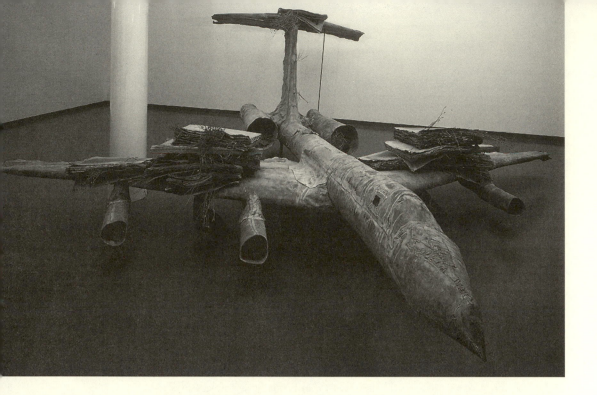

Anselm Kiefer
Poppy and Memory
1989

overloading works, and it works because it remains conceptual rather than turning narrative. The trajectory from the banal materiality of the lead object to the spirituality of a web of allusions rendered visual is successfully completed, the tension between the massive gravity of things and the light spirituality of Benjamin's image or Celan's poetic language is maintained, and the ridiculous avoided.

Similarly successful are the three library sculptures, especially the one entitled *Zweistromland* which refers to the land of the two rivers, Euphrates and Tigris, the land of Gilgamesh and of writing on fired clay tablets at the dawn of civilization, the legendary origin for Christian, Jewish, and Assyrian traditions. Two four-meter high steel shelves, slightly angled and separated only by a large piece of rectangular glass, hold close to two hundred heavy lead folios of different sizes, most of them in ruins. The tomes are loosely arranged; some of them are piled up horizontally. Some are more disintegrated than others; torn and crumpled lead pages flow over the edges of the shelves. Even though some seventy of the folios contain collaged materials (photographs of clouds, aerial views, landscapes and cityscapes worked over with emulsions, oxydations in colors reaching from light green, to pale pink to ocher), this is not a library for reading. These books remain inaccessible to the human gaze except in their sheer weight and materiality. They are simultaneously monument and elegy to the power of knowledge, an embodiment of the burden of wisdom written in lead, the primary matter destined to turn into gold, if not into pure spirituality. The clusters of copper wires, carriers

of energy, protruding here and there from the folios and sticking into space, may signal the electrical implications of "Zweistromland" (land of two rivers, *Strom* meaning both stream, river and current), but against the backdrop of the white wall or the transparent glass they work beautifully as a kind of drawing in space, much better than in some of the paintings that also feature copper wires in front of painted and sculpted surfaces.

The idea of welding thin lead sheets together into books gains yet another dimension in *Breaking of the Vessels*, a title that refers to the creation myths of the

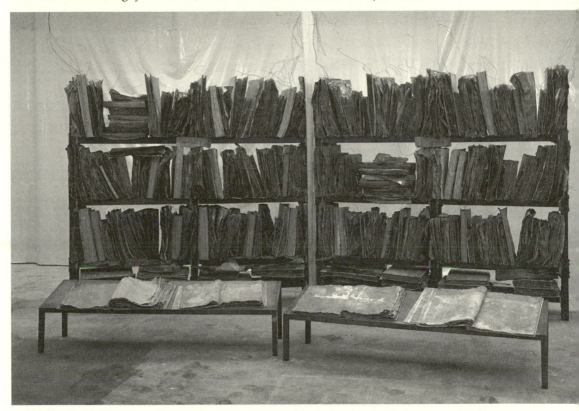

Kabbalah. Here the books represent the vessels of the Sefirot that held the divine light and substance but were unable to contain it and broke. But never mind the kabbalistic references. These books are visually overwhelming as they tumble off their shelves and release shards of glass that lie shattered on the ground. Here again a whole set of associations sets in—from the custom of breaking glass at wedding ceremonies (both in the Jewish and Christian tradition) to the Kristallnacht pogroms, the Night of Broken Glass, from the notion of shattered transparency to that of the ultimate fragmentation of all knowledge. But the

Anselm Kiefer
*The High Priestess
(Zweistromland)*
1985–89

central force that holds this work together is the material constellation of the lead books and the glass shards. The lead, which makes up the pages of the books, is impenetrable and opaque, the furthest away from the luminosity of white paper. But it remains flexible and soft rather than brittle like aging paper. Glass, on the other hand, is transparent, but hard, rigid and inflexible. What better material embodiment could there be imagined between the mysteries the scriptures hold and the reified use a culture makes of them in multiple fragmentary interpretations. But then there is also the inscribed half-circle of glass crowning the sculpture, as if it were a crucifix, and six, somehow and no doubt deliberately helpless looking arms or signposts sticking out from the sides and inscribed with the names of the vessels of the Sefirot.

**Anselm Kiefer
Detail from** *High
Priestess (Zweistromland)*
1985–89

Here, less would have been more, just as in the third library, *60 Millionen Erbsen*, which works as a whimsical satire on a recent and much opposed government attempt to use a national census as a means to increase surveillance and data gathering. The rectangular sculpture is made up on three sides of solid walls of lead books on steel shelves, leaving only a small entrance on the fourth side through which the spectator can enter this prison of dead data. Sixty million peas, one per capita of the population, have been pressed into the lead pages of the books. Counting peas (counting beans in American parlance) is a motif of punishment in folk-tales, but it signifies here the sheer stupidity of counting a population. Some of the peas have fallen off their pages, leaving little holes which make the page look like the early, punched computer cards. The claustrophobic effect inside this installation, combined with the humor of the pea-counting enterprise and the reminder of the authoritarian threat of writing and scripture would have carried the work. But Kiefer added a whole set of instruments of surveillance (such as lead cameras, film strips, a doctor's speculum, etc.), all of which serve to overcode and illustrate rather than add substantially to the play of significations the sculpture triggers. The question, of course, is whether such a critique, based on the notion "less is more," does not itself embody an aesthetic sensibility which Kiefer's work has set out to counteract in the first place. However one may stand on this issue, it is with the book sculptures that

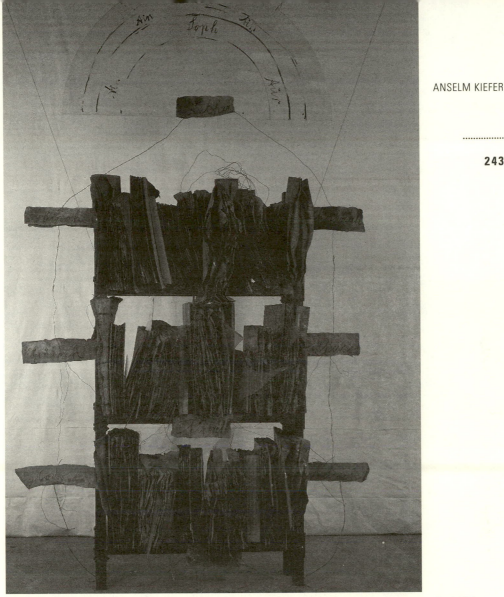

·················

243

Anselm Kiefer
Breaking of the Vessels
1989–1990

Kiefer has moved most successfully from "painting" into "sculpture."

All the more regrettable was the absence of examples of Kiefer's smaller scale book projects in this exhibition. The reason is understandable: an exhibition of Kiefer's books from 1969 to 1990 was on display in Tübingen, Munich, and Zurich in 1990 and 1991. And yet, at least a few representative samples could have provided another perspective on the book sculptures, just as they could have elucidated the function of the book as the experimentation ground for the large pictures. Kiefer's books are a necessary link between his painterly and sculptural projects.

Anselm Kiefer
The Cutting Table
1989–1990

If Kiefer's working process began with the book, then one will easily understand his recent turning to film as another medium based on sequential narrative rather than on visual simultaneity. While he does not (yet) make films, he mounts film strips and film spools on the surfaces of paintings. *The Golden Fleece* (1990, unfinished) and *The Cutting Table* (1990) are works that exemplify Kiefer's more recent aerial view, a gaze at a flat surface. The paraphernalia of film strips, spools, and cutting table equipment mounted on the surface have the same dysfunctional, desolate look as the books: another archive in ruin. While photography has always served Kiefer as a starting point for his picture making archeology in reverse, it is too early to tell what will become of his new engagement with film. So far, it seems primarily thematic.

The abandonment of illusionistic space and the return to sculpturally enriched abstract expressionist surfaces in what one might call the film paintings is less interesting than the attempt to experiment with multiple perspectives as in *Barren Landscape* (1987–1989), another powerful and threatening metropolitan scene which combines an angled aerial view of a metropolis with an almost indecipherable tunnel view from below. Also successful for its simultaneous positing and erasing of perspective is the overlay of cartography in lead over a high-horizon landscape in the painting entitled *Fuel Rods* (1984–1987), arguably one of the

most strikingly beautiful paintings in the exhibition. Nowhere is the ambivalence of lead as both destructive and protective suggested more imaginatively than in this work in which peeling-off and ripped sheet lead covers the landscape while simultaneously protecting it from nuclear radiation. Conceptual narrative and material surface are brought into a richly textured and suggestive negotiation. Similarly striking is the clash of illusionistic effects with large and flat oxydized lead surfaces, invading the picture space from above as a kind of emanation that resembles a curtain falling over a landscape, most effectively executed perhaps in *Entfaltung der Sefirot* (1985–1988).

Often these landscapes have been described as apocalyptic and catastrophic, landscapes after the end of history. Certainly the violence palpable in the treatment of the surfaces of the paintings might support that reading. But then there is the undeniable and stunning beauty of the visual effects, the luminosity of the horizon in *Brennstäbe*, the utopian promise of the lead book in front of the oceanscape in *The Book* (1979–1985). Thus one may just as well see them as landscapes of an imaginary mythic beginning, of creative chaos in which the grey and dead primary matter (lead) begins its trajectory toward new dimensions of visuality.

Just as in the case of the sculptures, the danger of overcoding and illustration haunts the paintings as well. Clearly, Kiefer uses the humorous, whimsical side of his imagination to retract or to relativize the potentially pompous and megalo-maniacal effect of his large-scale paintings and their apocalyptic subject matter. But when he affixes little self-made toy airplanes or ships to his canvases, the effect is in most cases too literal, if not outright silly. Again, the experiment on the

Anselm Kiefer
Fuel Rods
1984–87

threshold between the sublime and the banal slides into the ridiculous. But "failures" such as these are more than compensated by all the works in which sheer visual beauty and conceptual lucidity emerges from the clash of the non-representable and the trivial.

This newer work of Kiefer's has drawn a number of reproaches in Germany. I will not take up here the continuing inability of some German intellectuals to see Kiefer's use of myth as anything but an irrational denial of history, their obsessive rejection of Kiefer's references to first and last things, and the claim that such concerns only represent the artist's hubris of recreating a lost identity. These criticisms are patently false, and based more on a projection of the critics' own fears and self-righteousness than on a sustained looking at Kiefer's work. More interesting is the reproach that Kiefer's paintings are too beautiful, that while his work articulates the immolations of painting in the sheer violence of their execution, it fails to problematize its suggestive and seductive aesthetic semblance. Indeed, the lack of self-reflection is like original sin in the realm of contemporary art. The necessity of self-reflection was a modernist credo, and to engage with the beautiful remains a powerful taboo in the world of postmodern contemporary art. The beautiful is simply equated with design, if not with the affirmative lure of advertising or the machinations of mass culture. No place for it in art. The recent privileging of the sublime over the beautiful in Lyotard's influential work has given us the new postmodernist-modernist legitimation for denigrating the beautiful.[19] But isn't this Lyotardian coding of the sublime as the non-representable itself a rewriting of the old modernist desire for transcendence? Isn't the dichotomy of the sublime and the beautiful, inherited as it is from eighteenth-century aesthetics, indebted to the modernist struggle against mass culture, to the often obsessive separation of authentic art from the "merely beautiful," which was defined as false harmony or forced reconciliation?

I think one can respond in two ways to this reproach. The weaker, though by no means illegitimate response would be to insist that Kiefer actually does problematize the role of painting and sculpture. Crashing palettes, stranded airplanes, his use of materials—all the eclectic inscriptions of the art of the past forty years in his project point to the fact that he and his work are fully conscious of the crisis of art in the late twentieth century. The stronger response would be to say that, yes, there is this undeniable beauty even in the works that problematize painting today. But rather than collapse the beautiful with inconsequential affirmation (as if the sublime had a hold on critical aesthetic effectiveness), one can see Kiefer's

search for beauty, his deliberate embrace of visual theatricality, his immersion in
the diaspora of mythical stories and conceptual narratives as attempts to break
out of the prison-house of an aesthetic that remains tied to the long-standing
denigration of the "merely beautiful." Kiefer's work does indeed call for a
renewed engagement with the beautiful. That can be seen as its strength, rather

than as its weakness. It is a strength because he does not simply reverse the hier-
archy of terms by privileging the beautiful. His aesthetic practice eludes the tradi-
tional dichotomy by opening it up to a hidden third term centered on banality,
cliché, the trivial. With this triangular constellation, Kiefer destabilizes the
discourse of the sublime both visually and conceptually and suggests, however
indirectly, that the non-representable sublime (as in abstraction *after*
modernism) can be just as banal as the frills of the culture industry. Beauty, in
turn, can blend with the sublime by drawing on that which the sublime always
excluded with a vengeance: fleeting banality, simple and undramatic repetition,
the transitory register of the world.

It is too early to tell whether Kiefer's experimentations with the beautiful, the
sublime, and the banal will prove successful in the long term. Some have
answered that question, prematurely I think, by making Kiefer into the painter-
genius of the late twentieth century or, conversely, into our fin-de-siecle *pompier*.
In its complex mix of risks taken, embarrassing failures, and stunning successes,
Kiefer's work is not grasped by such facile generalizations. Only the sustained
gaze at specific works will reveal the extent to which the work partakes in the best
of an experimental, modern tradition and its often unstable transformations in a
postmodern age.

Monuments and Holocaust Memory
in a Media Age

... the abundance of real suffering tolerates no forgetting.

Theodor W. Adorno

Only that which does not cease to hurt remains in memory.

Friedrich Nietzsche

I

At a time when the notion of memory has migrated into the realm of silicon chips, computers, and cyborg fictions, critics routinely deplore the entropy of historical memory defining amnesia as a dangerous cultural virus generated by the new media technologies. The more memory stored on the data banks and image tracks, the less of our culture's willingness and ability to engage in active remembrance, or so it seems.

Remembrance shapes our links to the past, and the ways we remember define us in the present. As individuals and societies, we need the past to construct and anchor our identities and to nurture a vision of the future. In the wake of Freud and Nietzsche, however, we know how slippery and unreliable personal memory can be; always affected by forgetting and denial, repression and trauma, it, more often than not, serves a need to rationalize and maintain power. But a society's collective memory is no less contingent, no less unstable, its shape by no means permanent. It is always subject to subtle and not so subtle reconstruction. A society's memory is negotiated in the social body's beliefs and values, rituals and institutions. In the case of modern societies in particular, it is shaped by such public

sites of memory as the museum, the memorial, and the monument. Yet the permanence promised by a monument in stone is always built on quicksand. Some monuments are joyously toppled at times of social upheaval, and others preserve memory in its most ossified form, either as myth or as cliché. Yet others stand simply as figures of forgetting, their meaning and original purpose eroded by the passage of time. As Musil once wrote: "There is nothing in the world as invisible as monuments."[1]

But does it even make sense to oppose memory with forgetting, as we so often do, with forgetting at best being acknowledged as the inevitable flaw and deficiency of memory itself? Paradoxically, is it not the case that each and every memory inevitably depends both on distance and forgetting, the very things that undermine its desired stability and reliability and are at the same time essential to the vitality of memory itself? Isn't it a constitutive strength of memory that it can be contested from new perspectives, novel evidence and from the very spaces it had blocked out? Given a selective and permanently shifting dialogue between the present and the past, we have come to recognize that our present will inevitably have an impact on what and how we remember. It is important to understand that process, not to regret it in the mistaken belief that some ultimately pure, complete, and transcendent memory is possible. It follows that the strongly remembered past will always be inscribed in our present, from feeding our unconscious desires to guiding our most conscious actions. At the same time, the strongly remembered past may turn into mythic memory. It is not immune to ossification, and may become a stumbling block to the needs of the present rather than an opening in the continuum of history.

II

While the capacity to remember is an anthropological given, some cultures value memory more than others. The place of memory in any culture is defined by an extraordinarily complex discursive web of ritual and mythic, historical, political, and psychological factors. Thus, the lament that our postmodern culture suffers from amnesia merely reverses the familiar trope in cultural criticism which suggests that enlightened modernization liberates us from tradition and superstitions, that modernity and the past are inherently antagonistic to each other, that museums are not compatible with a truly modern culture, that a modern monument is a contradiction in terms—briefly, that to be radically modern means to sever all links to the past. Such was the credo of an un-self-critical modernity and many of its avant-gardist aesthetic manifestations earlier in this century. Modernization indeed was the often unacknowledged umbilical chord that tied

the various aesthetic modernisms and avant-gardes to the social and economic modernity of bourgeois society they so intensely hated and opposed.

Recent decades, however, have witnessed growing skepticism toward such ideologies of progress as the dark side of modernization has increasingly impressed itself on the public's consciousness in Western societies in the wake of this century's political totalitarianisms, colonial enterprises, and ecological ravages. In most Western accounts of this crisis of memory and modernity, the Holocaust plays a pivotal role. As Primo Levi once wrote, the Third Reich waged an obsessive war against memory, practicing "an Orwellian falsification of memory, falsification of reality, negation of reality."[2] And we know how such strategies of denial and repression did not end with the downfall of the Nazi regime. Fifty years after the notorious Wannsee Conference at which the Final Solution was first given political and bureaucratic shape, the Holocaust and its memory still stands as a test case for the humanist and universalist claims of Western civilization. The issue of remembrance and forgetting touches the core of Western identity, however multifaceted and diverse it may be.

There have been intensely fought debates on whether we should view Nazi barbarism as an aberration or a regression from Western civilization of which Germany after all was always a part, or if we should put the emphasis on those aspects of National Socialism that tie it, in however extreme and perverted ways, to the modernity of the West. While the thesis that Nazi Germany was an aberration more often than not served the interests of denial and forgetting, and by no means only in Germany, the notion that Nazism was but the logical outcome of the evolution of the West was compromised by the orthodox Marxist equation of capitalism with fascism. Such reductive conclusions, of course, can easily be dismissed. But the question remains a painful one, and it is hard to come up with a clear answer. It is one thing to acknowledge Auschwitz as the major wound of Western civilization whose tissues have not healed and can never heal. It is quite another thing to claim that the industrialized murder machinery of the Final Solution with its systematic degradation of human beings and its planned excesses in "useless violence" (Primo Levi) is inherent in Western civilization itself and represents its logical outcome.

At this juncture, the postmodern debate about amnesia centers on the memory of the Holocaust. Thus, the French philosopher Jean-François Lyotard has gone so far as to equate the post-war Germans' amnesia and repression vis-à-vis the Holocaust with the failure of Western civilization in general to practice anamnesis, to reflect on its constitutive inability to accept difference, otherness, and to draw the consequences from the insidious relationship between enlightened modernity and

Auschwitz.[3] In this view, National Socialism is the singular, but not unique case in which the narcissistic fantasies of omnipotence and superiority that haunt Western modernity have come to the surface. As an antidote to the seductive power of such fantasies, Lyotard has argued that recognition of the other as others—with their histories, aspirations, concrete life-worlds—is paramount. This it seems to me is the ethical and political core of much postmodern, poststructuralist thought, and it has been powerfully prefigured within modernism itself, particularly in the work of Theodor W. Adorno, who with great perspicacity analyzed the dialectic of enlightenment and violence at a time when the death factory in Auschwitz Birkenau was operating at maximum capacity and with ruthless efficiency. Without memory, without reading the traces of the past, there can be no recognition of difference (Adorno called it non-identity), no tolerance for the rich complexities and instabilities of personal and cultural, political and national identities.

Not everyone shares Lyotard's sweeping indictment of Western modernity, a view that foregrounds Auschwitz uncompromisingly as the litmus test for any contemporary reading of the history of modernity and identifies the lack of anamnesis, the weakness of memory, and the repression of otherness as a fatal disease of the modern condition. Thus some neo-conservative German philosophers such as Hermann Lübbe and Odo Marquard have argued that the undisputed erosion of tradition in modernity actually generated compensatory organs of remembrance such as the humanities, societies for historical preservation, and the museum. In this view, social and collective memory, as paradigmatically organized in the museum, in historiography, or in archeology, is not the opposite of modernity, but its product.

Of course, one argument does not exclude the other. Even as modernity generates its organs and discourses of remembrance, modernity's historical memory may still be deficient when it comes to the specific anamnesis Lyotard finds wanting: the recognition of difference and otherness; the reflection on the constitutive reliance, in the social body of modernity, on exclusion and domination; the work of mourning and memory that would move us beyond what Lyotard diagnoses as our "end-of-the-century melancholy." Despite their opposition in evaluating the status of memory in the Western tradition, both views are predicated on the notion that the very structure of memory (and not just its contents) is strongly contingent upon the social formation that produces it.

III

How, then, do the technological media affect the structure of memory, the ways we perceive and live our temporality? As the visual media invade all aspects of

political, cultural and personal life, we may well want to ask what a postmodern memory would look like, memory at a time in which the basic parameters of an earlier self-confident Western modernity have increasingly come under attack, in which the question of tradition poses itself anew precisely because the tradition of modernity itself is lacking answers for our predicament. What of the institutions and sites that organize our social memory in the age of proliferating cable television?

If we look at memory in the postmodern 1980s, we are immediately struck not by signs of amnesia, but rather by a veritable obsession with the past. Indeed, one might even speak of a memorial or museal sensibility that occupies ever larger chunks of everyday culture and experience. The philosopher Hermann Lübbe has diagnosed this expansive historicism of our contemporary culture, claiming that never before had a cultural present been obsessed with the past to the same extent as Western culture was in the 1970s and 1980s when museums and memorials were being built like there was no tomorrow.[4] Even the monument which, after its nineteenth-century excesses in poor aesthetics and shamelessly legitimizing politics, had fallen on hard times in modernism (despite Gropius or Tatlin) is experiencing a revival of sorts, clearly benefiting from the intensity of our memorial culture.

But what are the effects of such musealization and how do we read this obsession with various memorialized pasts, this desire to articulate memory in stone or other permanent matter? Both personal and social memory today are affected by an emerging new structure of temporality generated by the quickening pace of material life on the one hand and by the acceleration of media images and information on the other. Speed destroys space, and it erases temporal distance. In both cases, the mechanism of physiological perception is altered. The more memory we store on data banks, the more the past is sucked into the orbit of the present, ready to be called up on the screen. A sense of historical continuity or, for that matter, discontinuity, both of which depend on a before and an after, gives way to the simultaneity of all times and spaces readily accessible in the present. The perception of spatial and temporal distance is being erased. But this simultaneity and presentness, suggested by the immediacy of images, is of course largely imaginary, and it creates its own fantasies of omnipotence: channel-flicking as the contemporary strategy of narcissistic derealization. As such simultaneity wipes out the alterity of past and present, here and there, it tends to lose its anchor in referentiality, in the real, and the present falls victim to its magical power of simulation and image projection. Real difference, real otherness in historical time or in geographic distance can no longer even be perceived. In the most extreme case, the boundaries between fact and fiction, reality and perception have been blurred to the extent that it leaves us with only simulation, and the postmodern subject vanishes in the imaginary world

of the screen. The resulting dangers of relativism and cynicism have been much debated in recent years, but in order to overcome such dangers we must acknowledge that they are inherent in our ways of processing knowledge, rather than simply denouncing them as a game played by nihilistic intellectuals. The clarion call to objective truth will simply not do.

However, there is a generative paradox in this new temporal sensibility. For what looks in one perspective like the overwhelming victory of the modernizing present over the past can be seen in another perspective as an entropy of the space occupied by the present. The ever increasing acceleration of scientific, technological, and cultural innovation in a consumption and profit oriented society produces ever larger quantities of soon to be obsolete objects, life-styles, and attitudes, thereby effectively shrinking the chronological expansion of what can be considered present in a material sense. The temporal aspect of such planned obsolescence is, of course, amnesia. But then amnesia simultaneously generates its own opposite: the new museal culture as a reaction formation. Whether it is a paradox or a dialectic, the spread of amnesia in our culture is matched by a relentless fascination with memory and the past.

Critics who focus only on the loss of history, would claim that the new museum and memorial culture of recent years betrays any real sense of history, having turned to spectacle and entertainment instead. They would claim that this culture provides a postmodern surface imagery and destroys, rather than nurtures, any real sense of time—past, present, or future. But the fascination with the past is more than merely the compensatory or fraudulent side-effect of a new postmodern temporality which hovers between the need for memory and the rapid pace of forgetting. Perhaps it is to be taken seriously as a way of slowing down the speed of modernization, as an attempt, however fragile and fraught with contradiction, to cast lifelines to the past and counteract our culture's undisputed tendency toward amnesia under the sign of immediate profit and short-term politics. The museum, the monument, and the memorial have indeed taken a new lease on life after having been declared dead repeatedly throughout the history of modernism. Their newly acquired prominence in the public's mind, their success in contemporary culture begs for an explanation. It is simply no longer enough to denounce the museum as an elitist bastion of knowledge and power, nor is an older modernist critique of the monument persuasive when monument artists have incorporated that very critique into their creative practices. Boundaries between the museum, the memorial, and the monument have indeed become fluid in the past decade in ways that render obsolete the old critique of the museum as a fortress for the few and of the monument as a medium of reification and forgetting.

Holocaust museums, memorials and monuments cannot be seen as separate from this postmodern memorial culture. For even as the Holocaust presents intractable problems to any project of memorial representation, the increasing frequency with which Holocaust museums are built and monuments erected in Israel, Germany, and Europe, as well as the United States, is clearly part of a larger cultural phenomenon.[5] It should not be attributed only to the increasing generational distance from the event itself, to the attempt, as it were, to go against the unavoidable process of forgetting at a time when the generation of witnesses and survivors is diminishing and new generations are growing up for whom the Holocaust is either mythic memory or cliché.

One reason for the newfound strength of the museum and the monument in the public sphere may have something to do with the fact that both offer something that television denies: the material quality of the object. The permanence of the monument and the museum object, formerly criticized as deadening reification, takes on a different role in a culture dominated by the fleeting image on the screen and the immateriality of communications. It is the permanence of the monument in a reclaimed public space, in pedestrian zones, in restored urban centers, or in pre-existing memorial spaces that attracts a public dissatisfied with simulation and channel-flicking. This said, the success of any monument has to be measured by the extent to which it negotiates the multiple discourses of memory provided by the very electronic media to which the monument as solid matter provides an alternative. And there is no guarantee that today's monuments, designed and built with public participation, lively debate, and memorial engagement will not one day stand, like their predecessors from the nineteenth century, as figures of forgetting. For now, however, an old medium that once had succumbed to the pace and speed of modernization, is enjoying new possibilities in a hybrid memorial-media culture.

IV

Despite the growth of Holocaust revisionism in recent years,[6] the problem for Holocaust memory in the 1980s and 1990s is not forgetting, but rather the ubiquitousness, even the excess of Holocaust imagery in our culture, from the fascination with fascism in film and fiction, which Saul Friedlander has so persuasively criticized, to the proliferation of an often facile Holocaust victimology in a variety of political discourses that have nothing to do with the Shoah.[7] In a perverse way, even the denial of the Holocaust and the public debate surrounding that denial keep the Holocaust in the public mind. Short of denial, however, the original trauma is often reenacted and exploited in literary and cinematic representations

in ways that can also be deeply offensive. Certainly, the unchecked proliferation of the trope itself may be a sign of its traumatic ossification, its remaining locked in a melancholic fixation that reaches far beyond victims and perpetrators.

If such proliferation, whether in fiction and film or in contemporary politics, actually trivializes the historical event of the Nazi Final Solution, as many would argue, then the building of more and more Holocaust memorials and monuments may not offer a solution to the problems of remembrance either. The attempt to counteract seeming trivializations such as the television series *Holocaust* (1979) by serious museal and monumental representations may only, once again, freeze memory in ritualistic images and discourses. The exclusive insistence on the true representation of the Holocaust in its uniqueness, unspeakability, and incommensurability may no longer do in the face of its multiple representations and functions as an ubiquitous trope in Western culture. Popularizing representations and historical comparisons are ineradicably part of a Holocaust memory which has become multiply fractured and layered.

The criteria for representing the Holocaust cannot be propriety or awe as would be appropriate in the face of a cult object. Awed and silent respect may be called for vis-à-vis the suffering of the individual survivor, but it is misplaced as a discursive strategy for the historical event, even if that event may harbor something unspeakable and unrepresentable at its core. For if it is our concern and responsibility to prevent forgetting, we have to be open to the powerful effects that a melodramatic soap opera can exert on the minds of viewers today. The post-Holocaust generations that received their primary socialization through television may find their way toward testimony, documentary, and historical treatise precisely via a fictionalized and emotionalized Holocaust made for prime time television. If the Holocaust can be compared to an earthquake that has destroyed all the instruments for measuring it, as Lyotard has suggested, then surely there must be more than one way of representing it.

The increasing temporal and generational distance, therefore, is important in another respect: it has freed memory to focus on more than just the facts. In general, we have become increasingly conscious of how social and collective memory is constructed through a variety of discourses and layers of representations. Holocaust historiography, archives, witness testimony, documentary footage—all have collaborated to establish a hard core of facts, and these facts need to be transmitted to the post-Holocaust generations. Without facts, there is no real memory. But we are also free to recognize that the Holocaust has indeed become dispersed and fractured through the different ways of memorializing it. An obsessive focus on the unspeakable and unrepresentable, as it was compellingly

articulated by Elie Wiesel or George Steiner at an earlier time and as it informs the ethical philosophy of Jean François Lyotard today, blocks that insight. Even in its historically most serious and legitimate form, Holocaust memory is structured very differently in the country of the victims from the way it is in the country of the perpetrators, and differently again in the countries of the anti-Nazi alliance.[8]

All along, the same facts have generated significantly different accounts and memories. In Germany, the Holocaust signifies the absence of a strong Jewish presence in society and a traumatic burden on national identity. Genuine attempts at mourning, which have existed for some time, are hopelessly entangled with narcissistic injury, ritual breast-beating, and repression. Thus until recently there has been little public knowledge of, or even interest in, what was actually lost through the destruction. In Israel, the Holocaust became central to the foundation of the state, both as an endpoint to a disavowed history of Jews as victims *and* as a starting point of a new national history, self-assertion and resistance. In the Israeli imagination, the Warsaw Ghetto uprising has been invested with the force of a mythic memory of resistance and heroism unfathomable in Germany. The American imagination of the Holocaust focuses on America as the liberator of the camps and a haven for refugees and immigrants, and American Holocaust memorials are structured accordingly. In the Soviet account, the genocide of the Jews lost its ethnic specificity and was simply collapsed into the Nazi oppression of international communism. This was done to an extent which now requires a reconstruction of the narratives of East European and Soviet memorial sites.

Much of this, of course, is by now well-known, but it may not be fully grasped in its implications for the debate about remembrance, forgetting, and representation. Such multiple fracturing of the memory of the Holocaust in different countries and the multi-layered sedimentation of images and discourses that range from documentary to soap opera, survivor testimony to narrative fiction, concentration camp art to memorial painting has to be seen in its politically and culturally enabling aspects, as a potential antidote to the freezing of memory into one traumatic image or the mind-numbing focus on numbers. The new Holocaust museum in Washington D.C. is so successful because it is able to negotiate a whole variety of discourses, media, and documentations, thus opening up a space of concrete knowledge and reflection in the memories of its visitors.

V

What, then, of the monument in the larger field of Holocaust representations and discourses? Clearly, the Holocaust monument does not stand in the tradition of the monument as heroic celebration and figure of triumph. Even in the case of the

monument to the Warsaw Ghetto uprising we face a memorial to suffering, an indictment of crimes against humanity. Held against the tradition of the legitimizing, identity-nurturing monument, the Holocaust monument would have to be thought of as inherently a counter-monument. Yet the traditional critique of the monument as a burying of a memory and an ossifying of the past has often been voiced against the Holocaust monument as well. Holocaust monuments have been accused of topolatry, especially those constructed at the sites of extermination. They have been reproached for betraying memory, a reproach that holds memory to be primarily internal and subjective and thus incompatible with public display, museums, or monuments. As a variation on Adorno, who was rightfully wary of the effects of aestheticizing the unspeakable suffering of the victims, it has been claimed that to build a monument to the Holocaust was itself a barbaric proposition. No monument after Auschwitz. And in light of fascist excesses with monumentalization, some have even gone so far as to suggest that fascist tendencies are inherent in any monument whatsoever.

All these critiques of the medium itself focus on the monument as object, as permanent reality in stone, as aesthetic sculpture. They do not, however, recognize the public dimension of the monument, what James Young has described as the dialogical quality of memorial space. There is no doubt that we would be ill-served by the Holocaust monument as death mask or by an aestheticization of terror. On the other hand, in the absence of tombstones to the victims, the monument functions as a substitute site of mourning and remembrance. How, after all, are we to guarantee the survival of memory if our culture does not provide memorial spaces that help construct and nurture the collective memory of the Shoah? Only if we focus on the public function of the monument, embed it in public discourses of collective memory, can the danger of monumental ossification be avoided. Of course, public discourse is most intense at the time of planning, designing, and erecting a new monument. There is no guarantee that the level of dialogic intensity can be maintained in the long term, and the Holocaust monument may eventually fall victim to the memory freeze that threatens all monuments.

The great opportunity of the Holocaust monument today lies in its intertextuality and the fact that it is but one part of our memorial culture. As the traditional boundaries of the museum, the monument, and historiography have become more fluid, the monument itself has lost much of its permanence and fixity. The criteria for its success could therefore be the ways in which it allows for a crossing of boundaries toward other discourses of the Holocaust, the ways it pushes us toward reading other texts, other stories.

No single monument will ever be able to convey the Holocaust in its entirety.

Such a monument might not even be desirable, just as the Great Book about the Shoah, in Geoffrey Hartman's words, might "produce a deceptive sense of totality, throwing into the shadows, even into oblivion, stories, details and unexpected points of view that keep the intellect active and the memory digging."[9] There is much to be said for keeping Holocaust monuments and memorials site-specific, for having them reflect local histories, recalling local memories, making the Final Solution palpable not just by focusing on the sites of extermination, but on the lives of those murdered in the camps.

At some level, however, the question of the Holocaust as a whole, a totality, will reassert itself together with the problem of its unspeakability. After we have remembered, gone through the facts, mourned for the victims, we will still be haunted by that core of absolute humiliation, degradation, and horror suffered by the victims. How can we understand when even the witnesses had to say: "I could not believe what I saw with my own eyes." No matter how fractured by media, by geography, and by subject position representations of the Holocaust are, ultimately it all comes down to this core: unimaginable, unspeakable, and unrepresentable horror. Post-Holocaust generations can only approach that core by mimetic approximation, a mnemonic strategy which recognizes the event in its otherness and beyond identification or therapeutic empathy, but which physically innervates some of the horror and the pain in a slow and persistent labor of remembrance. Such mimetic approximation can only be achieved if we sustain the tension between the numbing totality of the Holocaust and the stories of the individual victims, families, and communities. Exclusive focus on the first may lead to the numbing abstraction of statistics and the repression of what these statistics mean; exclusive focus on the second may provide facile cathartic empathy and forget the frightening conclusion that the Holocaust as a historical event resulted, as Adi Ophir put it, from an exceptional combination of normal processes.[10] The ultimate success of a Holocaust monument would be to trigger such a mimetic approximation, but it can achieve that goal only in conjunction with other related discourses operating in the head of the spectator and the public sphere.

A monument or memorial will only take us one step toward the kind of knowledge Jürgen Habermas has described as an irreversible rupture in human history:

> "There [in Auschwitz] something happened, that up to now nobody considered as even possible. There one touched on something which represents the deep layer of solidarity among all that wears a human face; notwithstanding all the usual acts of beastliness of human history, the integrity of this common layer had been taken for granted. . . . Auschwitz has changed the basis for the continuity of the conditions of life within history."[11]

Such knowledge is all too easily forgotten or repressed. To maintain it is all the more urgent since postmodern, post-Auschwitz culture is fraught with a fundamental ambiguity. Obsessed with memory and the past, it is also caught in a destructive dynamics of forgetting. But perhaps the dichotomy of forgetting and remembering again misses the mark. Perhaps postmodern culture in the West is caught in a traumatic fixation on an event which goes to the heart of our identity and political culture. In that case, the Holocaust monument, memorial, and museum could be the tool Franz Kafka wanted literature to be when he said that the book must be the ax for the frozen sea within us.[12] We need the monument and the book to keep the sea from freezing. In frozen memory, the past is nothing but the past. The inner temporality and the politics of Holocaust memory, however, even where it speaks of the past, must be directed toward the future. The future will not judge us for forgetting, but for remembering all too well and still not acting in accordance with those memories.

Notes

Introduction

1 The theoretical understanding of memory as a cultural construction in the present rather than a storage and retrieval system is widely supported by recent neuro-physiology and neuro-biology. For a comprehensive survey of current positions in interdisciplinary memory research see Siegfried J. Schmidt, ed. *Gedächtnis: Probleme und Perspektiven der interdisziplinären Gedächtnisforschung* (Frankfurt am Main: Suhrkamp, 1991).

2 From a potentially interminable bibliography a few titles have proven particularly helpful for the writing of this introduction: Yosef Hayim Yerushalmi, *Zakhor: Jewish History and Jewish Memory* (Seattle: University of Washington Press, 1982); Jan Assmann and Tonio Hölscher, eds. *Kultur und Gedächtnis* (Frankfurt am Main: Suhrkamp, 1988); Aleida Assmann and Dietrich Harth, eds. *Mnemosyne: Formen und Funktionen der kulturellen Erinnerung* (Frankfurt am Main: Fischer, 1991); Schmidt, ed. *Gedächtnis: Probleme und Perspektiven*; Anselm Haverkamp and Renate Lachmann, eds. *Gedächtniskunst: Raum-Bild-Schrift. Studien zur Mnemotechnik* (Frankfurt am Main: Suhrkamp, 1991); Anselm Haverkamp and Renate Lachmann, eds. *Memoria: Vergessen und Erinnern* (Munich: Fink, 1993); Saul Friedlander, *Memory, History and the Extermination of the Jews of Europe* (Bloomington: Indiana University Press, 1993).

3 On the question of novelty and innovation in postmodern culture see the subtle and perceptive essay by Boris Groys, *Über das Neue: Versuch einer Kulturökonomie* (Munich: Hanser, 1992).

4 Koselleck's seminal essays on historically distinct experiences of time are collected in *Futures Past* (Cambridge: MIT Press, 1990).

Chapter 1: **E s c a p e F r o m A m n e s i a**

1 On the social history of the art museum see Walter Grasskamp, *Museumsgründer und Museumsstürmer* (Munich: Verlag C.H. Beck, 1981); on the universal survey museum see Carol Duncan and Alan Wallach, "The Universal Survey Museum," *Art History*, vol. 3, no. 4 (December 1980): 448–69; on the history museum see Gottfried Korff, Martin Roth, eds. *Das historische Museum: Labor, Schaubühne, Identitätsfabrik* (Frankfurt am Main: Campus Verlag, 1990).

2 On the relationship of Western museums to practices of collecting, disciplinary archives, and discursive traditions see James Clifford, "On Collecting Art and Culture," in James Clifford, *The Predicament of Culture: Twentieth-Century Ethnography, Literature, and Art* (Cambridge: Harvard University Press, 1988), 215–51.

3 On the development of the museum in the 1980s see Achim Preiß, Karl Stamm, Frank Günter Zehnder, eds. *Das Museum: Die Entwicklung in den 80er Jahren* (Munich: Klinkhardt & Biermann, 1990).

4 For an instructive and rather comprehensive collection of essays on this topic see Wolfgang Zacharias, ed. *Zeitphänomen Musealisierung: Das Verschwinden der Gegenwart und die Konstruktion der Erinnerung* (Essen: Klartext Verlag, 1990). For a critical assessment of museal tendencies in the art of the 1980s see Bazon Brock, *Die Re-Dekade: Kunst und Kultur der 80er Jahre* (Munich: Klinkhardt & Biermann, 1990).

5 Pierre Bourdieu and Alain Darbel, *L'Amour de l'art: Les musées d'art européens et leur public* (Paris, 1969), 165.

6 For a critique of the ideological inscriptions in the Museum of Modern Art's organization of architectural and exhibition space see Carol Duncan and Alan Wallach, "The Museum of Modern Art as Late Capitalist Ritual: An Iconographic Analysis," *Marxist Perspectives*, vol. 1, no. 4 (Winter 1978): 28-51. For a feminist critique of the Museum of Modern Art's narrative of the modern see Carol Duncan, "The MoMA's Hot Mamas," *Art Journal*, vol. 48, no. 2 (Summer 1989): 171–78.

7 Theodor W. Adorno, *Prismen: Kulturkritik und Gesellschaft* (Frankfurt am Main: Suhrkamp Verlag, 1955), 215.

8 Such a critical view is forcefully advanced by Rosalind Krauss who uses Fredric Jameson's postmodernism paradigm to collapse museum management (asset circulation), exhibition practices (the switch from the encyclopedic diachronic museum to the synchronic museum) and spectator psychology (the search for free-floating and impersonal intensities and schizo-euphoria). While this model is quite persuasive with regard to the type of art exhibit she discusses, it is theoretically limited for a broader discussion of contemporary museum practices. Rosalind Krauss, "The Cultural Logic of the Late Capitalist Museum," *October*, 54 (Fall 1990): 3–17.

9 I have attempted to differentiate historically between an avant-gardist postmodernism of the 1960s and an increasingly post-avant-gardist postmodernism of the 1970s in several essays within Andreas Huyssen, *After the Great Divide* (Bloomington: University of Indiana Press, 1986). English edition London: Macmillan 1986.

10 On museumphobia of the historical avant-garde see especially Grasskamp, *Museumsgründer und Museumsstürmer*, 42–72.

11 This avant-gardist position along with a rich and sophisticated critique of the modern museum in the context of contemporary artistic practices and institutional critiques is prevalent in Douglas Crimp, *On the Museum's Ruins* (Cambridge, London: MIT Press, 1993).

12 Douglas Crimp's (see note 11) and Rosalind Krauss's (see note 8) work contains good

examples of such site-specific critiques, but it does not quite leave the orbit of an earlier totalizing museum critique.

13 Jürgen Habermas, "Die neue Intimität zwischen Kultur und Politik," in *Die nachholende Revolution* (Frankfurt am Main: Suhrkamp, 1990), 9–18.

14 Ironically, the site where this museum was to be erected by Aldo Rossi, namely the Spreebogen near the Reichstag, is now reserved for new government buildings, and the Museum of German History has had to make way for the return of the German government to its new capital, Berlin.

15 Adorno, *Prismen*, 230.

16 Especially pertinent here is Ritter's 1963 essay entitled "Die Aufgabe der Geisteswissenschaften in der modernen Gesellschaft," in Ritter, *Subjektivität. Sechs Aufsätze* (Frankfurt am Main, 1974), 105 ff.

17 Hermann Lübbe, "Der Fortschritt und das Museum: Über den Grund unseres Vergnügens an historischen Gegenständen," *The 1981 Bithell Memorial Lecture* (London: University of London, 1982). Reprinted in Lübbe, *Die Aufdringlichkeit der Geschichte: Herausforderungen der Moderne vom Historismus bis zum Nationalsozialismus* (Graz/Vienna/Cologne: Verlag Styria, 1989), 13–29. Cf. also Lübbe, *Zeit-Verhältnisse: Zur Kulturphilosophie des Fortschritts* (Graz/Vienna/Cologne: Verlag Styria, 1983). The title essay of this volume "Zeit-Verhältnisse: Über die veränderte Gegenwart von Zukunft und Vergangenheit" is available in Zacharias, *Zeitphänomen Musealisierung*, 40–49.

18 See Raymond Williams, *Marxism and Literature* (Oxford: Oxford University Press, 1977), 128–35.

19 On the museum in Proust see Theodor W. Adorno, "Valéry Proust Museum," in *Prismen*, 215–31.

20 See Krauss, "Cultural Logic of the Late Capitalist Museum," 14.

21 Fredric Jameson, "Postmodernism, or the Cultural Logic of Late Capitalism," *New Left Review,* 146 (July/August 1984): 64.

22 For a similar critique of compensation theory see Gottfried Fliedl, "Testamentskultur: Musealisierung und Kompensation," in Zacharias, ed. *Zeitphänomen Musealisierung*, 166–79; Herbert Schnädelbach, "Kritik der Kompensation," *Kursbuch*, 91 (March 1988): 35–45.

23 See Odo Marquard, "Verspätete Moralistik," *Kursbuch*, 91 (March 1988): 17.

24 The pertinent references are to Jean Baudrillard, *Simulations* (New York: Semiotext(e), 1983) especially the essay "The Precession of Simulacra"; Jean Baudrillard, "Das fraktale Subjekt," *Ästhetik und Kommunikation*, 67/68 (1987): 35–39; Henri Pierre Jeudy, *Die Welt als Museum* (Berlin: Merve Verlag, 1987); Jeudy, "Der Komplex der Museophilie," in Zacharias, ed. *Zeitphänomen Musealisierung*, 115–21; Jeudy, "Die Musealisierung der Welt oder Die Erinnerung des Gegenwärtigen," *Ästhetik und Kommunikation*, 67/68 (1987): 23–30.

25 Jeudy, "Die Musealisierung der Welt," 25.

26 See the issue entitled *Kulturgesellschaft: Inszenierte Ereignisse* of *Ästhetik und Kommunikation*, 67/68 (1987), especially Dietmar Kamper, Eberhard Knödler-Bunte, Marie-Louise Plessen, Christoph Wulf, "Tendenzen der Kulturgesellschaft: Eine Diskussion," 55–74. The two approaches separated in my argument, namely the simulation theory approach and the Critical Theory approach, are indiscriminately intermingled in this issue.

Chapter 2: **After the Wall**

1 This essay was written in Berlin during the gulf war. For a superb analysis of a variety of responses to the gulf war see Anson Rabinbach, "German Intellectuals and the Gulf War," *Dissent* (Fall 1991): 459–64.

2 Peter Schneider, Extreme Mittelage: *Eine Reise durch das deutsche Nationalgefühl* (Reinbek: Rowohlt, 1990); Klaus Hartung, *Neunzehnhundertneunundachtzig* (Frankfurt/Main: Luchterhand, 1990).

3 The term *Wendehals,* frequently used by Christ Wolf, means "turn-neck" (literally, it refers to a bird, the Wryneck) and can be roughly translated as "weathervane."

4 Helmut Dubiel, "Linke Trauerarbeit," *Merkur* 496 (June 1990): 482–91.

5 Jürgen Habermas, *Die nachholende Revolution* (Frankfurt/Main: Suhrkamp, 1990); Misha Glenny, *The Rebirth of History: Eastern Europe in the Age of Democracy* (London: Penguin, 1990); Timothy Garton Ash, *The Uses of Adversity* (New York: Random House, 1989), and *We the People: The Revolution of 89* (London: Penguin, 1990).

6 See Hartung, *Neunzehnhundertneunundachtzig,* 67.

7 See for example the first issue of the new journal *Transit: Europäische Revue* 1 (1990), edited at the Institut für die Wissenschaften vom Menschen (Vienna) and published by the Verlag Neue Kritik.

8 Habermas, *Revolution,* 181.

9 Friedrich Dieckmann, "Die Stunde der West-Onkel," in *Glockenläuten und offene Fragen* (Frankfurt/Main: Suhrkamp, 1991), 189 ff. First published in *Die Zeit* (8 Mar. 1990). See also Robert Darnton, "Ein Zusammenbruch geborgter Legitimität," *Frankfurter Allgemeine Zeitung* (7 Nov. 1990).

10 Frank Hörnigk, "Die künstlerische Intelligenz und der Umbruch in der DDR," in *Die DDR auf dem Weg zur deutschen Einheit* (Köln: Edition Deutschland Archiv, 1990), 139–45.

11 Heiner Müller, *Zur Lage der Nation* (Berlin: Rotbuch, 1990), 19.

12 See Ulrich Greiner, "Der Potsdamer Abgrund," *Die Zeit* 26 (22 June 1990): 59.

13 Christa Wolf, *Was bleibt* (Frankfurt/Main: Luchterhand, 1990). Further references will be cited in the text by page number.

14 For documentation and discussion of the historians' debate, see *New German Critique* 44 (Spring/Summer 1988).

15 Ulrich Greiner, "Die deutsche Gesinnungsästhetik," *Die Zeit* 45 (2 Nov. 1990): 59.

16 For a sympathetic and subtle response to Wolf's *Was bleibt,* see Antonia Grunenberg, "Das Ende der Macht ist der Anfang der Literatur. Zum Streit um die Schriftstellerinnen in der DDR," *Aus Politik und Zeitgeschehen. Beilage zur Wochenzeitung Das Parlament* B 44/90 (26 Oct. 1990): 17-26. For a comprehensive treatment of the Wolf debate in relation to GDR literature as a whole see Wolfgang Emmerich, "Was bleibt? Nachdenken über die vielgeschmähte DDR-Literatur," unpubl. ms. I would like to thank Gabriele Dietze for sharing with me a lecture in which she persuasively hones in on the literary misjudgments of the Wolf critics: "Eine neue Voraussetzungslosigkeit, oder über den Triumph der Sekundärliteratur," unpubl. ms. For a perceptive and level-headed discussion of the Wolf debate, see Wolf Biermann, "Nur wer sich ändert, bleibt sich treu," *Die Zeit* 35 (24 Aug. 1990): 43 ff.

17 Ulrich Greiner, "Was bleibt? Bleibt was?," *Die Zeit* 23 (1 June 1990): 63; Frank Schirrmacher, "'Dem Druck des härteren, strengeren Lebens standhalten.' Auch eine Studie über den autoritären Charakter: Christa Wolf's Aufsätze, Reden und ihre jüngste Erzählung *Was bleibt,*" *Frankfurter Allgemeine Zeitung* (2 June 1990).

18 Helmut Karasek, "'Selbstgemachte Konfitüre,'" *Der Spiegel* 26 (25 June 1990): 162–8.

19 Volker Braun answering a question posed by the *Süddeutsche Zeitung*: "Schriftsteller in der DDR: Waren sie nur Mitläufer oder Opportunisten?" (25 June 1990.)

20 According to Karasek's *Spiegel* report of the Potsdam East-West colloquium, June 1990. Cf. Karasek, "Selbstgemachte Konfitüre," 162.

21 "Nötige Kritik oder Hinrichtung? SPIEGEL Gespräch mit Günter Grass über die Debatte um Christa Wolf und die DDR-Literatur," *Der Spiegel* 29 (16 July 1990): 138–43. The comment by the German PEN is reported in this piece.

22 Grass's accusations against the West German feuilleton were carried by radio, television, and *Das neue Deutschland*. For a response, see Frank Schirrmacher, "Literatur und Kritik" (front-page editorial), *Frankfurter Allgemeine Zeitung* (8 Oct. 1990).

23 Both comments were made at a panel discussion in Berlin and widely reported, e.g., in Greiner, "Gesinnungsästhetik," 60.

24 Frank Schirrmacher, "Abschied von der Literatur der Bundesrepublik. Neue Pässe, neue Identitäten, neue Lebensläufe: Über die Kündigung einiger Mythen des westdeutschen Bewußtseins," *Frankfurter Allgemeine Zeitung* (2 Oct. 1990). For a thorough critique of Schirrmacher, see Wolfram Schütte, "Auf dem Schrotthaufen der Geschichte: Zu einer denkwürdig-voreiligen Verabschiedung der 'bundesdeutschen' Literatur,'" *Frankfurter Rundschau* 245 (20 Oct. 1990): Beilage.

25 Karl Heinz Bohrer, "Kulturschutzgebiet DDR?," *Merkur* 500 (Oct./Nov. 1990): 1015–18.

26 Ulrich Greiner, "Die deutsche Gesinnungsästhetik. Noch einmal: Christa Wolf und der deutsche Literaturstreit/Eine Zwischenbilanz," *Die Zeit* 45 (2 Nov. 1990): 59 ff. The German term Gesinnung is difficult to render in English. The dictionary defines it as "opinion," "convictions," or "cast of mind." Applied to aesthetics, it seems to me that "good-will aesthetics" comes close enough to the German connotations and remains intelligible.

27 On November 11, 1990, Christa Wolf spoke of the demonization of the GDR, a kind of monster-show produced by the Western media, when she introduced Hans Mayer as lecturer in the lecture series "Nachdenken über Deutschland" that took place in the Deutsche Staatsoper on Unter den Linden in (East) Berlin. The event was described by Ursula Escherig, "Lehrer und Schülerin," *Der Tagesspiegel* (13 Nov. 1990): 4. Cf. also the report "Intellektuelle in Sandalen: Das erste Symposium der Wiener Erich-Fried-Gesellschaft," *Der Tagesspiegel* (27 Nov. 1990): 5. Wolf participated in this symposium on the panel "Die Schriftsteller und die Restauration."

28 Reported by Greiner, "Gesinnungsästhetik", 60. On the relationship between the German critiques of Wolf and the author's still growing international reputation, see Lothar Baier, "Scheidung auf literarisch," *Süddeutsche Zeitung* (2/3 Oct. 1990) (Literaturbeilage zur Frankfurter Buchmesse): 73.

29 For two statements by GDR authors on the Wolf debate, see Jan Faktor, "Grosser Ost-West-Sturm, oder Wo leben die letzten Gerechten," and the polemical response by Lutz Rathenow in *constructiv* 2:2 (Feb 1991): 30–33.

30 On Wolf's role at the 11th Plenum, see Therese Hörnigk, "Das 11. Plenum und die Folgen: Christa Wolf im politischen Diskurs der sechziger Jahre," *Neue deutsche Literatur* 10 (1990): 50–58. The events of 1979 at the Writers' Union are now documented in Joachim Walther, et al. *Protokoll eines Tribunals: Die Ausschlüsse aus dem DDR-Schriftstellerverband 1979* (Reinbek: Rowohlt, 1991). Wolf's letter is included here on p. 116 ff. Wolf's speeches and statements from 1989 are collected in Christa Wolf, *Reden im Herbst* (Berlin: Aufbau, 1990).

31 Schirrmacher, "'Dem Druck," final paragraph.

32 Karl Heinz Bohrer "Why We Are Not a Nation—And Why We Should Become One,"
New German Critique 52 (Winter 1991): 72–83.

33 Many of these arguments are advanced in a long essay in the same anniversary issue of
Merkur which carried Bohrer's contribution to the Wolf debate. Karl Heinz Bohrer,
"Die Ästhetik am Ausgang ihrer Unmündigkeit," *Merkur* 500 (Oct./Nov. 1990):
851–65. See also Bohrer, *Die Kritik der Romantik: Der Verdacht der Philosophie gegen
die literarische Moderne* (Frankfurt/Main: Suhrkamp, 1989).

34 Karl Heinz Bohrer, *Nach der Natur: Über Politik und Ästhetik* (Munich: Hanser, 1988).
See also Bohrer's more recent political reflections: "Und die Erinnerung der beiden
Halbnationen?," *Merkur* 493 (Mar. 1990): 183–88; "Ridley's Country," *Merkur* 499
(Sep. 1990): 797–804; "Provinzialismus," *Merkur* 501 (Dec. 1990): 1096–102.

Chapter 3: **N a t i o n , R a c e , a n d I m m i g r a t i o n**

1 Karl Jaspers, *Freiheit und Wiedervereinigung* (Munich: Piper 1960), 110 f. On Jaspers
and reunification see Wolfgang Schneider, *Tanz der Derwische: Vom Umgang mit der
Vergangenheit im wiedervereinigten Deutschland* (Lüneburg: zu Klampen, 1992),
93–100.

2 For a thorough account of unification see Peter H. Merkl, *German Unification in Euro-
pean Context* (University Park, Pennsylvania: The Pennsylvania State University Press,
1993). The politically most astute assessment of 1989–90, written during the events
themselves, still is Klaus Hartung, *Neunzehnhundertneunundachtzig* (Frankfurt am
Main: Luchterhand, 1991).

3 For a thorough analysis of the recent pogroms see Hajo Funke, *Brandstifter* (Göttin-
gen: Lamuv, 1993).

4 For a polemically negative view of the candlelight marches see Eike Geisel, "Triumph
des guten Willens," *taz*, 12 (December 1992).

5 Fritz Stern, "Deutschland um 1900—und eine zweite Chance," in Wofgang Hardtwig
and Harm-Hinrich Brandt, eds. *Deutschlands Weg in die Moderne: Politik, Gesellschaft
und Kultur im 19. Jahrhundert* (Munich: C.H. Beck, 1993), 32–44. Ralf Dahrendorf,
"Die Sache mit der Nation," *Merkur* 500 (Oct./Nov. 1990): 823–834.

6 See for example Dieter Henrich, *Nach dem Ende der Teilung: Über Identitäten und
Intellektualität in Deutschland* (Frankfurt am Main: Suhrkamp, 1993); Christian
Meier, *Die Nation, die keine sein will* (Munich: Hanser, 1991) and "Halbwegs anständig
über die Runden kommen, ohne daß zu viele zurückbleiben," in Siegfried Unseld, ed.
Politik ohne Projekt? Nachdenken über Deutschland (Frankfurt am Main: Suhrkamp
1993); Petra Braitling and Walter Reese-Schäfer, eds. *Universalismus, Nationalismus
und die neue Einheit der Deutschen* (Frankfurt am Main: Fischer, 1991). See also my
earlier essay "The Inevitability of Nation: German Intellectuals After Unification,"
written in September, 1991 after the pogrom of Hoyerswerda and published in *October*
61 (Spring 1992).

7 Recent works that have proven helpful to me in approaching this question include
Benedict Anderson, *Imagined Communities* (London: Verso, 1983); Ernest Gellner,
Nations and Nationalism (Oxford: Basil Blackwell, 1983); Anthony D. Smith, *Theories
of Nationalism* (New York: Holmes and Meier, 1983); Tom Nairn, The *Break-Up of
Britain: Crisis and Neo-Nationalism* (London: New Left Books, 1977); Peter Alter,
Nationalismus (Frankfurt am Main: Suhrkamp, 1985); Homi K. Bhabha, ed. *Nation
and Narration* (New York: Routledge, 1990); Slavoj Zizek, "Republics of Gilead," *New*

Left Review 183 (Sept./Oct. 1990): 50-62; Julia Kristeva, *Nations without Nationalism* (New York: Columbia University Press, 1993); Partha Chatterjee, *Nationalist Thought and the Colonial World* (Minneapolis: University of Minnesota Press, 1993). Not useful at all is Liah Greenfeld's *Nationalism: Five Roads to Modernity* (Cambridge: Harvard University Press, 1992). For a semantic history see the article "Volk, Nation, Nationalismus, Masse," in *Geschichtliche Grundbegriffe: Historisches Lexikon zur politisch-sozialen Sprache in Deutschland*, vol. 7 (Cotta: Stuttgart, 1992): 141–431.

8 Etienne Balibar, "Racism and Nationalism," in E. Balibar and I. Wallerstein, *Race, Nation, Class: Ambiguous Identities* (London, New York: Verso, 1991), 37, 48.

9 Ibid., 49. George Mosse, *Nationalism and Sexuality: Middle-Class Morality and Sexual Norms in Modern Europe* (Madison, WI: University of Wisconsin Press, 1985). Andrew Parker, Mary Russo, Doris Sommer, and Patricia Yaeger, eds. *Nationalisms and Sexualities* (New York: Routledge, 1992).

10 Tom Nairn, *The Break-Up of Britain: Crisis and Neo-Nationalism* (London: New Left Books, 1977).

11 See Michael Geyer, "Historical Fictions of Autonomy and the Europeanization of National History," *Central European History* 22 (1989): 316–42.

12 For a perceptive essay on the problem of migration see Hans Magnus Enzensberger, *Die große Wanderung* (Frankfurt am Main: Suhrkamp, 1992).

13 On the changing role of the concept of nation in the FRG see Wolfgang J. Mommsen, *Nation und Geschichte: Über die Deutschen und die deutsche Frage* (Munich and Zurich: Piper, 1990).

14 For a historical analysis of intellectuals and their codifications of German national identity see Bernhard Giesen, *Die Intellektuellen und die Nation* (Frankfurt am Main: Suhrkamp, 1993). Paul Noack offers a sharp critique of German intellectuals today in *Deutschland, deine Intellektuellen: Die Kunst sich ins Abseits zu stellen* (Frankfurt am Main: Ullstein, 1993).

15 See especially Jürgen Habermas, "Yet Again: German Identity," *New German Critique* 52 (Winter 1991): 84–101; "Citizenship and National Identity: Some Reflections on the Future of Europe," *Praxis International* 12:1 (April 1992): 1–19.

16 Among the many recent publications on this topic see Hajo Funke, *Brandstifter*; Matthias von Hellfeld, *Die Nation erwacht: Zur Trendwende der deutschen politischen Kultur* (Cologne: Papy Rossa Verlag, 1993).

17 See the superb study by Rogers Brubaker, *Citizenship and Nationhood in France and Germany* (Cambridge: Harvard University Press, 1992); for a thorough legal comparison of the U.S. with Germany see Gerald L. Neumann, "'We Are the People': Alien Suffrage in German and American Perspective," *Michigan Journal of International Law* 13:2 (Winter 1992):159–335.

18 For one of the few enlightened discussions of citizenship and immigration in Germany today see Daniel Cohn-Bendit and Thomas Schmid, *Heimat Babylon: Das Wagnis der multikulturellen Demokratie* (Hamburg: Hoffmann und Campe, 1992). Cf. also Bahman Nirumand, ed. *Angst vor den Deutschen* (Reinbek: Rowohlt, 1992); Daniel Cohn-Bendit, et al., *Einwanderbares Deutschland* (Frankfurt am Main: Horizonte Verlag, 1991).

19 For a good summary see M. Rainer Lepsius, "Nation und Nationalismus in Deutschland," in Michael Jeismann und Henning Ritter, eds. *Grenzfälle: Über neuen und alten Nationalismus* (Leipzig: Reclam, 1993), 193–214.

20 For a recent sociological profile of East and West Germans since reunification see

Ulrich Becker, Horst Becker, Walter Ruhland, *Zwischen Angst und Aufbruch* (Düsseldorf: Econ, 1992).

21 On this idea of blaming the thief of one's identity see Slavoj Zizek, "Republics of Gilead," *New Left Review* 183 (September/October 1990): 50–62.

22 Jürgen Habermas, "Citizenship and National Identity," *Praxis International*, 12:1 (April 1992): 3.

23 For a good example on how the historians' debate can overdetermine reactions to current events, in this case the asylum debate, see Jürgen Habermas, "Die zweite Lebenslüge der Bundesrepublik: Wir sind wieder 'normal' geworden," first published in *Die Zeit* (December 11, 1992) and translated in *New Left Review* 197 (January/February 1993): 58–66 as "The Second Life Fiction of the Federal Republic: We Have Become 'Normal' Again."

24 For a documentation and discussion of key texts of the debate see *New German Critique* 44 (Spring/Summer 1988). For a thorough analysis see Charles S. Maier, *The Unmasterable Past: History, Holocaust, and German National Identity* (Cambridge: Harvard University Press, 1988).

25 On the history of German antisemitism and philosemitism in the late 1940s and the 1950s see Frank Stern, *Im Anfang war Auschwitz: Antisemitismus und Philosemitismus im deutschen Nachkrieg* (Gerlingen: Bleicher Verlag, 1991). See also Frank Stern's reflection on unification and its aftermath in his essay "The 'Jewish Question' in the 'German Question,'" *New German Critique* 52 (Winter 1991): 155-172.

26 For a critique of left discussions of the Holocaust see for example the special issue on Germans and Jews, *New German Critique* 19 (Winter 1980).

Chapter 4: **Memories of Utopia**

1 Karl Mannheim, *Ideology and Utopia* (New York: Harcourt, Brace, and World, n.d.), 262.

2 Peter Sloterdijk, *Critique of Cynical Reason* (Minneapolis: University of Minnesota Press, 1987).

3 Jürgen Habermas, "*Die Krise des Wohlfahrtsstaates und die Erschöpfung utopischer Energien*," Die neue Unübersichtlichkeit (Frankfurt am Main: Suhrkamp, 1985), 145.

4 Reinhart Koselleck, "Die Verzeitlichung der Utopie," in Wilhelm Voßkamp, ed. *Utopieforschung*, vol. 3 (Frankfurt am Main: Suhrkamp, 1985), 1–14.

5 See "Postmodernism and Consumer Society," *The Anti-Aesthetic*, ed. Hal Foster (Port Townsend, Washington: Bay Press, 1983); "The Politics of Theory," *New German Critique* 33 (Fall 1984); "Postmodernism, or The Cultural Logic of Late Capitalism," *New Left Review* 146 (July–August 1984).

6 Theodor W. Adorno, *Ästhetische Theorie* (Frankfurt am Main: Suhrkamp, 1973), 200 (my translation).

7 For details on this debate see the essay "After the Wall: The Failure of German Intellectuals" in this volume.

8 In a seminal article entitled "Wahrheit, Schein, Versöhnung" Albrecht Wellmer has suggested ways in which the utopian dimension of art in its relationship to aesthetic experience, truth, beautiful semblance, and the life-world might be reread in light of Constance reception theory and Habermas's concept of communicative rationality. In: Albrecht Wellmer, *Zur Dialektik von Moderne und Postmoderne: Vernunftkritik nach Adorno* (Frankfurt am Main: Suhrkamp, 1985), 9–47.

9 See Hans Magnus Enzensberger, "The Aporias of the Avant-garde" in *The Consciousness Industry* (New York: Seabury Press, 1974), 16–41. Peter Bürger, *Theorie der*

Avantgarde (Frankfurt am Main: Suhrkamp, 1974), American translation: Minneapolis: University of Minnesota Press, 1984.

10 Friedrich Nietzsche, *The Will to Power*, ed. by Walter Kaufmann (New York: Vintage Books, 1967), 327.

11 See Karl Heinz Bohrer, *Suddenness: On the Moment of Aesthetic Appearance* (New York: Columbia University Press, 1994).

12 On the question of avant-gardism in Peter Weiss's three volume novel see, Andreas Huyssen, "Memory, Myth, and the Dream of Reason: Peter Weiss's *Die Ästhetik des Widerstands*," in *After the Great Divide* (Bloomington: Indiana University Press, 1986), 115–138.

Chapter 5: **Paris/Childhood**

1 Hugo Friedrich, *Die Struktur der modernen Lyrik* (Reinbek: Rowohlt, 1956).

2 Of course the criteria of negativity, dominant in the high modernist readings, could be seen as parallel to the existentialist emphasis on alienation and *Geworfenheit*, except that existentialism put a stronger emphasis on a notion of self that the high modernist readings, and justifiably so, had begun to put in doubt.

3 E.g., Otto Friedrich Bollnow, *Rilke* (Stuttgart: Kohlhammer, 1951).

4 Most recently, Judith Ryan has again emphasized this point in her essay "Rainer Maria Rilke: *Die Aufzeichnungen des Malte Laurids Brigge* (1910)," in Paul Michael Lützeler ed., *Deutsche Romane des 20. Jahrhunderts* (Königstein: Athenäum, 1983).

5 Theodore Ziolkowski, *Dimensions of the Modern Novel* (Princeton: Princeton University Press, 1969), 3–36.

6 Ernst Fedor Hoffmann, "Zum dichterischen Verfahren in Rilkes *Aufzeichnungen des Malte Laurids Brigge*," in *Rilke's "Aufzeichnungen des Malte Laurids Brigge*," ed. Hartmut Engelhardt (Frankfurt am Main: Suhrkamp), 214–44.

7 Ulrich Fülleborn, "Form und Sinn der Aufzeichnungen des Malte Laurids Brigge: Rilkes Prosabuch und der moderne Roman," ibid., 175–97.

8 Judith Ryan, "'Hypothetisches Erzählen': Zur Funktion von Phantasie und Einbildung in Rilkes 'Malte Laurids Brigge'," ibid., 244-79. In a certain register, Ryan's approach is not that different from Fülleborn's, except that she emphasizes subjectivity rather than the objectivity of narrative form.

9 The major exception still is Erich Simenauer's *Rainer Maria Rilke: Legende und Mythos* (Bern: Verlag Paul Haupt, 1953). The rejection of a psychoanalytic approach was often simply based on the observation that Rilke himself refused explicitly to subject himself to analysis.

10 Thomas Anz, *Literatur der Existenz: Literarische Psychopathographie und ihre soziale Bedeutung im Frühexpressionismus* (Stuttgart: Metzler, 1977). Anz explains Malte's anxieties and insecurities primarily as those of the artist outsider whose social position is increasingly devalued and who therefore begins to question the validity of traditional norms and meanings. In this account, Malte's problems with perception and with himself result only from the changing social position of the artist under the onslaught of modernization and the traumatic experience of the city. The fact that all of Malte's problems have their roots in his childhood, which is precisely not "die heilere Welt der Vergangenheit" (84), falls through the cracks of Anz's approach.—For a critique of Anz's treatment of *Malte* and a more complex focus on Malte's reflections on the social function of writing in bourgeois society, see Brigitte L. Bradley, *Zu Rilke's Malte Laurids Brigge* (Bern and Munich: Francke, 1980), especially 36 ff.

11 Paradigmatically analyzed by Walter Sokel, "Zwischen Existenz und Weltinnenraum: Zum Prozess der Ent-Ichung im Malte Laurids Brigge," in Fritz Martini ed., *Probleme des Erzählens: Festschrift für Käte Hamburger* (Stuttgart: Klett, 1971), 212–33.

12 Rainer Maria Rilke, *The Notebooks of Malte Laurids Brigge,* trans. Stephen Mitchell (New York: Random House, 1985), 22. All further page references will be given by page number in the text.

13 Sigmund Freud, "The Uncanny," *Collected Papers,* 4 (New York: Basic Books, 1959), 369.

14 Ibid., 403.

15 Lou Andreas-Salomé, *Rainer Maria Rilke* (Leipzig: Insel Verlag, 1928). Andreas-Salomé is one of the few critics who emphasized the importance of Rilke's fractured and ambivalent relationship to his own body and to gender for a reading of the *Notebooks.*

16 Many of the relevant letters are now easily available in Hartmut Engelhardt., ed. *Rilke's "Aufzeichnungen des Malte Laurids Brigge."*

17 Maurice Betz, *Rilke in Frankreich* (Vienna, Leipzig, Zurich: Herbert Reichner Verlag, 1938), 114.

18 Freud, "The Uncanny," 403. Translation modified.

19 Ibid., 397.

20 Lou Andreas-Salomé, *Aus der Schule bei Freud,* ed. Ernst Pfeiffer (Zurich: M. Niehans Verlag, 1958), 213.

21 Michael Balint, *Therapeutische Aspekte der Regression: Die Theorie der Grundstörung* (Stuttgart: Klett-Cotta, 1970); Margaret S. Mahler, *Symbiose und Individuation,* 1 (Stuttgart: Klett-Cotta, 1972); Melanie Klein, *Das Seelenleben des Kleinkindes und andere Beiträge zur Psychoanalyse* (Reinbek: Rowohlt, 1972).

22 Both Lou Andreas-Salomé and Erich Simenauer have provided the relevant facts and interpretations.

23 Carl Sieber, *René Rilke: Die Jugend Rainer Maria Rilkes* (Leipzig: Insel Verlag, 1932), 69. Also mentioned in Simenauer, *Rilke,* 245.

24 Translation modified. The crucial phrase "weil ich zerbrochen bin" is inexplicably missing in the English translation.

25 Andreas-Salomé, *Rilke,* 48.

26 Jacques Lacan, "The Mirror Stage," *Ecrits: A Selection,* trans. Alan Sheridan (New York: Norton, 1977).

27 Whether Lacan is right or wrong with his analysis of the mirror stage as pivotal in development is not my concern here. There are indeed good reasons to believe that the mirroring process is already under way at a much earlier stage and does not need to be interpreted as thoroughly pessimistically as Lacan does. What is at stake in the novel is at any rate not the clinical event but rather its metaphoric reenactment. In this context, however, Lacan's account allows me to reread the scene in support of my general argument about Malte's ego-weakness.

28 I want to mention at least two more instances that make the reading of this scene in relation to Lacan's account so appealing. First, Lacan theorizes the relationship between the phantasm of identity as linked to an image of the fortified body and the developmentally earlier, but complementary phantasm of the fragmented body, thus permitting us to read this mirror scene in relation to Malte's persistent anxiety of body fragmentation. Second, it must be more than coincidence that both Rilke and Lacan make explicit references at crucial junctures of their texts to that perhaps paradigmatic painter of the fragmented body, Hieronymous Bosch. See Rilke, *Malte,* 184 f.; Lacan, *Ecrits,* 4–5.

29 Jacques Lacan, "The Split Between the Eye and the Gaze," *Four Fundamental Concepts of Psychoanalysis,* trans. Alan Sheridan (New York: Norton, 1978), 74.

30 Thus Benjamin quotes Simmel's reflections approvingly in his essay "Das Paris des Second Empire bei Baudelaire," *Gesammelte Schriften,* 1:2 (Frankfurt am Main: Suhrkamp, 1974), 540.

31 Rilke actually heard some of Simmel's famous lectures on modernity in Berlin, and Baudelaire's poetic prose clearly provided a model for Rilke's own prose in the *Notebooks,* especially in the fragmentary segments of the first part. Benjamin in turn not only made Baudelaire the centerpiece of his writings on the prehistory of the nineteenth century, but he also was very familiar with Simmel's work. As to Benjamin's relationship to Rilke, it seems clear that he never thought much of Rilke's poetry, which to him was fatally vitiated by its origins in Jugendstil. In the only text where he deals with Rilke, he does not mention the *Notebooks.* Walter Benjamin, "Rainer Maria Rilke und Franz Blei," *Gesammelte Schriften,* 4:1 (Frankfurt am Main: Suhrkamp, 1972), 453f.

32 Charles Baudelaire, "The Painter of Modern Life," in *Baudelaire: Selected Writings on Art and Artists* (London, New York: Cambridge University Press, 1981), 399 f.

33 Georg Simmel, "The Metropolis and Mental Life," *The Sociology of Georg Simmel,* trans. and ed. Kurt H. Wolff (New York: The Free Press, 1964), 410.

34 Ibid., 410 f.

35 However, Benjamin does deal with this dimension of experience in his more autobiographic texts such as *Berlin Childhood.*

36 Ernst Pfeiffer, "Rilke und die Psychoanalyse," *Literaturwissenschaftliches Jahrbuch,* Neue Folge 17 (1976): 296.

37 Klaus Theweleit, *Male Fantasies,* vol. 1 (Minneapolis: University of Minnesota Press, 1987). Theweleit shows that it is not the desire for the authority of the father that is at stake, but rather a desire for fusion.

38 That Rilke shared this view was pointed out by Simenauer, *Rilke,* 634.

Chapter 6: Fortifying the Heart—Totally

1 The original German version published in *Die Zeit* 29 (16 July 1993): 36.

2 See for example Heimo Schwilk, ed. *Das Echo der Bilder: Ernst Jünger zu Ehren* (Stuttgart: Klett-Cotta, 1990), especially Gerd Bergfleth's introductory essay "Das Urlicht der Natur."

3 For analyses of the 1990 literature debate see Karl Deiritz and Hannes Krauss, eds. *Der deutsch-deutsche Literaturstreit oder "Freunde, es spricht sich schlecht mit gebundener Zunge"* (Hamburg: Luchterhand, 1991).

4 The most ambitious attempt to date to claim Jünger as a central figure of European modernism was made by Karl Heinz Bohrer in his massive study *Die Ästhetik des Schreckens* (Frankfurt am Main: Ullstein 1983). First edition Munich: Hanser, 1978. Bohrer bases his reading almost exclusively on *Das abenteuerliche Herz.* He acknowledges the impact of the war experience on Jünger's writing, but understates its experiential dimension preferring instead to emphasize the influences of literary decadence on Jünger's obsession with horror. The main flaw of Bohrer's otherwise fascinating study is his by now legendary and stubborn insistence on a complete separation of the aesthetic dimension from political and historical contingency, a claim, however, that he himself is not always able to adhere to. Other critics, in their desire to free Jünger from the fascism reproach, have claimed that there is a total break between Jünger's war diaries and the right-wing political pamphlets of the 1920s on the one hand and

texts like *Das abenteuerliche Herz* and *Auf den Marmorklippen* (1939) on the other.

5 Russell Berman's brilliant tour de force "Written Right Across Their Faces: Ernst Jünger's Fascist Modernism" in Andreas Huyssen and David Bathrick, eds. *Modernity and the Text* (New York: Columbia University Press, 1989, paperback 1991) has not convinced me to read Jünger as a modernist. Particularly Berman's observations on body and text, seeing and writing, and his thesis that Jünger flees from language into the visual can easily be marshalled for the argument that Jünger is not a modernist writer. See also Russell Berman's more extended study of liberal, leftist and fascist modernisms *The Rise of the Modern German Novel: Crisis and Charisma* (Cambridge: Harvard University Press, 1986).

6 The concept of the armored text draws on the image of the armored body as Klaus Theweleit has analyzed it in *Male Fantasies*, 2 vols. (Minneapolis: Minnesota Press, 1987/89). Inspirational for my critique of Jünger as a modernist was Hal Foster's superb essay "Armor Fou," *October* 56 (Spring 1991): 65–97, especially since its analysis of Max Ernst's early Dada collages provides an example of how Weimar machine phantasies can take on a genuinely modernist form radically opposed to the ways they are coded in Jünger.

7 J.P. Stern, Ernst *Jünger: A Writer of Our Time* (Cambridge: Bowes and Bowes, 1953), 27.

8 Ernst Jünger, "Das abenteuerliche Herz: Erste Fassung," in: *Sämtliche Werke*, Zweite Abteilung, Essays III, Volume 9 (Stuttgart: Klett-Cotta, 1979), 107.

9 Here Döblin's *Wallenstein* and *Berlin Alexanderplatz* would provide a genuinely modernist counter-example to Jünger.

10 "Großstadt und Land," *Deutsches Volkstum* 8 (1926): 577–81.

11 Siegfried Kracauer, "Gestaltschau oder Politik?" in Kracauer, *Schriften* 5:3, ed. Inka Mülder-Bach (Frankfurt am Main: Suhrkamp, 1990), 122–23.

12 Benjamin uses the term in his seminal essay "The Work of Art in the Age of Mechanical Reproduction" in *Illuminations* (New York: Schocken, 1969), 217–51; see also his review of Ernst Jünger's *Krieg und Krieger*, published in English as "Theories of German Fascism," *New German Critique* 17 (Spring 1979): 120–28. Klaus Theweleit, *Male Phantasies*, 2 vols. (Minneapolis: University of Minnesota Press, 1987/89). Cf. also the chapter on Weimar cynicism in Peter Sloterdijk, *Critique of Cynical Reason* (Minneapolis: University of Minnesota Press, 1987).

13 "Nicht wofür wir kämpfen ist das Wesentliche, sondern *wie* wir kämpfen." *Der Kampf als inneres Erlebnis*, in *Sämtliche Werke*, Zweite Abteilung, Essays I, vol. 7 (Stuttgart: Klett-Cotta, 1980), 74.

14 Jünger, *Der Kampf als inneres Erlebnis*, 50.

15 Jünger, "Der Wille," *Standarte* (May 6, 1926). Republished as *Grundlagen des Nationalismus. Vier Aufsätze von Ernst Jünger* in *Stahlhelm-Jahrbuch 1927*. Im Auftrage der Bundesleitung des Stahlhelm, Bund der Frontsoldaten, ed. Frank Schauwecker (Magdeburg: Stahlhelm Verlag, 1927), 74–76.

16 Jünger, "Der Geist," in *Grundlagen des Nationalismus*, 84–86.

17 I owe this notion to Russell Berman's essay "Written Right Across Their Faces."

18 Cf. Heinz Ludwig Arnold's excellent study *Krieger, Waldgänger, Anarch: Versuch über Ernst Jünger* (Göttingen: Wallstein Verlag, 1990).

19 Walter Benjamin, "The Storyteller," in *Iluminations*, 84. Translation slightly altered.

20 Ernst Jünger, *The Storm of Steel* (London: Chatto and Windus, 1929), 246.

21 My translation from Jünger, *In Stahlgewittern* (Stuttgart: Klett-Cotta, 1985), 252.

22 Jünger, *In Stahlgewittern*, in *Sämtliche Werke*, vol. 1 (Stuttgart: Klett-Cotta, 1978), 234.

23 Ernst Jünger, *Feuer und Blut*, in *Sämtliche Werke*, vol. 1 (Stuttgart: Klett-Cotta, 1978), 473 f.

24 Bohrer, *Die Ästhetik des Schreckens*, 110.

25 Jünger, *In Stahlgewittern*, 6th edition (Berlin: Mittler und Sohn, 1925), 20 f.

26 Ernst Jünger, *Über den Schmerz*, in *Sämtliche Werke*, vol. 7 (Stuttgart: Klett-Cotta, 1980), 181.

27 Jünger, *Über den Schmerz*, 182.

28 Ernst Jünger, *Feuer und Blut*, in *Sämtliche Werke*, vol. 1 (Stuttgart: Klett-Cotta, 1978), 532.

29 Bohrer, *Die Ästhetik des Schreckens*, 110.

30 Bohrer, *Die Ästhetik des Schreckens*, 77.

31 To the best of my knowledge, both capriccios are available in English translation only in Marcus Bullock's recent Jünger book entitled *The Violent Eye: Ernst Jünger's Visions and Revisions on the European Right* (Detroit: Wayne State University Press, 1992), 226 f.

32 Ernst Jünger, "Grausame Bücher," in *Das abenteuerliche Herz*, 2nd version, *Sämtliche Werke*, vol. 9 (Stuttgart: Klett Cotta, 1979), 226.

33 Bohrer, *Die Ästhetik des Schreckens*, 248, 249.

34 On Kafka's relationship to Octave Mirbeau and late nineteenth-century decadence see Mark Anderson, *Kafka's Clothes* (New York: Oxford University Press, 1992), especially the chapter on *The Penal Colony*.

Chapter 7: **Alexander Kluge**

1 Hans Magnus Enzensberger, "Ein herzloser Schriftsteller," *Der Spiegel*, no. 1 (January 2, 1978): 81–83.

2 Serious critical studies of Kluge's literary texts have only begun to appear since the early 1980s. See Rainer Lewandowski, *Alexander Kluge* (Munich: Beck, 1980), Gerhard Bechtold, *Sinnliche Wahrnehmung von sozialer Wirklichkeit* (Tübingen: Gunter Narr, 1983); Stefanie Carp, *Kriegsgeschichten: Zum Werk Alexander Kluges* (Munich: Fink, 1987), as well as the essay collections published by Suhrkamp Materialien and *Text + Kritik*, 85/86 (January 1985).

3 Alexander Kluge *Lebensläufe* (Frankfurt: Fischer, 1964), 5.

4 On the relationship between Kluge and Adorno, see especially Miriam Hansen, "Introduction to Adorno: 'Transparencies on Film'," *New German Critique* 24/25 (Fall/Winter 1981–82): 186–98. Also see Carp, *Kriegsgeschichten*.

5 In German, the word *Sinn* is ambivalent. It can be translated as "meaning," but it also refers to "sense," as in "senses," "sensual," "sensuality." When Kluge talks of *Sinnentzug*, then, he also refers to an atrophy of the human senses brought about by the processes of modernization.

6 Kluge, *Lernprozesse mit tödlichem Ausgang* (Frankfurt: Suhrkamp, 1973), 5.

7 On Kluge's technique of mixing text and illustrations, see Gerhard Bechtold, *Sinnliche Wahrnehmung*. See also Bechtold's essay in Thomas Böhm-Christl, ed. *Alexander Kluge: Materialien* (Frankfurt: Suhrkamp, 1983), 212–32.

8 Dietmar Kamper, "Phantastische Produktivität," in Böhm-Christl, *Materialien*, 287.

9 Stefanie Carp, *Kriegsgeschichten*, 110.

10 Kluge, "Die schärfste Ideologie: dass die Realität sich auf ihren realistischen Charakter beruft," in *Gelegenheitsarbeit einer Sklavin: Zur realistischen Methode* (Frankfurt: Suhrkamp, 1975), 222.

11 For an account of this aspect of Kluge's work, see Rainer Stollman, "Alexander Kluge als Realist," in Böhm-Christl, *Materialien*, 245–78.

12 Kluge, "Die schärfste Ideologie," 216.

13 For an excellent analysis of the pivotal place of this story in Kluge's oeuvre, see David Roberts, "Kluge und die deutsche Zeitgeschichte: *Der Luftangriff auf Halberstadt am 8.4.1945*," in Böhm-Christl, *Materialien*, 77–116.

14 Kluge, "Die Differenz," in Kluge, *Theodor Fontane, Heinrich von Kleist, Anna Wilde* (Berlin: Wagenbach, 1987), 89.

Chapter 8: Postenlightened Cynicism

1 Peter Sloterdijk, *Critique of Cynical Reason* (Minneapolis: University of Minnesota Press, 1987), 45. All further references will be given by page numbers in the text.

2 Michel Foucault, "The Subject and Power," in Hubert L. Dreyfus and Paul Rabinow, *Michel Foucault: Beyond Structuralism and Hermeneutics* (Chicago: University of Chicago Press, 1983), 216. It should be said that Foucault speaks only to a minor, if well-known text in Kant's oeuvre. The fact that Kant's subject is ultimately as unhistorical and universal as that of Descartes and partakes in the same problematic trajectory of the construction of Western rationality was already well worked out by Adorno and has recently been subtantiated in new ways by Hartmut and Gernot Böhme in *Das Andere der Vernunft* (Frankfurt am Main: Suhrkamp, 1983). Nevertheless Foucault's brief observations here point to his own commitment to a form of enlightenment that has not severed all its ties to the by now notorious siècle des lumières.

3 Fredric Jameson, "Postmodernism, or the Cultural Logic of Late Capitalism," *New Left Review* 146 (July/August 1984): 53–92.

4 Ibid., 65.

5 Ibid.

6 In: *Der Tod der Moderne. Eine Diskussion* (Tübingen: Konkursbuchverlag, 1983), 104.

7 For a critique of Baudrillard and Lyotard and their reception in West Germany, see Klaus R. Scherpe, "Dramatisierung und Entdramatisierung des Untergangs: Zum ästhetischen Bewusstein von Moderne und Postmoderne," in Andreas Huyssen and Klaus R. Scherpe, eds. *Postmoderne: Zeichen eines kulturellen Wandels* (Reinbek: Rowohlt, 1986), 270–301. American translation in *Cultural Critique* 5 (Winter 1986–87).

8 Leslie A. Adelson, "Against the Englightenment: A Theory with Teeth for the 1980s," *German Quarterly* 57 (Fall 1984): 631.

Chapter 9: In the Shadow of McLuhan

1 Jean Baudrillard, "The Ecstasy of Communication," in Hal Foster, ed. *The Anti-Aesthetic: Essays on Postmodern Culture* (Port Townsend: Bay Press, 1983), 138.

2 John Fekete, *The Critical Twilight* (London: Routledge & Kegan Paul, 1977).

3 Marshall McLuhan, *The Medium Is the Message: An Inventory of Effects* (New York: Bantam Books, 1967), 26.

4 Jean Baudrillard, "The Precession of Simulacra," in *Simulations* (New York: Semiotext(e), 1983), 8.

5 Thus the hyperquote on the back cover of *Simulations*.

6 Peter Sloterdijk, *Critique of Cynical Reason* (Minneapolis: University of Minnesota Press, 1987). Sloterdijk is more successful in his critique of postenlightened cynicism than he is in his proposal of countercultural kynical alternatives.

7 Fekete, *Critical Twilight*, 149.

8 Marshall McLuhan, *Understanding Media: The Extensions of Man* (New York: McGraw-Hill, 1964), 20.

9 "Marshall McLuhan: A Candid Conversation with the High Priest of Popcult and Metaphysician of Media," *Playboy* (March 1969), 158.

10 Cf. Andreas Huyssen, "Mass Culture as Woman: Modernism's Other," in *After the Great Divide* (Bloomington: University of Indiana Press, 1986).

11 McLuhan, *Understanding Media*, 19.

12 Daniel Bell, *The Cultural Contradictions of Capitalism* (New York: Basic Books, 1976), 73.

13 McLuhan, *Understanding Media*, 20.

14 Jonathan Crary, "Eclipse of the Spectacle," in Brian Wallis, ed. *Art After Modernism: Rethinking Representation* (New York: The New Museum of Contemporary Art, 1984), 284.

15 McLuhan, *Understanding Media*, 21.

16 Jean Baudrillard, "Marshall McLuhan: *Understanding Media*," *L'Homme et la société*, 5 (July–September 1967): 229.

17 Ibid., 230.

18 Ibid.

19 Ibid.

20 For an excellent discussion of Baudrillard's cultural politics, see Meaghan Morris, "Room 101, Or a Few Worst Things in the World," in André Frankovits, ed. *Seduced and Abandoned: The Baudrillard Scene* (Glebe: Stonemoss Services, 1984).

21 Jean Baudrillard, *In the Shadow of the Silent Majorities , Or The End of the Social* (New York: Semiotext(e), 1983), 40.

22 Ibid., 13.

23 This is also the argument, as well as a critique of Brecht and Enzensberger's paradigm of *Umfunktionierung* (or refunctioning, reutilization) in Baudrillard's essay "Requiem for the Media," in *For a Critique of the Political Economy of the Sign* (St. Louis: Telos Press, 1981).

24 Baudrillard, "Implosion of Meaning in the Media," in *Silent Majorities*, 107–08.

25 Jean Baudrillard, *Les stratégies fatales* (Paris: Grasset, 1983).

26 Baudrillard, "Ecstasy of Communication," 136.

27 Baudrillard, "Marshall McLuhan," 227.

28 Jean Baudrillard, "L'Ordre des simulacres," in *L'Echange symbolique et la mort* (Paris: Gallimard, 1976). Translated as "The Orders of Simulacra," in *Simulations*, 83.

29 Baudrillard, *Silent Majorities*, 58 ff. See also idem, "Sur le nihilisme," in *Simulacres et simulation* (Paris: Editions Galilée, 1981), 229–36.

30 Baudrillard, *Simulations*, 11.

31 Ibid., 12

Chapter 10: **Back to the Future**

1 Dick Higgins, "Fluxus: Theory and Reception," manuscript, 1982. A revised version of this essay appears in *Lund Art Press* 2, no. 2 (1991): 25–50. Robert Watts, cited by Matthew Rose, "Fluxussomething? Is There a Renaissance in Fluxus or Just Boredom With Everything Else? A Survey of Fluxus in America," ibid., 16.

2 Maciunas's comments on Fluxus as rear-guard are contained in a document of three handwritten pages "Comments on the relationship of Fluxus to the so called 'Avant-garde Festival,'" Archiv Sohm, Staatsgalerie Stuttgart, George Maciunas papers no. 86.

3 George Maciunas, "Neo-Dada in Music, Theater, Poetry, Art," Archiv Sohm, Staatsgalerie Stuttgart. Printed in Janet Jenkins, ed. *In the Spirit of Fluxus* (Minneapolis: Walker Art Center, 1993), 156 f.

4 Harold Rosenberg, *The Tradition of the New* (Chicago: University of Chicago Press, 1960).

5 Hans Magnus Enzensberger, The Aporias of the Avant-garde," in *The Consciousness Industry* (New York: Seabury Press, 1974), 16–41.

6 Guy Debord, *The Society of the Spectacle,* revised English edition (Detroit: Black & Red, 1983).

7 Susan Sontag, *Against Interpretation and Other Essays* (New York: Farrar, Straus and Giroux, 1966), 13–23.

8 Walter Benjamin, "Surrealism," in *Reflections* (New York and London: Harcourt Brace Jovanovich, 1979), 179.

9 Sontag, *Against Interpretation,* 23.

10 Dick Higgins, "Intermedia," *Something Else Newsletter* 1, no. 1 (February 1966). Reproduced in Thomas Kellein, *Fröhliche Wissenschaft: Das Archiv Sohm,* exh. cat. (Stuttgart: Staatsgalerie Stuttgart, 1986), 15.

11 Entitled Degenerate Art, this exhibition was the high-point of the Nazi attack on the avant-garde and of their desecration of modernism as decadent and un-German. The exhibition was reconstructed by the Los Angeles County Museum of Art in 1991. See Stephanie Barron et al., *"Degenerate Art": The Fate of the Avant-Garde in Nazi Germany,* exh. cat. (Los Angeles County Museum of Art, 1991).

12 Walter Benjamin, "On Some Motifs in Baudelaire," *Illuminations* (New York: Schocken Books, 1969), 177–180.

13 Theodor W. Adorno, "Kunst und die Künste," in *Ohne Leitbild: Parva Aesthetica* (Frankfurt am Main: Suhrkamp, 1967), 158–182.

Chapter 11: **Anselm Kiefer**

1 See the foreword to the catalogue for Anselm Kiefer's American retrospective. Mark Rosenthal, *Anselm Kiefer* (Chicago and Philadelphia: Art Institute of Chicago and the Philadelphia Museum of Art, 1987).

2 Donald B. Kuspit, "Flak from the 'Radicals': The American Case Against German Painting," in Brian Wallis, ed. *Art After Modernism: Rethinking Representation* (New York: New Museum of Contemporary Art, 1984), 141.

3 Documented in Ernst Bloch et al., *Aesthetics and Politics: Debates between Bloch. Lukács, Brecht, Benjamin, and Adorno* (London: Verso, 1980).

4 See especially Benjamin H.D. Buchloh, "Figures of Authority, Ciphers of Regression," *Art After Modernism: Rethinking Representation,* 107–36.

5 For comprehensive analysis and documentation see the special issue on the *Historikerstreit* in *New German Critique* 44 (Spring/Summer 1988).

6 For example, Peter Schjeldahl, "Our Kiefer," *Art in America* 76:3 (March 1988): 124.

7 *Christian Science Monitor* (21 March 1988): 23.

8 R.H. Fuchs, *Anselm Kiefer* (Venice: Edizioni La Biennale di Venezia, 1980), 62.

9 Steven Henry Madoff, "Anselm Kiefer: A Call to Memory," *ARTnews,* 86 (October 1987): 127.

10 Rosenthal, *Kiefer,* 7.

11 Roger Ebert, *Images at the Horizon. Workshop with Werner Herzog* (Chicago: Facets Multimedia, 1979), 21.

12 Jürgen Harten, *Anselm Kiefer* (Düsseldorf: Städtische Kunsthalle, 1984), 41 ff. Catalogue of the 1984 Kiefer exhibition in Düsseldorf, Paris, and Jerusalem.

13 The poem's full text is given in Rosenthal, *Kiefer*, 95 ff.

14 See for instance Petra Kipphoff, "Das bleierne Land," in *Die Zeit* 31 (July 28, 1989), or Hans Joachim Müller, "Der Alchemist, der Erlöser," in *Die Zeit* 13 (March 22, 1991).

15 See Peter Schjeldahl, "Our Kiefer," *Art in America* 76:3 (March 1988).

16 See, for example, Eduard Beaucamp, "Der Prophet und sein Bildertheater," in *Frankfurter Allgemeine Zeitung* 74 (March 28, 1991).

17 Christian Kämmerling and Peter Pursche, "Nachts fahre ich mit dem Fahrrad von Bild zu Bild. Ein Werkstattgespräch mit Anselm Kiefer," *Süddeutsche Zeitung, Magazin* 46 (16 November 1990); Axel Hecht and Alfred Nemeczek, "Bei Anselm Kiefer im Atelier," *Art* 1 (January 1990), Hamburg.

18 Kämmerling/Pursche, "Nachts fahre ich...," 24 (my translation).

19 See, for example, Jean François Lyotard, "Presenting the Unpresentable: The Sublime," *Artforum* 20 (April 1982): 64–69.

Chapter 12: **Monuments and Holocaust Memory in a Media Age**

1 Robert Musil, "Nachlaß zu Lebzeiten," in Adolf Frisé, ed. *Prosa, Dramen, späte Briefe,* (Hamburg: Rowohlt, 1957), 480.

2 Primo Levi, *The Drowned and the Saved* (New York: Vintage International, 1989), 31.

3 Jean-François Lyotard, "Ticket to a New Decor," *Copyright* 1 (Fall 1987): 14–15. On the relationship of Holocaust memory to postmodernism and the discourse of mourning see Eric L. Santner's study *Stranded Objects: Mourning, Memory, and Film in Postwar Germany* (Ithaca and London: Cornell University Press, 1990).

4 See Hermann Lübbe, "Zeit-Verhältnisse," in Wolfgang Zacharias, ed. *Zeitphänomen Musealisierung: Das Verschwinden der Gegenwart und die Konstruktion der Erinnerung* (Essen: Klartext Verlag, 1990), 40–50. See also Hermann Lübbe, *Die Aufdringlichkeit der Geschichte* (Graz, Vienna, Cologne: Verlag Styria, 1989).

5 See the collection of essays, edited and introduced by Saul Friedlander, *Probing the Limits of Representation: Nazism and the "Final Solution"* (Cambridge: Harvard University Press, 1992).

6 For a compelling account see Deborah Lipstadt, *Denying the Holocaust: The Growing Assault on Truth and Memory* (New York: The Free Press, 1993).

7 Saul Friedlander, *Reflections of Nazism: An Essay on Kitsch and Death* (New York: Harper and Row, 1984).

8 See James Young's groundbreaking study *The Texture of Memory: Holocaust Memorials and Meaning in Europe, Israel, and America* (New Haven and London: Yale University Press, 1993).

9 Geoffrey Hartman, "The Book of Destruction," in Friedlander, ed. *Probing the Limits of Representation,* 319.

10 *Adi Ophir, "On Sanctifying the Holocaust: Anti-Theological Treatise," Tikkun* 2:1 (1987): 64

11 Jürgen Habermas, *Eine Art Schadensabwicklung* (Frankfurt am Main: Suhrkamp, 1987), 163.

12 Kafka, *Letter to Oskar Pollak,* 27 January 1904.

Index